MATHEW B. BRADY

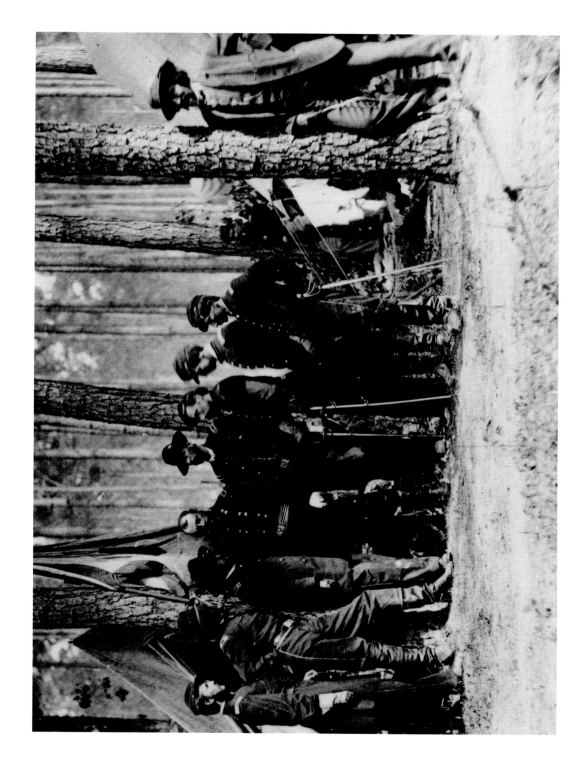

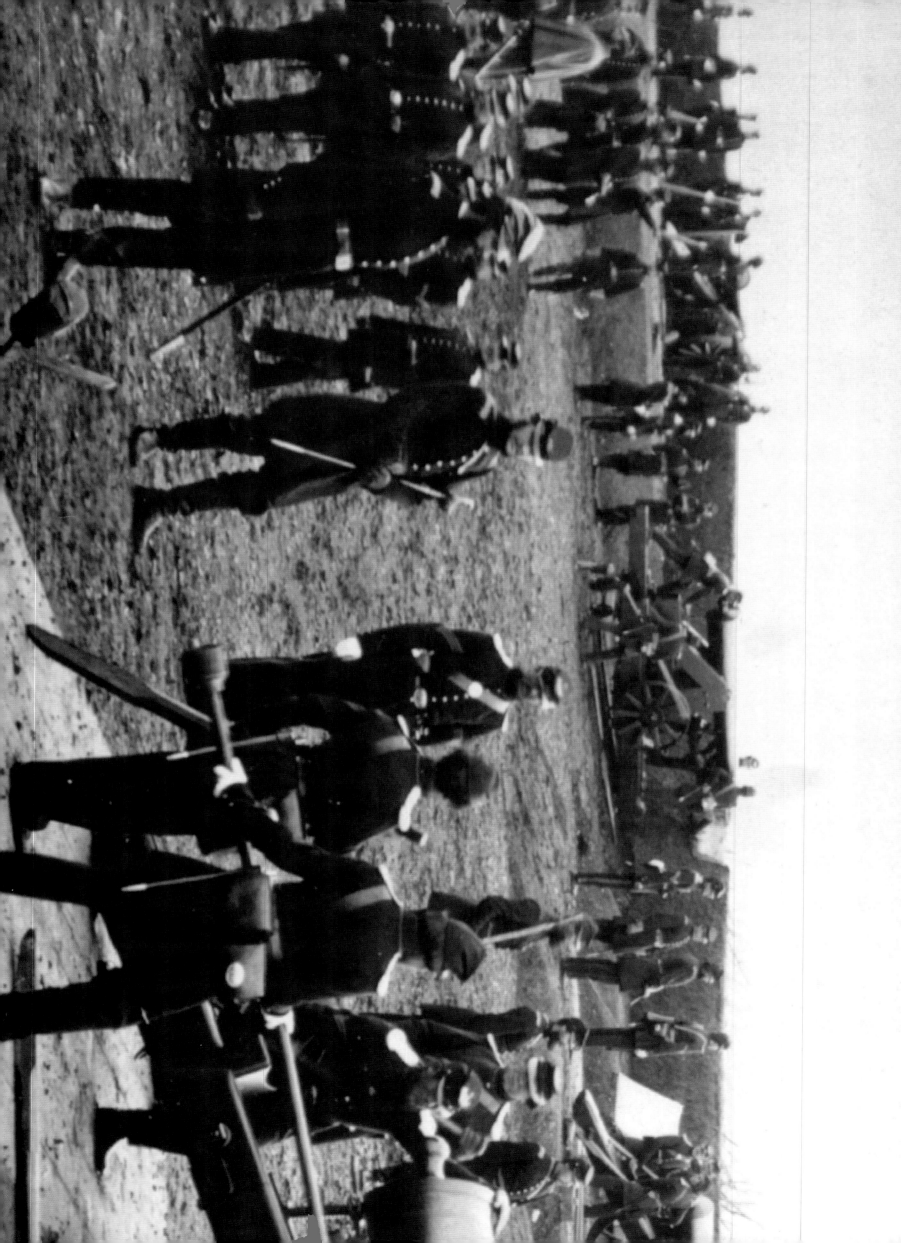

MATHEW B. BRADY

WAYNE YOUNGBLOOD AND RAY BONDS

CHARTWELL
BOOKS, INC.

This edition published in 2010 by

CHARTWELL BOOKS, INC
A Division of
BOOK SALES, INC.
276 Fifth Avenue Suite 206
New York, New York 10001

ISBN 13: 978-0-7858-2666-8
ISBN 10: 0-7858-2666-1

Printed in China

Project Manager: Ray Bonds
Designer: Mark Tennent

Publisher's Note

As explained in the introduction, many of the photographs attributed to Mathew Brady were actually made by photographers from his New York and Washington, D.C., studios and galleries, and by hired operatives in the field. Many were taken by photographers who left Brady's employ to set up on their own during the Civil War. Exhaustive attempts have been made to verify the creators of the images, a task made impossible by the passage of time, and the Publisher apologizes if some images have been incorrectly attributed. The Publisher has taken a conscious decision to reproduce the photographs without retouching or any attempt being made to "repair" damage that is evident on the original glass plates and other materials, nor have archivists' notes or numbers been removed.

Additional Photographs

FRONT COVER: Commanding officers of the Irish Brigade, including General Robert Nugent seated at center, and Medal of Honor recipient 1st Lieutenant George W. Ford at left.

BACK COVER: Battery 4 near Yorktown, Virginia, with ten 13-inch mortars.

PAGE 1: Mathew Brady is shown at right, beside a tree, with what appears be a delayed shutter device in his right hand.

PAGES 2–3: The 1st Connecticut Heavy Artillery manning one of the fifteen huge cannon at Fort Richardson, Arlington, Virginia.

PAGES 4–5: Officers of the 69th New York State Militia at Fort Corcoran, Virginia.

PAGES 6–7: A civilian believed to be Mathew Brady (at left) causes a stir of interest among the crew of the steamer *Clinch* on the Tennessee River.

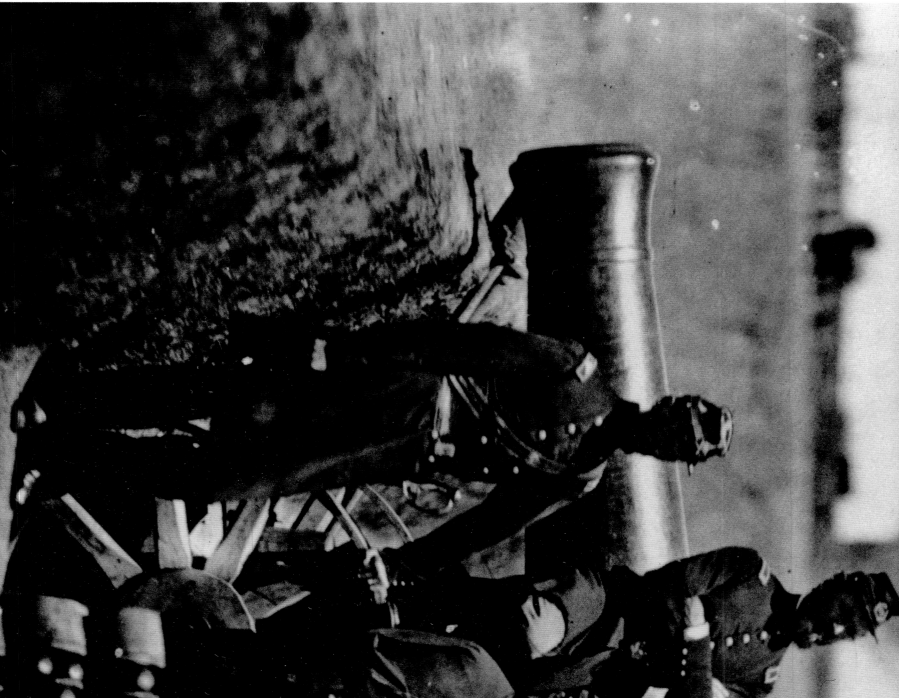

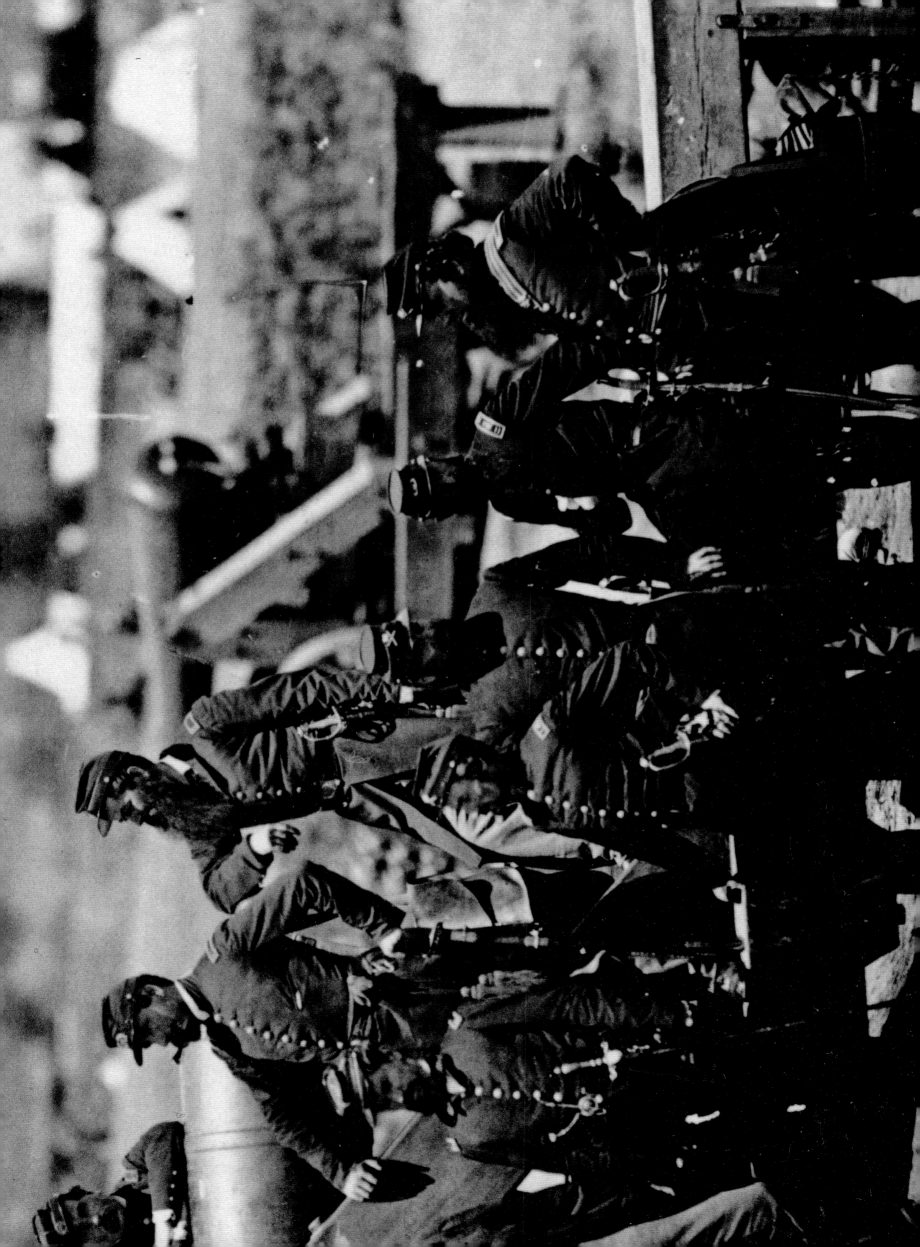

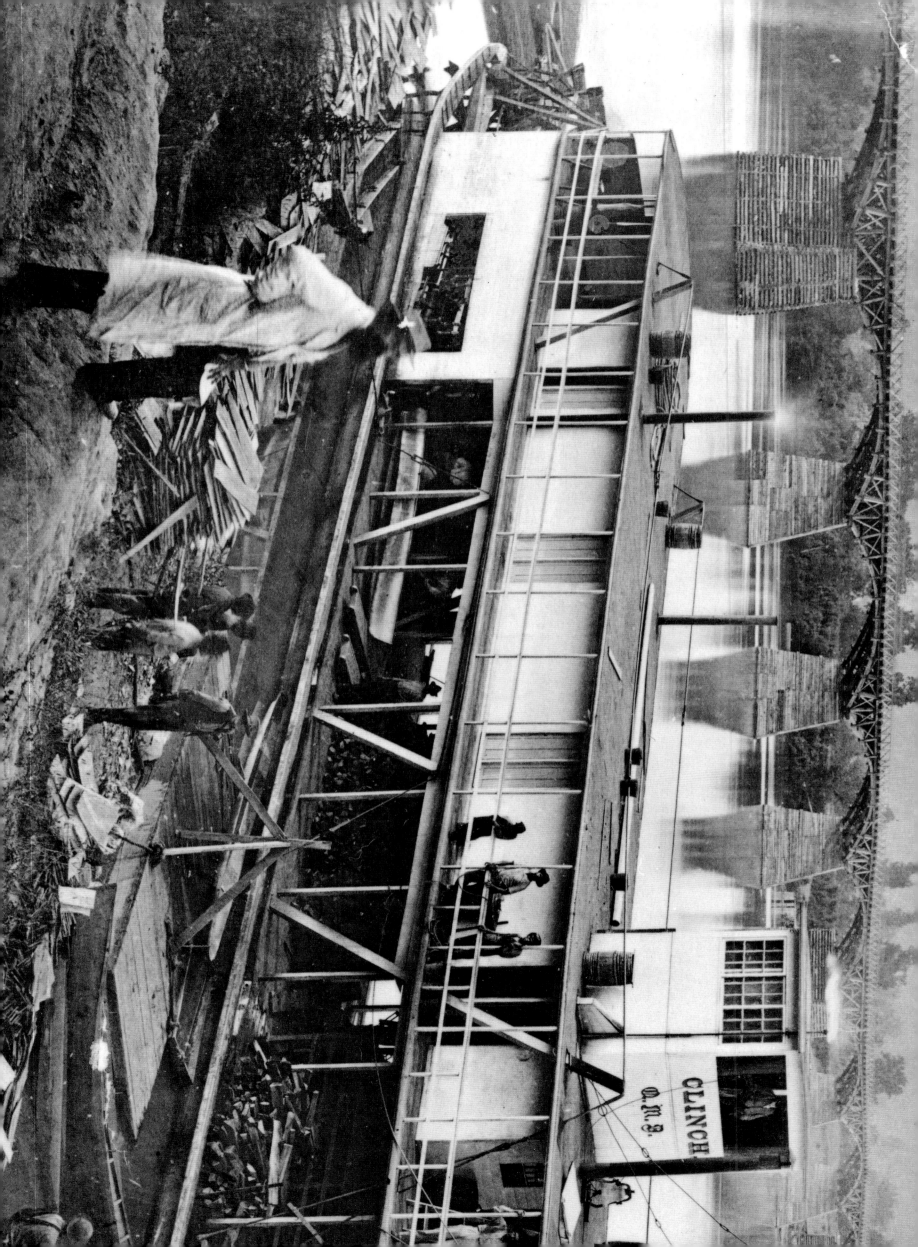

CONTENTS

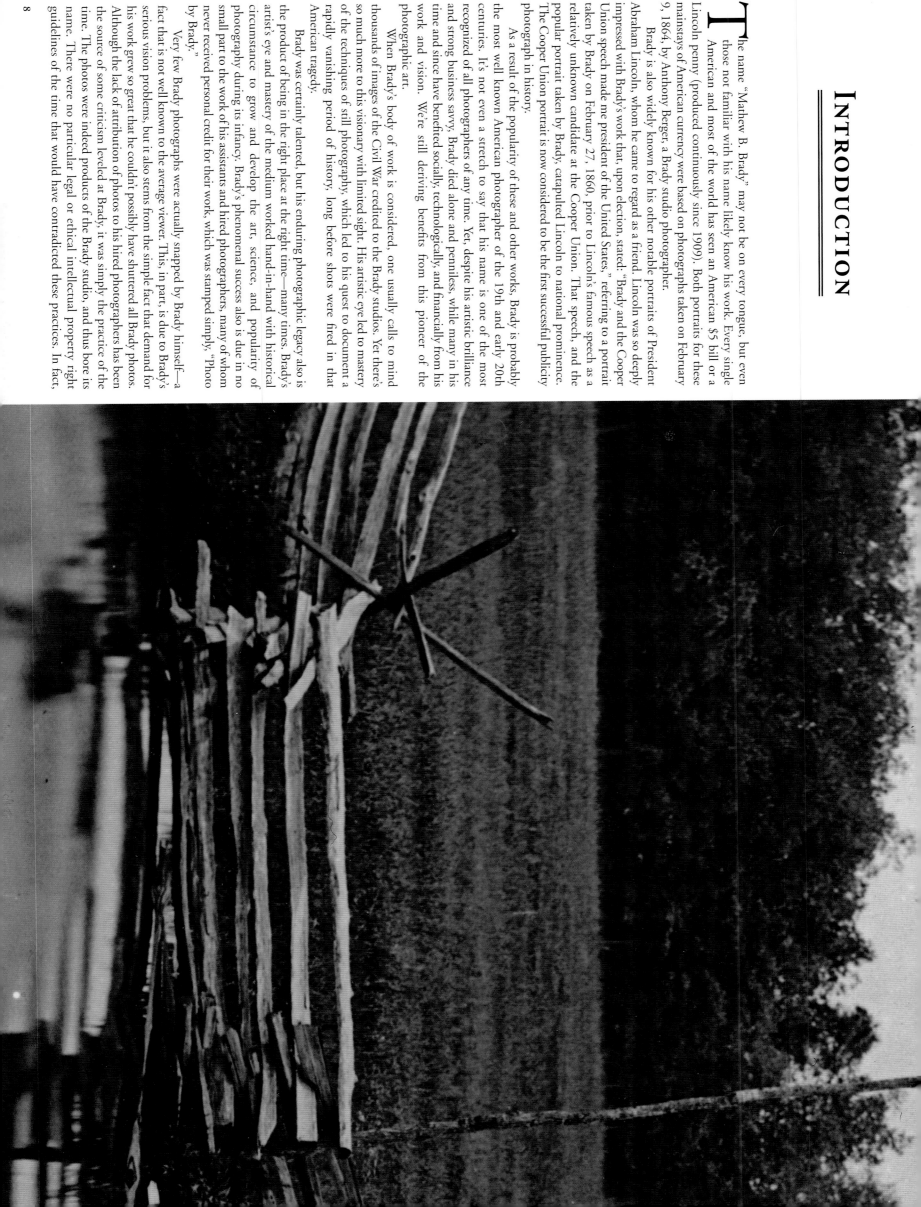

INTRODUCTION

The name "Mathew B. Brady" may not be on every tongue, but even those not familiar with his name likely know his work. Every single American and most of the world has seen an American $5 bill or a Lincoln penny (produced continuously since 1909). Both portraits for these mainstays of American currency were based on photographs taken on February 9, 1864, by Anthony Berger, a Brady studio photographer.

Brady is also widely known for his other notable portraits of President Abraham Lincoln, whom he came to regard as a friend. Lincoln was so deeply impressed with Brady's work that, upon election, stated: "Brady and the Cooper Union speech made me president of the United States," referring to a portrait taken by Brady on February 27, 1860, prior to Lincoln's famous speech as a relatively unknown candidate at the Cooper Union. That speech, and the popular portrait taken by Brady, catapulted Lincoln to national prominence. The Cooper Union portrait is now considered to be the first successful publicity photograph in history.

As a result of the popularity of these and other works, Brady is probably the most well known American photographer of the 19th and early 20th centuries. It's not even a stretch to say that his name is one of the most recognized of all photographers of any time. Yet, despite his artistic brilliance and strong business savvy, Brady died alone and penniless, while many in his time and since have benefited socially, technologically, and financially from his work and vision. We're still deriving benefits from this pioneer of the photographic art.

When Brady's body of work is considered, one usually calls to mind thousands of images of the Civil War credited to the Brady studios. Yet there's so much more to this visionary with limited sight. His artistic eye led to mastery of the techniques of still photography, which led to his quest to document a rapidly vanishing period of history, long before shots were fired in that American tragedy.

Brady was certainly talented, but his enduring photographic legacy also is the product of being in the right place at the right time—many times. Brady's artist's eye and mastery of the medium worked hand-in-hand with historical circumstance to grow and develop the art, science, and popularity of photography during its infancy. Brady's phenomenal success also is due in no small part to the work of his assistants and hired photographers, many of whom never received personal credit for their work, which was stamped simply, "Photo by Brady."

Very few Brady photographs were actually snapped by Brady himself—a fact that is not well known to the average viewer. This, in part, is due to Brady's serious vision problems, but it also stems from the simple fact that demand for his work grew so great that he couldn't possibly have shuttered all Brady photos. Although the lack of attribution of photos to his hired photographers has been the source of some criticism leveled at Brady, it was simply the practice of the time. The photos were indeed products of the Brady studio, and thus bore its name. There were no particular legal or ethical intellectual property right guidelines of the time that would have contradicted these practices. In fact,

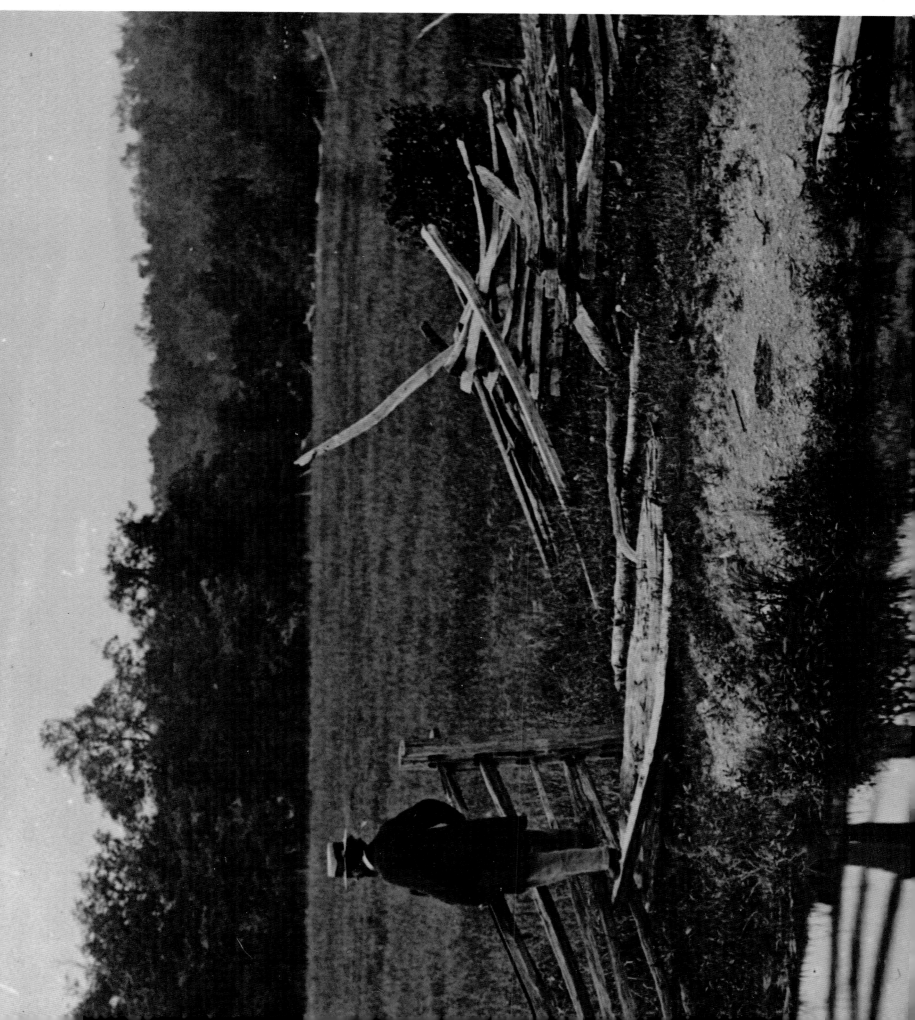

LEFT: Mathew Brady visited the Gettysburg battlefield, July 15, 1863, two weeks after the battle. Here, in a panorama that was made by Brady's associates from two images, Brady is shown contemplating the carnage of the first fighting near McPherson's Woods. (*National Archives*)

Brady's work was copied extensively during his lifetime—both with and without attribution—by countless newspapers, magazines, and even other photographers. Publications often created engravings from the photos, while many rival photographers simply copied his work and stamped it as their own.

However ownership of the actual shutter work is viewed, much as films reflect the vision of the director. His vision as an artist and his supervision of much of the execution was essential to the success of all forms and types of photography his gallery created, whether it was original daguerreotype and ambrotype portraiture, or albumen photos and *cartes de visite* of officers and men off to fight on the battlefields of the Civil War.

Although photographers sprang up like mushrooms as the art of photography became established, most came and went with the wind, many never tasting any significant success. Yet, almost from the beginning, Brady stood out as the leader and the one to copy.

In fact, during the early years of the art of photography, the true cachet of quality work was the imprint "Photo by Brady." These three words, which appeared on works leaving Brady's studio, communicated not only an inherent quality of the work, but name recognition and associations with the rich, powerful, and famous—something very desirable to the average man and the developing middle class.

Little is known of Brady's early life. His tombstone tells us he was born "ca 1822." He more likely was born in 1823 or 1824 in Warren County, N.Y. His parents were Andrew and Julia Brady, Irish immigrants who had come to the United States in 1820. One of the other few things known of Brady's childhood is that as a young teenager he apparently contracted some serious form of inflammation that left his eyes weakened for life and seriously affected his vision.

As a young teenager, Brady was sent to Saratoga Springs, where it was felt that treatments with mineral waters at a resort would help his eyes. The secondary effect of this move was a life-changing event for young Brady.

Even though the treatments did nothing to help his eyes, Brady met William Page, a 28-year-old artist. Page took an interest in the young boy and the artist's eye he saw residing therein. Brady soon began studying portraiture under Page. He also learned how to create jewelry cases.

In 1839, Page and Brady moved to New York City, where Page opened an art studio on Chambers Street. Soon afterward, Page introduced Brady to one of his fine art teachers from the University of the City of New York, Samuel Finley Breese Morse. Morse, who was indeed an art teacher, also was an inventor. He is better known as Samuel F. B. Morse, inventor of the telegraph. Morse had recently returned from Paris, France, where he was working on patenting his invention. While there, he had learned of a new art form—indeed, the earliest form of photography—being developed by Louis Daguerre whereby, using light, images could be fixed permanently onto specially treated thin sheets of silver-plated copper. The almost luminous images formed by this technique were known as daguerreotypes. This was just thirteen years after the first known photograph had been taken by Daguerre's partner, Joseph N. Niepce, who died July 1, 1833.

Unfortunately for Morse, the process of inventing and patenting the telegraph had seriously tapped his resources, and he needed a new way to make money. His plan was to use the technique of photography as a laborsaving device so that he could paint portraits without having to have customers sit for long hours. Brady later noted that Morse was making a living by "painting portraits at starvation prices."

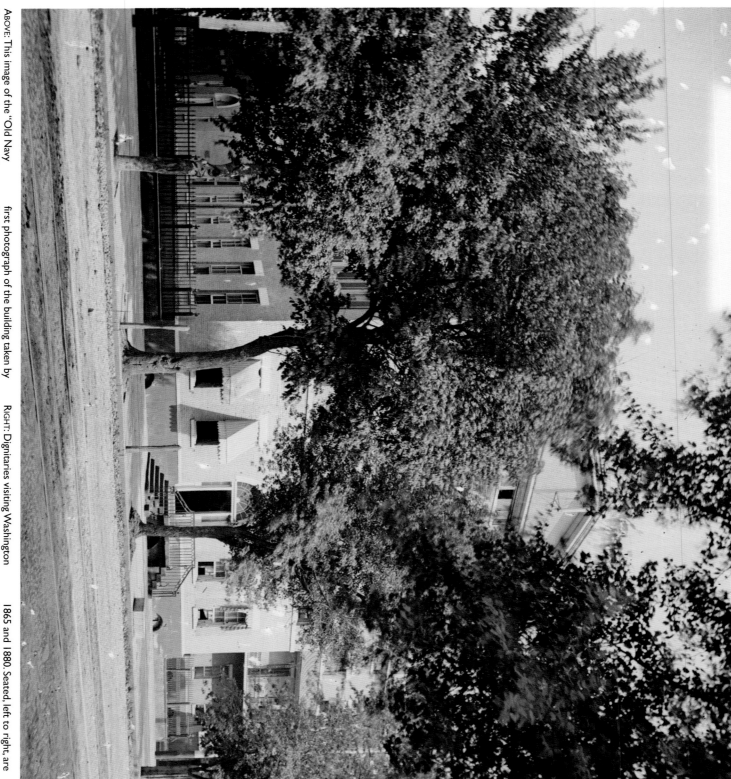

ABOVE: This image of the "Old Navy Department" in Washington, was taken from a glass plate negative, created between 1860 and 1880, on which is intriguingly scratched "1st photo of Brady," which has been taken to mean it was the first photograph of the building taken by Mathew Brady. *(Brady-Handy Collection, Library of Congress)*

RIGHT: Dignitaries visiting Washington were apt to call in on Brady's studio to have their photograph taken. There couldn't have been many more unusual groups than this delegation of Sioux and Arapahoe Indians, photographed between 1865 and 1880. Seated, left to right, are Red Cloud, Big Road, Yellow Bear, Young Man Afraid of his Horses, and Iron Crow; standing, left to right are Little Bigman, Little Wound, Three Bears, and He Dog. *(Brady-Handy Collection, Library of Congress)*

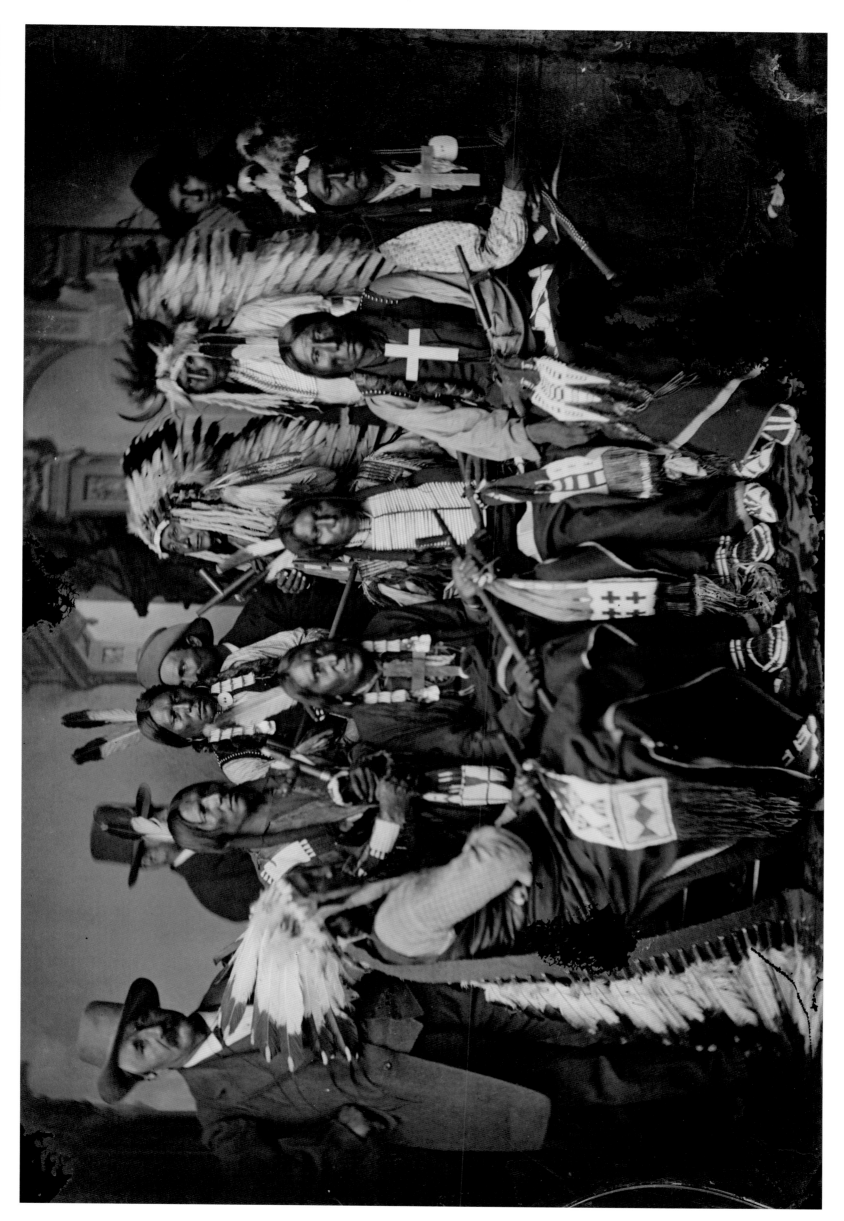

To supplement his income, Morse began teaching—for a fee of $50—this new state-of-the-art technology, and Brady became an early student, raising the fee money by working in a dry goods store and making jewelry cases. This meeting, as Brady later recalled, was to alter his life, which was now "inextricably enmeshed with the infant art of photography." Very shortly after, Daguerre was given a lifetime pension by the government of France to make the process of photography available to all.

In 1844, Brady opened his first photographic studio, Brady's Daguerrian Miniature Gallery, which was located on the fourth floor of a building that stood on the corner of Broadway and Fulton Street in New York City. By the end of the year there were almost a hundred photography studios in New York City, but Brady was soon the acknowledged leader. Even from the beginning, Brady was dedicated to quality and professional excellence. "The camera is the eye of history," he once noted. "You must never make bad pictures."

As an artist, Brady knew there was more to good photography than simply opening the shutter and waiting for the proper exposure time to elapse. He understood, for example, the need for his portrait subjects to wear darker clothes that would help expose the plate more evenly than lighter-colored garments. He also recognized the need for a large amount of natural light for quality exposures. To that end, he installed skylights in his studio to provide additional light, and kept appropriate clothing for clients to change into as needed. Brady's first studio building is still standing, and has skylights where Brady installed them more than 160 years ago!

As luck would have it, the location of Brady's first studio was essentially across the street from P. T. Barnum's American Museum, where one could see all kinds of wonders, from the Swedish Nightingale Jenny Lind to Siamese twins, giants, and the midget, Gen. Tom Thumb. Barnum and some of his star attractions became early subjects of Brady photography. It has even been suggested that Barnum may have been an early Brady financial backer, since he seemed to use every opportunity to send business his way.

Within a year, Brady was working on expanding and finessing his portraiture business, focusing on recording for posterity the famous and powerful visages of the day. This mission was driven initially by Brady's thought that his portrait business would build on itself as more and more important faces appeared on his gallery walls. But he soon became convinced that he was a historian, and that it was important to record images for posterity. Due largely to Brady's efforts we have photographic images of many of our nation's early leaders, including all U.S. presidents from John Quincy Adams (the sixth president) through William McKinley (the twenty-fifth), with the exception of William Henry Harrison (the ninth president), who died in office in 1841, three years before Brady opened his first gallery.

As testament to Brady's outstanding reputation, Zachary Taylor—during his presidency—brought his entire cabinet to Brady's studio one day to have their portraits taken.

Sometime during the spring of 1849, Brady opened his first Washington, D.C., gallery as something of an experiment. He rented a home and opened his studio primarily during sessions of congress. While Brady maintained his studio in Washington, he met Juliet Elizabeth Handy, daughter of a well-known lawyer, Samuel Handy. They were married in late 1849 or early 1850, shortly before a dispute with his landlord caused Brady to let his lease expire and move back to New York City. The couple took up residence in the Astor Hotel, where Brady was able to court many celebrities of the day.

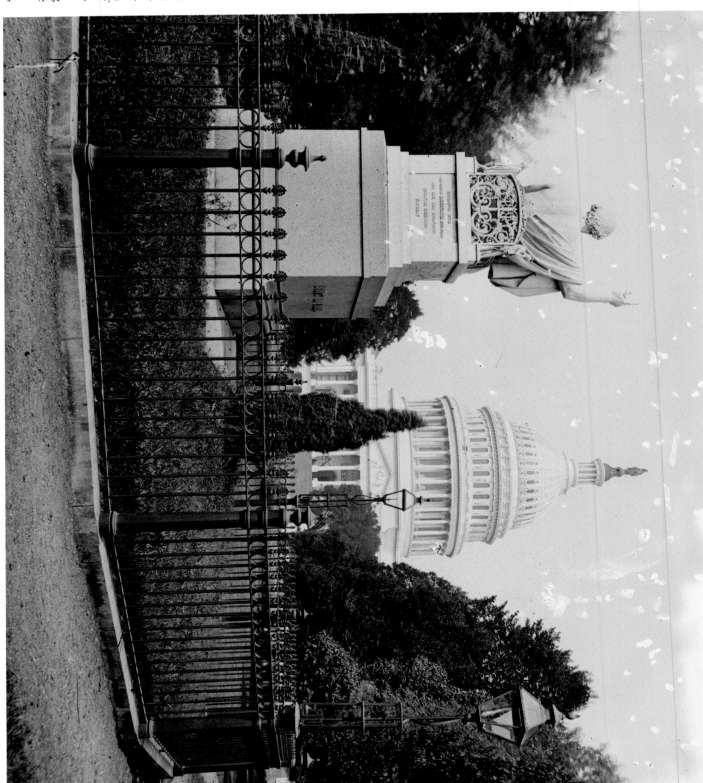

ABOVE: Brady's Washington studio had a broad canvas on which to work, from individual portraits to significant landmarks; here is a rear view of the statue of George Washington, with the U.S. Capitol building in the background. (Brady-Handy Collection, Library of Congress)

On January 1, 1850, Brady published a book titled "Gallery of Illustrious Americans," which included twelve portraits and accompanying biographical sketches. The price for this hefty volume, which weighed five pounds, was $30! Although the book didn't sell well, it was a great marketing tool for Brady's business. It more closely identified Brady with the rich and powerful, and clients wanted their portrait taken where so many famous people had been.

Late in 1850, England's Queen Victoria made a timely announcement that would—once again—help Brady succeed. A special category for daguerreotypes was to be added to competitive exhibits at the first World's Fair, to be held in London in the spring of 1851. Brady and his new wife took an extended trip to England, where his art was awarded top honors and special felicitations of the jury. While there, Brady also observed a new technique known as the wet-plate process, which eventually rendered the art of one-of-a-kind daguerrean photography obsolete. That process, involving a new compound called collodian (a thick mixture of alcohol, ether, and nitrated cotton), allowed the creation of a glass negative, from which countless paper photographs could be printed.

One of the early masters of the wet-plate process was Alexander Gardner, a Scotsman whom Brady met while touring, and who would later become an important business partner.

By March 1853, Brady was successful enough to open a second New York studio, at 359 Broadway. This was not an undertaking done lightly, since there were now more professional photographers in New York City than in all England. Hundreds of these photographers were two-bit artists, both literally and figuratively. Their fee (as opposed to Brady's $2 and upwards) frequently was 25c, and the quality of their work was often questionable. This concerned Brady enough to run an advertisement in several New York City newspapers.

"Being unwilling to abandon any artistic ground to the producers of inferior work," he wrote, "I have no fear of appealing to an enlightened public as to their choice." He was hoping that the public would see the difference and preserve the artistry of the medium, lest it would "degenerate by inferiority of materials which I must correspond with the meanness of the price."

But Brady's hope was somewhat in vain, complicated further by the wet-plate process, which was now sweeping the 25c photographic galleries of the nation. Brady was forced to begin using the new process. Perhaps in part because of his philosophy of the artistry of photography, but mainly due to his vision problems, Brady began spending less time behind the camera. He also had the very real business need of supervising three galleries.

Over the years Brady had numerous assistants and photographers working for him, but perhaps none was as talented or as important to his success as Alexander Gardner, who was already familiar with the wet-plate process when he was hired by Brady in 1856. The two worked well together. One of the offerings Gardner brought to Brady's business was the ability to produce 17- by 21-inch photos called "imperials" by Brady. These large paper photos, produced by the wet-plate process, were usually colorized and touched up to resemble paintings (and hide blemishes of the subject). They were sold for prices ranging from $50 to $750 each.

Another technological development about this time allowed Brady's work to be even more broadly distributed. This involved the production of small photos mounted on slightly larger cards. The French called these new novelties *cartes de visite* (visitor calling cards). Collecting and trading these items soon became a popular pastime. *Cartes de visite*—often, but not always, bearing photos—could be mass-produced inexpensively and allowed even the common

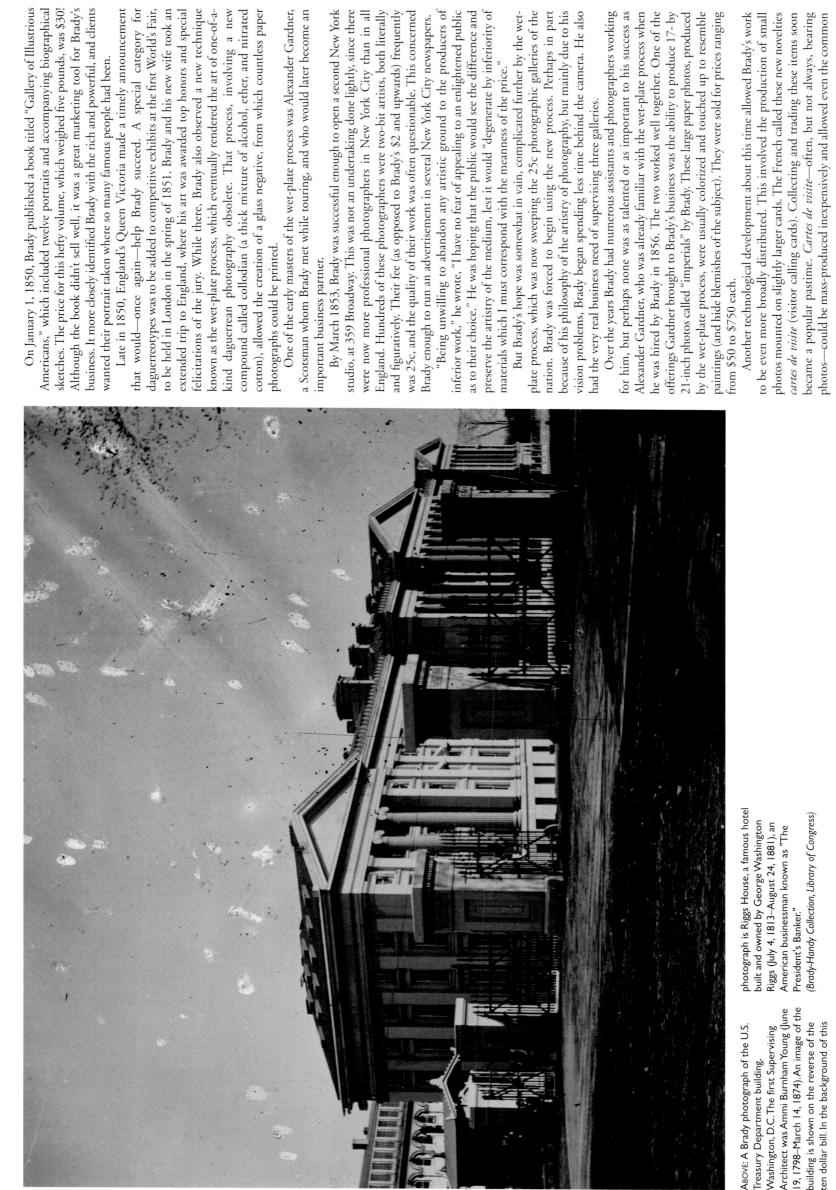

ABOVE: A Brady photograph of the U.S. Treasury Department building, Washington, D.C. The first Supervising Architect was Ammi Burnham Young (June 19, 1798–March 14, 1874). An image of the building is shown on the reverse of the ten dollar bill. In the background of this photograph is Riggs House, a famous hotel built and owned by George Washington Riggs (July 4, 1813–August 24, 1881), an American businessman known as "The President's Banker."

(Brady-Handy Collection, Library of Congress)

citizen to not only be photographed, but to begin building family photo albums as well. The inexpensive nature of commercial *cartes de visite* also allowed people to have celebrities in their photo albums, alongside other loved ones.

Brady felt strongly that the cards, which were comparatively small (many were about 2¼ inches by 3½ inches), cheapened the art of photography and he didn't care for them at all. Gardner, however, immediately saw the revenue potential and convinced Brady to begin creating them. Ironically, this remained the only profitable part of the business during the darkest part of the Civil War. Gardner immediately ordered special four-lens cameras that could take four to eight exposures at once and contracted with E. & H. T. Anthony & Co. to produce *cartes de visite* from Brady images for a percentage of the sales.

In 1858, Brady opened a permanent studio in Washington, D.C., which he called the "National Photographic Art Gallery." Gardner was brought in to manage the gallery, aided by his brother, James, and one of Brady's New York photographers, Timothy O'Sullivan.

The following year Brady opened a third studio in New York, located at 643 Bleecker St., and, in 1860, a fourth gallery at the intersection of 10th and Broadway. This fourth gallery was called the "National Portrait Gallery." Soon afterward, Brady received one of his biggest professional breaks.

On February 27, 1860, the members of the Young Men's Republican Committee accompanied a relatively unknown lawyer from Illinois to Brady's studio for a formal portrait. The lawyer, Abraham Lincoln, was scheduled to speak that evening at the Cooper Union. Lincoln's speech was highly successful, as was the photo. Many felt the portrait, which had been difficult to take due to Lincoln's height and ungainly features, showed Lincoln's calm determination and found it comforting. Huge quantities of the image were sold as *cartes de visites* and it was also reproduced as wood engravings and Currier & Ives lithographs. This would be the first of several Brady sittings with Lincoln, leading up to one just days before the president's death in 1865.

As the year 1860 drew to a close, Brady had much to be thankful for. He had four New York City galleries, and a further one in Washington, D.C. and was one of the most successful photographers in the world. The rich, famous, and powerful consistently sought him out for portraits. Even England's Prince of Wales made a special trip to see Brady when he visited the United States in October.

But there were dark clouds on the horizon. Despite Lincoln's guarantee that he wouldn't interfere with slavery where it already existed, states began seceding from the Union within a few weeks of his election.

Brady was commissioned by Lincoln to take his official inaugural portrait upon Lincoln's arrival in Washington. Between the time Lincoln was elected and his March 14, 1861, inauguration, seven states seceded (leaving twenty-six), and war seemed imminent. U.S. Army sharpshooters hid on rooftops along the inaugural parade route, and infantrymen lined the street. The unfinished Capitol also was guarded heavily, with both visible and hidden gunmen.

Brady set up on the lawn of the Capitol to create the first photographic record of a U.S. presidential inauguration. Tight security, however, prevented the photographer and his assistants from getting a close view.

On April 12, 1861, Fort Sumter, a Union fort in South Carolina, was seized by the Confederates. Although there were no battle casualties, the war had begun. In those states that had seceded, U.S. flags were lowered and state flags raised. Brady's studio filled with new volunteer soldiers who wanted their portraits taken before heading off to war. New regiments arrived daily, setting up camp in the nation's capital.

RIGHT: Close by Brady's New York studio was P.T. Barnum's American Museum, whose curios photographed by Brady included "little people" "General" Tom Thumb (Charles Sherwood Stratton) and his wife Lavinia, George Washington Morrison "Commodore" Nutt (left), and The Giant.
(Brady-Handy Collection, Library of Congress)

In addition to having strong feelings about slavery and the breakup of the Union, most of these new volunteers (many of whom had never fired a rifle) were infatuated with a very romanticized view of war. This misunderstanding was soon shattered.

On Sunday July 21, 1861, the Union and Confederate armies clashed in the First Battle of Bull Run, near Manassas, Virginia. In addition to the volunteer and regular armies, there were numerous citizens out for the day (it was gorgeous weather) to watch the battle—complete with parasols and picnic supplies. They had no idea what was about to take place. "Every carriage, gig, wagon and hack has been engaged by people going out to see the fight," wrote one reporter. Few of those going to watch had any real idea what actual battle looked like. They thought they'd get to see the "Civil War"—all of it—in a single afternoon from a comfortable hillside.

The outnumbered Confederates put up far more resistance than anticipated and scored a huge rout. Retreating Union troops had their route blocked by spectators, and it was only by chance that numerous civilians weren't injured. The romance of war lost its gloss for many as they viewed the snarl from beneath overturned carriages and buggies.

Among the civilians present was photographer Mathew Brady, complete with two Whatsit Wagons, as they became known. These were his on-the-road developing rooms. No photographs survived the chaos, which damaged his wagons and smashed supplies—much of which had been purchased with his first loan of $3,628, earlier in the year.

The First Battle of Bull Run galvanized Brady. He was determined that the war—which he and many others thought would last only a few weeks—needed to be photographed and documented as an important part of American history. This move concerned everyone close to Brady because of the very real risks involved—physical and financial.

Both Brady and Gardner claimed the idea of photographically documenting the war was their own, but the "who" no longer matters. Brady was committed physically, emotionally, and financially to the effort and took the associated risks and responsibility.

Brady received special permission to photograph the war, first from Allan Pinkerton, head of the Secret Service (although Pinkerton couldn't offer protection). The photographer also went to Abraham Lincoln, who scrawled, on a card, "Pass Brady. A. Lincoln." He received final approval to go onto the battlefields from Secretary of War Edwin Stanton. He next began setting up teams of photographers to document the war in photos, although at his own cost. He envisioned having teams all over, camped strategically near to where Union armies were in the field.

While Brady truly felt it was important to document the war, he also believed that the enormous costs of outfitting battlefield photographers (more than thirty-five teams) would be repaid many times over through the sale of "War Views" at his various galleries. Unfortunately, he seriously underestimated the duration of the war and considerably overestimated the contemporary demand for photos of it.

Throughout the war, Brady and his photographers followed the Union troops, sometimes having their supplies carried along with the military's. Among the early military actions captured by Brady's photographers' shutters were the battles of Fair Oaks, Seven Days, Second Bull Run, and Antietam, where it is thought that the only photo of actual battle was taken. It is also from the aftermath of this gruesome battle that many photos of corpse-strewn fields—the first such photos of the war—were made. These photos, a total of

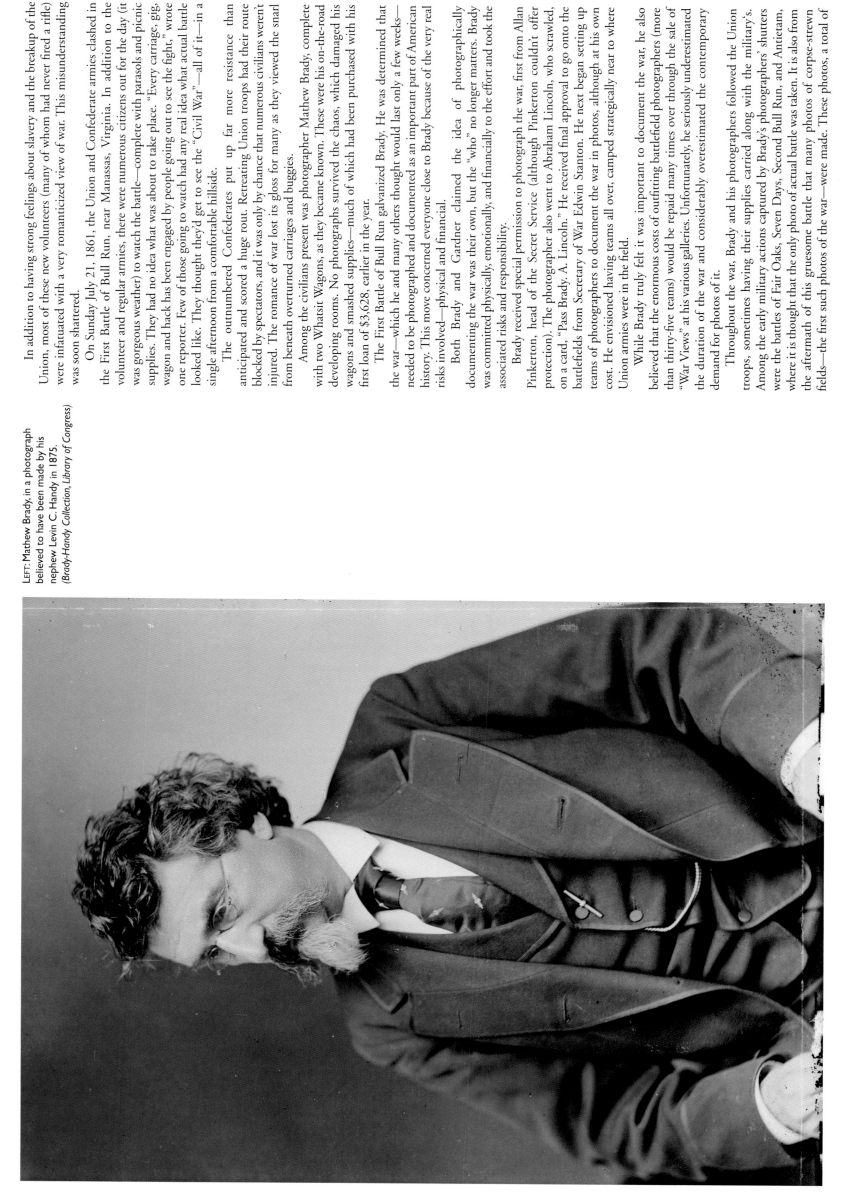

LEFT: Mathew Brady, in a photograph believed to have been made by his nephew Levin C. Handy in 1875. *(Brady-Handy Collection, Library of Congress)*

almost seventy, were displayed for a time in one of Brady's New York galleries and brought war and its truly high cost home to the general public in a way nothing else could. The photos also served another purpose, as mothers, fathers, and other loved ones searched the images of the carnage for likenesses of those they knew among the dead.

A *New York Times* writer commented that, unlike the endless lists of the names of the war dead, "Mr. Brady has done something to bring home to us the terrible reality and earnestness of the war. If he has not brought bodies and laid them in our door-yards [doorsteps] and along streets, he has done something very like it." He continued to describe the solemn display and how it affected those viewing the photos by mentioning the frequency with which "one of the women bending over them should recognize a husband, a son, or a brother in the still, lifeless lines of bodies that lie ready for the gaping trenches."

Many Brady photos, capturing everything from military leaders to the battle dead, were mounted and sold on stereograph cards, another new development that allowed the viewer to see something akin to a three-dimensional image.

Despite the initial shock to viewers, early photography of battle is deceptively peaceful. Because Brady's teams frequently traveled near the end of the procession they were the last to get to a site. Because exposures took time, action such as jabbing with bayonets or clubbing with rifles, was impossible to capture on film. Most photos were either studio-style posed shots of officers and men (with trees used for classical columns and tents for draping), or the more graphic images of the war's dead in the field. Occasionally, bodies were moved and posed to achieve a more impactive effect.

Late in 1862, Brady's business took a significant blow when he and Alexander Gardner parted ways. Although no one knows why Gardner left Brady's employ (other than to start his own business), the two remained on good terms. However, Gardner took with him copies of all the negatives of photos that were made during the Peninsular Campaign, Second Battle of Bull Run, and Antietam.

By July 1, 1863, when the battle at Gettysburg broke out, Brady was beset by creditors and deeply in debt, yet he remained committed to seeing the war through to the end. Gardner, now a competitor of Brady, packed up his equipment immediately upon hearing of the battle and arrived July 5, after fighting was done but before the dead had been entirely removed from the battlefields. He took numerous photos, reminiscent of the sorrowful scenes at the earlier Antietam battlefield, sometimes posing the dead so that they would look even more tragic.

Brady and his studio operatives didn't arrive until a week after Gardner had finished and left the battlefield. However, using his artistic eye, Brady directed that photos be taken of the area and of the important landmarks, documenting the battle through nature and scenery, rather than blood. *Harper's Weekly* magazine devoted its entire August 27, 1863, issue to Gettysburg, utilizing engravings made from Brady's photographs.

A few months later, on November 19, 1863, the Gettysburg Battle Cemetery was officially dedicated to honor the many thousands of Union soldiers (more than 3,000) from all over the country who had fallen during the bloody battle and were buried there. Senator Edward Everett was the featured speaker during the ceremony, and spoke for more than two hours. After he was done, President Lincoln gave "a few remarks," which we now know as the "Gettysburg Address." Although this is the most well-known speech Lincoln ever gave, it was so short that not one of the photographers present—including

ABOVE: The U.S. Naval Academy, Annapolis, Maryland, photographed between 1860 and 1880.
(*Brady-Handy Collection, Library of Congress*)

RIGHT: Brady's photograph of General Lee's home, the Custis-Lee Mansion (also called Arlington House) on Arlington Plantation, Virginia. It was seized by Union forces during the war, but handed back to the Custis-Lee family in 1882.
(*Brady-Handy Collection, Library of Congress*)

Brady's crew—was able to get a camera set up quickly enough to take even a single exposure of Lincoln speaking.

On February 9, 1864, Brady's studio shot what are considered some of the finest portraits of Abraham Lincoln, when he—accompanied by his ten-year-old son, Tad—visited Brady's studio. In all, eight different photos were made of Lincoln, and an additional father and son portrait was taken. Since then, these photos have been the source of countless illustrations of Lincoln, including the previously mentioned $5 bill, the penny, and several different postage stamps. The photo of Lincoln and Tad was circulated widely as a popular lithograph for many years. It, too, was the source of a U.S. postage stamp released in 1984.

As the war finally drew to a close on April 9, 1865, with the surrender of Robert E. Lee at Appomattox Court House, Brady was not on hand to photograph the historic moment. By the time he did arrive, everyone was gone and the house was empty. He headed for Richmond, which had been set ablaze by retreating Confederate soldiers. He was able to photograph the smoking ruins of the once-thriving city, but then learned that Lee had returned to his home in Richmond. Brady determined to photograph the beaten general.

"It was supposed that after his defeat it would be preposterous to ask him to sit," Brady explained later, "but I thought it would be the time for the historical picture,"

"It is utterly impossible, Mr. Brady," Lee protested. "How can I sit for a photograph with the eyes of the world upon me as they are today?" After Brady consulted with Lee's wife and others, Lee reluctantly agreed and, on April 17, 1865, became the subject of a set of superb photos of the vanquished general. The sitting, which produced the finest images of the Southern general, must have been a quiet and reflective one indeed, with a saddened, tired photographer who had recently learned of the assassination of the president, aiming his camera at the tired and defeated general.

With the war finally over, the photographer found his financial situation dire. He had borrowed money several times during the war and had, in 1864, sold half of his Washington gallery to James Gibson, the gallery manager. Now, living on credit and with business slack, Brady had few options. He had never been awarded any form of governmental grant to document the war, despite a high level of cooperation from Lincoln's administration. Perhaps, if Lincoln had lived, he would have seen the need for a federally funded and maintained Civil War collection. Now, however, the government was preoccupied with reconstruction and the public no longer wanted to see images of the terrible war. Brady was on his own, trying to recoup some of the monumental expenses he'd borne during the war years. He could have sold much of his work and memorabilia to rich foreign collectors, but turned them down, feeling that the collection needed to remain intact and in the United States.

He approached the New York Historical Society in 1865, asking them to purchase his large collection of Civil War photographs (both those taken by his photographers and those that he traded with or purchased from others). Victorious General Ulysses S. Grant was extremely supportive, stating that the collection would be invaluable to both present and future generations. The NYHS agreed to the purchase, but it never took place. The following year Brady approached congress, but it, too, turned him down after extensive debate.

In 1867, after Gibson abruptly left the country with his share of the studio's money, the Washington gallery went bankrupt. Brady now had to face the creditors alone, but was able to repurchase his gallery at auction and placed it in his wife's name.

ABOVE: Made in the 1860s, this Brady image is thought to be the earliest known photograph of the White House. (Brady-Handy Collection, Library of Congress)

RIGHT: A group of artists assembled for a formal photograph (probably in the 1850s), with Mathew Brady seated at left. (Library of Congress)

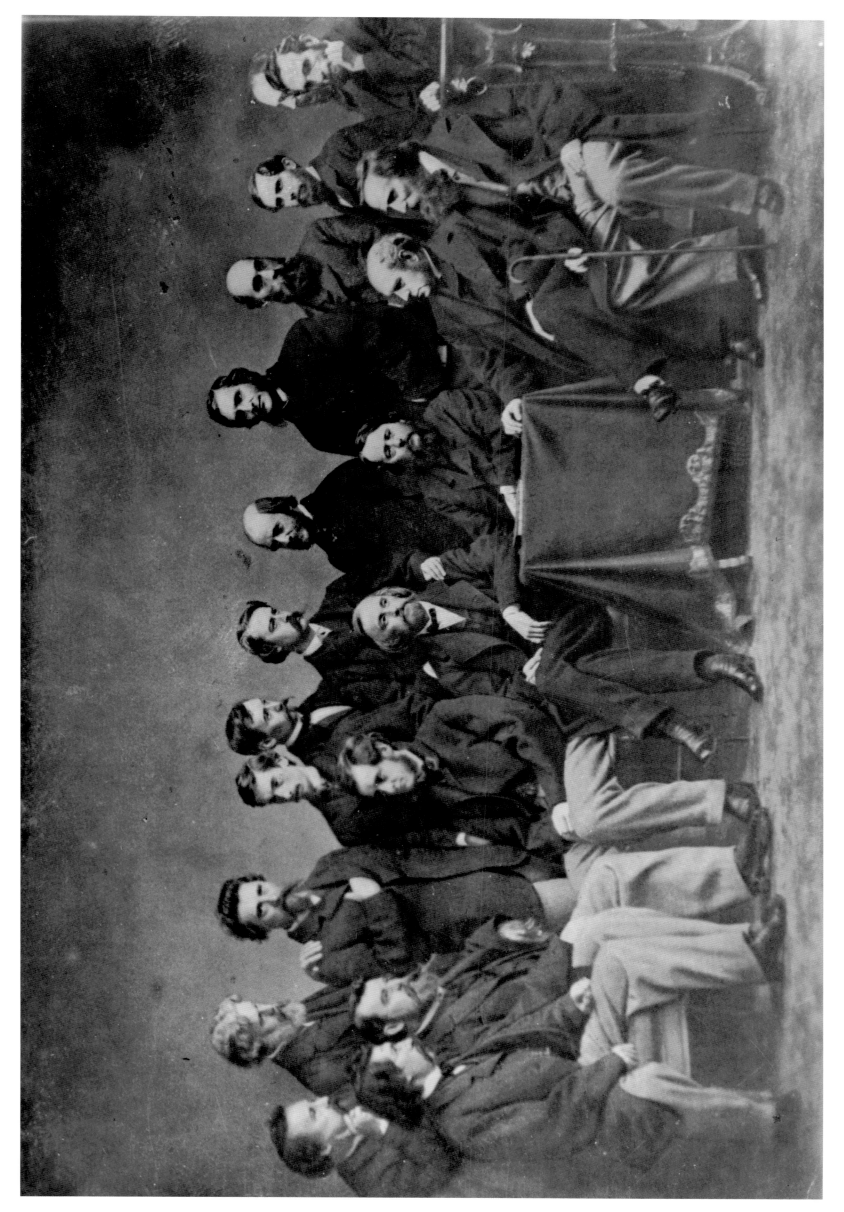

Brady's primary New York creditor, Anthony & Co. (which had sold him supplies throughout the war), began pressing hard for payment. To settle the debt, Brady gave the firm a complete set of his war photos, which Anthony & Co. published and sold, without Brady benefiting from their sale.

By 1871, Brady was trying hard to get congress to appropriate funds to purchase a complete set of his collection, but the wheels of governmental progress ground slowly. In a letter to congress, Brady wrote:

"I have spent a lifetime collecting the works I now offer; I have kept an open gallery at the Capital of the nation for more than a quarter of a century, to assist in obtaining historical portraits and have spent time and money enough, dictated by pride and patriotism, to have made me independently wealthy; In my exertions to save the collection entire, I have impoverished myself and broken up my business and although not commissioned by the Government to do the work I did, still, I was elected by the general consent of the officers of the Government, from the President down, to do the work."

During the period that Brady was working towards getting congress to move, the William "Boss" Tweed scandal broke in New York City. Tweed, who was accused of embezzling millions of dollars from the city, also had been protecting Brady, keeping creditors at bay. Without the protection of Tweed, Brady fell, and was declared bankrupt in January 1873. Although he had assets of about $12,000, Brady had debts (to nearly a hundred creditors) of about $25,000.

Finally, in 1875, congress appropriated $25,000 to secure the entire collection of Brady's prints and negatives. Brady's debts were finally paid, but everything was gone, save the Washington gallery. He once again stepped in as the favored photographer in the nation's capital, but business dwindled over time.

And what of Alexander Gardner, his old partner and more recent rival? Gardner heeded politician and newspaper editor Horace Greeley's advice and headed west, where he became chief photographer for the Union Pacific Railroad as it spidered across the country. Many other photographers, including Timothy O'Sullivan, followed.

As he was working on General Grant's biography during the early 1880s, Mark Twain visited Brady's studio and was so highly impressed with what he saw that he felt that if he weren't so busy he'd very much like to publish a book of Brady's photos. They would "make the noblest subscription book of the age," Twain stated.

By 1881, Brady was forced to sell to the government his prized daguerreotypes of John C. Calhoun, Henry Clay, and Daniel Webster to help make ends meet. They had held an honored place on his gallery walls for many years. Complicating things further was a lawsuit by a former employee, which led to foreclosure of the Washington gallery.

In 1887, Brady's wife, Julia, died. He was heartbroken. By then, Brady's vision was extremely poor, he suffered painful arthritis, and he began to drink heavily. Several years later, Brady was struck by a horse-drawn streetcar—an accident from which he never fully recovered, and which put a permanent end to all his photographic work.

In November 1895, as he was preparing to receive honors and give a stereopticon presentation for a group of Civil War veterans, Brady developed a

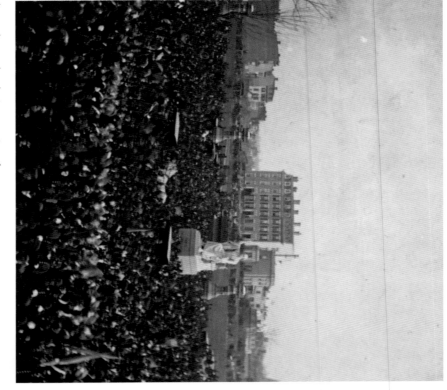

ABOVE: A crowd at the inauguration of Rutherford B. Hayes (1822–1893), nineteenth president of the USA (from 1877 to 1881) on the east front grounds of the U.S. Capitol, surrounding Horatio Greenough's statue of George Washington. The photograph is attributed to "Brady National Photographic Art Gallery, Washington, D.C."
(Library of Congress)

RIGHT: American hero Zachary Taylor (1784–1850), who had distinguished himself in the War of 1812, and who became twelfth president of the United States, was photographed by Mathew Brady in Washington in 1849. Taylor died the following year. This image is a reproduction of a daguerreotype made by Brady.
(Library of Congress)

ABOVE: This portrait of Andrew Jackson (1767–1845), hero of the War of 1812 and president of the United States from 1829 to 1837, is a copy daguerreotype attributed to Mathew Brady's studio in 1844-45, possibly from an original photograph by Edward Anthony.
(Library of Congress)

RIGHT: An artist's impression, published in *Frank Leslie's Illustrated Newspaper*, January 5, 1861, depicts people looking at photographs in Brady's new photographic gallery on the corner of Broadway and Tenth Street, New York City.
(Library of Congress)

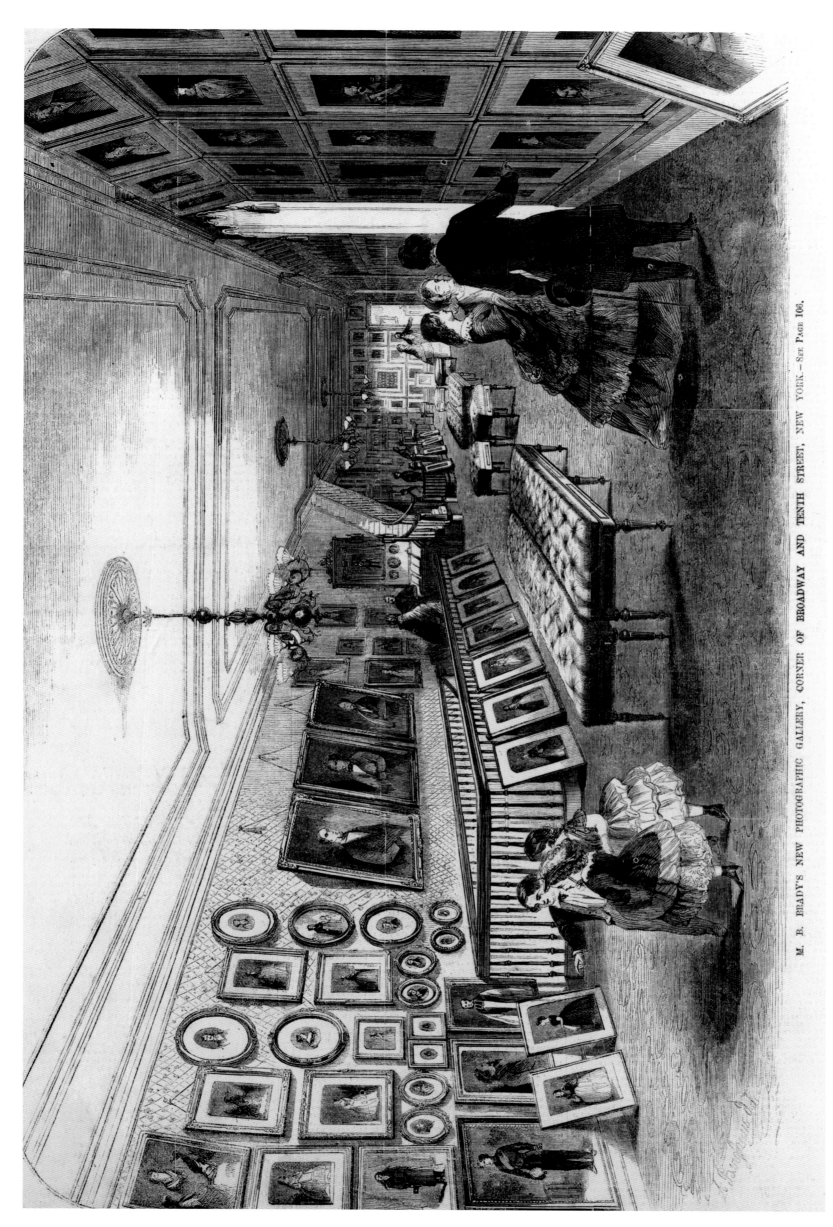

M. B. BRADY'S NEW PHOTOGRAPHIC GALLERY, CORNER OF BROADWAY AND TENTH STREET, NEW YORK. — SEE PAGE 106.

painful kidney problem and was confined to bed. He died in the alms ward of New York City Presbyterian Hospital on January 15, 1896.

Despite his worldwide fame and acclamation, Brady died as had many other visionaries: broke, alone, and in relative obscurity. The final phase of Brady's life, according to a letter from close friend William Riley to Brady's nephew, ended with the artist having nearly nothing left. "I have made a thorough examination of Mr. Brady's effects," wrote Riley, "and find no papers or other property that it would pay to send you....The balance consists of some underwear, a few shirts and socks, etc., not of suficient [value] to send, and so I thought I would send them to the needy."

Both Brady and his wife were buried in the Congressional Cemetery, located a mile and a half from the Capitol, at 1801 E Street, Washington, D.C. But the grave, too, suffered tremendous neglect over the years, and was in shambles by the 1970s. A few years ago, dog owners who walked their pets on the thirty-three-acre wooded grounds began volunteering to tend the garden and perform repairs. Today, the Association for the Preservation of Historic Congressional Cemetery collects $80,000 per year for upkeep from dog walkers—more than three times the amount Brady was finally paid by the U.S. Government for his Civil War photos.

RIGHT: In a photograph made probably just after the Civil War, Mathew Brady is shown at right rear (wearing top hat), along with General Samuel P. Heinzelman (at far left) and his staff, with ladies, at Arlington House (also known as the Custis-Lee Mansion), family home of General Robert E. Lee. "Networking" among the rich, famous, and influential was an important part of Brady's marketing effort to obtain photographic commissions and to persuade the government to purchase his wartime photo collection. Arlington House was taken over by Union forces during the war, but handed back to the Custis-Lee family in 1882, although Lee and his wife never set foot in it again. Today, the house is a memorial to Lee, and is on the National Register of Historic Places. (Library of Congress)

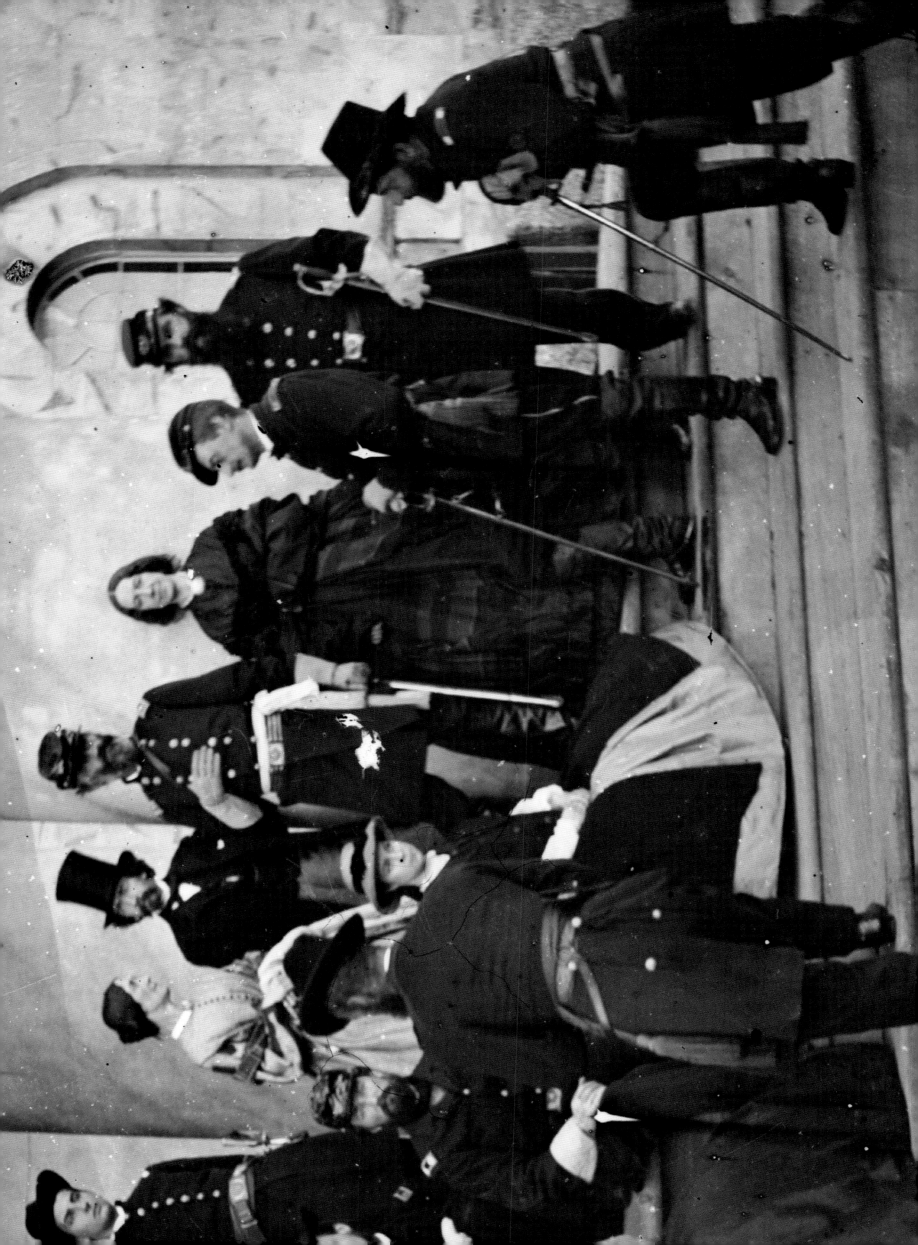

PORTRAITS IN THE STUDIO AND THE FIELD

"From the first," said Mathew Brady, "I regarded myself as under obligation to my country to preserve the faces of its historic men and women." Brady truly considered himself a photo historian, but this strong sense of purpose was something of a byproduct of an idea he had to build his young business.

About a year after Brady opened his Broadway photography studio in 1844, he began seeking out and collecting photographic portraits of as many important Americans as he could. To Brady, these individuals, including past presidents and other politicians, military leaders, actors, actresses, artists, writers, and even the attractions found in P. T. Barnum's American Museum, as well as royalty from overseas, were part of a shrewd attempt to build business. The portraits would serve essentially as testimonials by celebrities in Brady's gallery. The tactic was successful. It didn't take long before leaders were coming to Brady, rather than the other way around.

Brady's first famous subject was the ailing seventh president of the United States, Andrew Jackson. By 1845, Jackson was an invalid. Brady sent Dan Adams, a young photographer from Nashville, to capture Old Hickory's likeness. Jackson saw the importance of the project and, against doctor's orders, steeled himself to make one last appearance—for the camera. A few days later he died.

By 1849, Brady was able to open an additional small studio in Washington, D.C. Other early subjects of Brady included John Tyler, John J. Audubon, Dolley Madison, Daniel Webster, John C. Calhoun, Edgar Allen Poe, Brigham Young, Washington Irving, Henry Clay, Walt Whitman, and many others. Clay, incidentally, was a very reluctant sitter for Brady. He felt strongly that a photographic portrait was a poor substitute for a "real" portrait.

By the time the Civil War broke out, Brady systematically photographed a great many of the notable officers and men of the Union—individually and in groups—in the field.

How did one convince both the truly busy and the egocentric to sit perfectly still for long periods of time for proper exposures? It helped if you were Mathew Brady, who by all accounts was a truly interesting conversationalist with impeccable manners, charm, and grace.

An incident that underscores Brady's grace and charm was when, just a few months before his mysterious death in 1849, a depressed, abject, and penniless Edgar Allan Poe accompanied a friend to Brady's studio. Noting the interest with which Poe watched the proceedings, Brady asked if Poe would like to have his portrait taken as well. The poet declined with a shake of his head. Brady, thinking quickly and sensing it was a refusal based purely on financial grounds, graciously informed Poe that his offer would attract no charge, since he was a fan of Poe's and it would be an honor to have his portrait on the wall alongside those of so many other notables. After some cajoling, Poe sat before the camera as Brady's guest.

RIGHT: Commanding officers of the Irish Brigade in 1865 (note mourning badges worn for assassinated President Lincoln). Gen. Robert Nugent, of the famed 69th NY State Militia and subsequently the 69th NY Volunteers is seated at center, with saber, while Medal of Honor recipient 1st Lt. George W. Ford of the 88th NY Volunteer Infantry stands at left and Capt. William H. Terwilliger of the 63rd NY Volunteers stands at right. (Library of Congress)

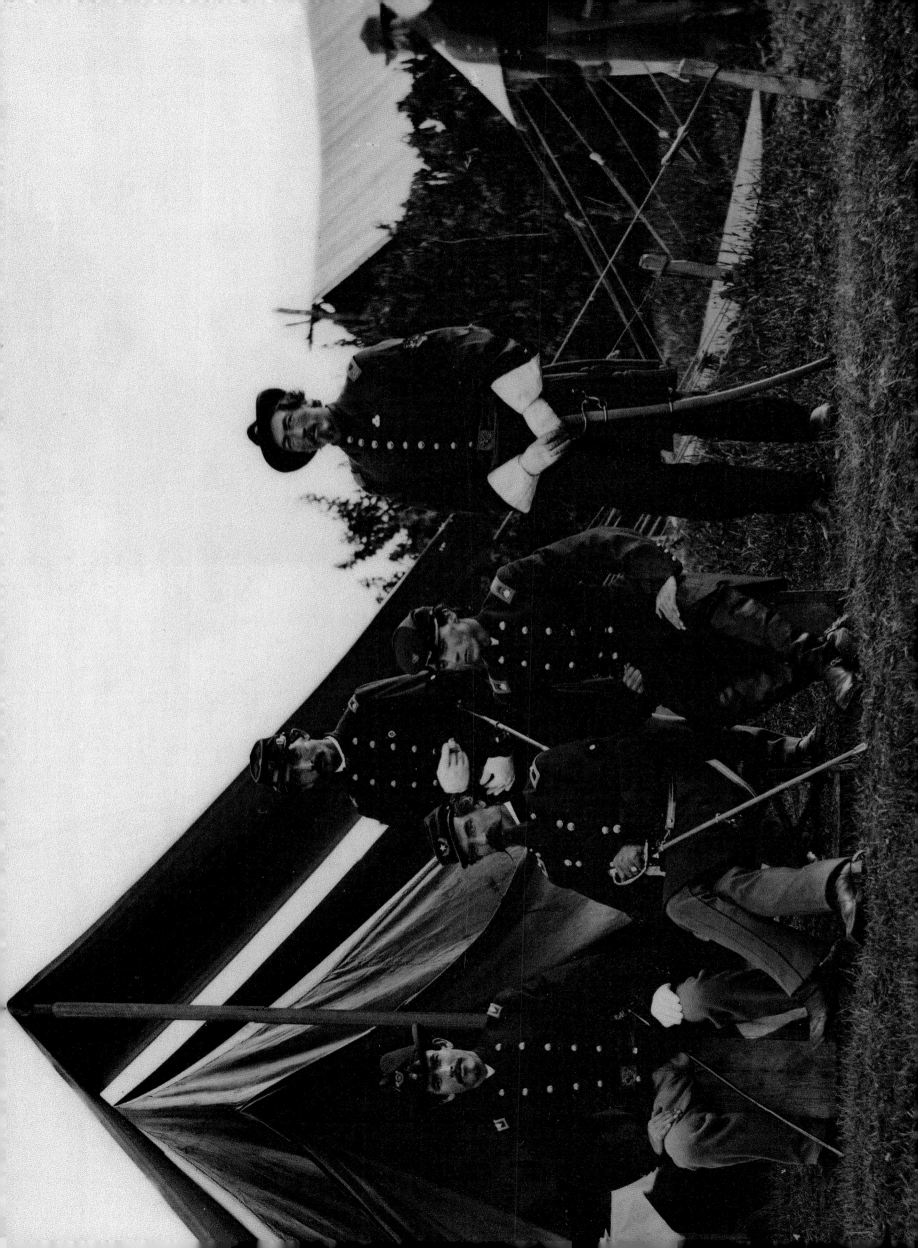

ABOVE: Rose O'Neal Greenhow and her daughter "Little Rose." Being a notable socialite in Washington, D.C., leading up to and early during the Civil War, she was a natural subject for the Brady studio. But Greenhow was a Confederate spy, whose position as "hostess" helped her gain information on Union activities, which she passed on to Confederacy sympathizers and officers, including General P.G.T. Beauregard. She was arrested by Allan Pinkerton's Secret Service men and, on January 18, 1862, was incarcerated in Old Capitol Prison before being deported to Richmond, Va. On October 1, 1864, apparently weighed down by $2,000 worth of gold in royalties for her memoirs, intended for the Confederate treasury, she drowned in the Cape Fear River, S.C., when a rowboat she was in capsized while she was fleeing a Union gunboat.
(From the collection of L. C. Handy, Library of Congress)

ABOVE: Although he died a decade before the American Civil War broke out, John C. Calhoun (March 18, 1782–March 31, 1850), a leading Southern politician and political philosopher from South Carolina, vice president of the United States from 1825 to 1832, was a major inspiration to the secessionists who created the short-lived Confederate States of America. He was also an adviser and companion to Rose O'Neal, who would be deported early in the war for being a Confederate spy. Brady's studio managed to photograph Calhoun, who was believed to have been the first vice president to have his photo taken.
(Brady-Handy Collection, Library of Congress)

ABOVE: Twice secretary of state, Daniel Webster (January 18, 1782–October 24, 1852) was an influential American statesman who, with colleagues Henry Clay and John C. Calhoun, came to be known as the "Great Triumvirate" of American politics before the Civil War—a conflict that Webster tried hard to avoid.
(Brady-Handy Collection, Library of Congress)

RIGHT: Sixteen civilian members of the U.S. Sanitary Commission gathered with General John A. Dix (seated, third from left). The Commission was established to give soldiers supplies and medical aid that were not available through military channels, and became an immense organization by war's end.
(Library of Congress)

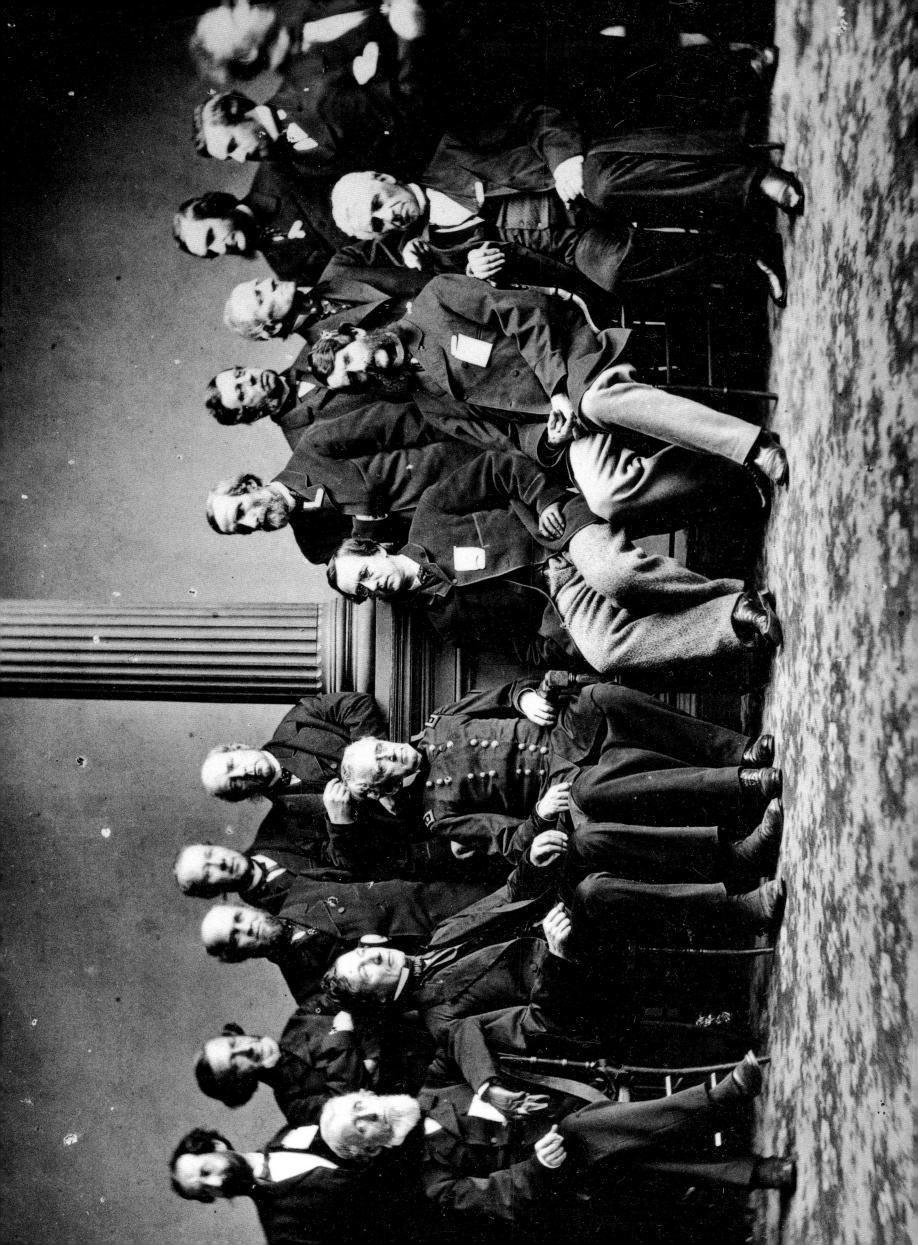

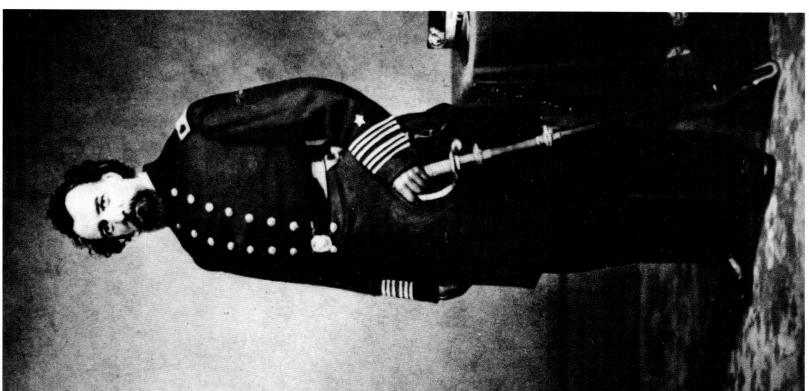

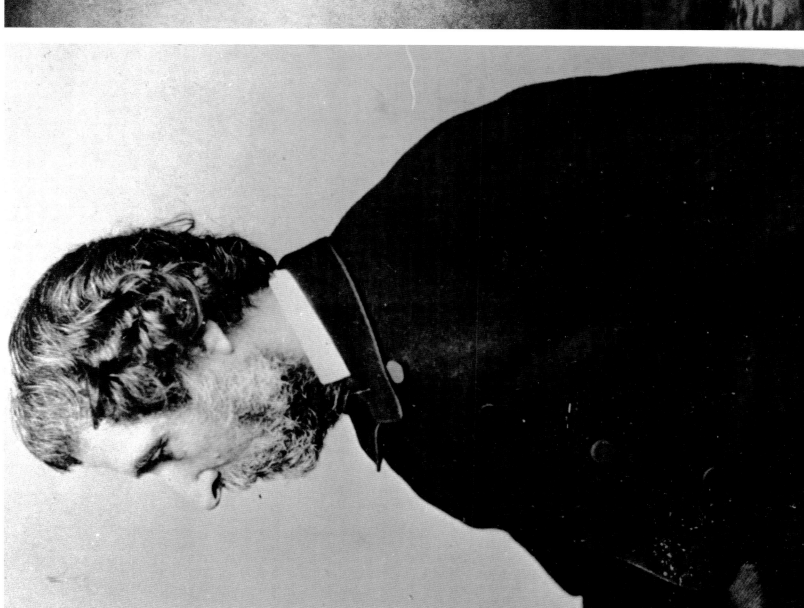

FAR LEFT: Gideon Welles, Secretary of the Navy, 1861-69, photographed with congressional chair "borrowed" by Brady. During his time Welles developed the Union Navy into the strongest in the world. Although untrained in naval matters, Welles had a reputation for sound administrative ability, prompting one historian to write: "By temperament, Welles was a combination of stubborn righteousness and hard-bitten practicality, mixed with devotion to duty and a penchant for thrift."
(Library of Congress)

LEFT: Edwin M. Stanton, Secretary of War in Lincoln's cabinet. Although opposed to Lincoln, he nevertheless stepped in as Secretary of War in 1862 to "save the country." Despite his lack of military experience, Stanton proved to be the most effective of all Lincoln's cabinet ministers, holding his post for the balance of the war and beyond.
(Library of Congress)

RIGHT: General John C. Frémont, explorer. Considered egotistical, Fremont was not well-liked by many of his men. During the Civil War he surrounded himself with a staff that many felt were more akin to a palace guard in their high-handedness and finery.
(From the collection of L. C. Handy, Library of Congress)

FAR RIGHT: At the outbreak of war Captain Melancton Smith (May 24, 1810-July 19, 1893) commanded the USS Massachusetts, which captured the British blockade-runner Perthshire. He fired on the CSS Selma in 1861, attacked the ram Albemarle, and commanded the frigate USS Wabash during two attacks on Fort Fisher.
(Library of Congress)

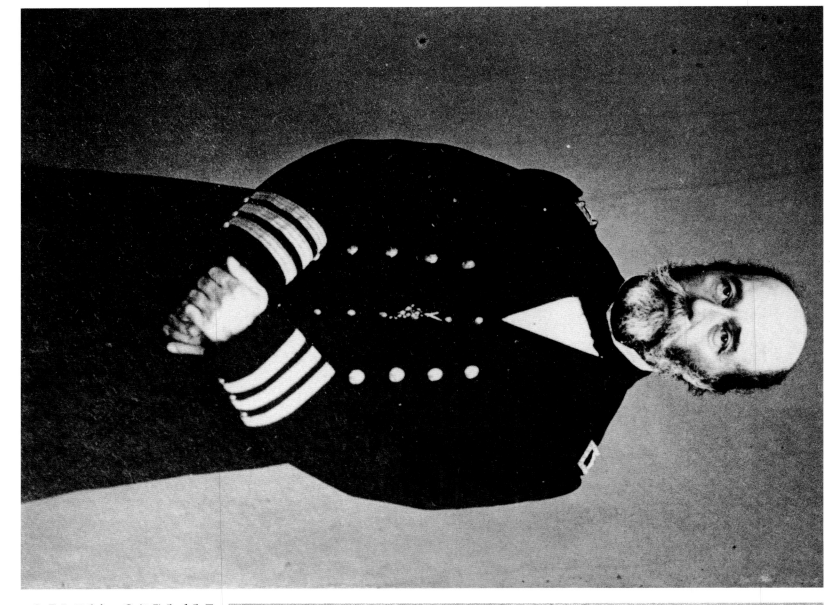

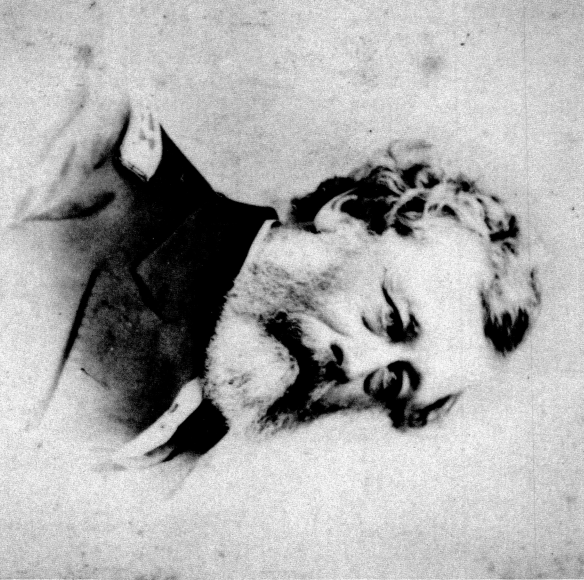

LEFT: Commander Charles Boggs was already a veteran by the time the Civil War began, having served in the Mexican-American War. He commanded the USS *Varuna*, a screw gunboat, which "ran the gauntlet" on the Mississippi in the epic Battle of New Orleans in 1862, but *Varuna* was lost to the CSS *Governor Moore* and CSS *Stonewall Jackson* in 1862. *(Library of Congress)*

ABOVE: Rear Adm. James Hooker Strong was a commander at the time he was in charge of the USS *Monongahela*, one of the U.S. Navy's newest wooden screw steamers, and is known for ramming the CSS *Tennessee* in 1864, during the last great naval battle of the war. *(Library of Congress)*

RIGHT: General Robert Anderson was a Kentuckian married to a Georgia woman, but he did his duty as Union commander of Fort Sumter when fired upon in 1861 (he was major at that time). He held out for five months until the constant bombardment rendered the wooden portion of his fort in flames. Accorded a hero's welcome in the Union, he was forced to leave active duty in 1863 due to poor health. *(Library of Congress)*

FAR RIGHT: Photographed ca. 1864, Thomas "Tad" Lincoln, the president's fourth and youngest son, wore a captain's uniform after Secretary of War Edwin M. Stanton gave him an honorary commission. His nickname came from his father, who thought the boy's head too large for his body, resembling a tadpole. *(Library of Congress)*

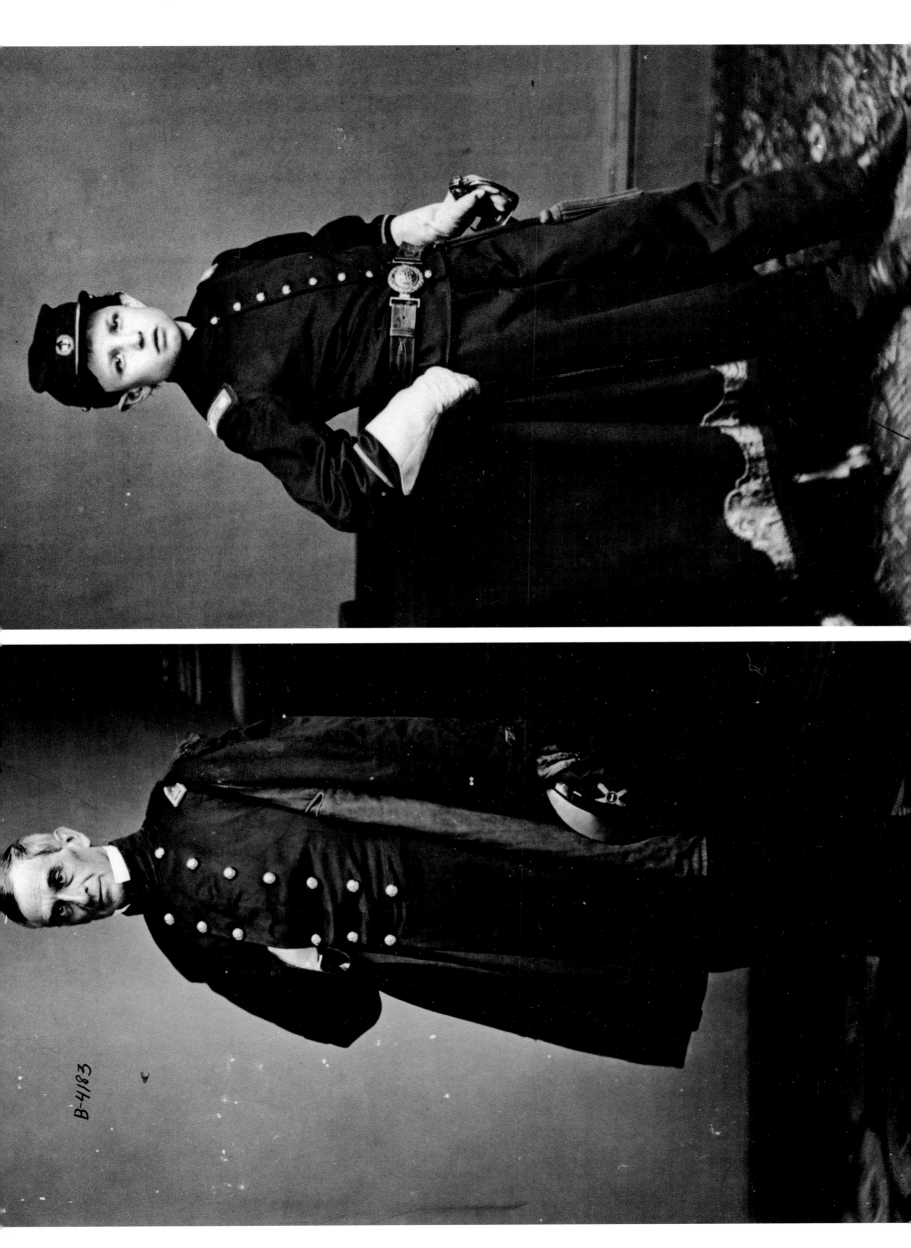

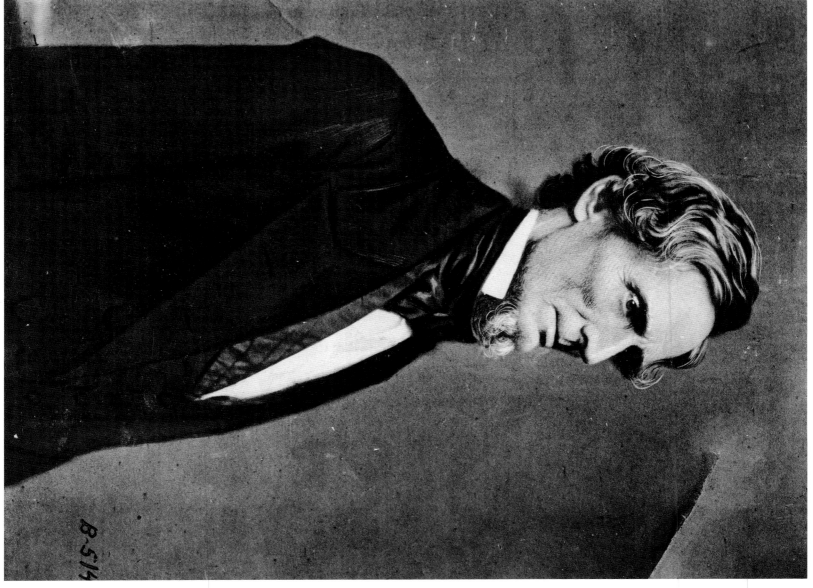

B-514

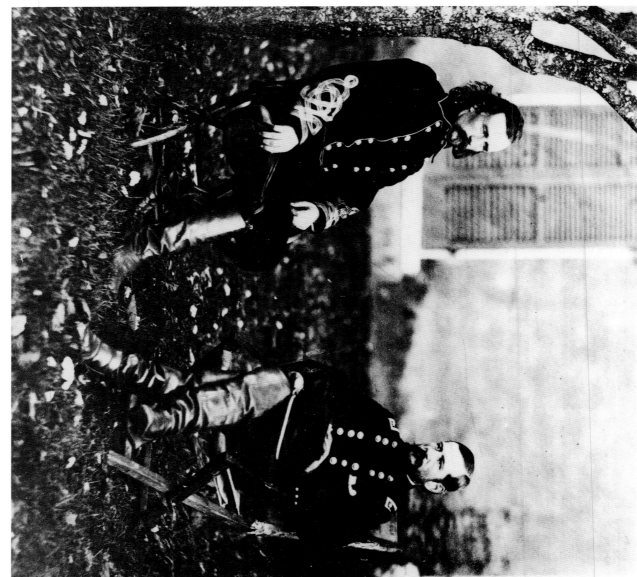

LEFT: This image of Jefferson Davis, president of the Confederacy, was taken from a negative created by Brady in his Washington studio, ca. 1859-60.
(From the collection of L. C. Handy, Library of Congress)

ABOVE: General George Armstrong Custer (left) poses with his superior officer, Major General Alfred Pleasanton, 1865. The braiding on Custer's sleeves drew much derision from his men.
(Courtesy Little Bighorn Battlefield National Monument)

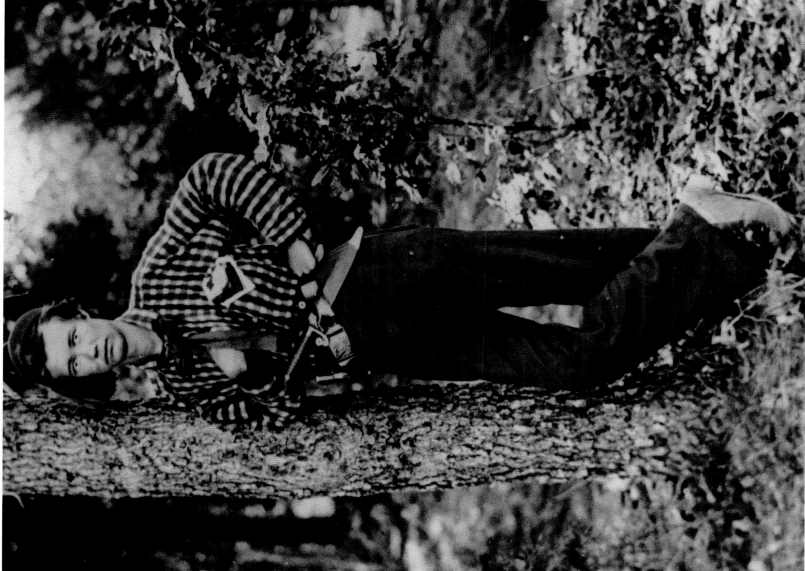

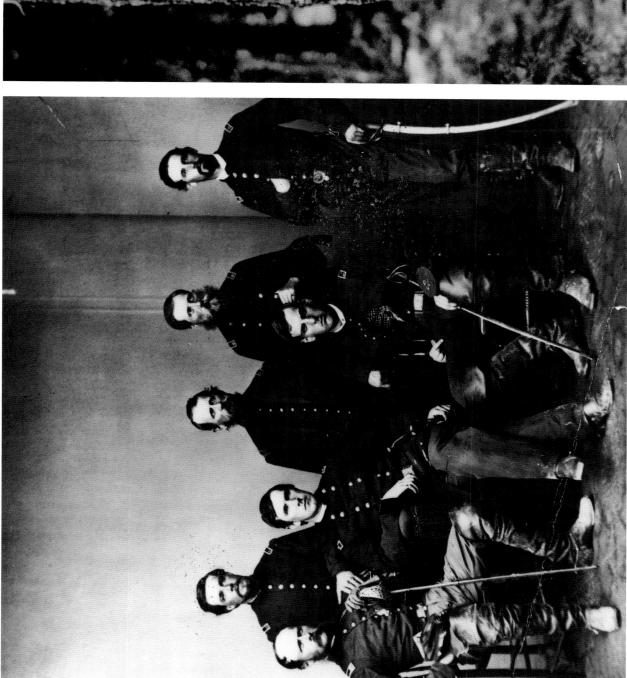

ABOVE: General Martin T. McMahon (seated, left) and staff—five captains and a lieutenant (shirt unbuttoned), 1865-66. McMahon received the Medal of Honor in 1891 for his heroic actions at White Oak Swamp, Va., on June 30, 1862. (National Archives/Office of the Chief Signal Officer)

RIGHT: Private Emery Eugene Kingin of the 4th Michigan Infantry strikes a military pose while off duty, sporting a large Bowie knife in his belt. (Library of Congress)

B-1758

FAR LEFT: General Joseph "Fighting Joe" Hooker posing with one of his horses in 1863. He rarely rode a white horse into battle, though, fearing it made him a good target.
(Library of Congress)

LEFT: Numerous volunteer militia groups took great pride in sending their men to war in unusual uniforms. Here, Sergeant Patrick Hogan of the 1st Vermont Cavalry sports plenty of gold braid and a Prussian-style helmet as he poses for Brady's studio in Washington, D.C., in November 1861, probably before he and his comrades had faced the deadly earnestness of battle.
(From the collection of L. C. Handy, Library of Congress)

ABOVE: General Ambrose E. Burnside, standing in front his tent, was known for bold (and sometimes costly) moves during the war. He is at least as well known, however, for his flamboyant mutton-chops, which eventually became known as sideburns.
(From the collection of L. C. Handy, Library of Congress)

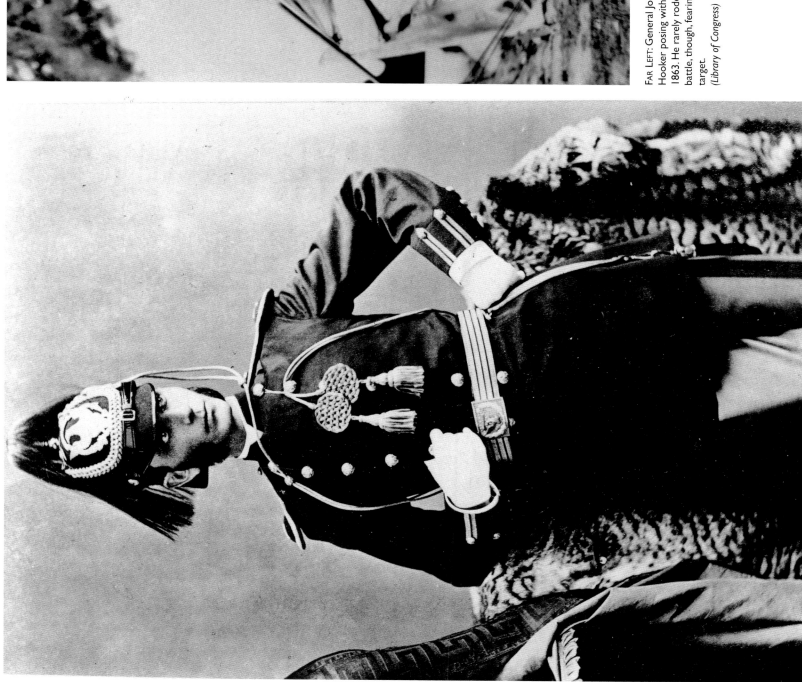

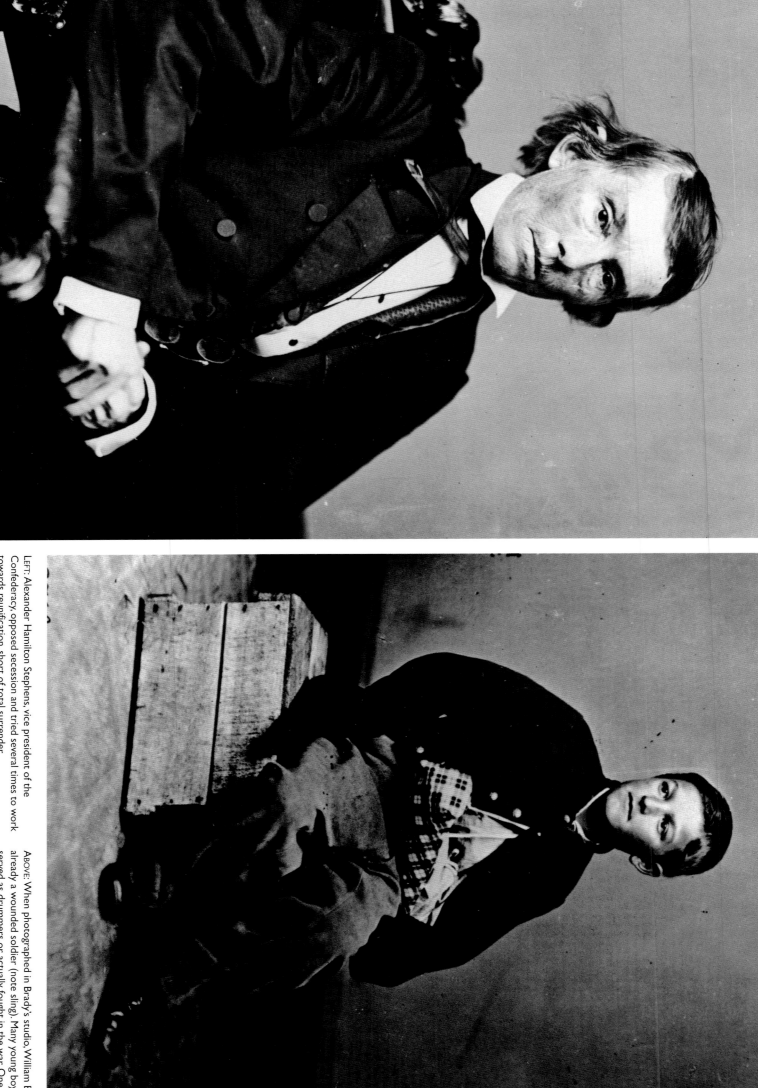

LEFT: Alexander Hamilton Stephens, vice president of the Confederacy, opposed secession and tried several times to work towards reunification, short of total surrender.
(Library of Congress)

ABOVE: When photographed in Brady's studio, William Black was already a wounded soldier (note sling). Many young boys either served as drummers or actually fought in the war. One source suggests the youngest soldier of the war was Edward Black, who joined the 21st Indiana as a musician, aged nine years.
(Library of Congress)

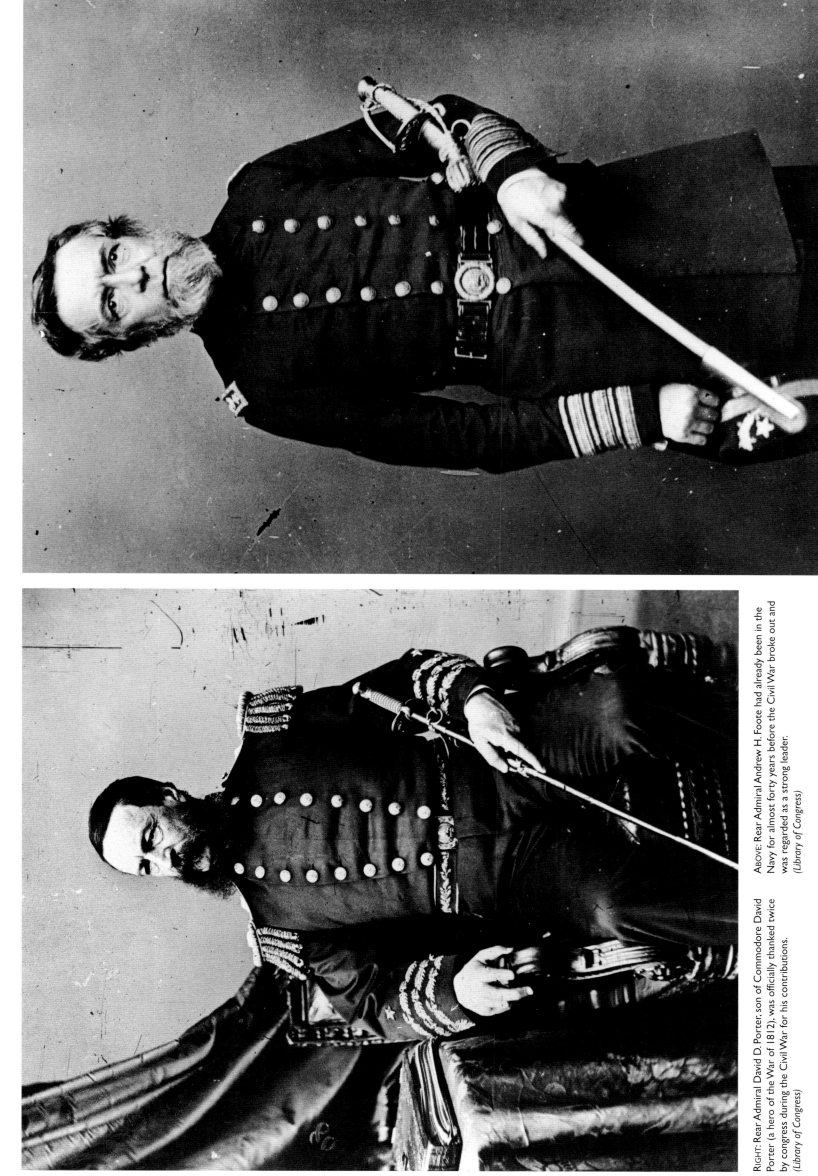

RIGHT: Rear Admiral David D. Porter, son of Commodore David Porter (a hero of the War of 1812), was officially thanked twice by congress during the Civil War for his contributions.
(Library of Congress)

ABOVE: Rear Admiral Andrew H. Foote had already been in the Navy for almost forty years before the Civil War broke out and was regarded as a strong leader.
(Library of Congress)

38

FAR LEFT: Christopher "Kit" Carson, Rocky Mountain explorer, had already made a name for himself prior to the war. He was assigned colonel of the 1st New Mexico in 1861. Although he was supposed to fight Rebels, most of his time was spent battling Indians.
(From the collection of L. C. Handy, Library of Congress)

LEFT: 1st Lt. James H. Wood, Co. C, 4th Regiment, New York State Heavy Artillery. In March 1865 the 4th Regiment, fighting as infantry, replaced the 7th New York Heavy Artillery in the famed but much-depleted Irish Brigade that was reorganized before disbanding and mustering out on June 30.
(U.S. Army Military History Institute)

RIGHT: Hiram Berdan, wealthy inventor and engineer, was the most accurate marksman in America for fifteen years prior to the Civil War. Backed by General Winfield Scott and President Lincoln, in November 1861 he formed and served as colonel to two sharpshooter regiments, the famed 1st and 2nd U.S. Sharpshooters, that bore his name. After fighting in major battles, including the Seven Days, Second Bull Run, and Gettysburg, he moved to Russia, where a rifle he designed was adopted by the government (it had been rejected by the United States).
(Library of Congress)

FAR RIGHT: Just sixteen years old when the Civil War broke out, Galusha Pennypacker volunteered for the 9th Pennsylvania Infantry and a few weeks later formed a new company that became part of the 97th Pennsylvania. He was just seventeen when promoted to major, and still only twenty when he became brigadier general—the youngest in American history, and too young to vote for the president who appointed him. He was wounded eight times during the war, and later was awarded the Medal of Honor for his service during the amphibious assault on Fort Fisher, where his commander declared he was the greatest hero of the action.
(Chester County Historical Society)

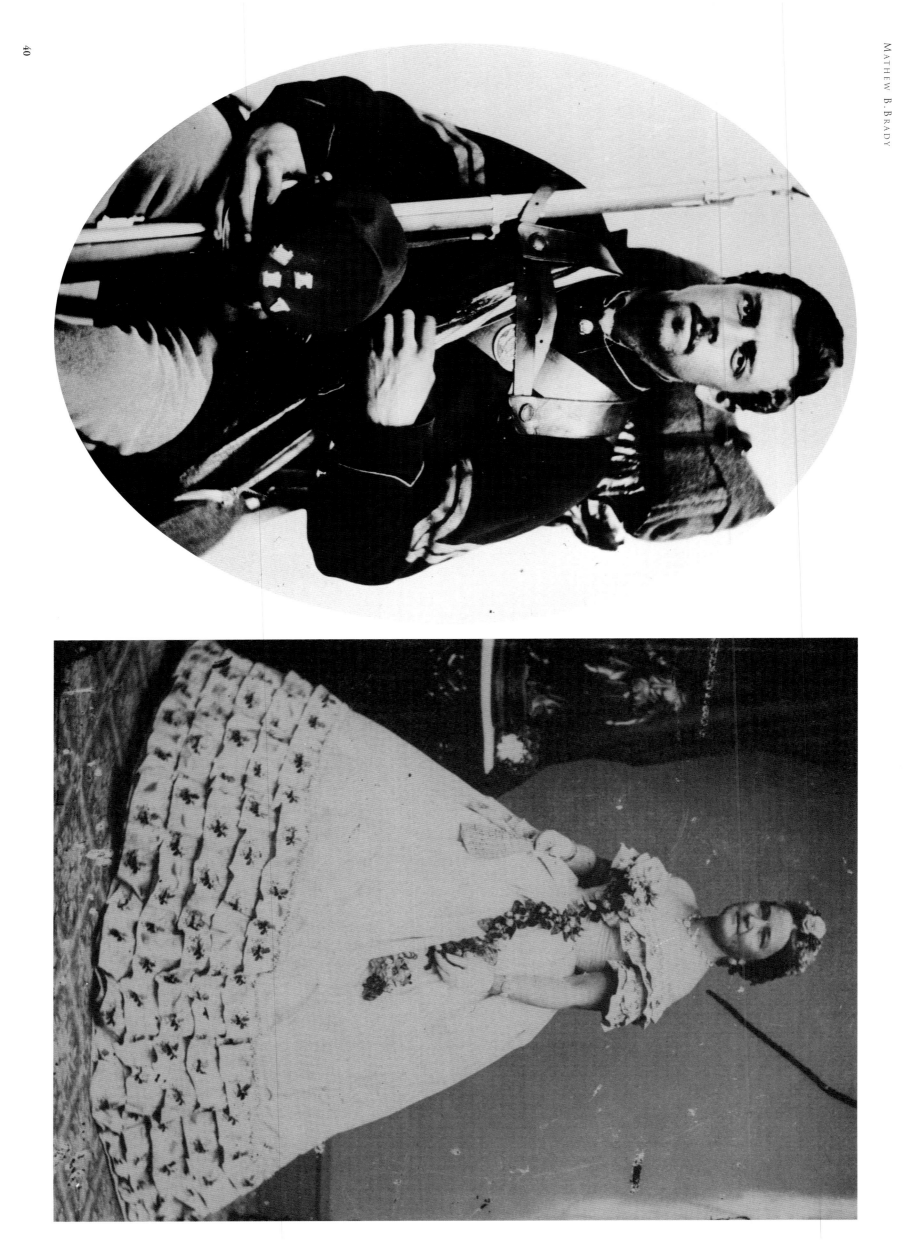

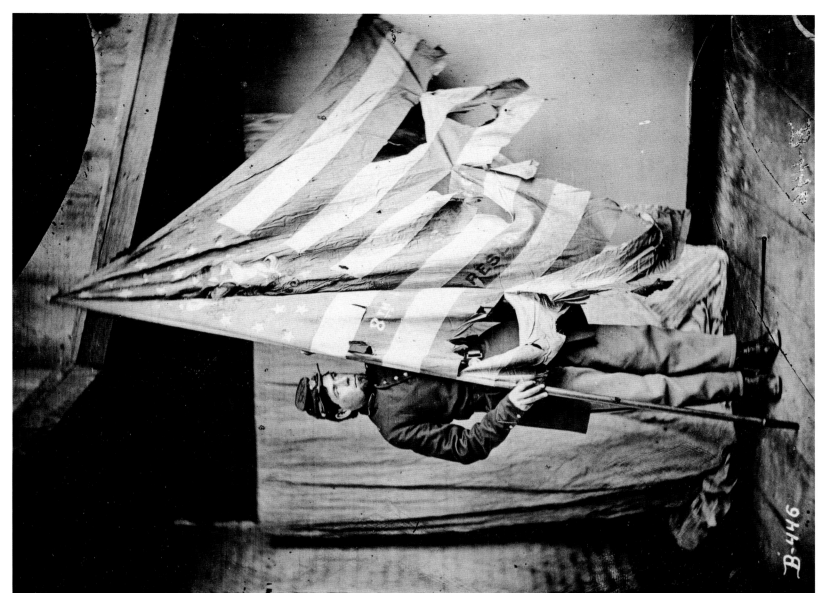

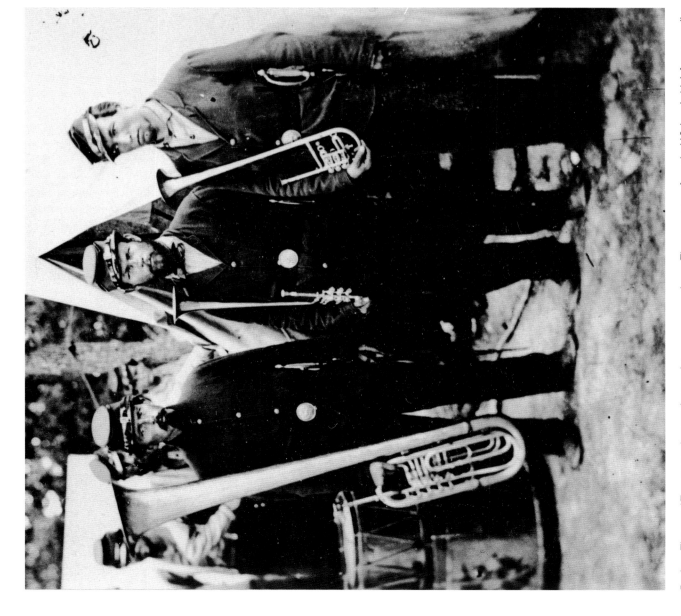

FAR LEFT: This proud Tennessee volunteer chose to be photographed in complete gear, including rifle, backpack, and canteen.
(Tennessee State Museum)

LEFT: President's wife Mary Todd Lincoln in inaugural gown, March 4, 1861, one of a series of portraits that she felt made her look too stern.
(From the collection of L. C. Handy, Library of Congress)

ABOVE: These musicians, from the U.S. Army's 4th Infantry, are all wearing regulation hats, indicating they were regular Army rather than volunteers.
(Library of Congress)

RIGHT: An unidentified color bearer holds a tattered flag with respect. Because color bearers led the advance, their mortality rate was higher than that of any other specialist. Showing the bullet holes of tough service, this flag typically carried reminders of past victories to spur the soldiers on.
(Library of Congress)

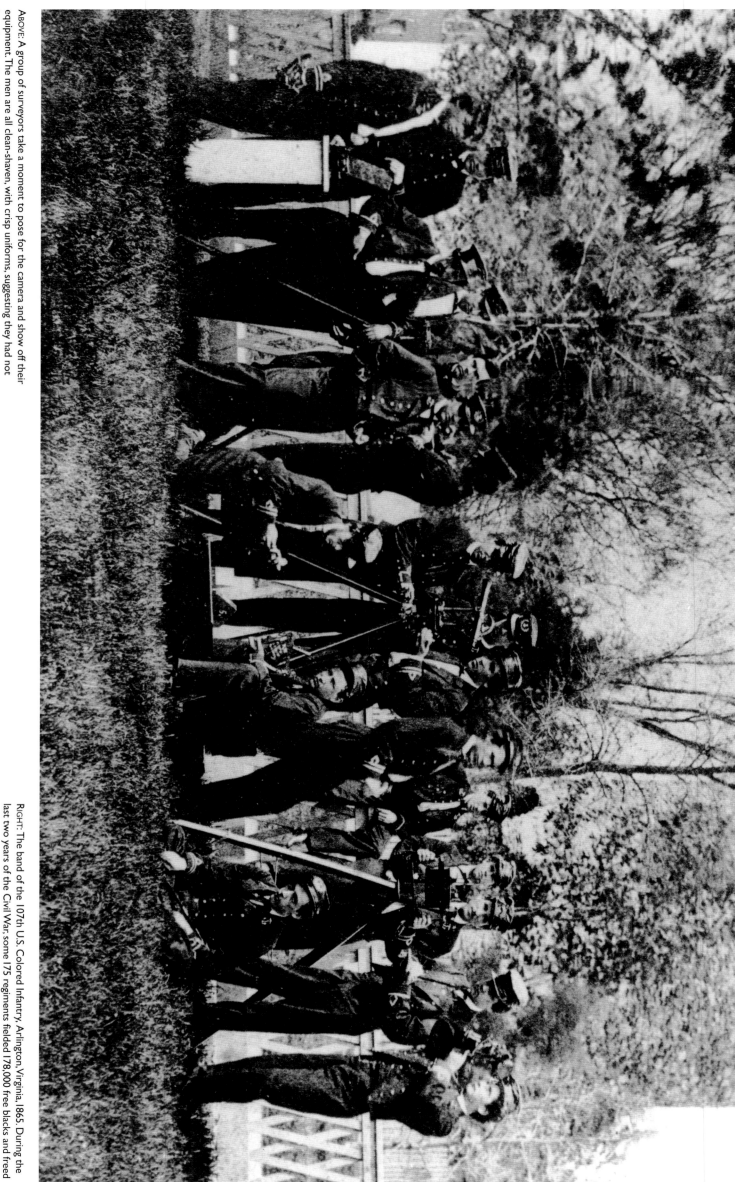

ABOVE: A group of surveyors take a moment to pose for the camera and show off their equipment. The men are all clean-shaven, with crisp uniforms, suggesting they had not long been in the field.
(Library of Congress)

RIGHT: The band of the 107th U.S. Colored Infantry, Arlington, Virginia, 1865. During the last two years of the Civil War, some 175 regiments fielded 178,000 free blacks and freed slaves. They were openly discriminated against, especially with regard to promotion, and it was not until 1864 that they received the same pay as their white comrades.
(Library of Congress)

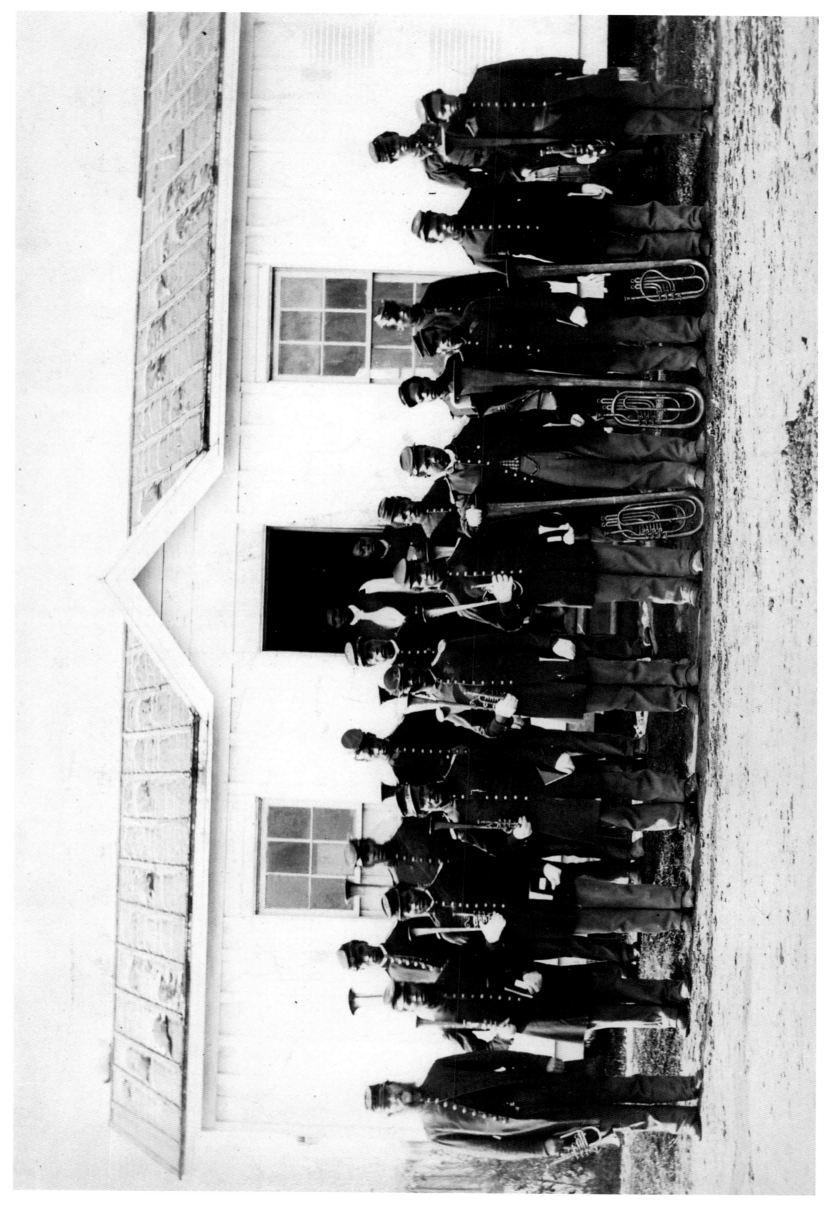

LEFT: Rear Admiral Hiram Paulding was one of the oldest individuals in the military during the Civil War. He joined the Navy as a midshipman in 1811, and was sixty-three when war broke out. Although he was officially retired in December 1861 he was immediately called into active duty and served the remainder of the war.
(Library of Congress)

RIGHT: Captain Percival Drayton, U.S.N., captured by the camera in 1864. Drayton was given command of the ironclad Passaic in 1862, and led the attacks on Forts McAllister and Sumter in 1863.
(Library of Congress)

CENTER RIGHT: David Wood was just a little boy, aged ten years and barely old enough to hold his pistol, when he enlisted. Although most of the very young "men" who fought in the Civil War were somewhat older, thousands of others like him managed to sign up.
(Library of Congress)

FAR RIGHT: Despite a poor academic record at West Point (graduating last in his class of fifty-nine in 1846) George E. Pickett, having resigned from the U.S. Army, rose to brigadier general in the Confederate States Army. He is best remembered for the Gettysburg charge that bears his name.
(Library of Congress)

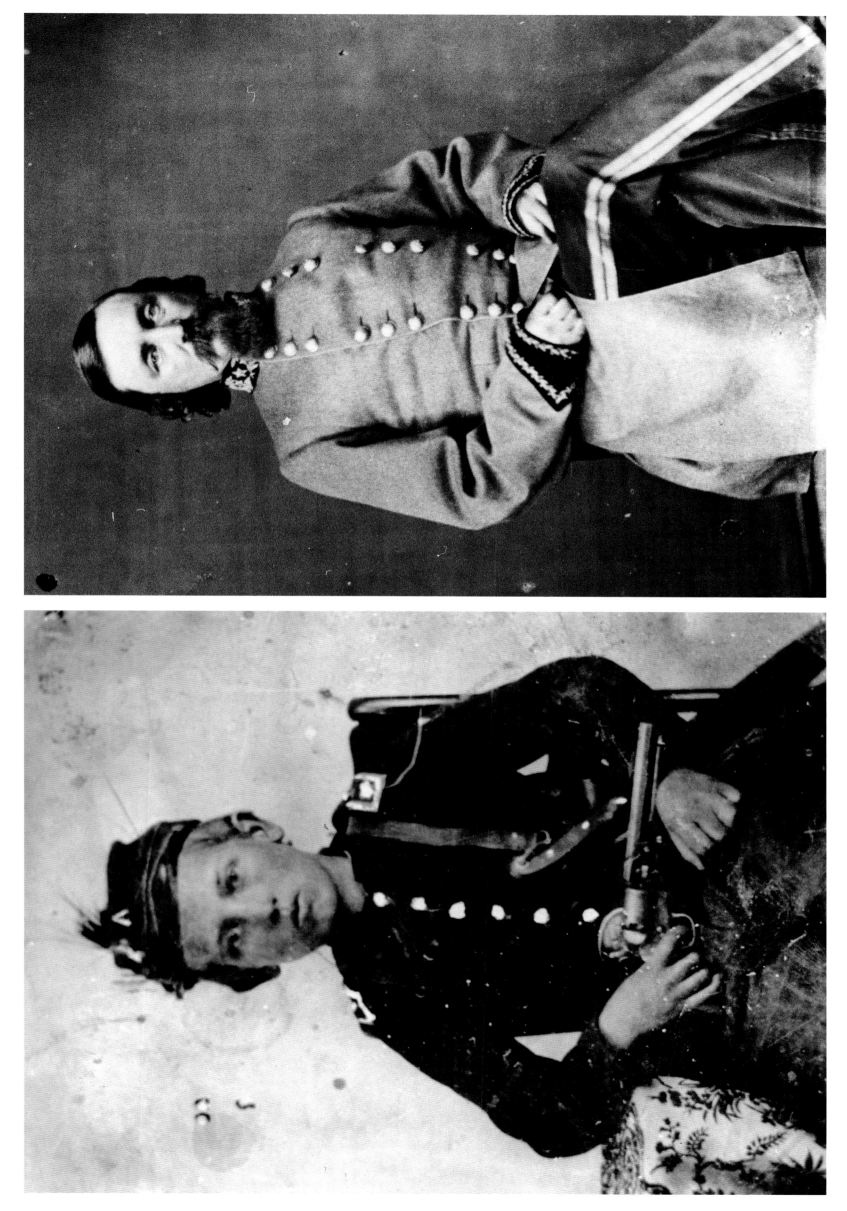

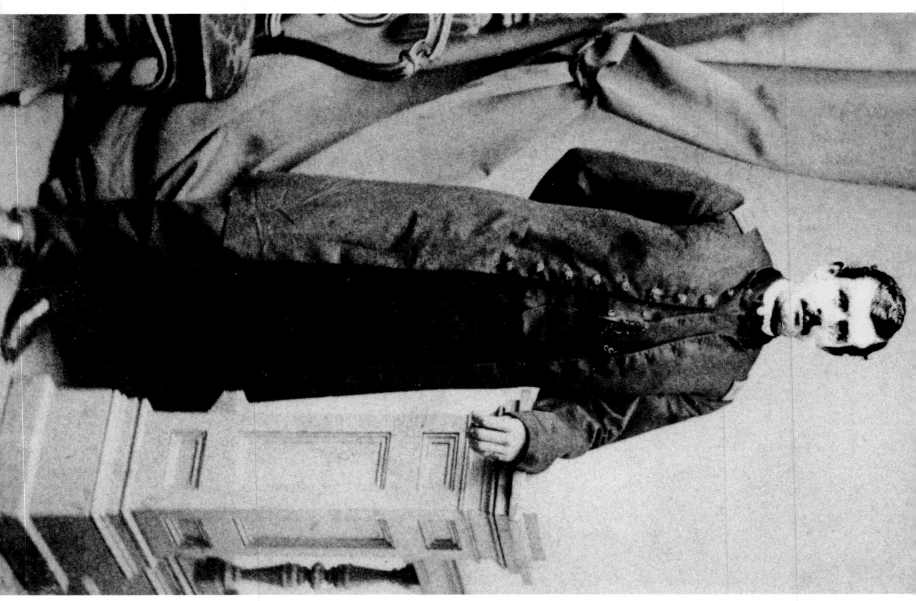

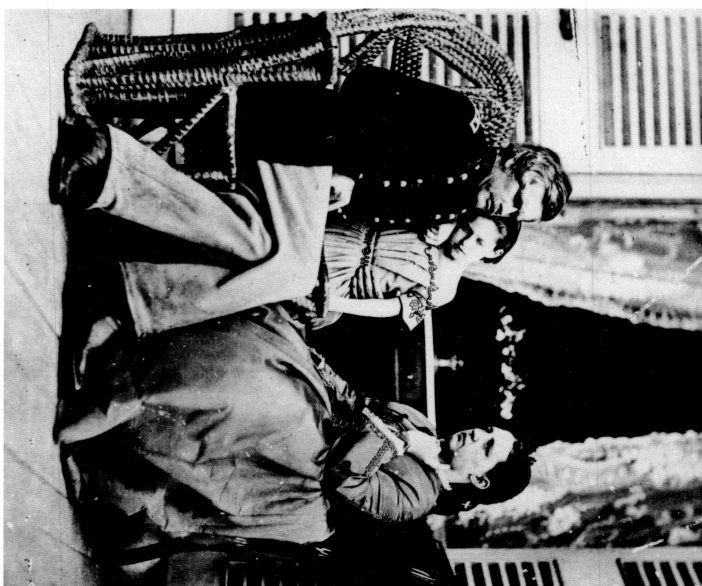

LEFT: Captain Jeremiah Coveney of the 28th Massachusetts (which joined the Irish Brigade just before the Battle of Fredericksburg, December 1862). He and two other captains were brought up on somewhat trumped-up "mutinous and seditious conduct" charges in 1863, but charges were dropped on April 27, allowing the men to lead their troops in the spring campaign.
(U.S. Army Military History Institute)

ABOVE: General Edward Ortho Cresap Ord with his wife and child at the residence of Jefferson Davis, Richmond, Virginia, after the war's end. In the doorway is the table upon which General Robert E. Lee's surrender was signed.
(Library of Congress)

RIGHT: President Lincoln and General George B. McClellan photographed in the general's tent at Antietam, 1862. The two did not get on well, and the president eventually removed McClellan from his post as general-in-chief of the Union Army, and then from the Army of the Potomac. It is probable that Alexander Gardner, one of Brady's most experienced photographers, made this image.
(Library of Congress)

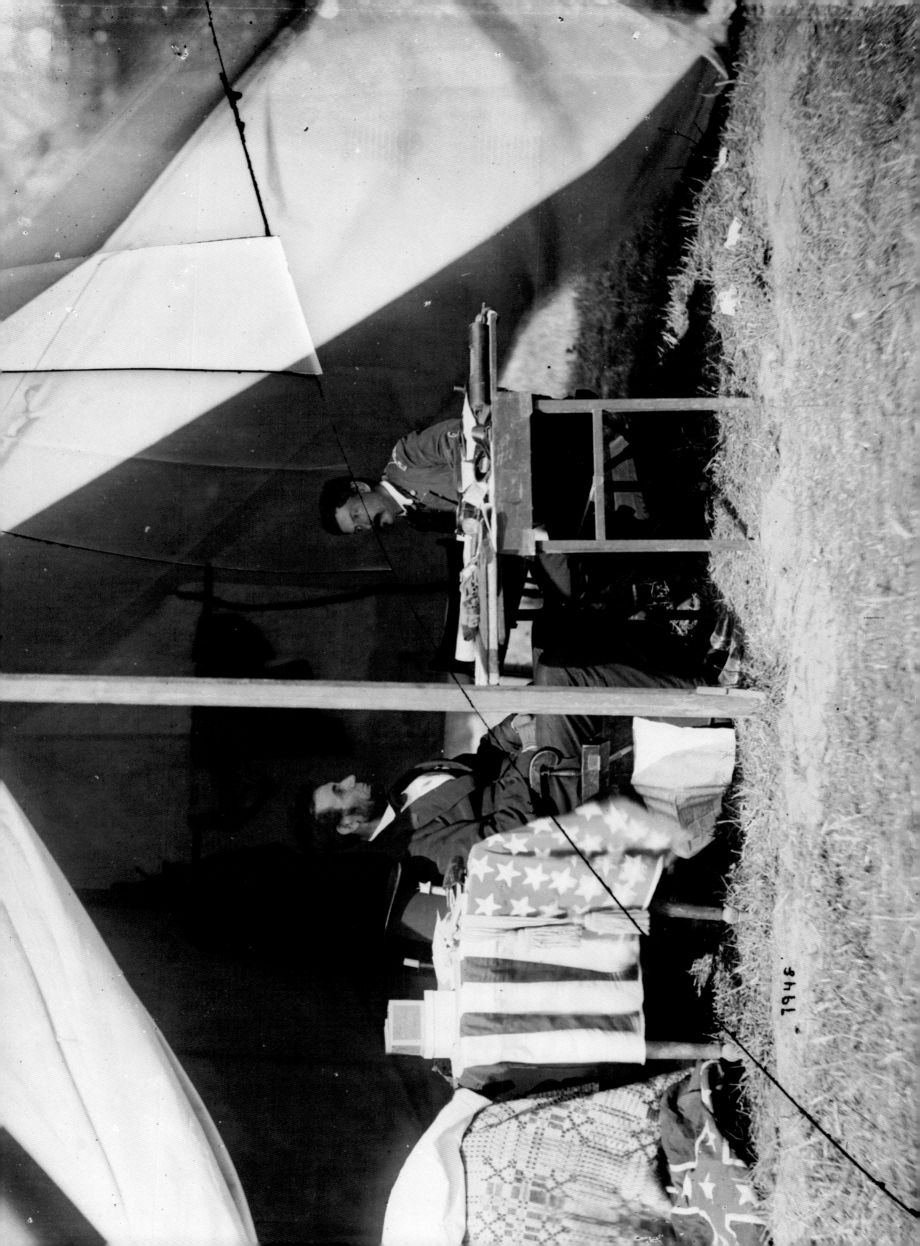

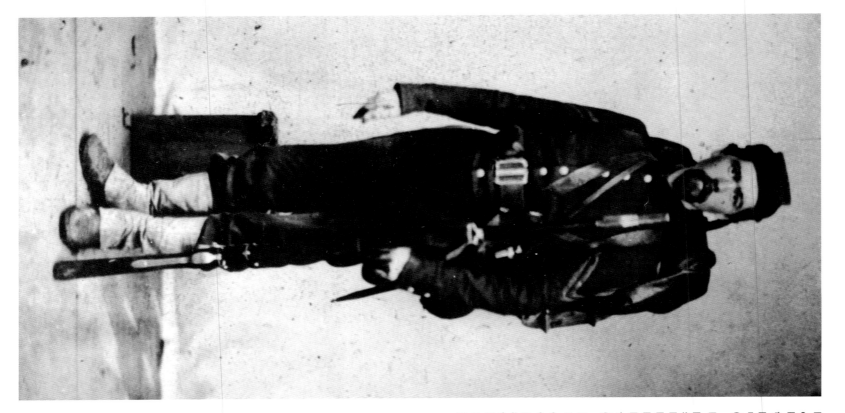

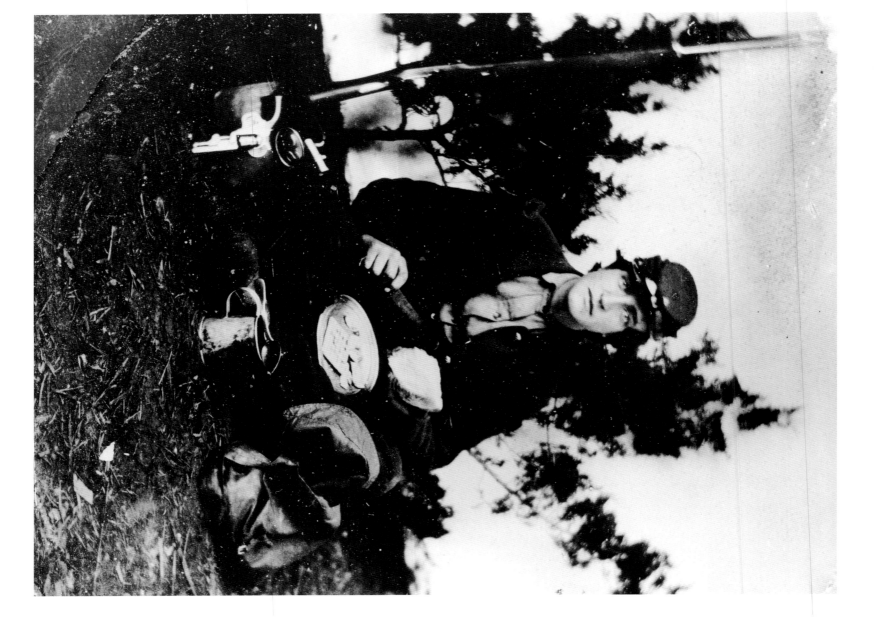

LEFT: A quarter-plate tintype of a Union corporal in full battle gear. The soldier had to be fit to carry it all on the march through rural areas, and as the war progressed he likely ditched some of the non-essential items.
(Library of Congress)

RIGHT: In an outrageously posed photograph, this young, well-fed soldier sits with his mess kit (complete with hardtack), his pistol by his side, while behind him is the photographer's background sweep and shrubs that in all likelihood have been dug up and transported here for atmospheric effect.
(Library of Congress)

FAR RIGHT: Sketch artist for *Harper's Weekly* magazine, Alfred R. Waud was a companion of Mathew Brady (whose colleague Timothy H. O'Sullivan made this photograph in 1863). Brady generously allowed Waud to hitch a ride in one of his wagons to the site of the First Battle of Bull Run, July 21, 1861, when vehicles were in short supply.
(Library of Congress)

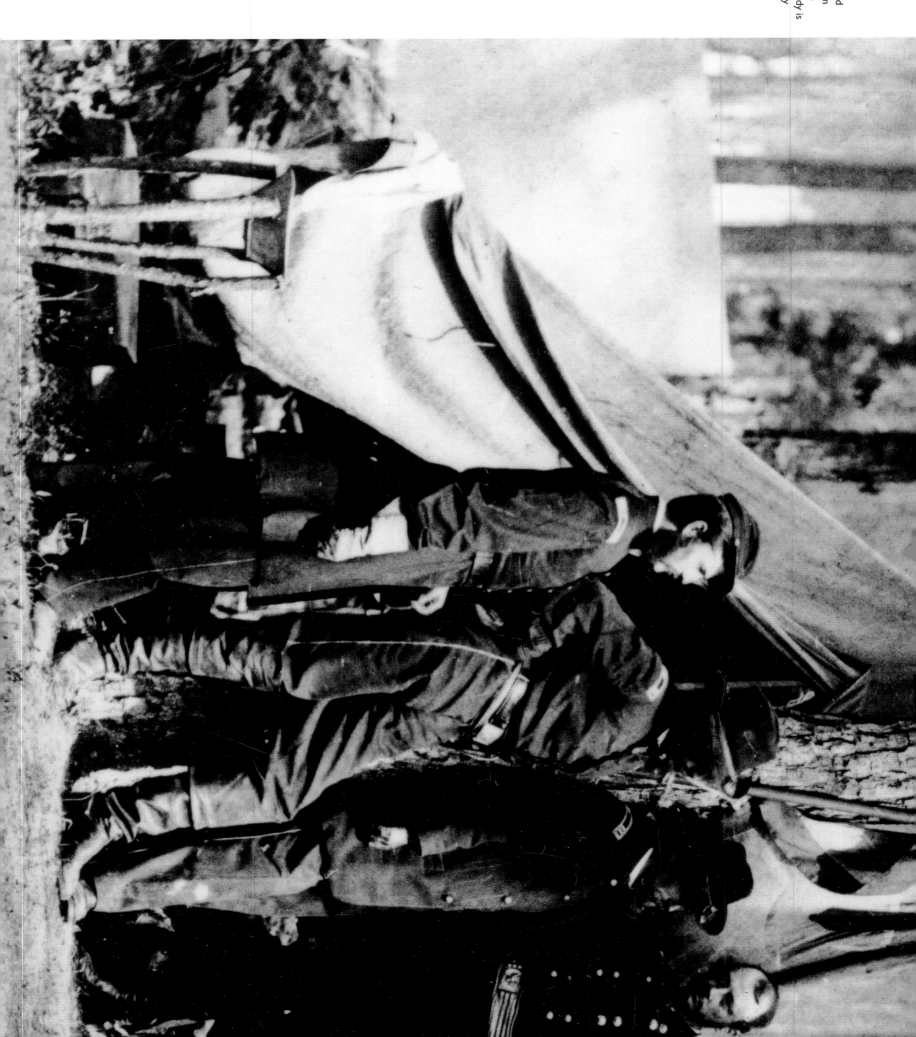

RIGHT: Major General Robert Potter (fourth from left) and his staff grouped together to have their picture taken in May/June 1864, during the Wilderness Campaign. Photographer Mathew Brady is leaning against a tree at right, probably holding a remote control device for triggering the shutter. (Library of Congress)

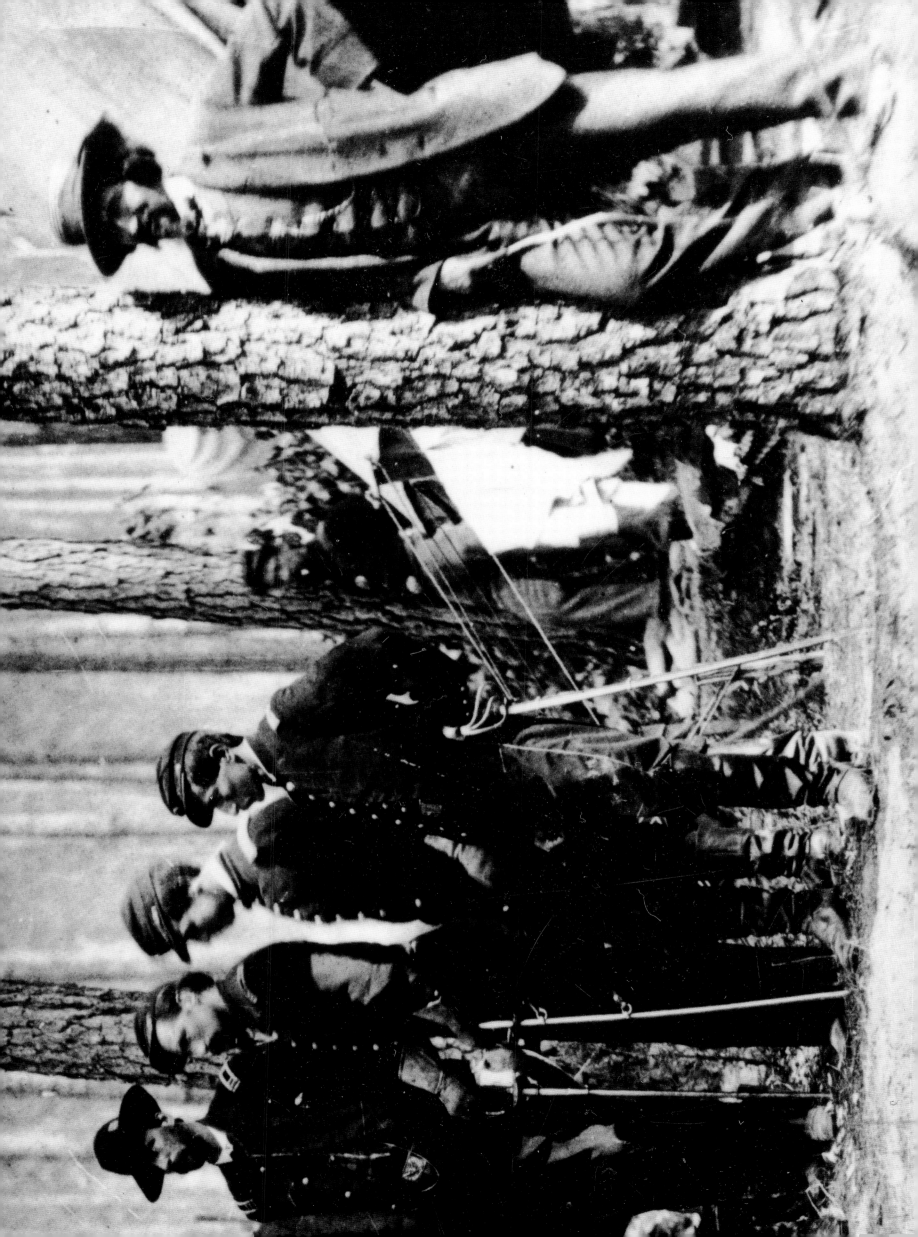

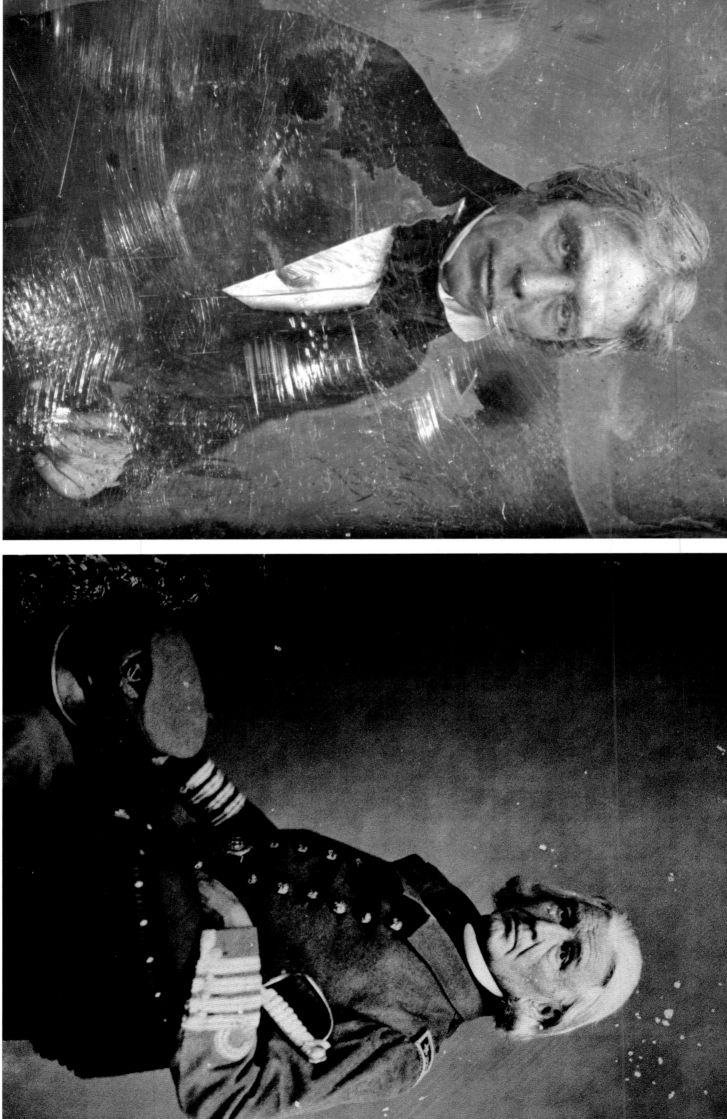

ABOVE: One of Brady's distinguished subjects was English physicist and chemist Michael Faraday (1791–1867), who, in a single year, 1831, invented the dynamo, the transformer, and the electric motor. (Library of Congress)

ABOVE: Captain French Forrest, C.S.N., was in charge of raising the 3,200-ton wooden frigate, USS Merrimac, and converting her to the Confederate ironclad Virginia. (From the collection of L. C. Handy, Library of Congress)

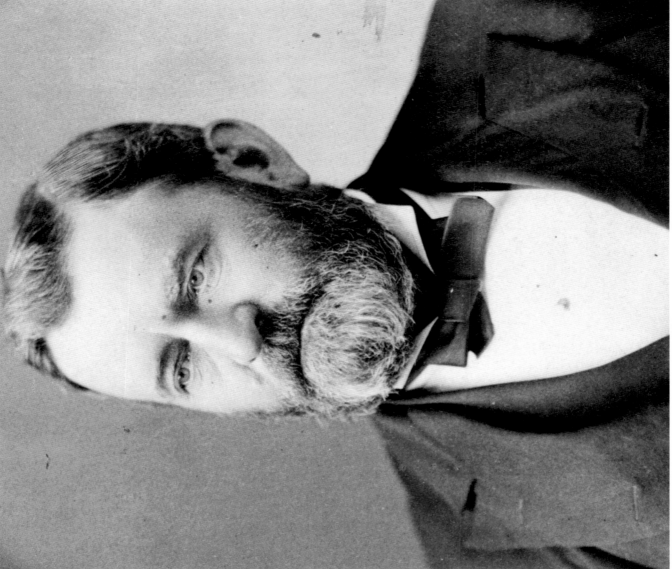

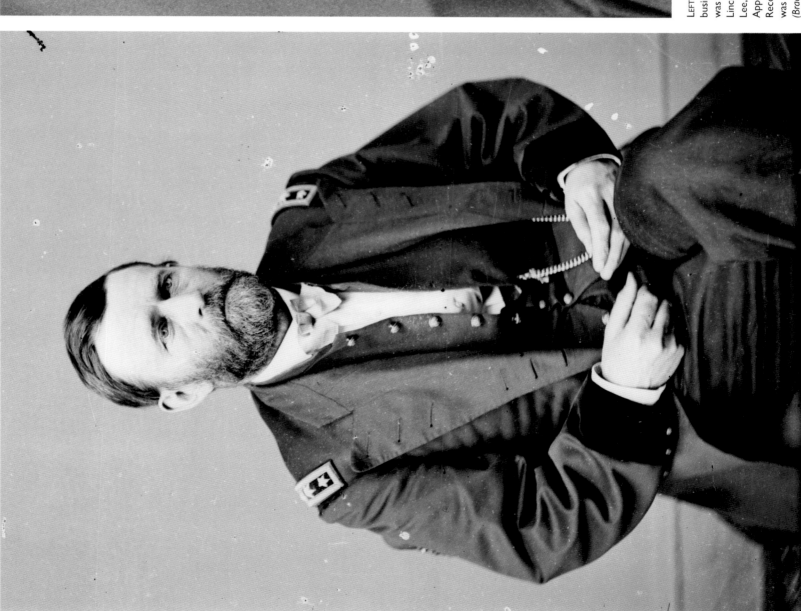

LEFT: Despite an unspectacular early military career, and failure in business, Ulysses S. Grant (actually born Hiram Ulysses Grant) was given overall command of the Union's armies by President Lincoln in March 1864. He ground down his opponent, Robert E. Lee, for ten months, before finally surrounding him at Appomattox in April 1865. He became embroiled in Reconstruction politics, then was elected president in 1877, and was reelected four years later.
(Brady-Handy Photograph Collection/Library of Congress)

ABOVE: Ulysses Simpson Grant, photographed in Brady's Washington studio in about 1880, served two terms of office as president.
(Library of Congress)

RIGHT: General Ulysses S. Grant (April 27, 1822–July 23, 1885) held office as the eighteenth president of the United States from 1869 to 1877. This photograph was made by Mathew Brady between 1865 and 1880.
(Brady-Handy Collection, Library of Congress)

CENTER RIGHT: Jesse Root Grant (1794–1873), father of General Ulysses S. Grant. Jesse, a tanner, was born in Pennsylvania.
(Brady-Handy Collection, Library of Congress)

FAR RIGHT: Ulysses S. Grant's wife, Julia Boggs Dent (1826–1902), the daughter of a slave owner, Frederick, photographed with her father, daughter Nellie, and son Jesse.
(Brady-Handy Collection, Library of Congress)

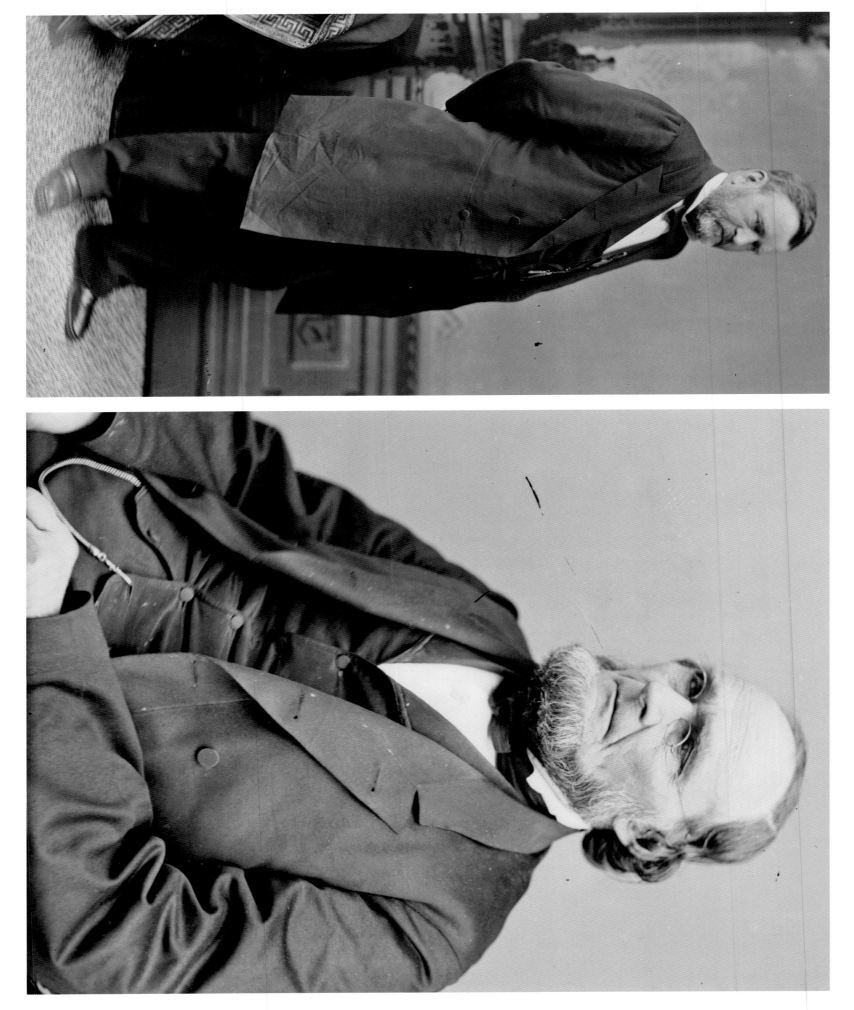

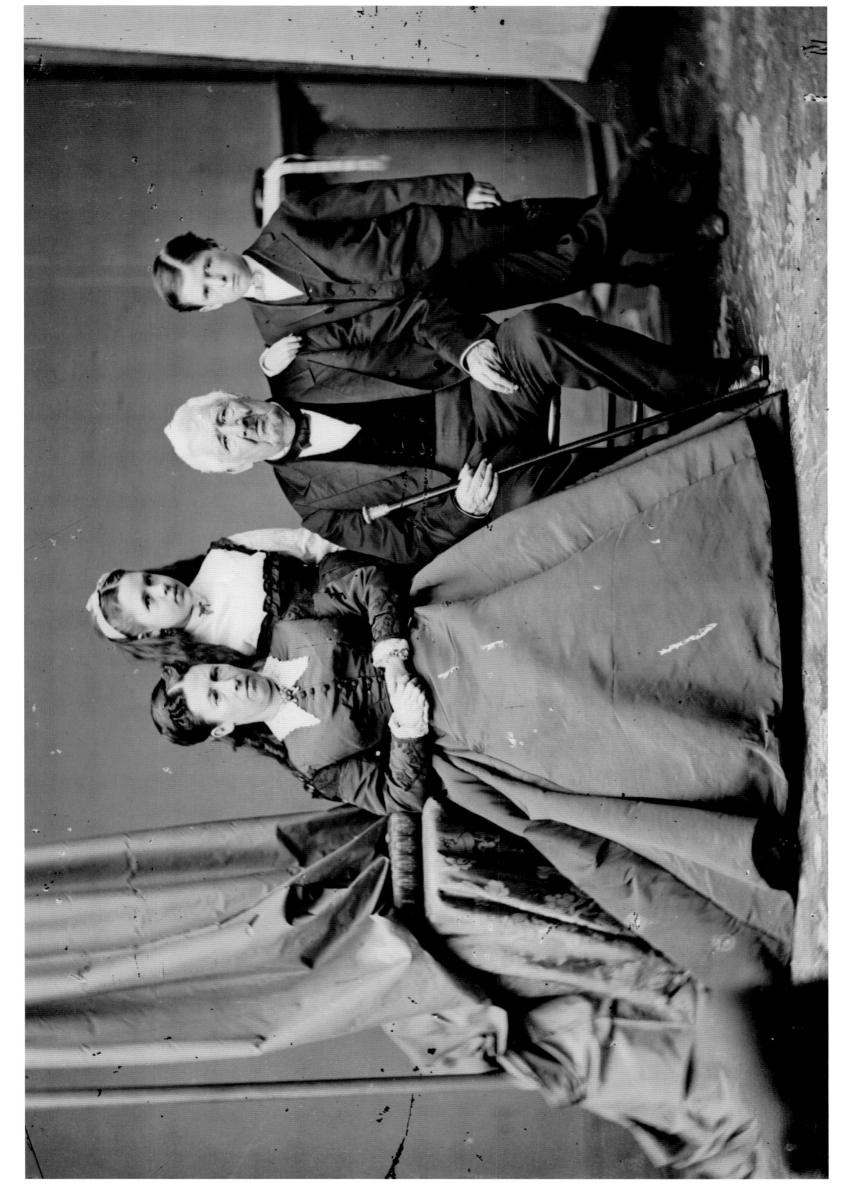

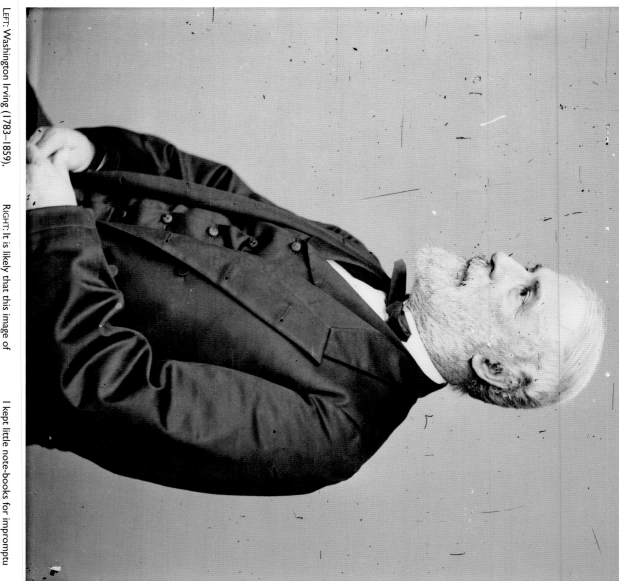

LEFT: Washington Irving (1783–1859), American essayist and short story writer. (Brady-Handy Collection, Library of Congress)

ABOVE: Just days after the Confederacy's surrender, Mathew Brady asked a most reluctant General Robert E. Lee to sit for him. "How can I sit for a photograph with the eyes of the world upon me as they are today?" protested Lee. But Brady persisted and, with the help of Lee's wife, the general was persuaded. (Brady-Handy Collection, Library of Congress)

RIGHT: It is likely that this image of controversial and influential poet and essayist Walt Whitman (May 31, 1819–March 26, 1892) was made in the Brady studio in Washington between 1862 and 1865. Whitman's brother George was wounded in the Battle of Fredericksburg, and as the poet set out to find him he wrote (in his work, "Memoranda During the War"), "During the Union War I commenced at the close of 1862, and continued steadily through '63, '64 and '65, to visit the sick and wounded of the Army, both on the field and in the Hospitals in and around Washington city. From the first I kept little note-books for impromptu jottings in pencil to refresh my memory of names and circumstances, and what was specially wanted…." (Brady-Handy Collection, Library of Congress)

FAR RIGHT: Painter, inventor of the telegraph, and co-inventor of the Morse code, Samuel F. B. Morse (April 27, 1791–April 2, 1872) taught the art of photography during the 1840s, and Mathew Brady was an early student. Brady made this fine image of Morse between 1855 and 1865. (Brady-Handy Collection, Library of Congress)

FAR LEFT: Horace Greeley (February 3, 1811–November 29, 1872) was founder of the Republican party and editor/ proprietor of the campaigning *New York Tribune* newspaper. This Brady photograph of him was made between 1855 and 1865. *(Brady-Handy Collection, Library of Congress)*

LEFT: Among the colorful characters who visited Brady's studios (between 1855 and 1865) was Seth Kinman, a Californian hunter. *(Brady-Handy Collection, Library of Congress)*

ABOVE: Belle Boyd (Maria Isabella Boyd, May 4, 1844–June 11, 1900), photographed between 1855 and 1865, was a spy for the Confederacy, operating out of Front Royal, Virginia, where she would sweet-talk Union officers then pass information to Confederate generals, including Turner Ashby and Stonewall Jackson. *(Brady-Handy Collection, Library of Congress)*

RIGHT: Mathew Brady must have licked his lips in anticipation when actress and dancer Ann Gilbert (October 21, 1821–December 2, 1904) flounced into his New York studio and asked for her photograph to be taken (between 1855 and 1865). Born Anne Jane Hartley, in England, she married George H. Gilbert, a performer in the theater company of which she was a member. They moved to the United States in 1859 and she continued to perform until two days before her death. *(Brady-Handy Collection, Library of Congress)*

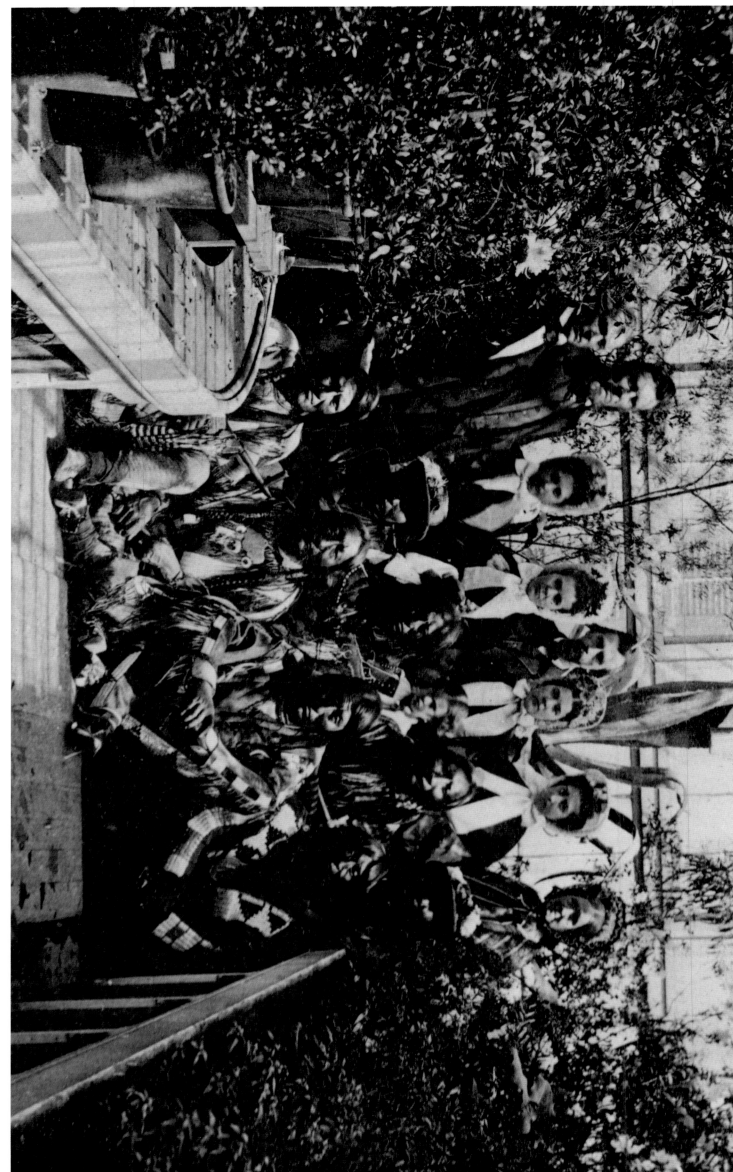

ABOVE: It is not known why Brady's photographer (or Brady himself) chose to cram his subjects together in the White House Conservatory, with its pot plants and benching obscuring the camera's view. These are members of the Southern Plains delegation in the capital, March 27, 1863: the Indians in the front row are, left to right, War Bonnet,

Standing in the Water, and Lean Bear of the Cheyenne, and Yellow Wolf of the Kiowa. The identities of the Indians in the second row are not known. At the back center stands President Lincoln's private secretary, John C. Nicholay, while interpreter William Simpson Smith and agent Samuel G. Colley stand at the left of the group. The woman standing at

far right is often identified as the president's wife, Mary Todd Lincoln.
(Library of Congress)

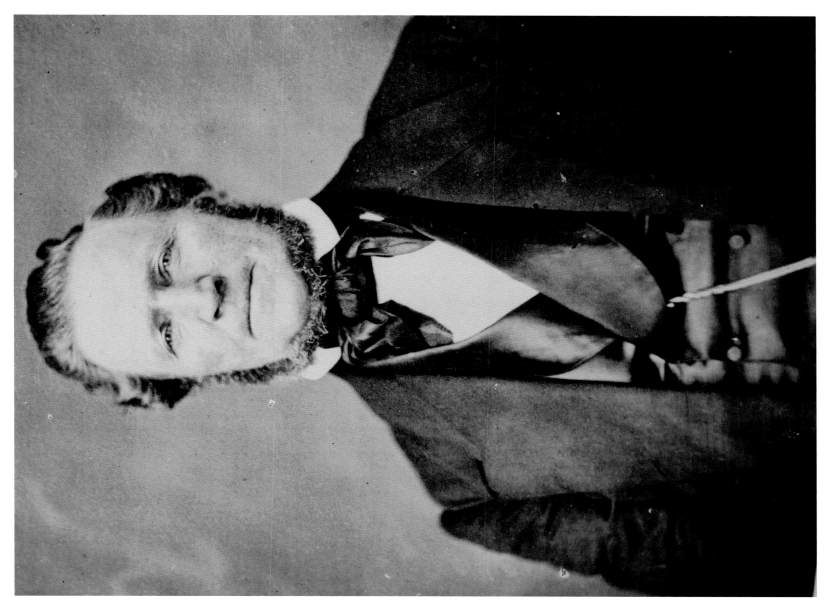

RIGHT: Brigham Young (June 1, 1801–August 29, 1877) was a leader in the Latter Day Saint movement and was the president of The Church of Jesus Christ of Latter-day Saints from 1847 until his death. Young led his followers, the Mormon pioneers, in an exodus through a desert, to what they saw as a promised land, Utah.
(Brady-Handy Collection, Library of Congress)

ABOVE: A rare photograph of Dolley Madison (May 20, 1768–July 12, 1849), wife of President James Madison, and often referred to as First Lady of the United States for fulfilling functions during the administration of widower President Thomas Jefferson that would normally be carried out by the president's wife.
(Library of Congress)

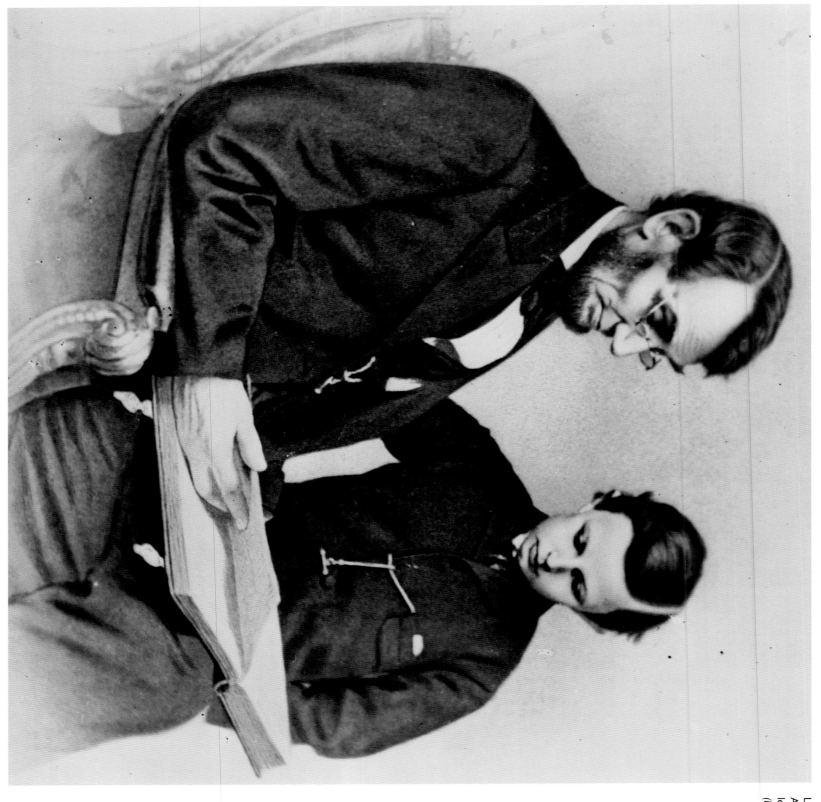

LEFT: This famous image of President
Abraham Lincoln has on its mount the
legend, "by Brady, 1863."
(Library of Congress)

LEFT: At Fair Oaks, Virginia, on May 31, 1862, Gibson spotted and photographed Captain George A. Custer of the Union's 5th Cavalry (right) chatting to an old friend from West Point, Confederate Lieutenant James B. Washington, a prisoner at the time.
(Library of Congress)

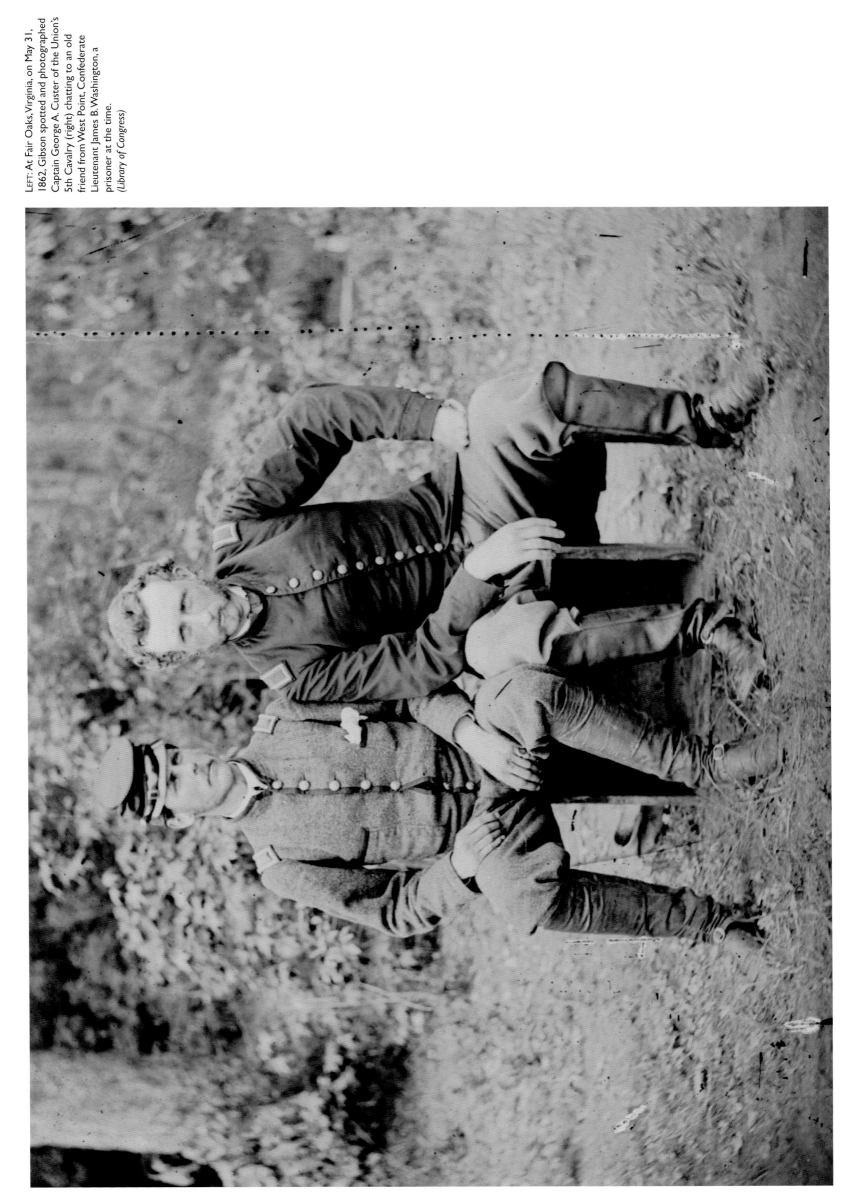

ABOVE: U.S. Army General William S. Rosecrans had success early in the Civil War, but suffered a disastrous defeat at the Battle of Chickamauga in 1863, which pretty well ended his military career. "Old Rosey," as his men called him, was considered to have had a brilliant military mind, but could fly into rages at subordinates, and had a pronounced stutter when excited or flustered, making him difficult to comprehend.
(Library of Congress)

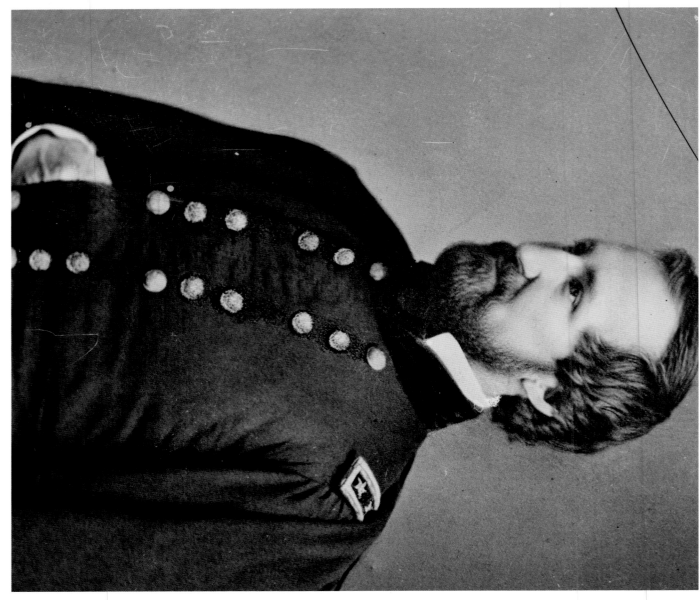

RIGHT: Even on a social occasion such as having his photograph taken in Brady's studio, General William Tecumseh Sherman displays an intensity such that made him ill during the first year of the Civil War. However, aided by his friend and mentor Grant, he recovered to become one of the greatest (and most ruthless) commanders of the war.
(Library of Congress)

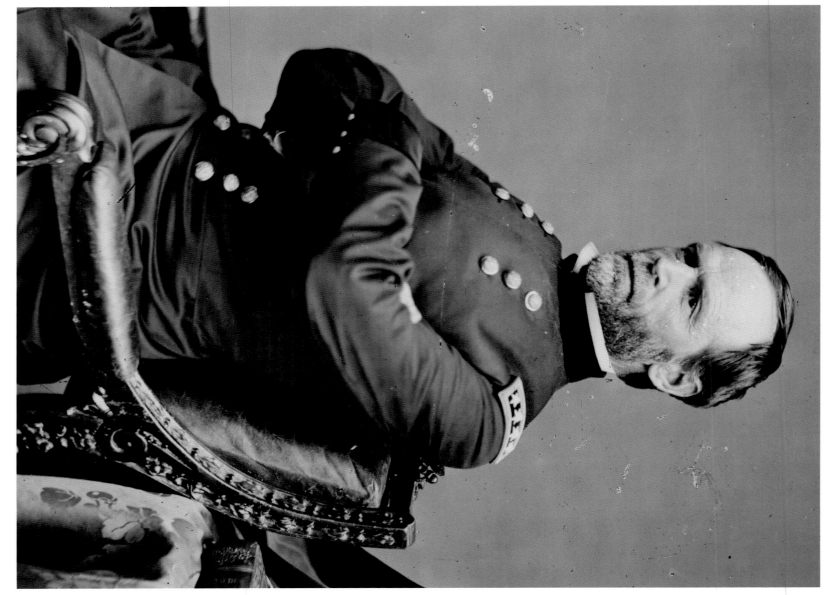

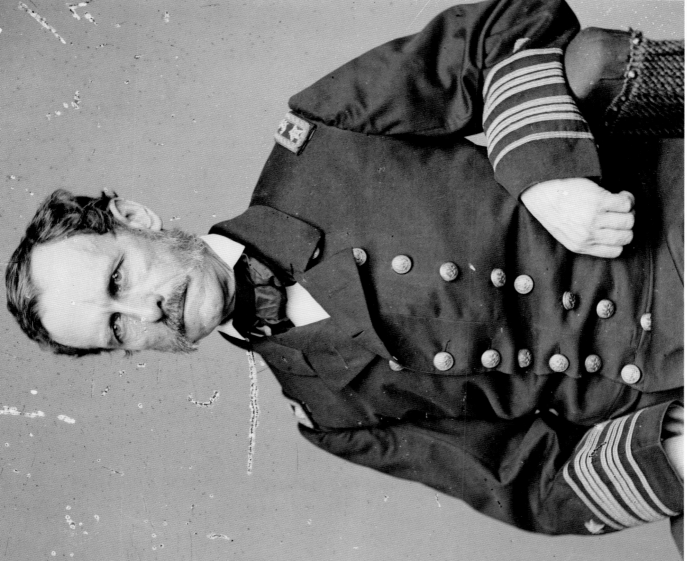

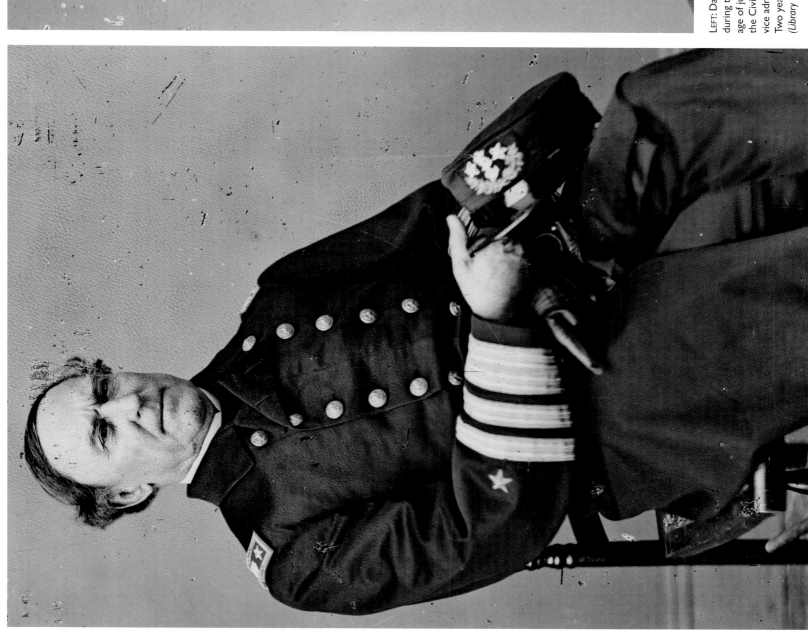

LEFT: David Glasgow Farragut was a life-long navy man who, during the War of 1812, had commanded his first prize ship at the age of just twelve years. He was the greatest naval commander of the Civil War, being promoted by Lincoln to the first ever post of vice admiral following his victory at Mobile Bay in January 1865. Two years later, Congress created the rank of full admiral for him. (Library of Congress)

ABOVE: Rear Admiral John A. Dahlgren was head of the U.S. Navy's ordnance department during the Civil War, and designed several different kinds of naval guns that bore his name. In 1863 he also took command of the South Atlantic Blockading Squadron, and was most successful in starving the South of vital supplies. (Library of Congress)

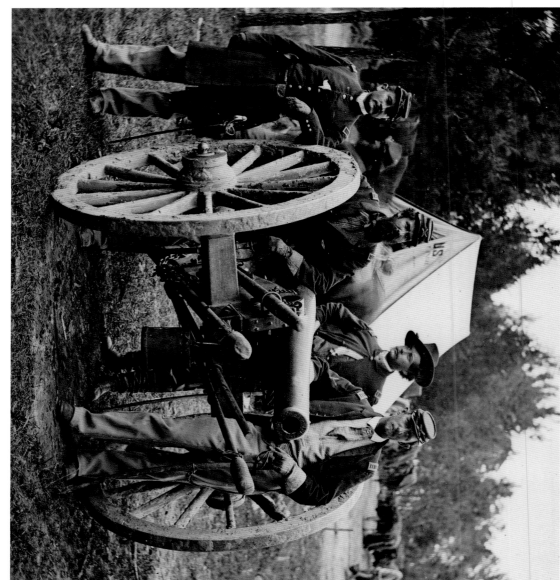

LEFT: John Lincoln Clem (August 13, 1851–May 13, 1937), photographed in Brady's studio with his brother, became variously known as the "Drummer Boy of Shiloh" and the "Drummer Boy of Chickamauga" during the Civil War. At age nine he attempted to enlist in the 3rd Ohio Volunteer Infantry, but was rejected, and was again rejected by the 22nd Michigan, although he followed them and was eventually adopted as their mascot. He was wounded twice in the war, and promoted to sergeant after Chickamauga, becoming the youngest ever non-commissioned officer of the U.S. Army. Clem went on to become a major general before retiring in 1916.
(Library of Congress)

ABOVE: Officers of Battery A, 2nd U.S. Artillery, pose for the camera near Fair Oaks, Virginia, June 1862, during the Federal Peninsular Campaign. They are Lt. Robert Clarke, Capt. John C. Tidball, Lt. William N. Dennison, and Capt. Alexander C. M. Pennington. During the war Dennison was awarded two brevet promotions for gallantry in combat, and a further brevet promotion at war's end for his overall service and conduct. Even more highly decorated was his commander, Tidball of "flying battery" fame, who was brevetted five times for gallant and meritorious conduct in the field.
(Library of Congress)

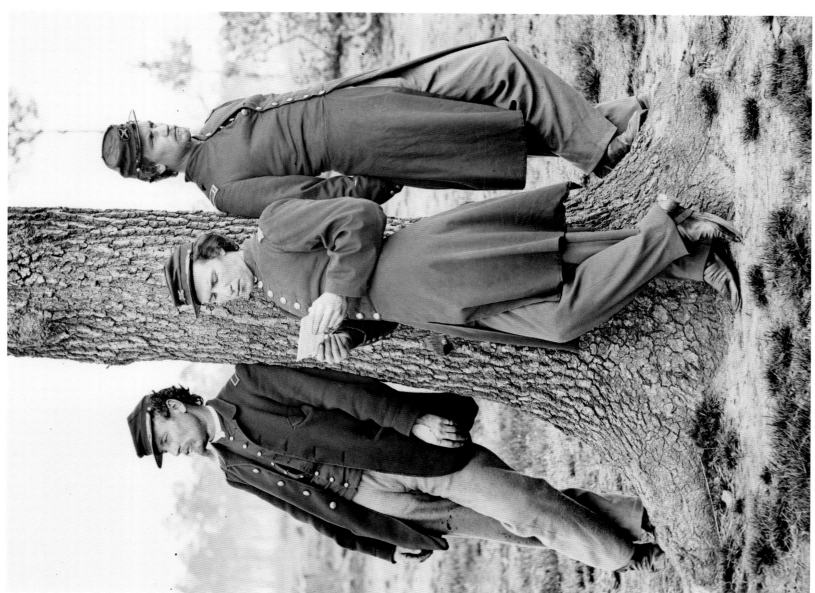

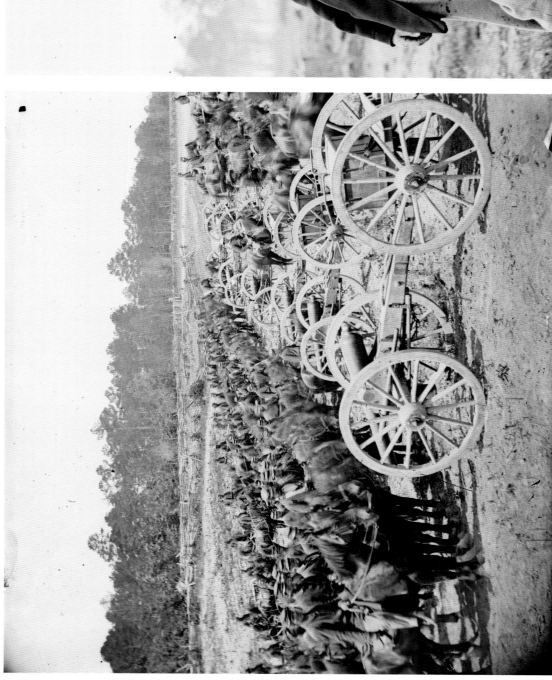

ABOVE: Major James M. Robertson's Battery of Horse Artillery near Richmond, Virginia, in June 1862. Robertson, who was engaged in most of the major battles in the eastern theater, commanded the Union's combined Batteries B and L of the 2nd U.S. Artillery during the Peninsular Campaign in mid-1862, was given command of the U.S. Horse Artillery Brigade, and was awarded successive brevet promotions to brigadier general by the end of the war.
(Library of Congress)

RIGHT: Three officers of Company C, 1st Connecticut Heavy Artillery, take time out from their duties at Fort Brady, Virginia, between June 1864 and April 1865.
(Library of Congress)

BATTLES AND BATTLEFIELDS

Prior to the firing on Fort Sumter in April 1861, Mathew Brady was convinced that he needed to photograph and document the war—something that had never before been possible. He felt deeply enough that this was an important project to which he was willing to commit his time and resources, and even stake his business on it. He also thought that people would later clamor for his "War Views."

Wartime photography during the infancy of the art was difficult at best. Even though the Civil War dragged on for more than four years, there is only one known photographic image of actual fighting. The reason for this is simple. Even under optimal conditions of a well-lit day, exposures frequently took five seconds or so. Thus, any movement in the field would be seen as a blur. For war photography, attention needed to be focused in other areas, which break down into three larger categories, including posed photos, war carnage, and the scenery of the battlefield.

Brady's photographers, including Alexander and James Gardner, Timothy O'Sullivan, George N. Barnard, Thomas C. Roche, William Pywell and close to twenty others, all focused on these areas with their "Whatsit Wagons."

Battlefield portraiture was done as much as possible like studio portraiture. Officers and soldiers posed in camp, with the props of camp life serving as those you'd find in classic studios. Thus, trees became classical columns and tents became drapes.

Photographing the carnage of war wasn't as difficult as it might seem. Dead soldiers never move and blur the exposure, and they were occasionally posed by the photographer for better effect. The same holds true for destroyed towns and villages. Cameramen set up at points that would best communicate the level of destruction they found. These are among the most emotionally moving of all war photographs.

The scenery of the battlefield was, arguably, perhaps the most important of the categories, since these photographs showed the battlefield landmarks. For those who had only heard about places such as Little Round Top or Dunker Church at Gettysburg, these images were a vital part of understanding the war. Indeed, the perfect example of this was at Gettysburg in July 1863, where Brady and his crew arrived too late to photograph any of the carnage.

Instead, Brady concentrated on the lay of the land, landmarks, and notable locations. As a result, his depictions of Gettysburg received far more acclaim and were copied by the contemporaneous press more than Alexander Gardner's more graphic photos taken shortly after the same battle.

RIGHT: The destruction of a Confederate caisson after being hit by a 32-pound shell fired by the 2nd Massachusetts Heavy Artillery at Marye's Heights, Fredericksburg, May 3, 1863. The image was created by Brady studio photographer Andrew Russell. (Library of Congress)

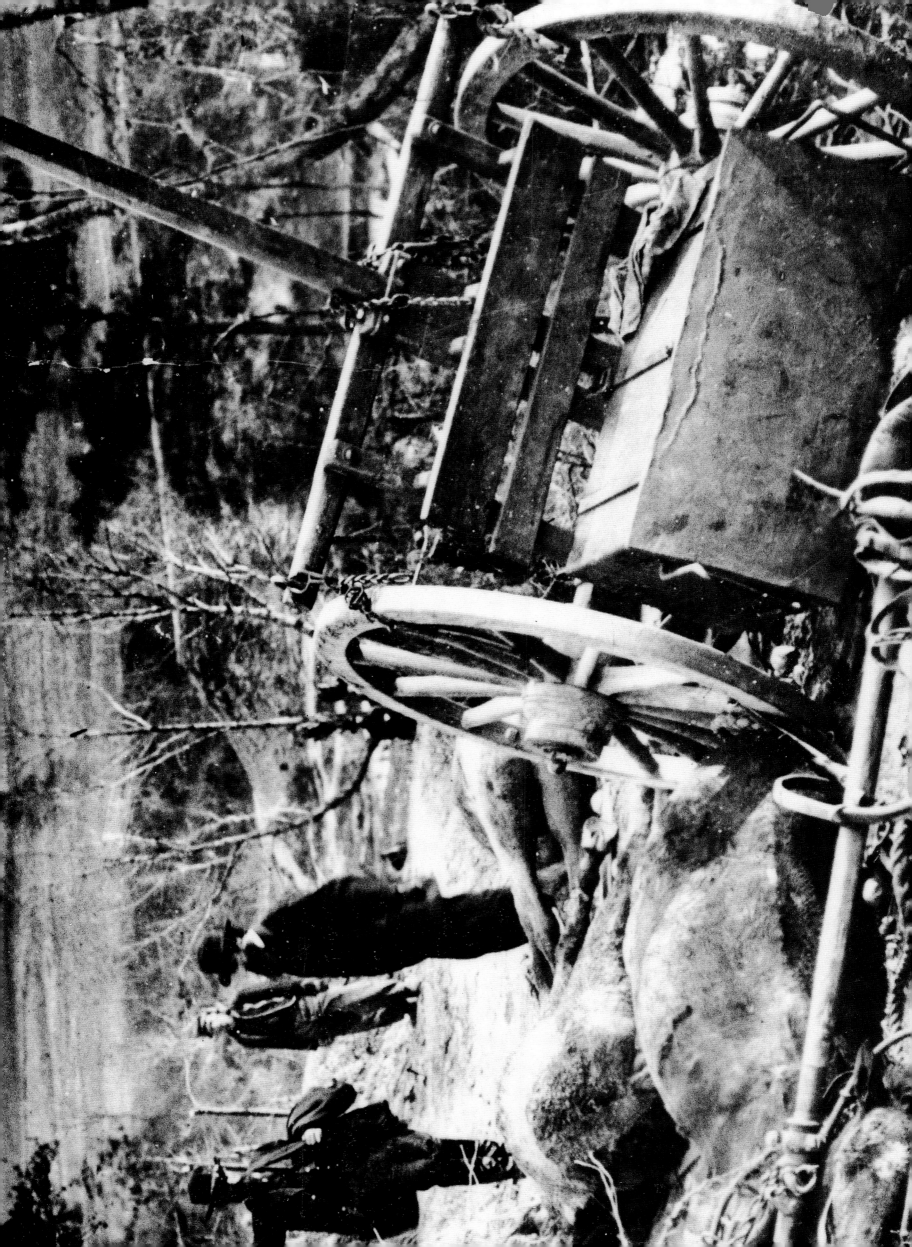

FAR LEFT: A pontoon bridge over a ford at Bull Run, Va., 1862. When several of these pontoon boats were lashed closely together, a roadway could be laid over the top to take wagons, horses, and soldiers across even wide rivers.
(National Archives)

LEFT: The entrance to the Mahone Mine, discovered after the siege of Petersburg, April 1865. The mine ran for some 600 yards, but was poorly planned and executed, nor was it completed.
(Library of Congress)

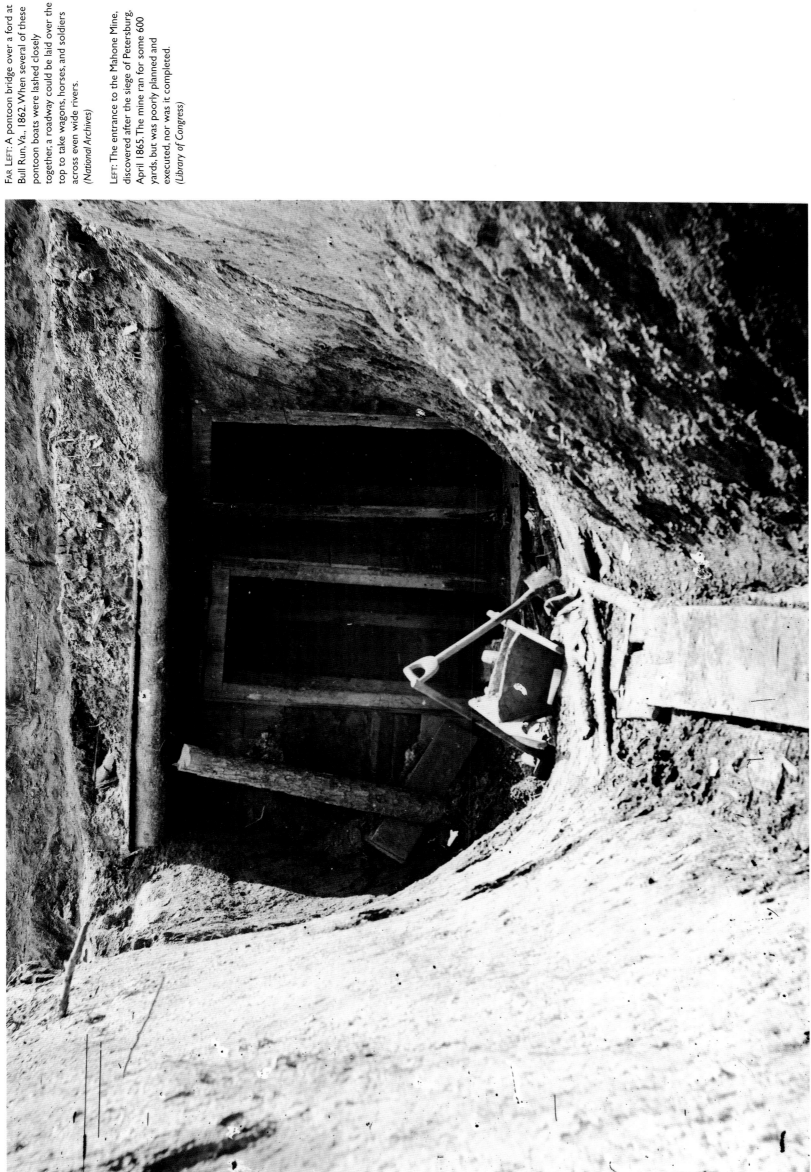

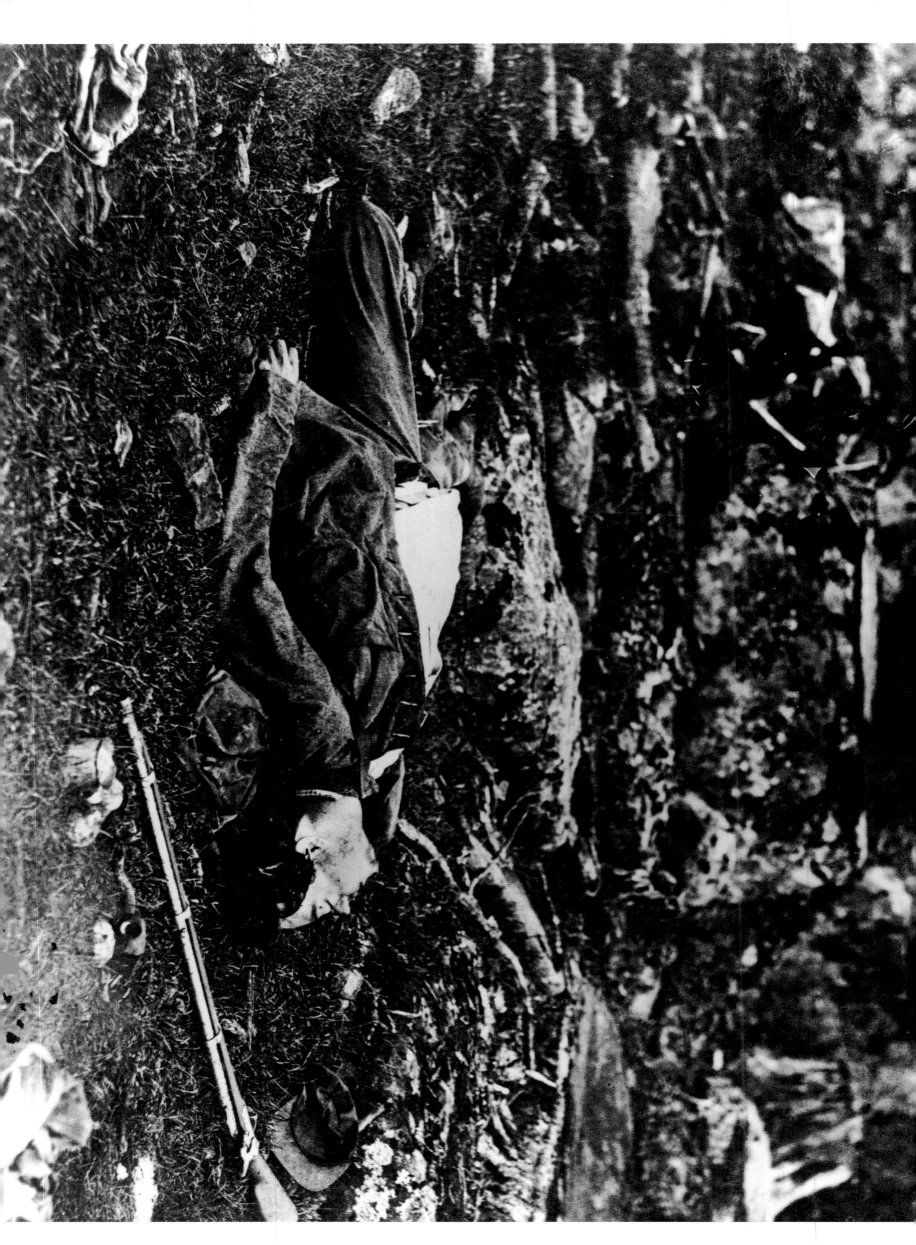

FAR LEFT: A Confederate soldier killed in April 1865 during the siege of Petersburg. The image was created by Thomas C. Roche, one of the many photographers hired to work under Mathew Brady during the war. Roche traveled extensively with the Union troops assigned to the Army of the James.
(*National Archives*)

LEFT: Alexander Gardner, who had left Brady's employ late the previous year, got to the Gettysburg battlefield shortly after the battle had ended on July 3, 1863, ahead of Brady. As here, Gardner concentrated on the dead—between the two armies some 6,000 of them were strewn across the battlefield—often moving them into more "photogenic" positions.
(*National Archives*)

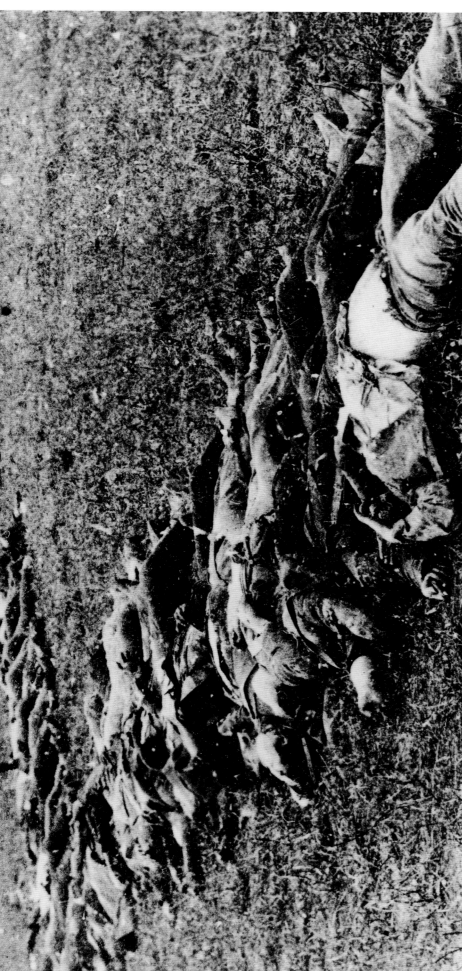

LEFT: Bodies of Confederate dead gathered for burial at Antietam, Md., September 1862. The photograph (and many others showing the terrible scenes at Antietam) was taken by Alexander Gardner, at the time still working for Brady, and exhibited under the title "The Dead of Antietam," in the New York gallery, where for the first time the full horrors of war were brought home to the American public.
(*Library of Congress*)

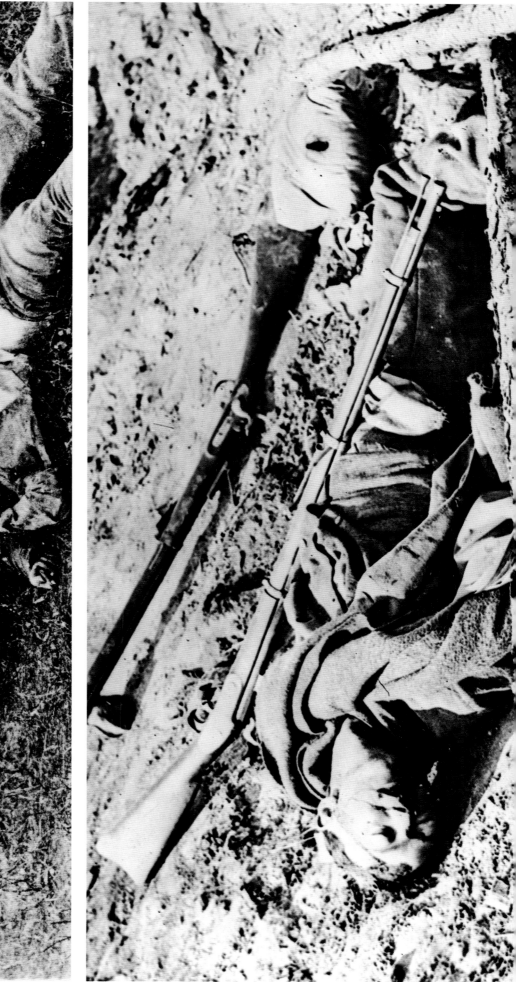

RIGHT: Officers of the 69th New York State Militia at Fort Corcoran, Va., which was built in 1861 from wood and earthwork as part of the defenses of Washington, D.C. The fort overlooked the Potomac River, protecting the southern end of the Aqueduct Bridge. It was named after Colonel Michael Corcoran (at far left), commander of 69th New York Volunteer Regiment, one of the units that built the fort.
(Library of Congress)

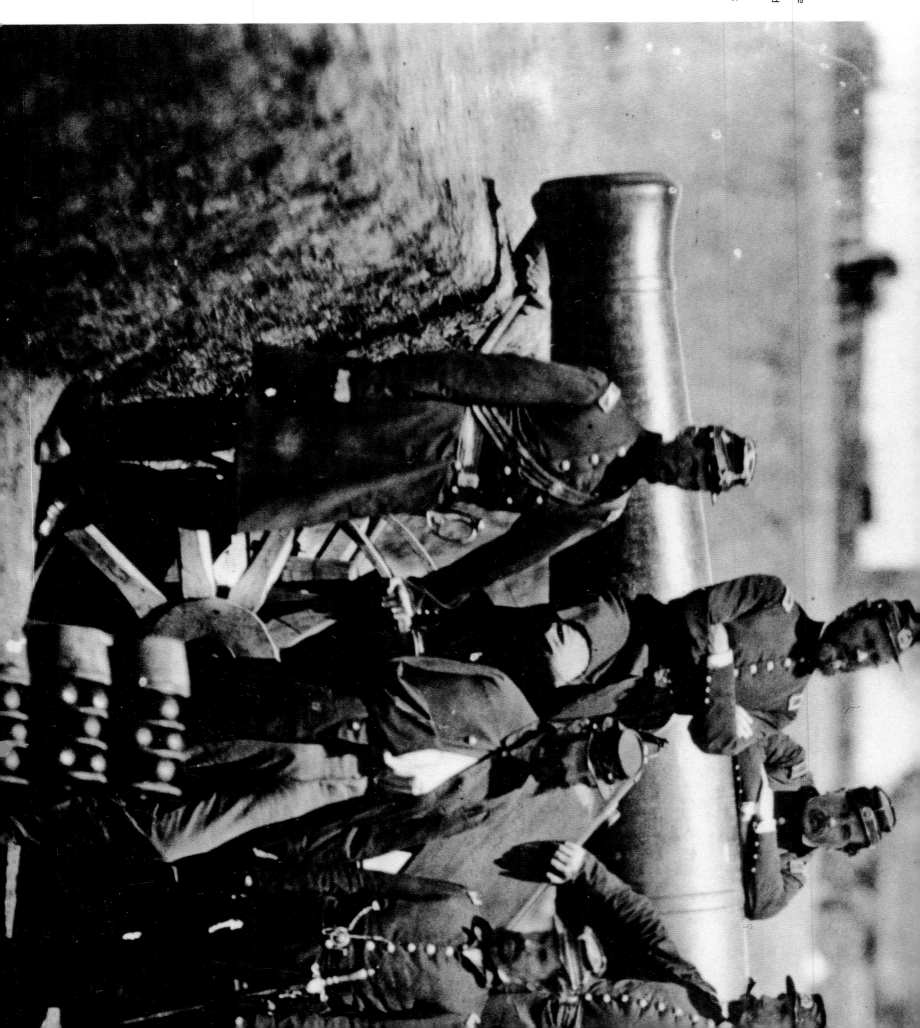

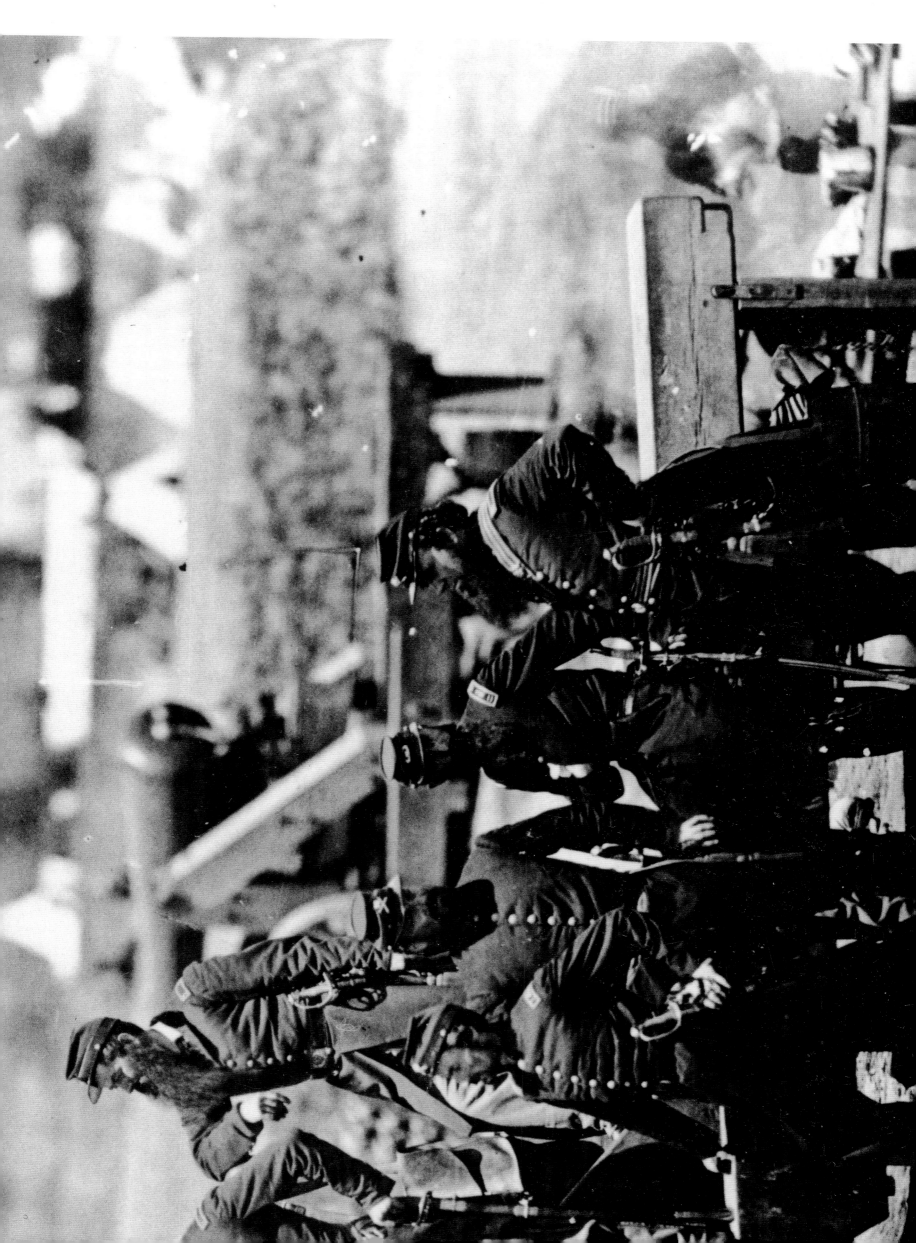

RIGHT: Having worked for both Brady's and Alexander Gardner's outfits, Timothy O'Sullivan was following General Grant's trail near Richmond when he photographed this "council of war" on May 21, 1864, at Massaponax Church, Va. Grant is seen at left, leaning over a pew and examining a map held by Gen. George G. Meade.
(Library of Congress)

FAR RIGHT: Soldiers of 4th New York Heavy Artillery loading an early model 24-pounder seacoast cannon.
(Library of Congress)

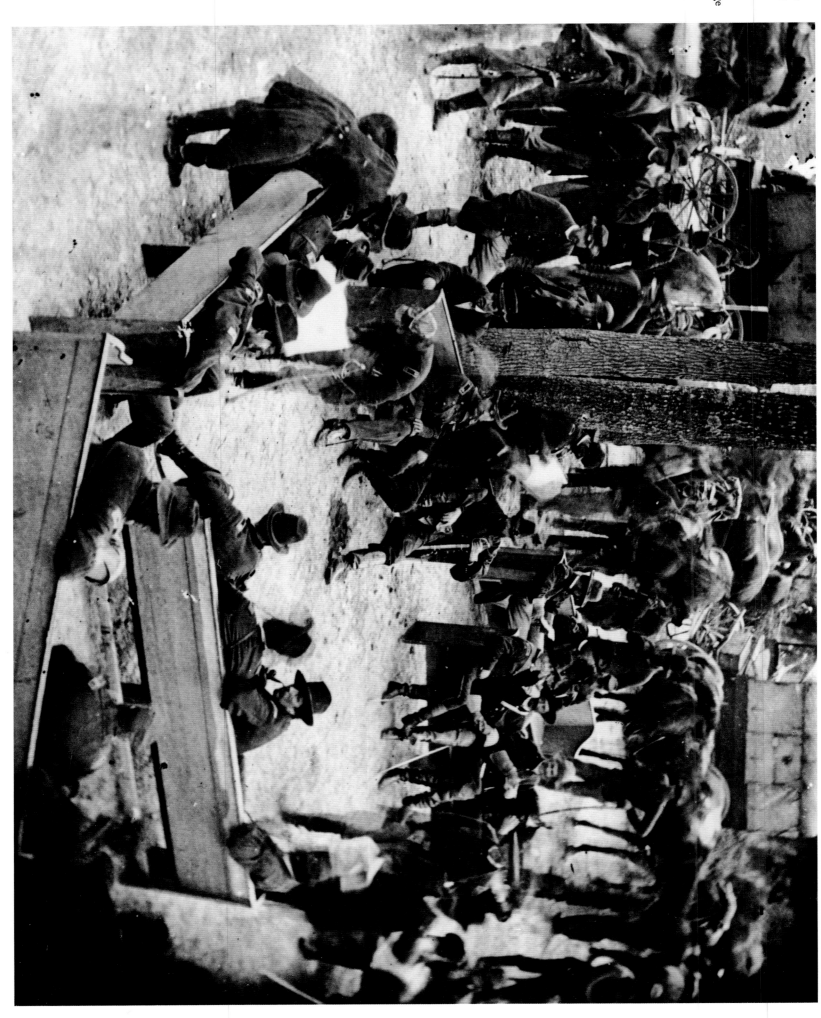

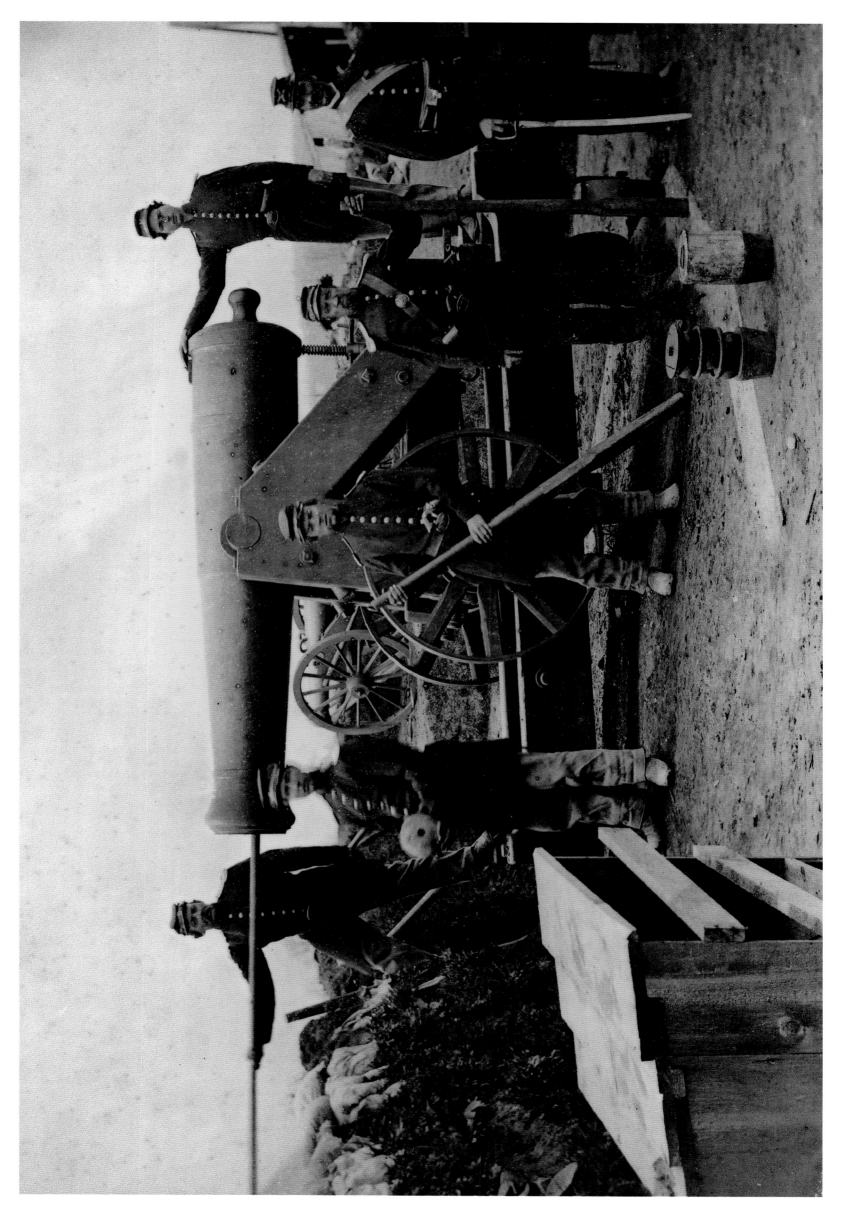

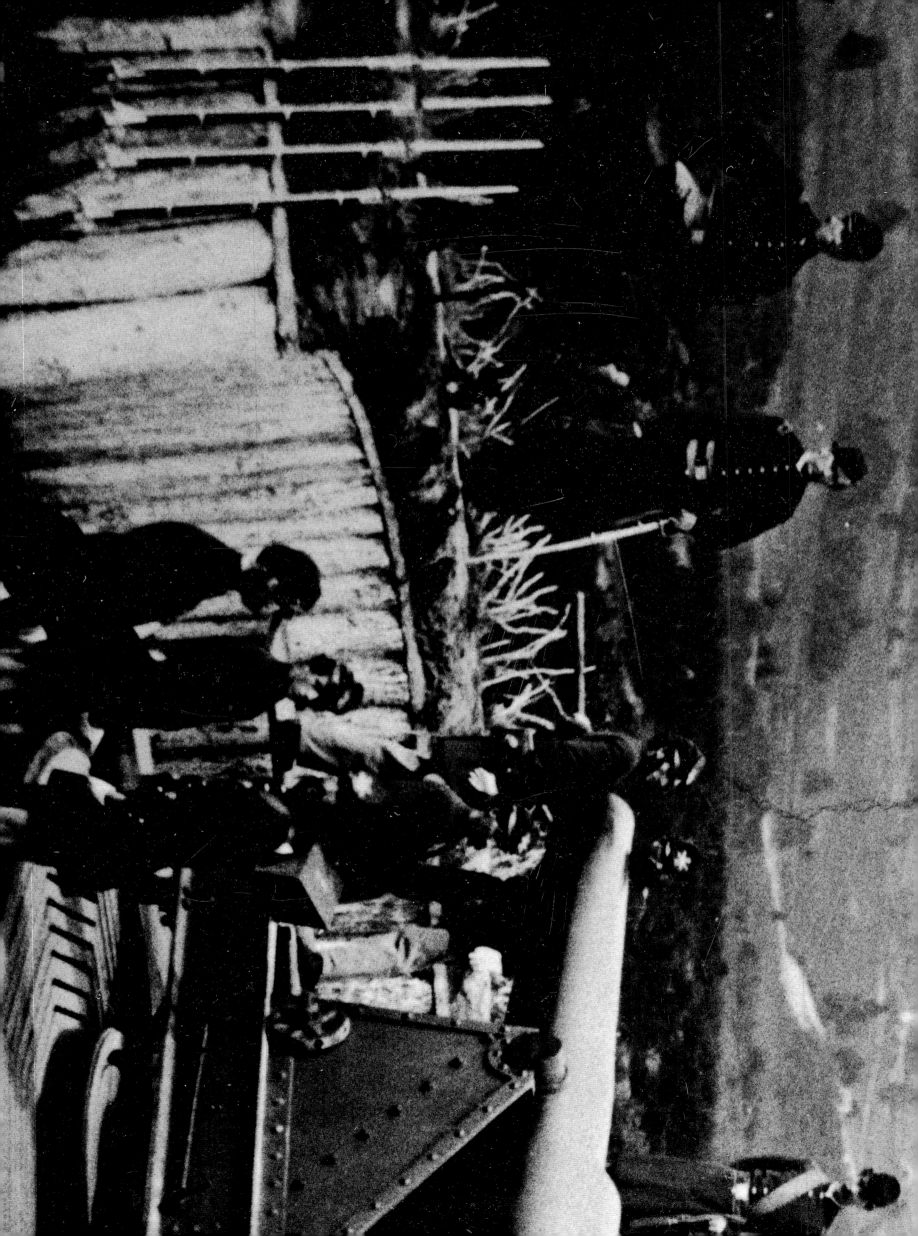

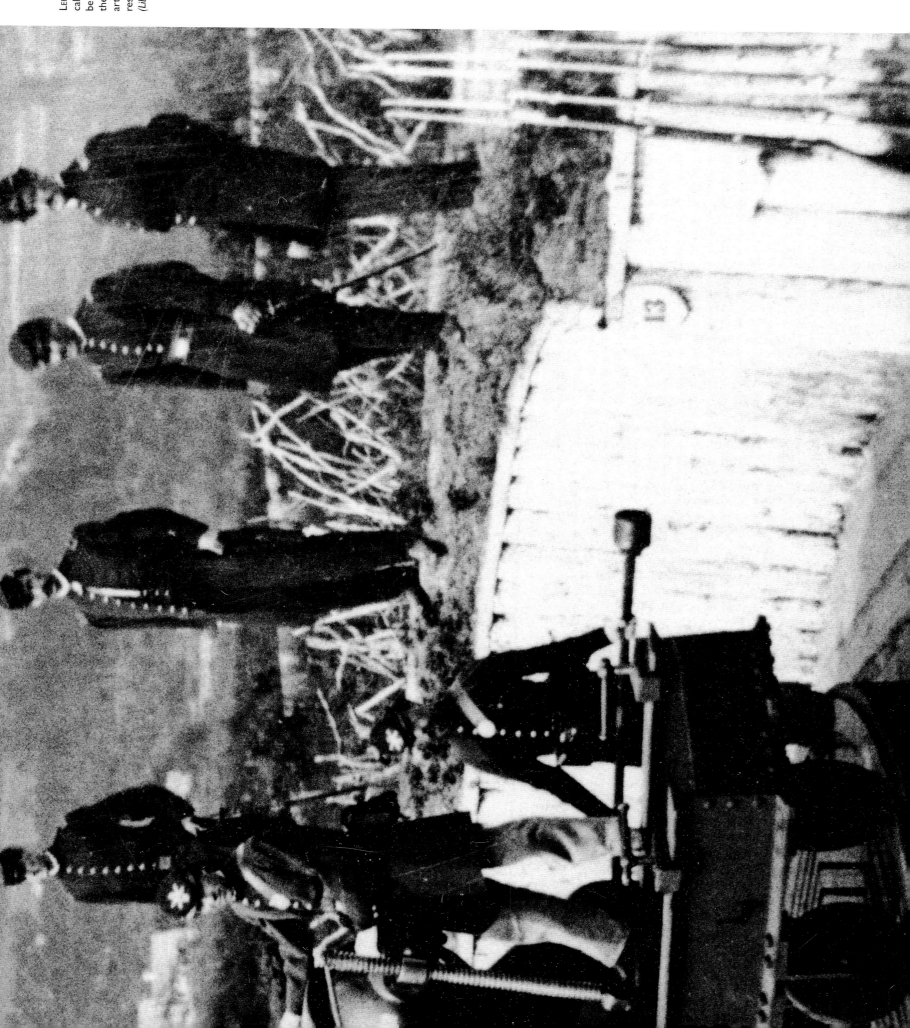

LEFT: Mounted on wheels, this 6.3-inch caliber Parrott 100-pounder cannon could be swiveled round a wide arc and was therefore more effective than many other artillery pieces whose movement was restricted.
(*Library of Congress*)

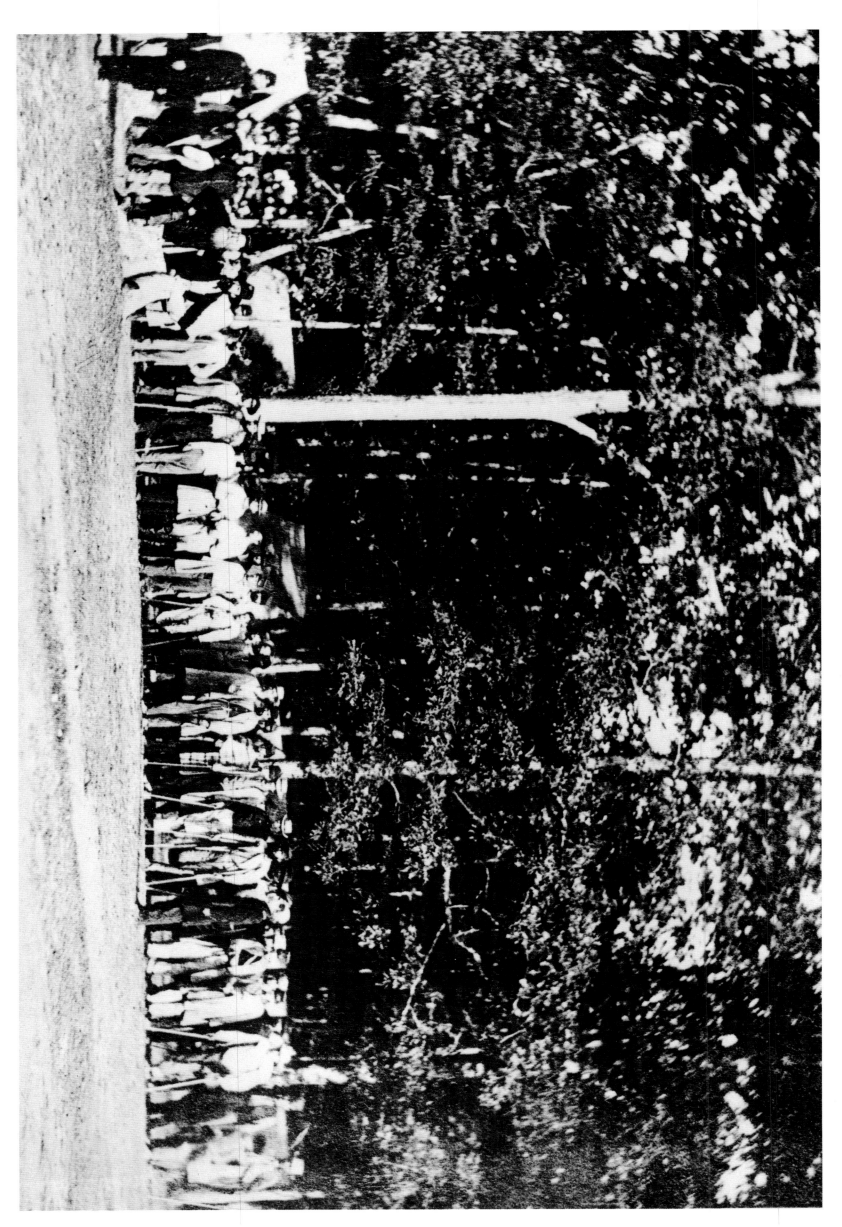

FAR LEFT: Their war is over: a large group of wounded Confederate soldiers gaze at the photographer at the Federal Camp Letterman, Gettysburg, July 1863. The camp was named for surgeon Jonathan Letterman, who originated a system for recovering and treating thousands of battlefield casualties efficiently through the establishment of forward first aid centers at the regimental level and mobile field hospitals located at division and corps headquarters, all connected by an efficient ambulance corps.
(U.S. Army Military History Institute)

LEFT: After the battle, the gruesome sight of Confederate soldiers lying dead in a ditch, used as a rifle pit, at Antietam, Maryland, September 1862.
(U.S. Army Military History Institute)

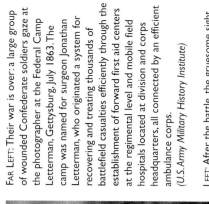

RIGHT: A wagon train crosses one of the most photographed bridges of the Civil War—the 12-foot-wide, 125-foot-long Burnside's Bridge near Antietam, September 1862, where for several hours a few Confederate soldiers held off repeated attacks by Maj. Gen. Ambrose Burnside's Union forces.
(National Archives)

FAR RIGHT: Dead soldiers from the Irish Brigade strewn across the Antietam battlefield, September 1862. During the battle, the brigade served in the Federal 1st Division, II Corps, commanded by Major General Israel Bush Richardson, also known as "Fighting Dick." The fighting Irishmen were at the fore during charges against the Confederates in the Sunken Road (Bloody Lane), but had to retire because of the high number of casualties and shortage of ammunition.
(Library of Congress)

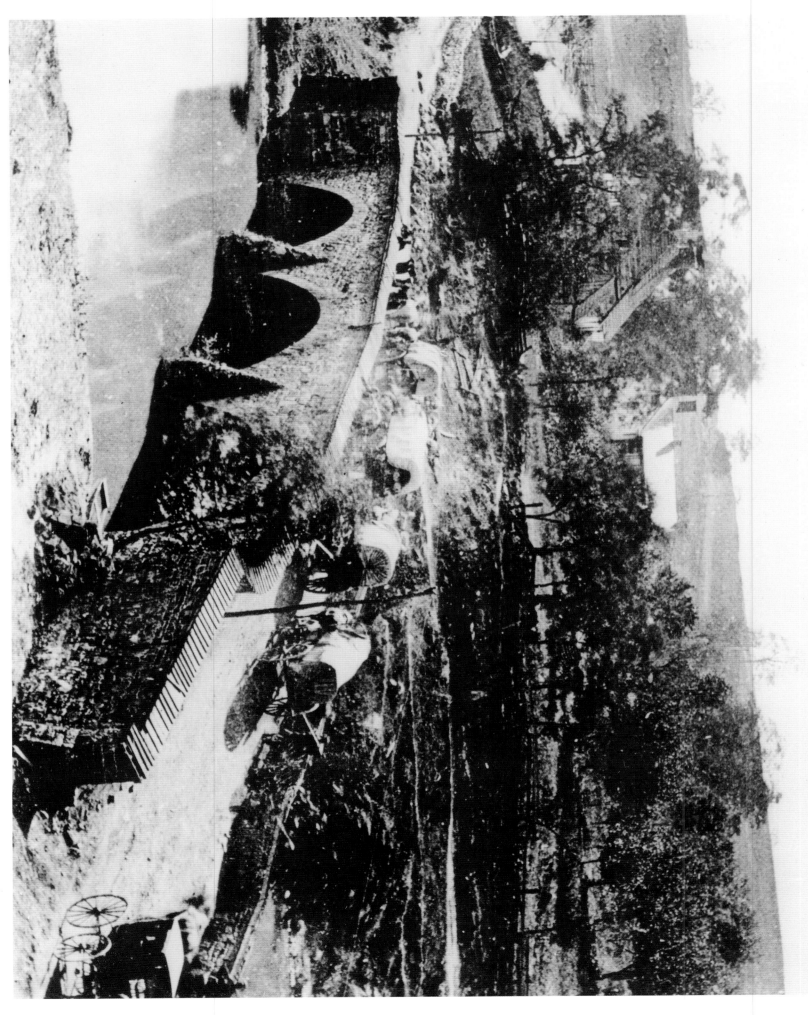

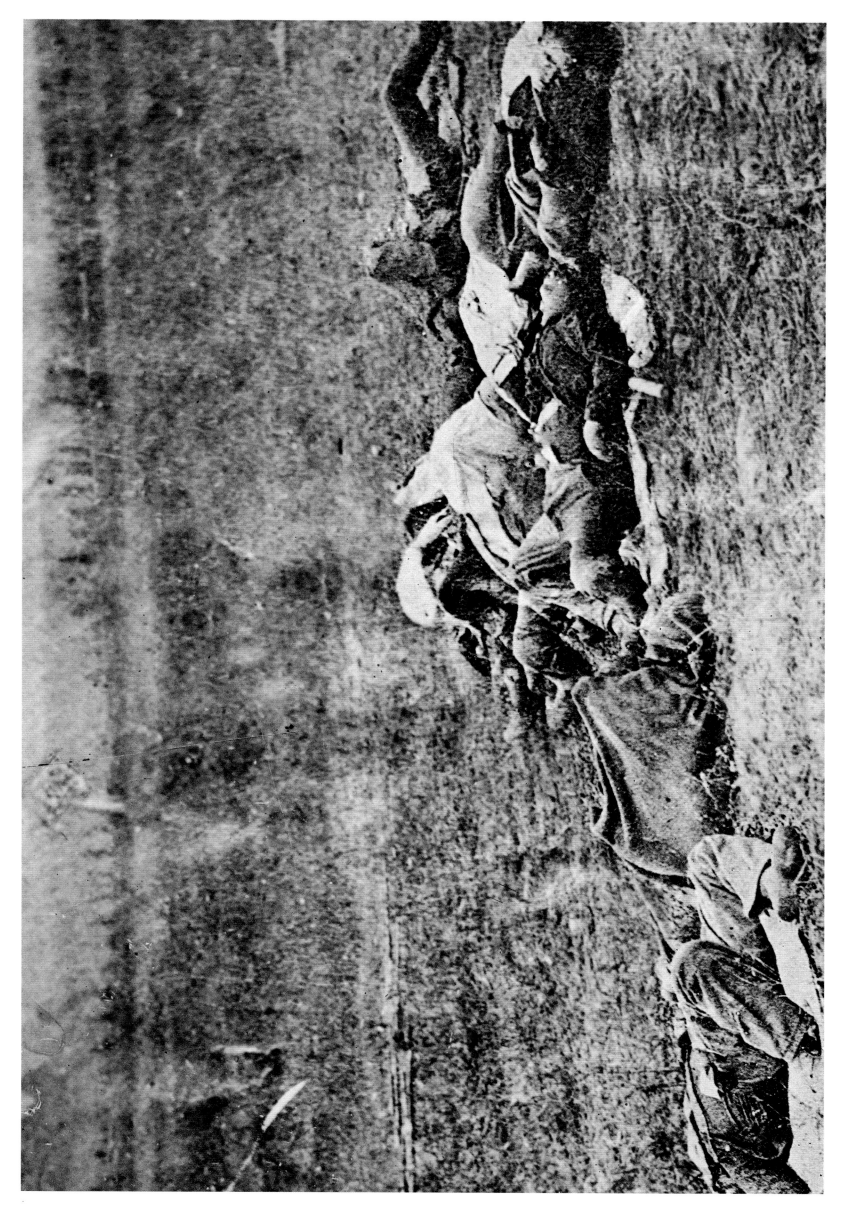

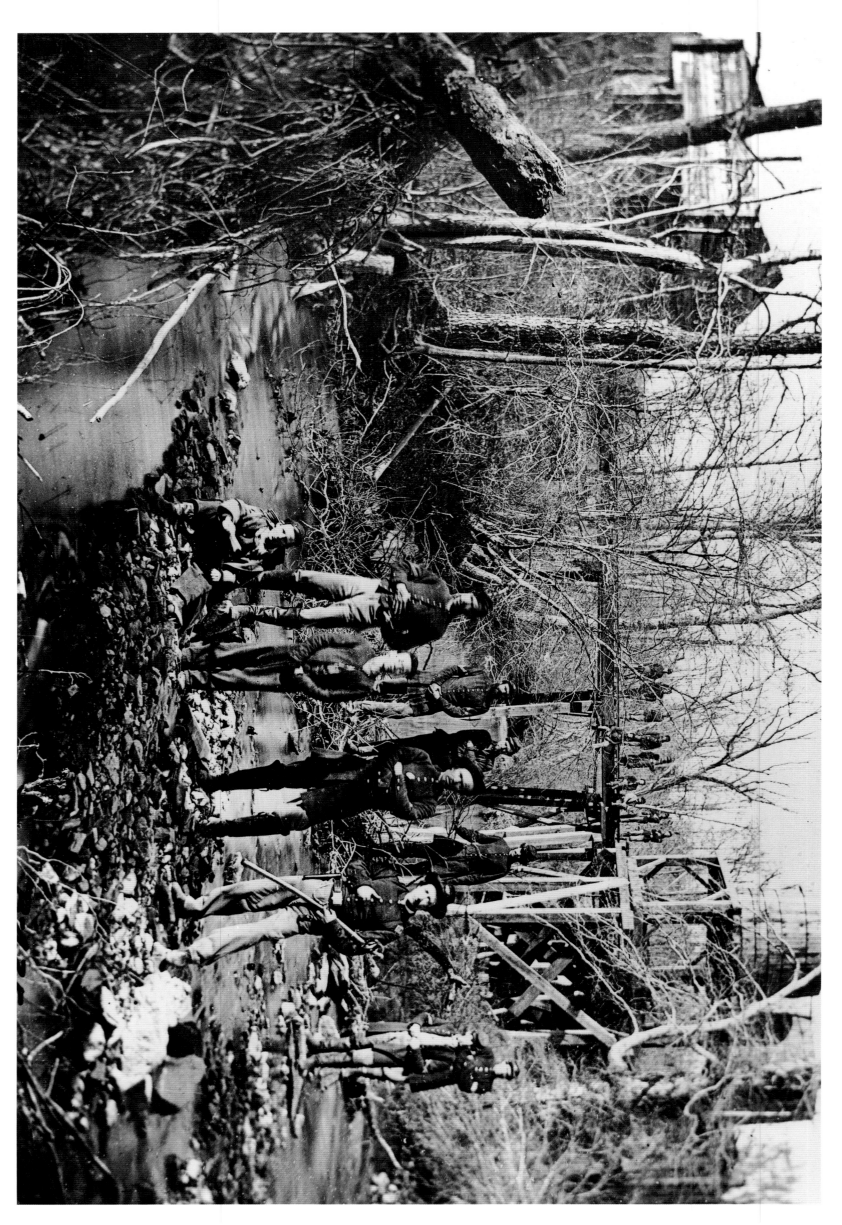

FAR LEFT: Union cavalry troops guarding a bridge on the Orange & Alexandria Railroad, 1864. This bridge was part of Grant's strategic supply line in the Virginia Wilderness Campaign. Northern Armies found it necessary to detach large portions of their armies along their lines of communication to protect against impending raids by Confederate cavalry. *(National Archives)*

LEFT: With a camp shanty in the background, a Union cavalryman blows "draw sabers" while withdrawing his own. *(U.S. Army Military History Institute)*

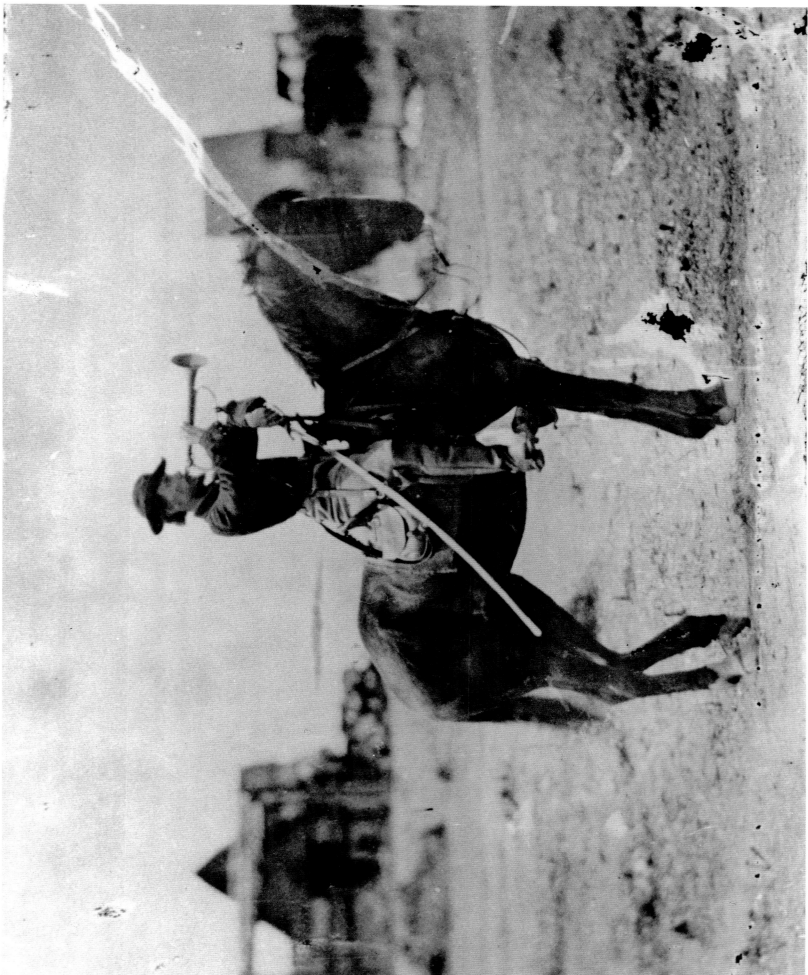

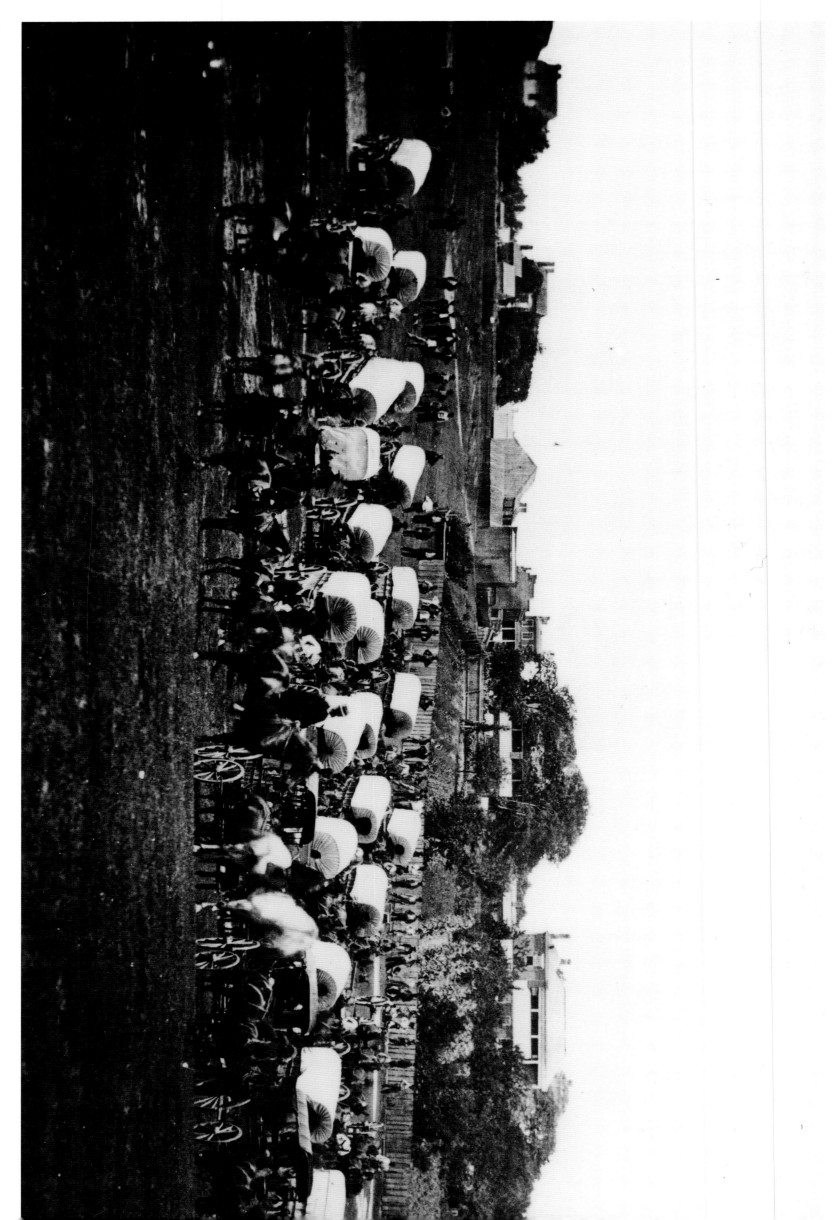

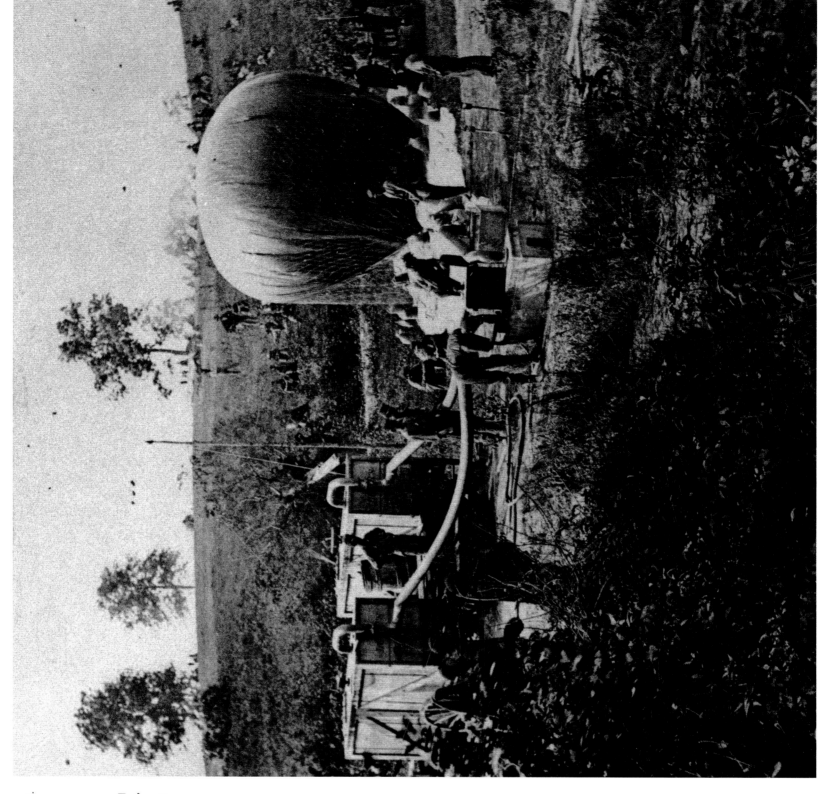

LEFT: A wagon train of the Military Telegraph Corps, Richmond, Va., June 1865. During the Civil War, the telegraph put armies and capitals in almost constant touch with each other.
(U.S. Army Military History Institute)

RIGHT: Professor Thaddeus Lowe's observation balloon "Intrepid" is prepared for hoisting during the Battle of Fair Oaks, Va., May 31, 1862. Lowe made several ascents over many battlefields, and he was the first aerial observer to spot enemy batteries and direct fire toward them.
(Library of Congress)

RIGHT: Light horse-drawn field artillery, highly valued because of its mobility, could wreak havoc among an advancing army. *(Library of Congress)*

FAR RIGHT: General Grant and eight members of his staff are caught by the camera, conferring near Petersburg, June 1864. Second from right is Grant's adjutant, Ely S. Parker, an American Indian, who wrote the final draft of the Confederate surrender at Appomattox. Parker rose to become brigadier general. *(Library of Congress)*

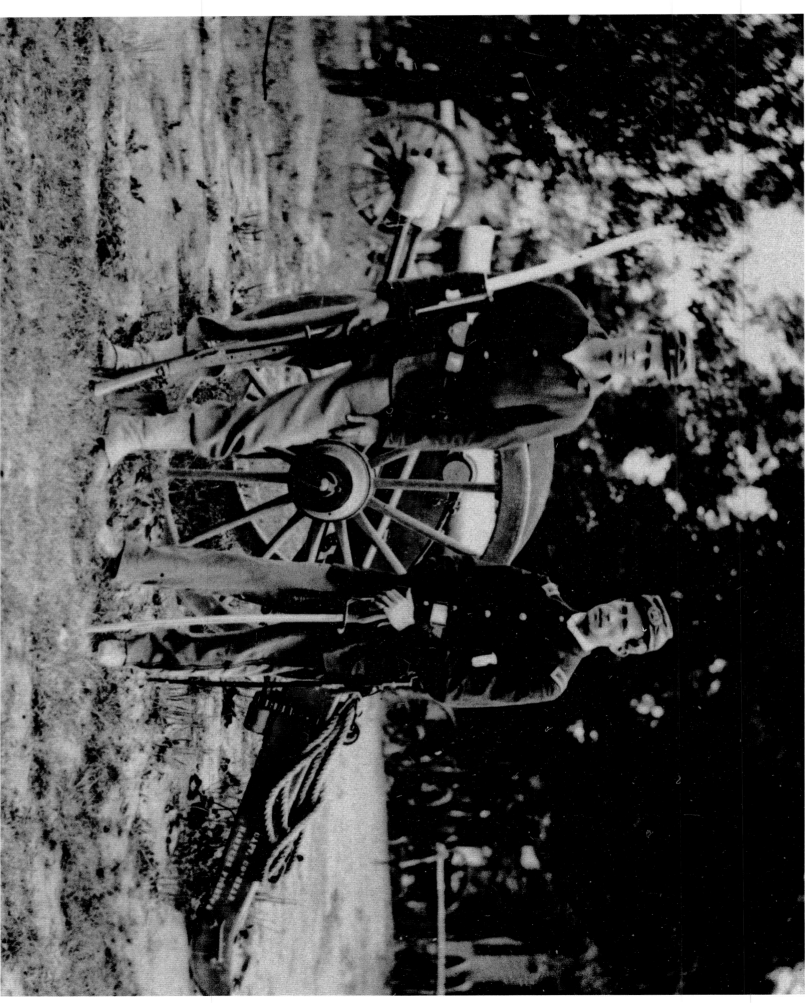

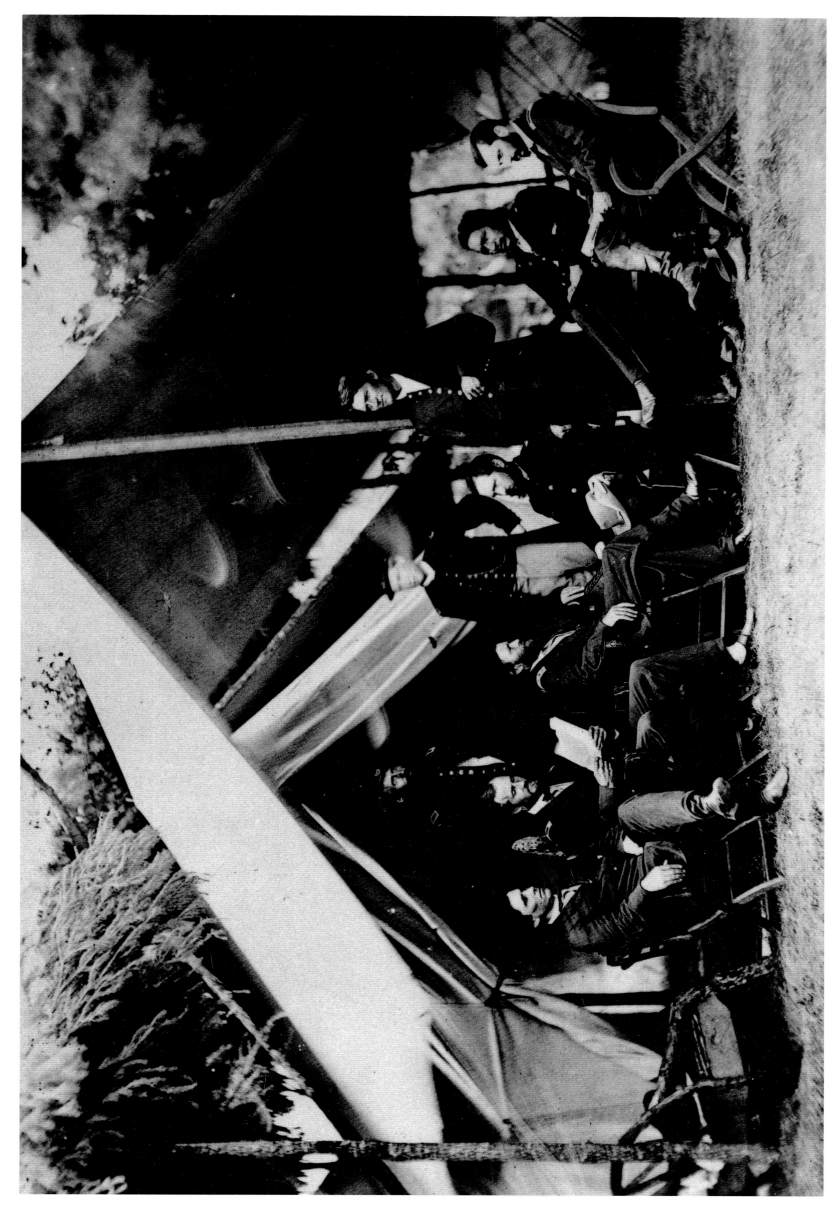

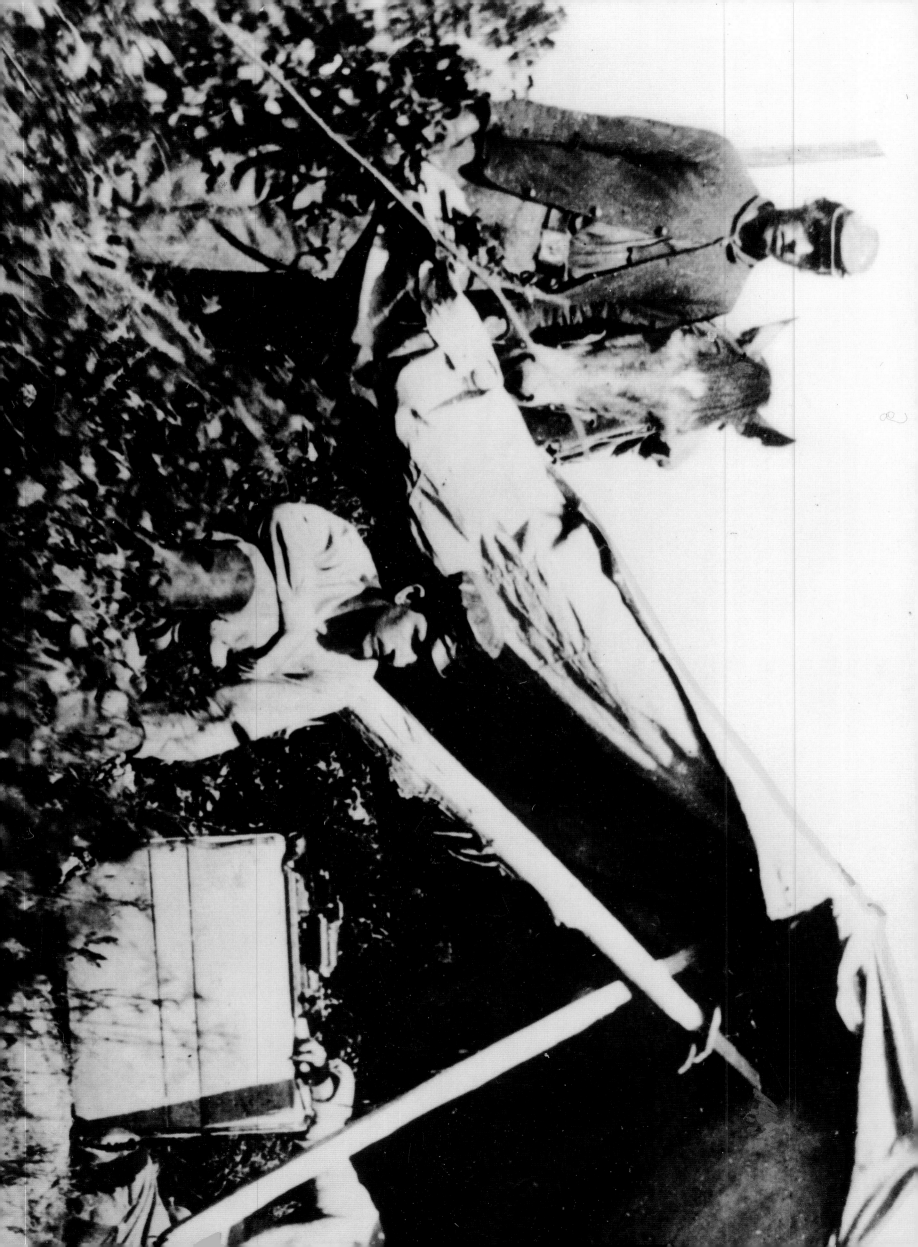

LEFT: Federal telegraph operators in a
hastily erected tent at Wilcox's Landing,
near the James River, probably 1864.
(Library of Congress)

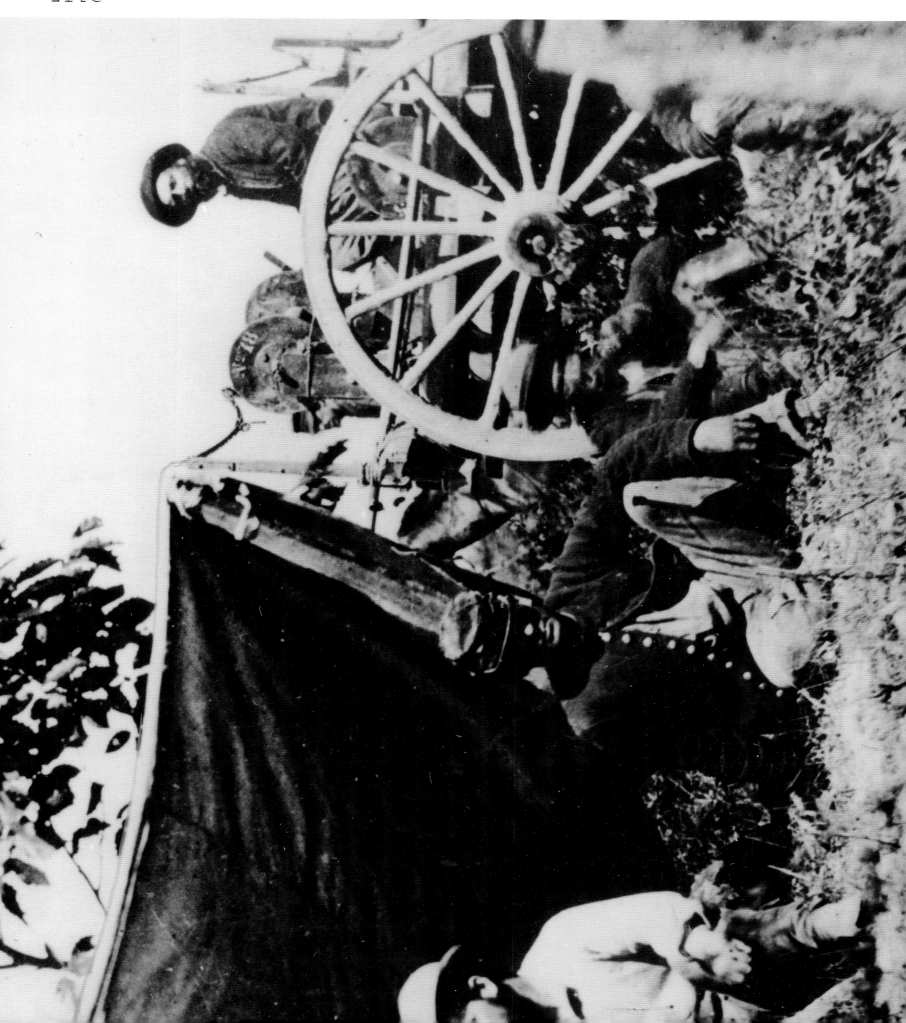

MATHEW B. BRADY

RIGHT: A regimental drum corps. Drummers, who were required to learn at least fifteen drum rolls, were the heartbeat of an advance and suffered a very high mortality rate in battle. (*Library of Congress*)

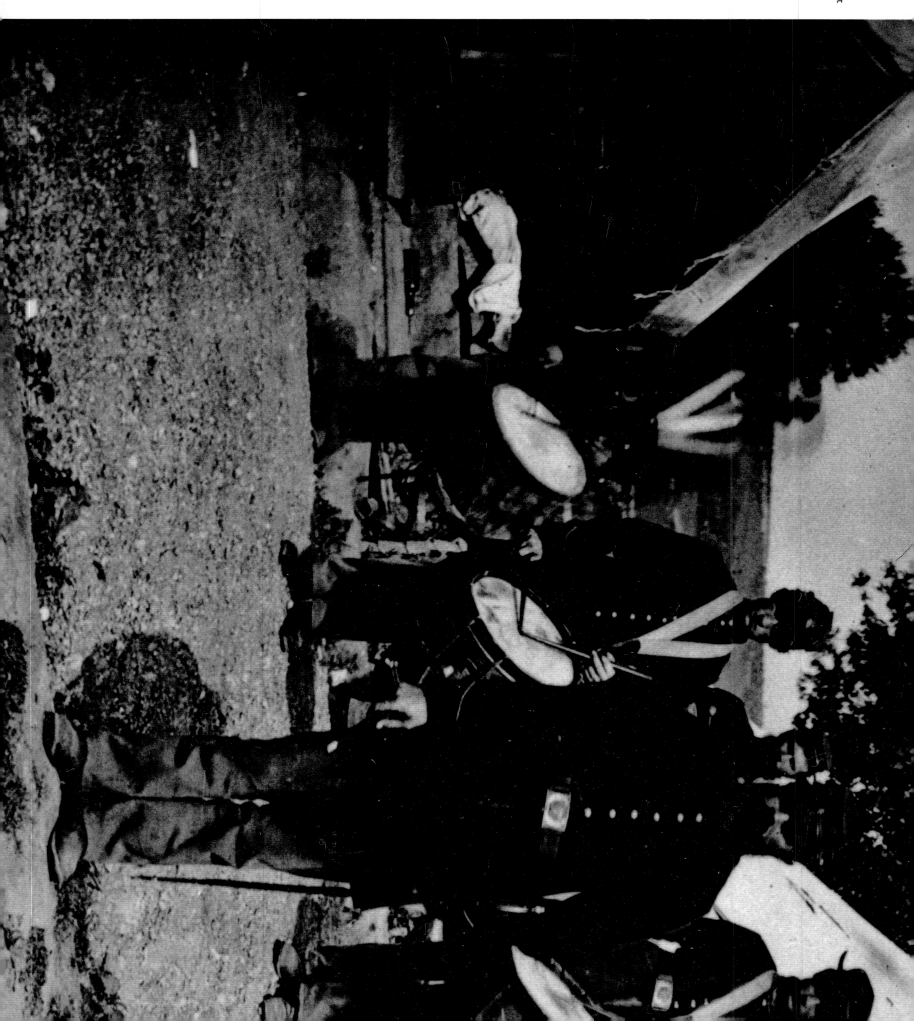

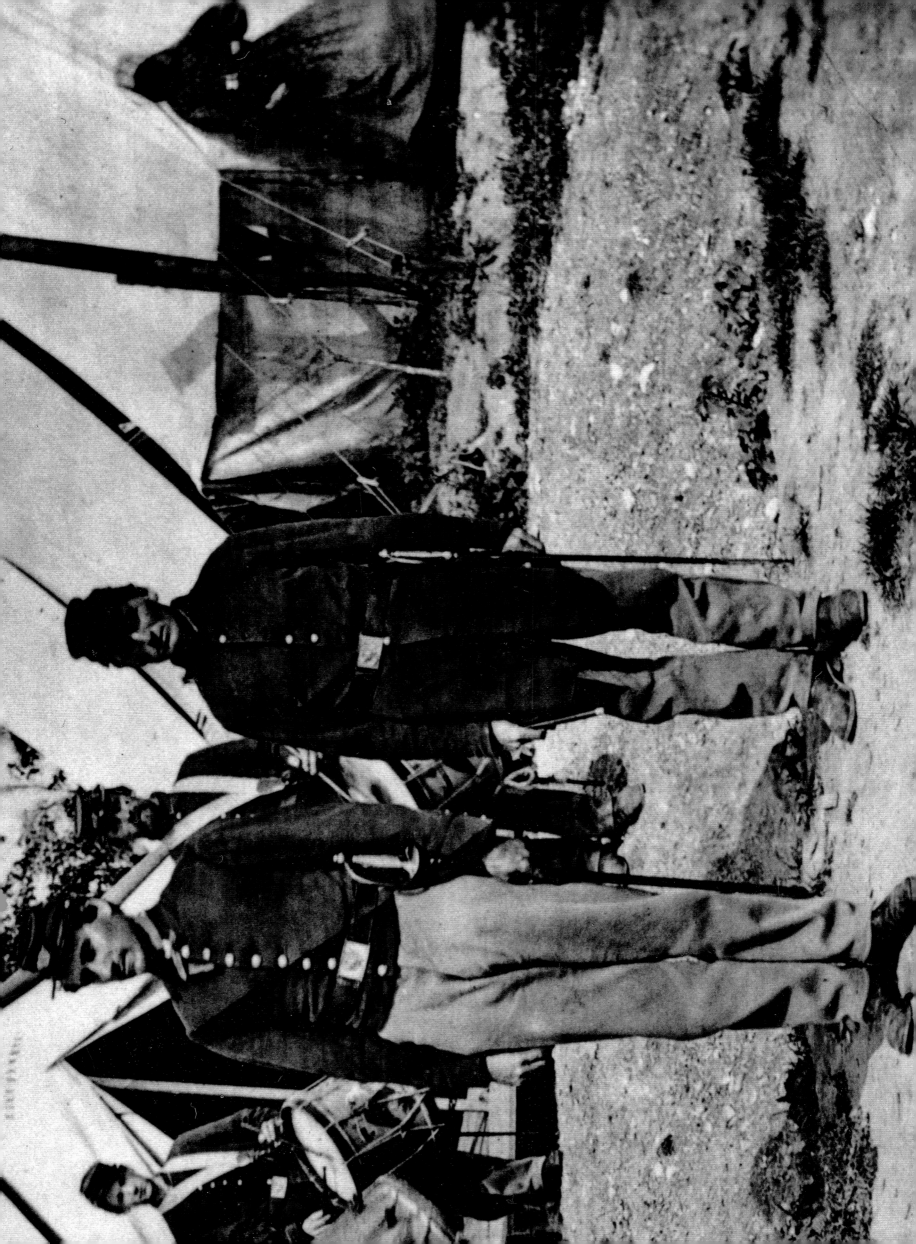

RIGHT: An officer and four men of the U.S. Army's 4th Infantry. Rather than disperse experienced regulars such as these specialists throughout the volunteer regiments, Washington decided to keep the Army intact. However, many analysts believed it would have been advantageous for "green" troops to have trained with the regulars.
(Library of Congress)

CENTER RIGHT: Members of the 15th New York Engineers, near Malvern Hill during the Peninsular Campaign, probably June 1862. Such specialists were responsible for construction of fortifications, bridges, roads, and railroads.
(Library of Congress)

FAR RIGHT: Head of the Union Intelligence Service (forerunner of the U.S. Secret Service) Allan Pinkerton (left) poses for Brady's camera with President Lincoln and Maj. Gen. John A. McClernand at the Antietam battlefield, 1862.
(Library of Congress)

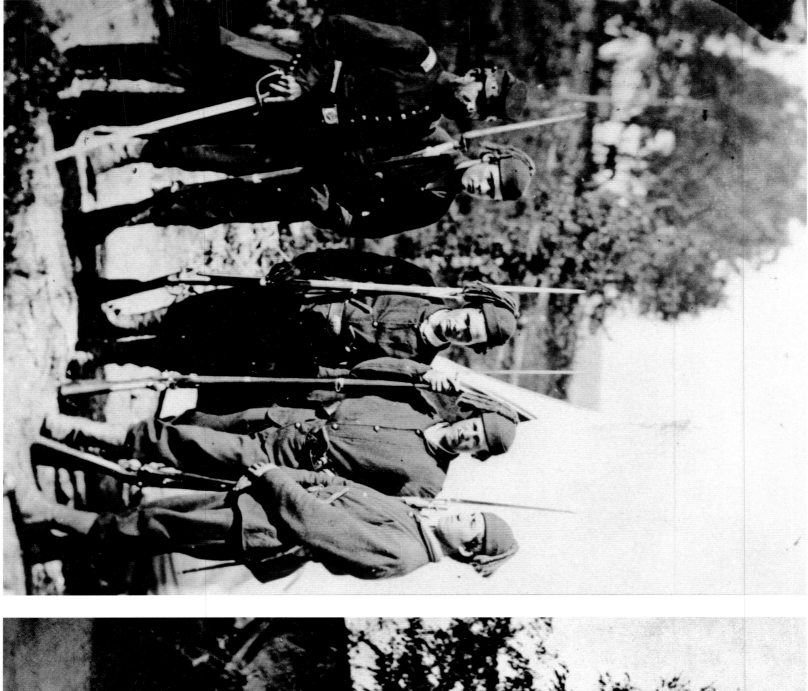

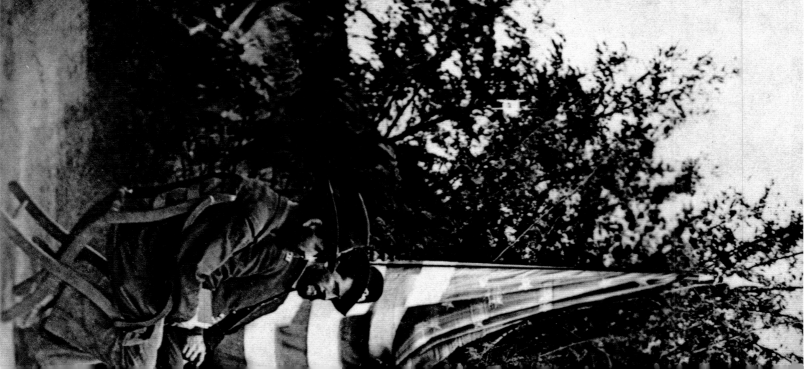

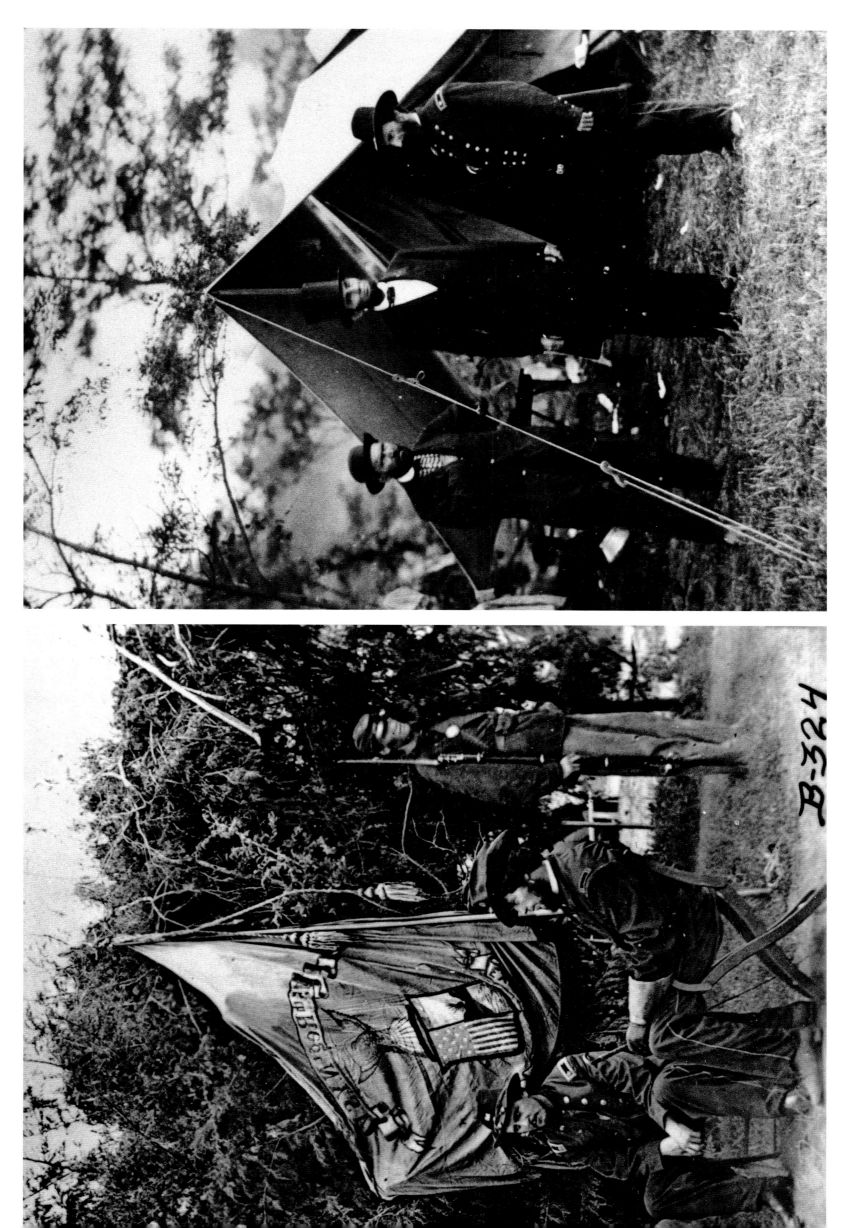

FAR LEFT: Photographer Alexander Gardner captured Dr. Anson Hurd of the Federal 14th Indiana Volunteer Infantry Regiment as he treated Confederate wounded at a field hospital established at Smith's Barn in the vicinity of Keedysville, Md., after the Battle of Antietam, September 17, 1862. The bloodiest day of the Civil War—of all American history, in fact—ended with the North suffering 2,108 killed, 9,500 wounded and several hundred missing, while the Confederates lost 1,546 dead, 7,750 wounded, and more than a thousand missing. When Mathew Brady displayed this and other photographs of the aftermath of the battle in his New York gallery, in an exhibition entitled "The Dead of Antietam," it brought home to the public for the first time the full horrors of war.
(Library of Congress)

LEFT: Six-foot-four President Lincoln faces diminutive General George B. McClellan, with his staff at the Antietam Battlefield, 1862. George Armstrong Custer, stands at right, separate from the main group in what is apparently the only known photograph of the "Boy General" with the president.
(Library of Congress)

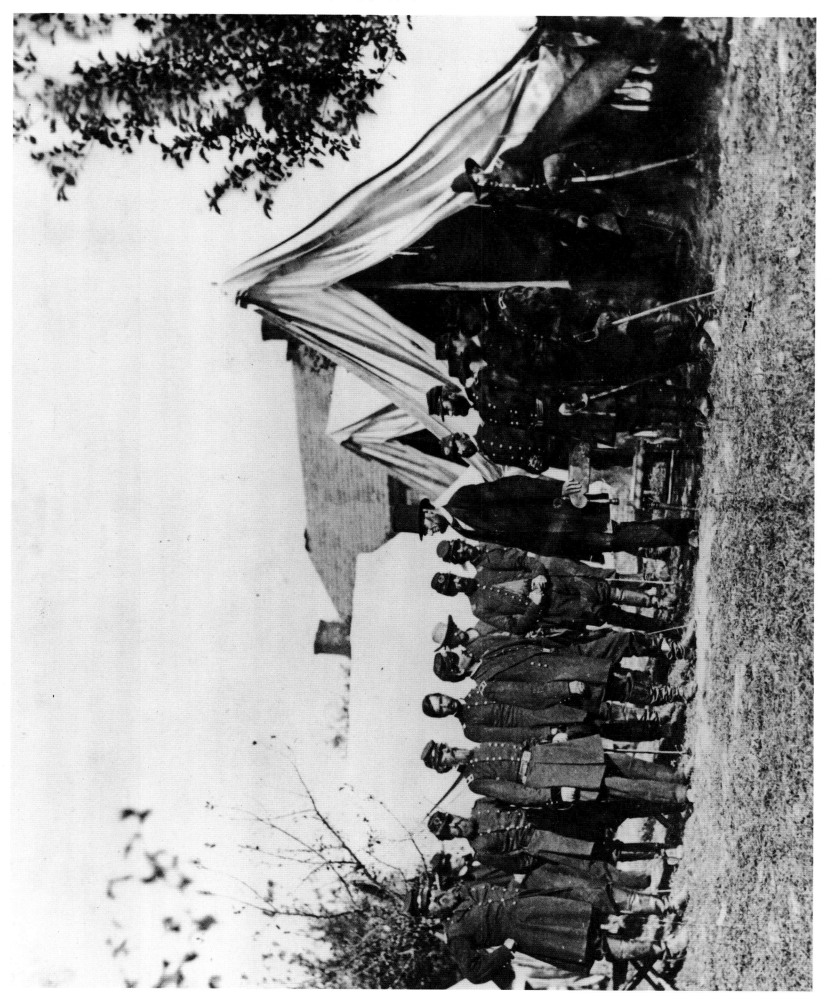

RIGHT: Staff of General Andrew Porter,
including George Armstrong Custer
(at age twenty-two years), reclining and
stroking a dog, take time out to relax with
drinks and pipes (all but three are
smoking) during the Peninsular Campaign
in Virginia. (March to July 1862).
(Library of Congress)

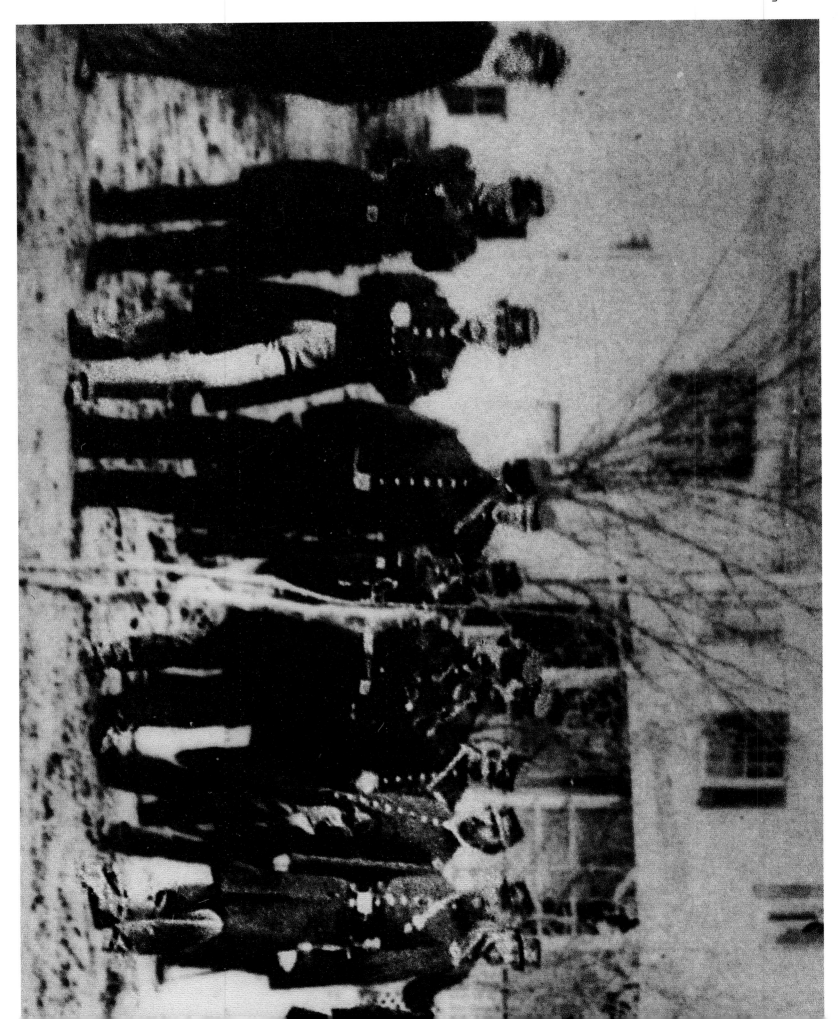

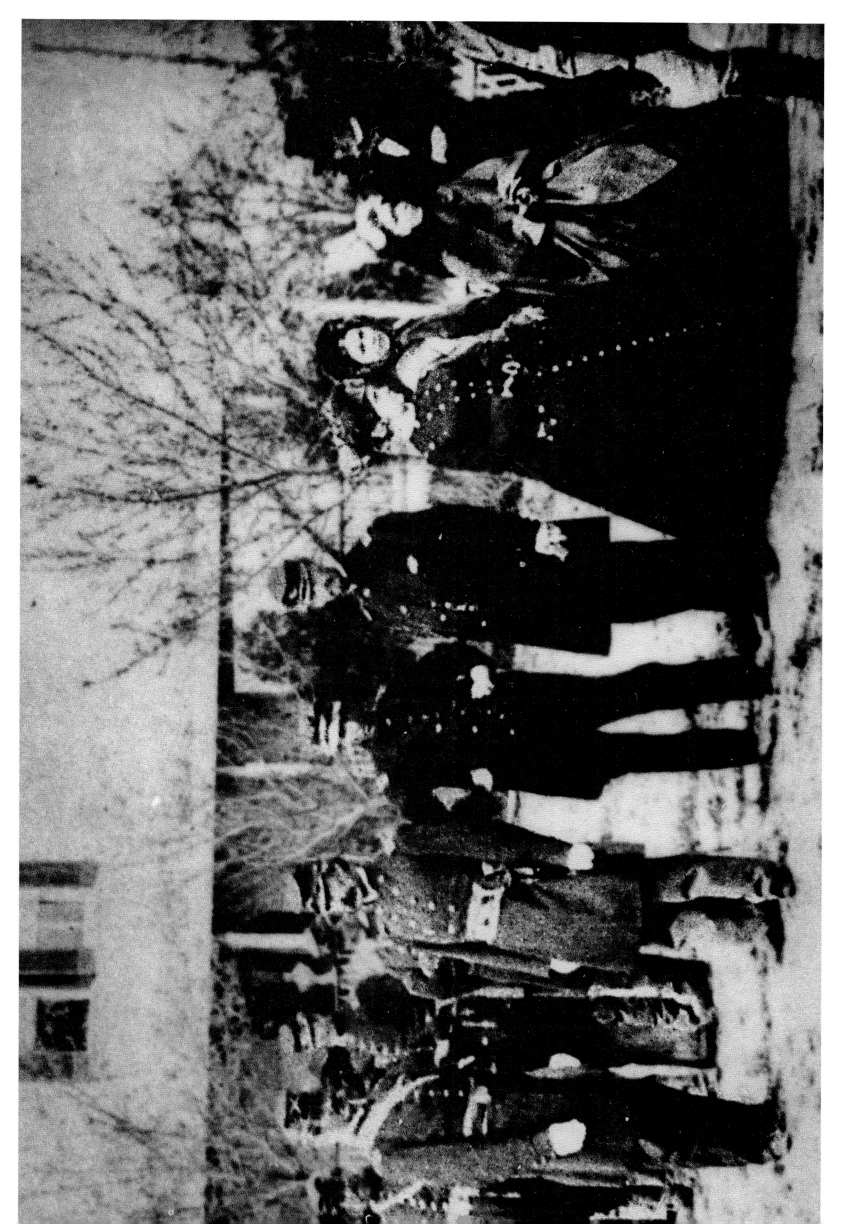

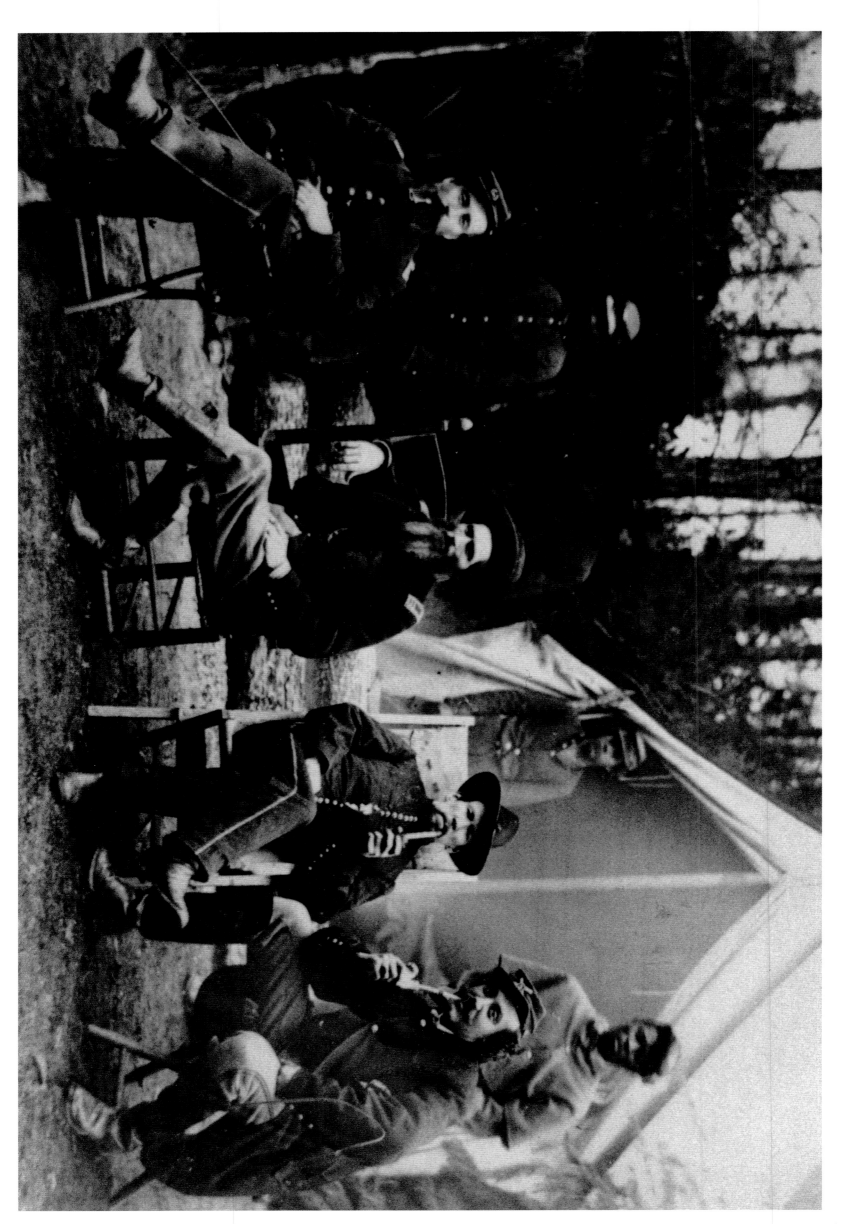

FAR LEFT: Seated in a camp near Brandy Station, Virginia, these four "colorful" soldiers, part of a horse artillery brigade, appear to be amused, or vaguely interested at least, in the photographer's work.
(*Library of Congress*)

LEFT: A team of telegraphers for the Army of the Potomac, July 1863. Organized by the U.S. Army Signal Corps, telegraphy was still in its relative infancy by the time of the Civil War. It had specific missions, including battlefield observation, intelligence gathering, artillery fire directing, and of course general communications.
(*Library of Congress*)

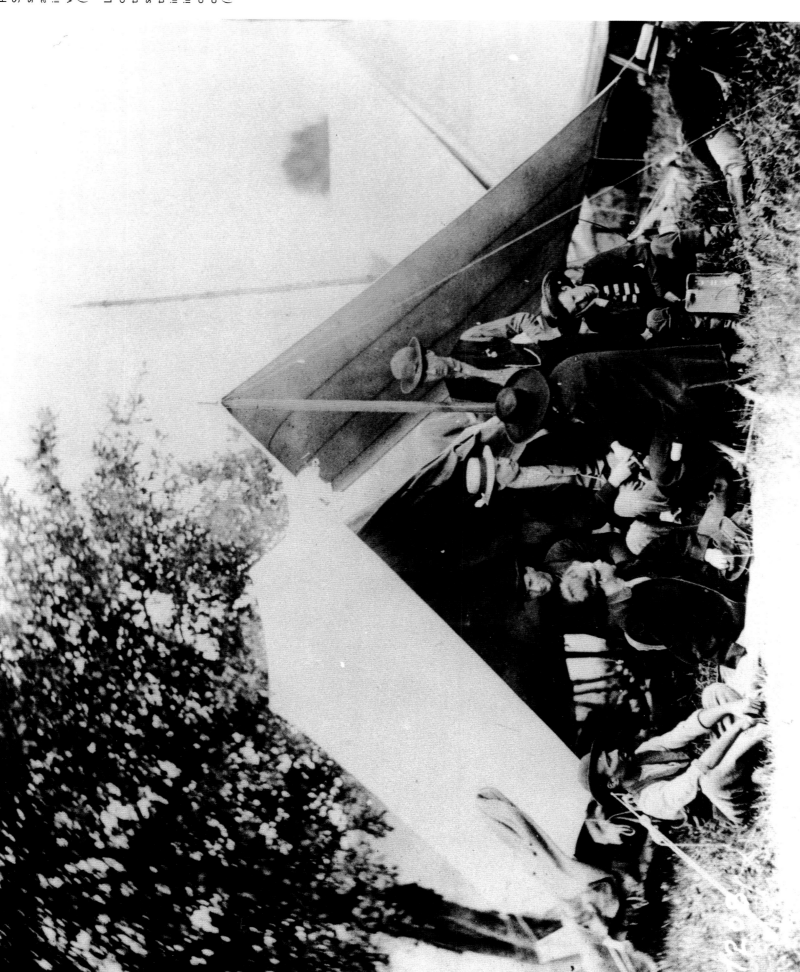

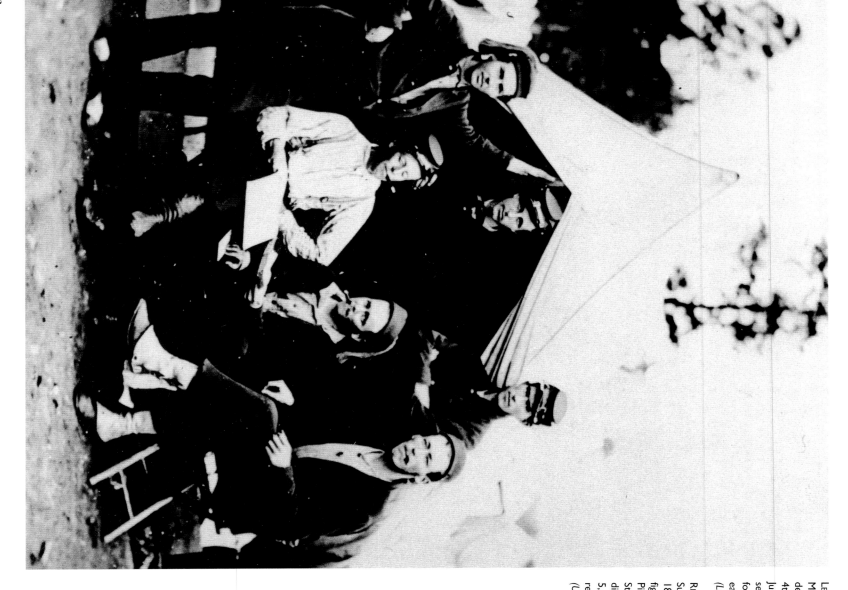

LEFT: Six members of Company F, 4th Michigan Infantry, outside Tent No. 8, designed to house a total of four men. The 4th Michigan was organized at Adrian on June 20, 1861, mustered into Federal service for a three-year enlistment, and fought in most of the epic battles in the eastern theater.
(Library of Congress)

RIGHT: The guns are about to roar at Fort Sumner, near Fair Oaks, Va., May 31-June 1, 1862, during the Peninsular Campaign. The fighting has been called the Battle of Seven Pines, the Battle of Fair Oaks or Fair Oaks Station. Although more than 11,000 men died or were captured or missing (Federal 5,031; Confederates 6,134), the result was regarded as "inconclusive."
(U.S. Army)

RIGHT: Regular Army members of
Company D, the 4th U.S. Infantry. The 4th
Infantry saw much action during the war,
including the Siege of Yorktown, Gaines
Mill, Second Bull Run, Antietam,
Gettysburg, Wilderness, Cold Harbor, and
the Siege of Petersburg. By June 1864
battle casualties had reduced the
complement to fewer than 150 men, who
became General Grant's headquarters
guard at City Point, Virginia.
(Library of Congress)

FAR RIGHT: Members of Company C, the
8th Wisconsin Volunteer Infantry of the
old Iron Brigade, with mascot "Old Abe."
The eagle, bought from a farmer who
traded it from an Indian, hovered over the
battlefields of Tennessee and Georgia,
returning to its tenders when the fighting
was done. Today it is the insignia of the
101st Airborne Division.
(Library of Congress)

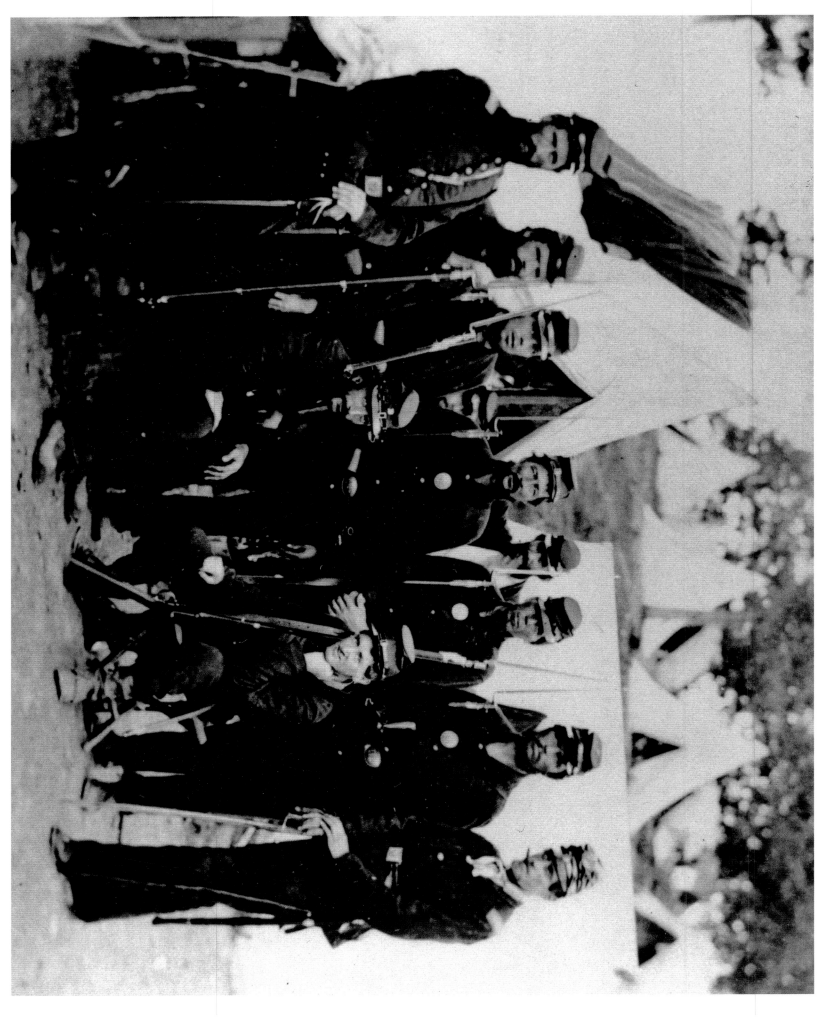

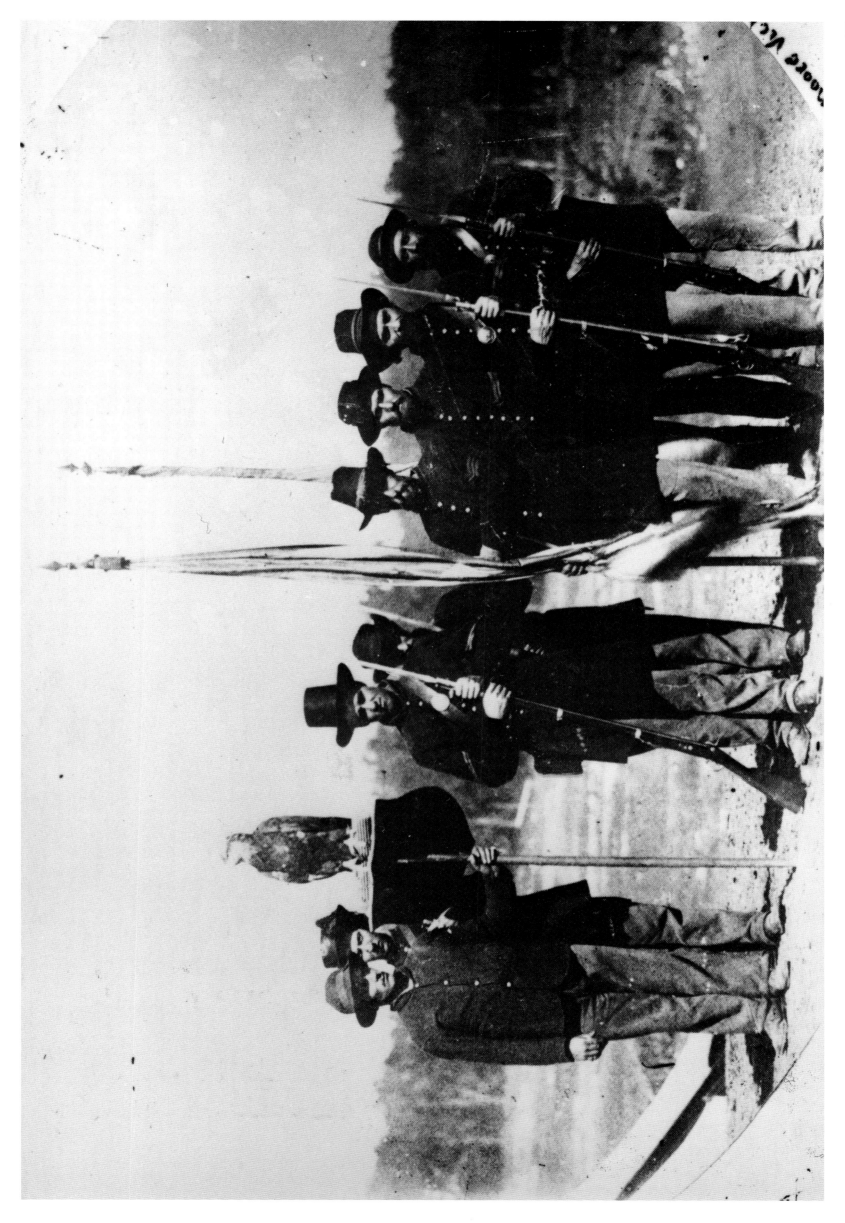

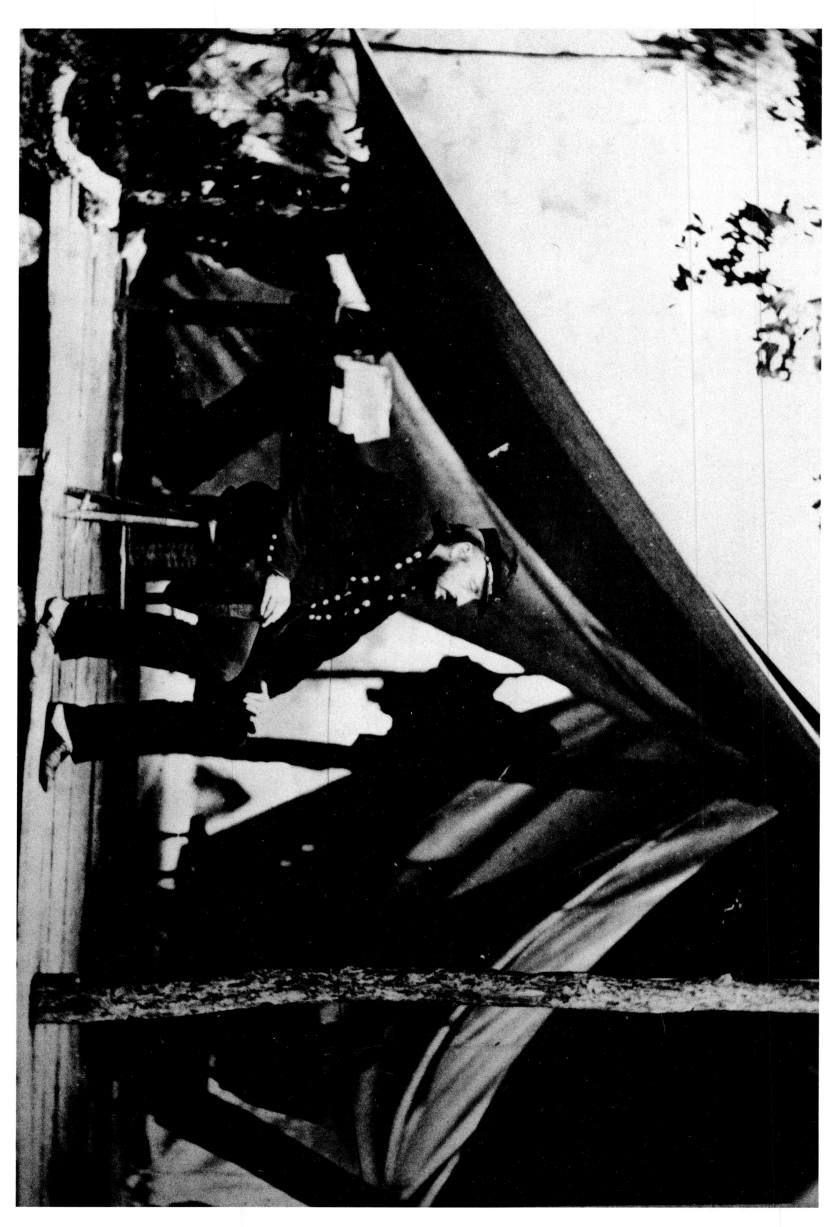

FAR LEFT: Major General Benjamin F. Butler, in tent on Ship Island, Mississippi, was the very first (and, some believe, the most inept) general of volunteers appointed by Lincoln, yet for a time outranked every other general in the army except Winfield Scott and George B. McClelland.
(Library of Congress)

LEFT: Blackburn's Ford, inside White Oak Swamp, before Second Bull Run (Manassas), 1862.
(Library of Congress)

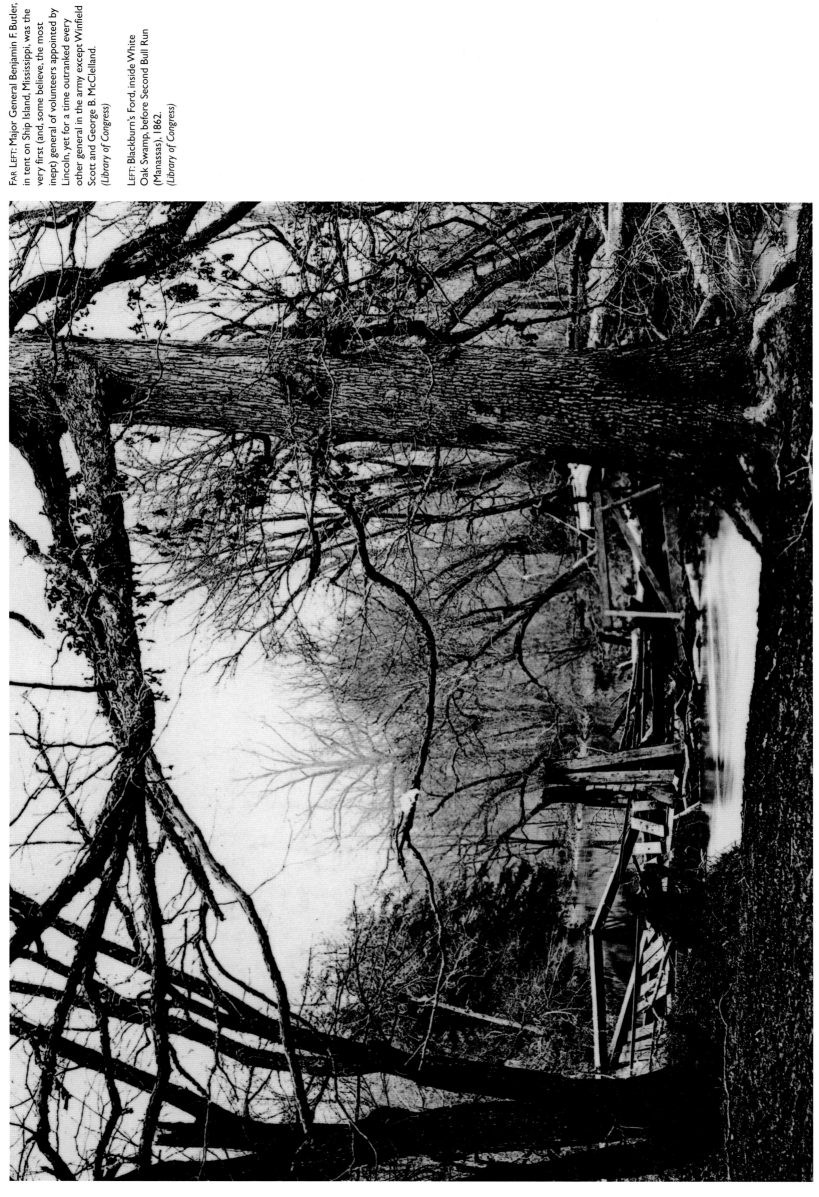

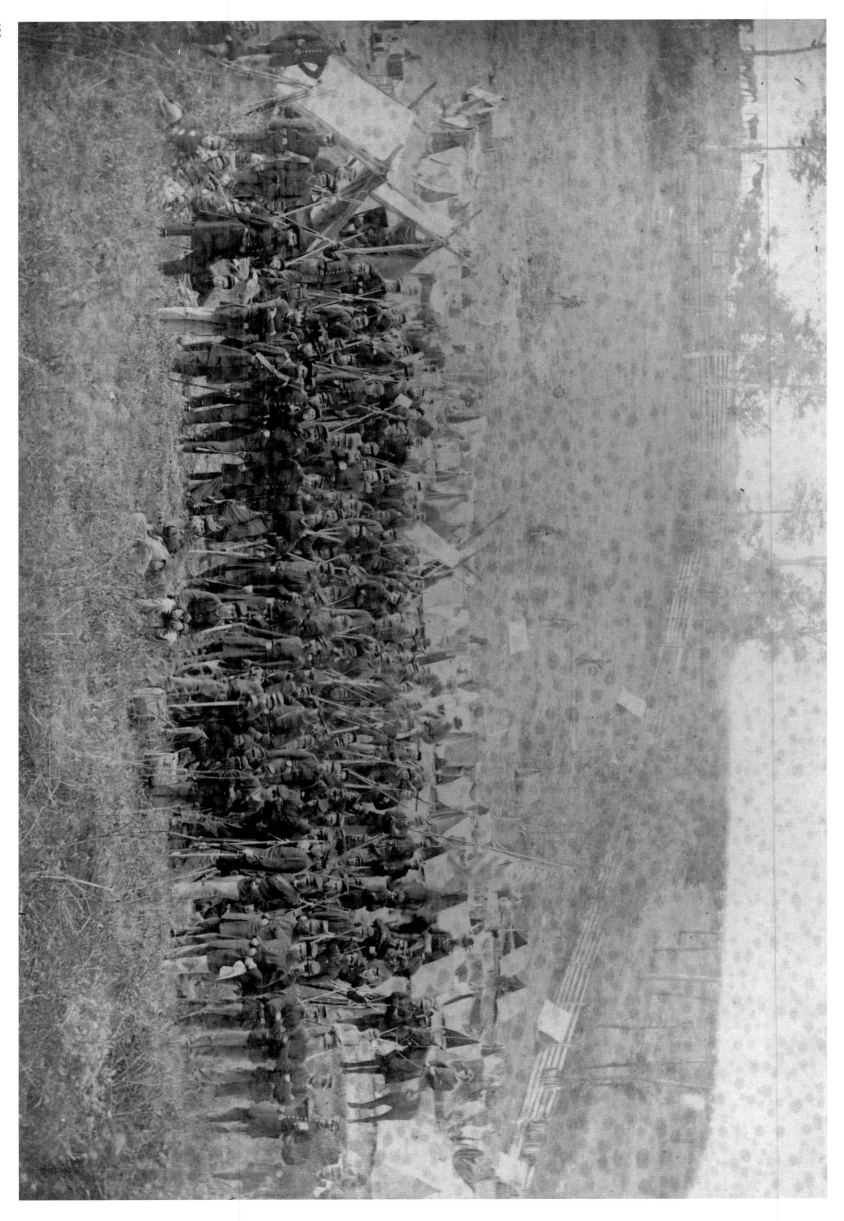

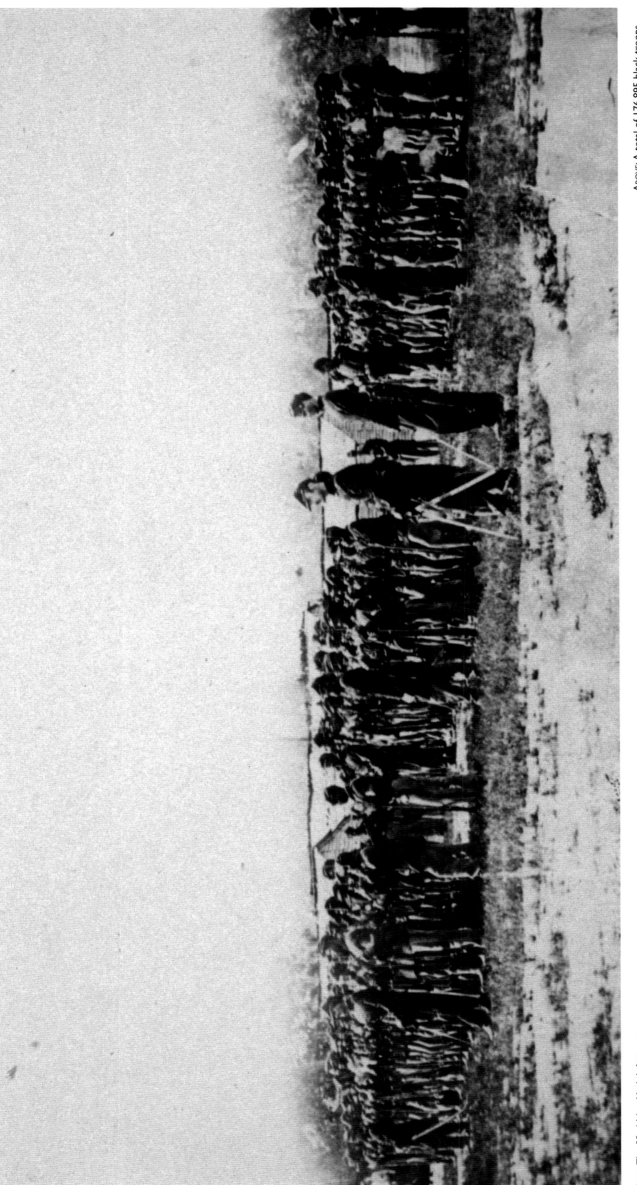

Left: The 93rd New York Infantry at
Antietam, Maryland, September 1862, in a
photograph attributed to Brady associate
Alexander Gardner.
(*Library of Congress*)

Above: A total of 176,895 black troops
served the Union during the Civil War,
fighting bravely for their brothers'
freedom in the South; 68,100 (more than
a third) died in Yankee uniform. Here, men
of the 1st U.S. Colored Infantry line up
on parade.
(*Library of Congress*)

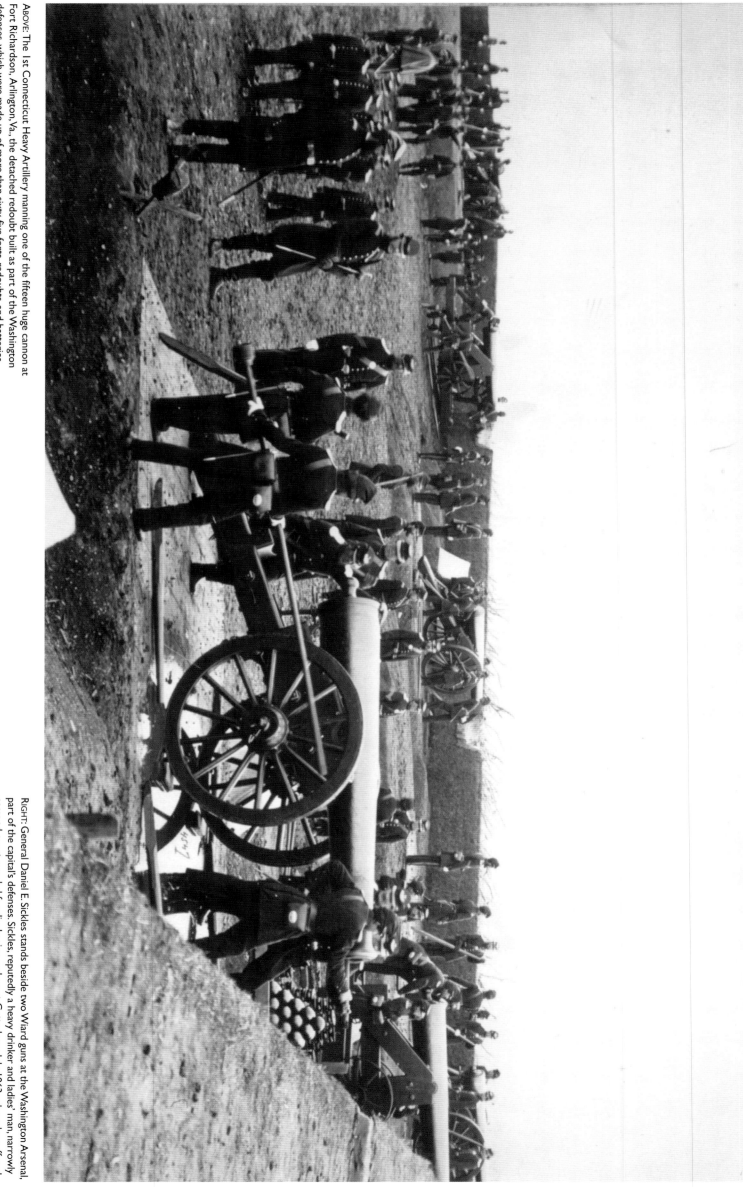

ABOVE: The 1st Connecticut Heavy Artillery manning one of the fifteen huge cannon at Fort Richardson, Arlington, Va., the detached redoubt built as part of the Washington defenses, which were made up of more than sixty-five forts, redoubts, and batteries. (Library of Congress)

RIGHT: General Daniel E. Sickles stands beside two Wiard guns at the Washington Arsenal, part of the capital's defenses. Sickles, reputedly a heavy drinker and ladies' man, narrowly escaped court marshal for disobeying orders at Gettysburg, July 1863, where he suffered amputation of a wounded leg. Using his political influence, he even managed to have a Medal of Honor awarded him—some thirty-four years after his actions in the battle. (Library of Congress)

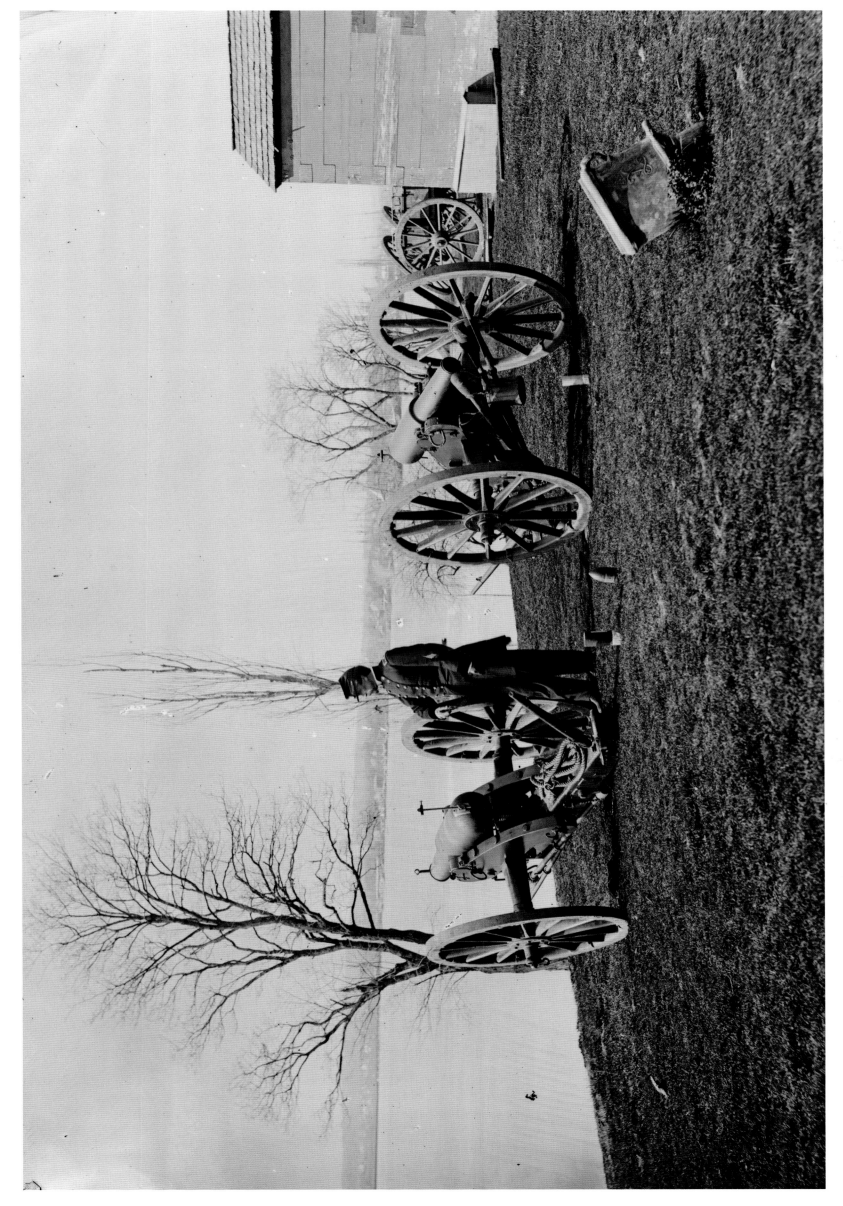

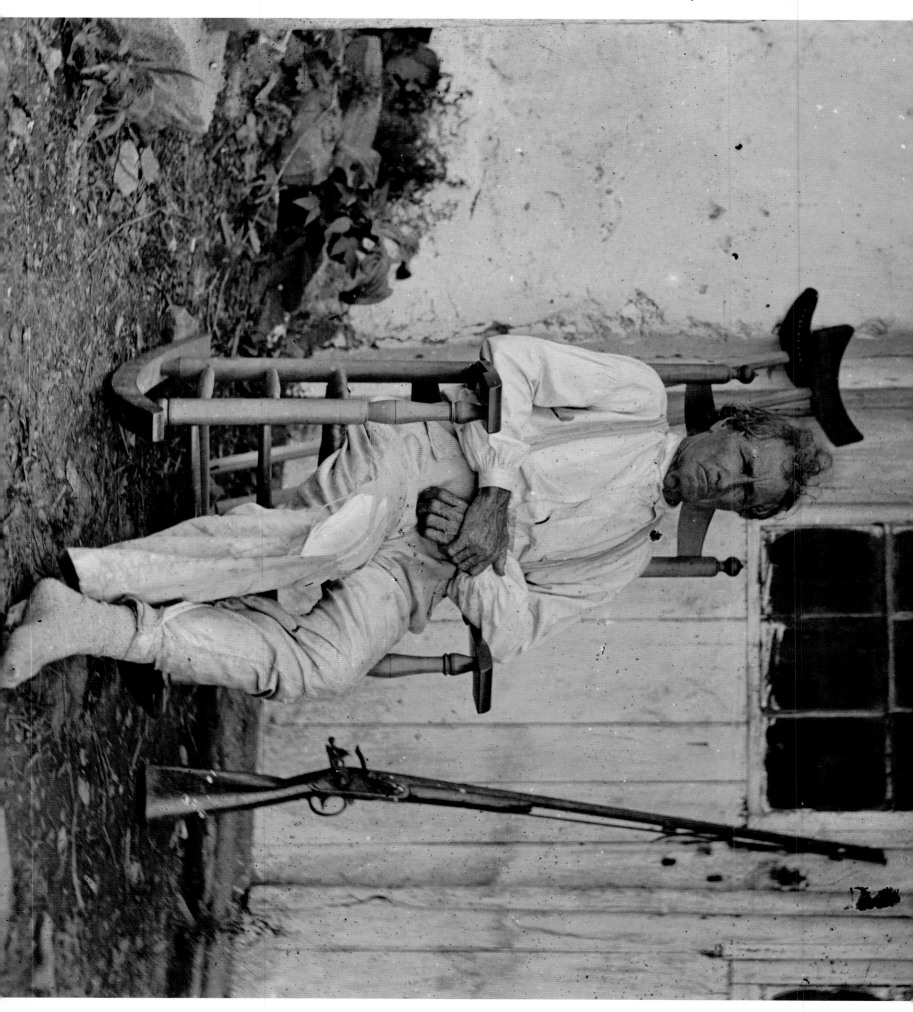

RIGHT: John L. Burns (September 5, 1794–February 7, 1872), "old hero of Gettysburg," shown with musket and crutches, recovering from wounds received in the battle, in a photograph by Timothy H. O'Sullivan, July 1863.
(Library of Congress)

FAR RIGHT: Members of the Horse Artillery commanded by Lt. Col. William Hays (seated center, second row) in a James F. Gibson photograph made at Fair Oaks, Va., during the Peninsular Campaign, May–August 1862.
(Library of Congress)

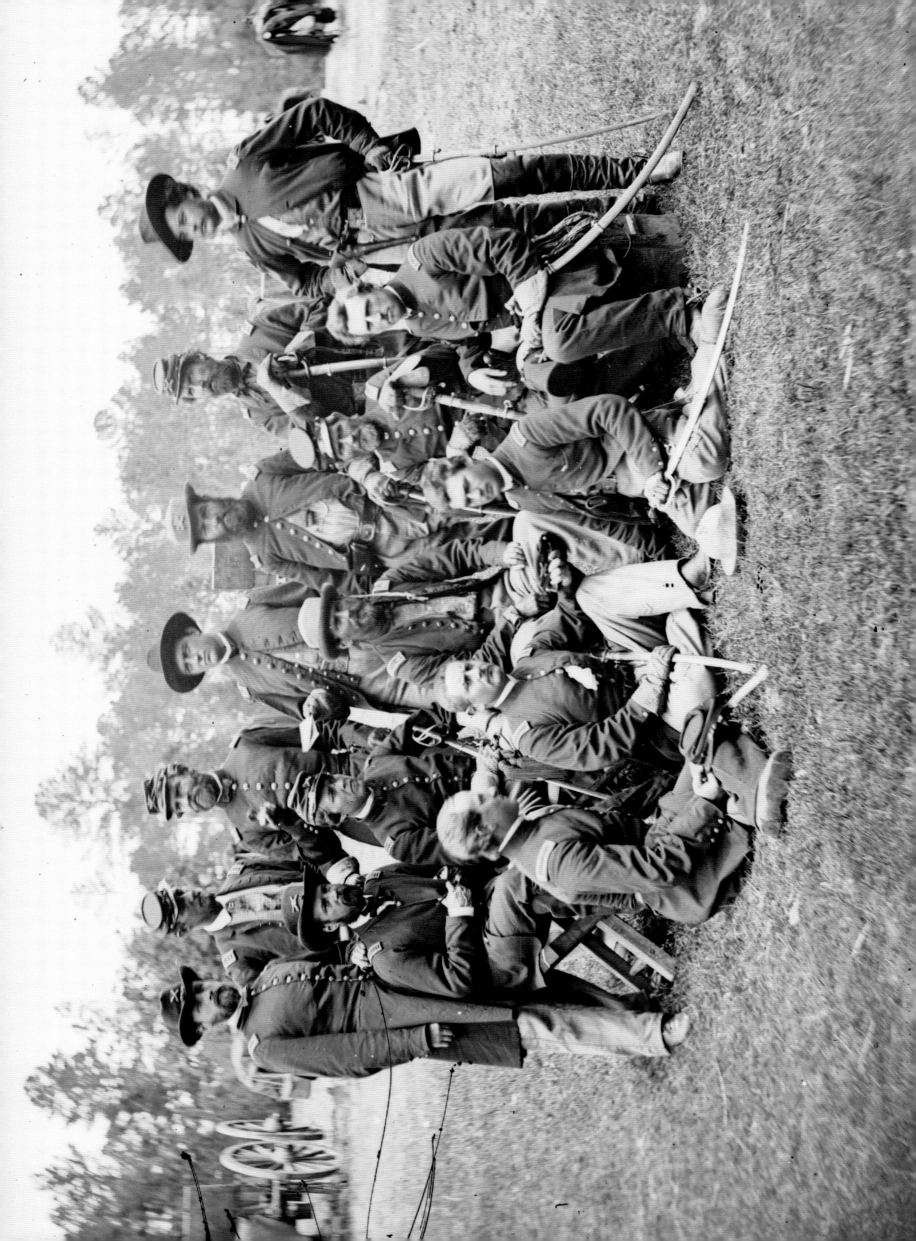

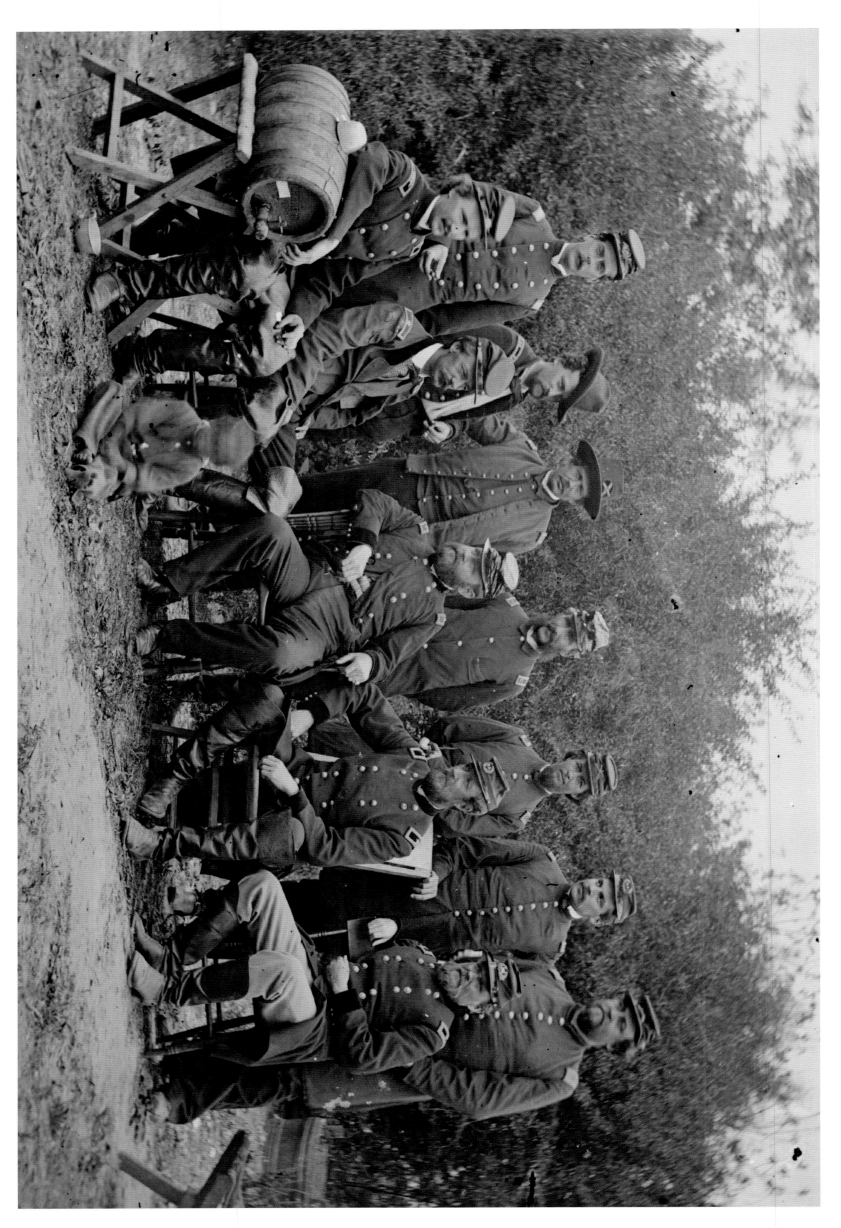

FAR LEFT: Gibson photo of (seated, left to right) Generals Andrew A. Humphreys, Henry Slocum, Wm B. Franklin, Wm F. Barry, and John Newton, together with unidentified standing officers, at Cumberland Landing, Virginia, May 14, 1862.
(Library of Congress)

LEFT: Horatio G. Gibson's C and G Batteries prepare to move out of camp in the vicinity of Fair Oaks, Virginia, June 1862.
(Library of Congress)

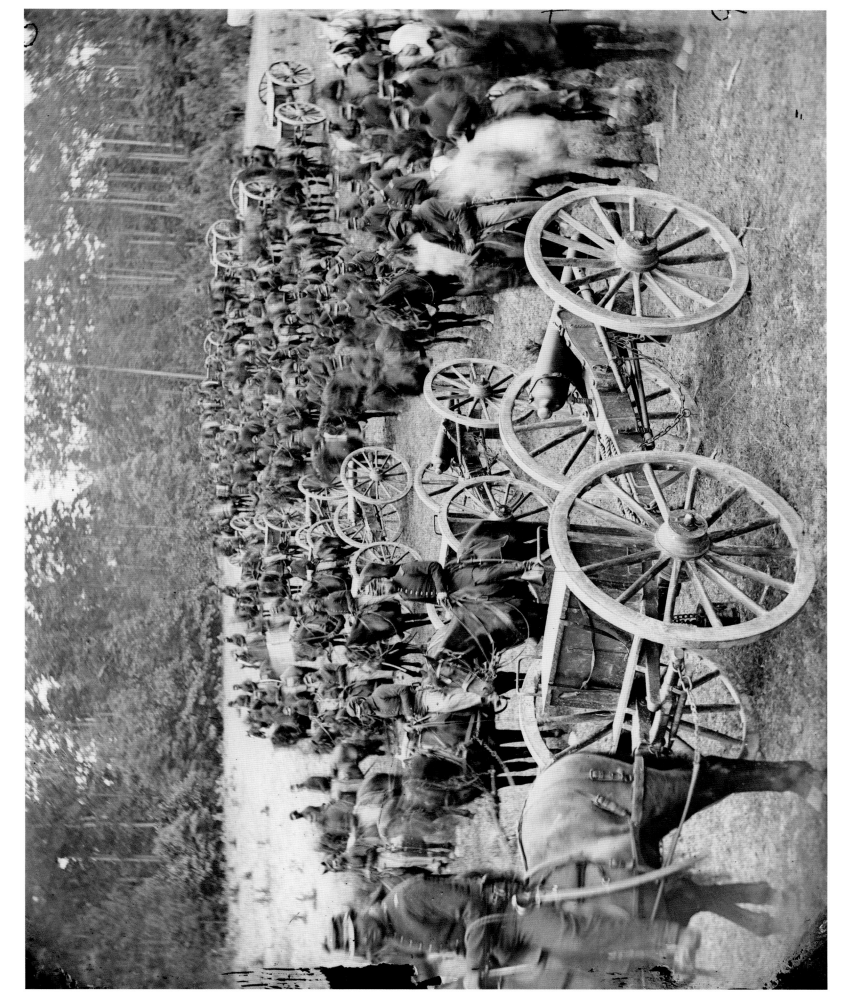

MATHEW B. BRADY

RIGHT: Battery No. 4, south end, near
Yorktown, Virginia, photographed in May
1862, mounting ten 13-inch mortars each
weighing 20,000 pounds.
(Library of Congress)

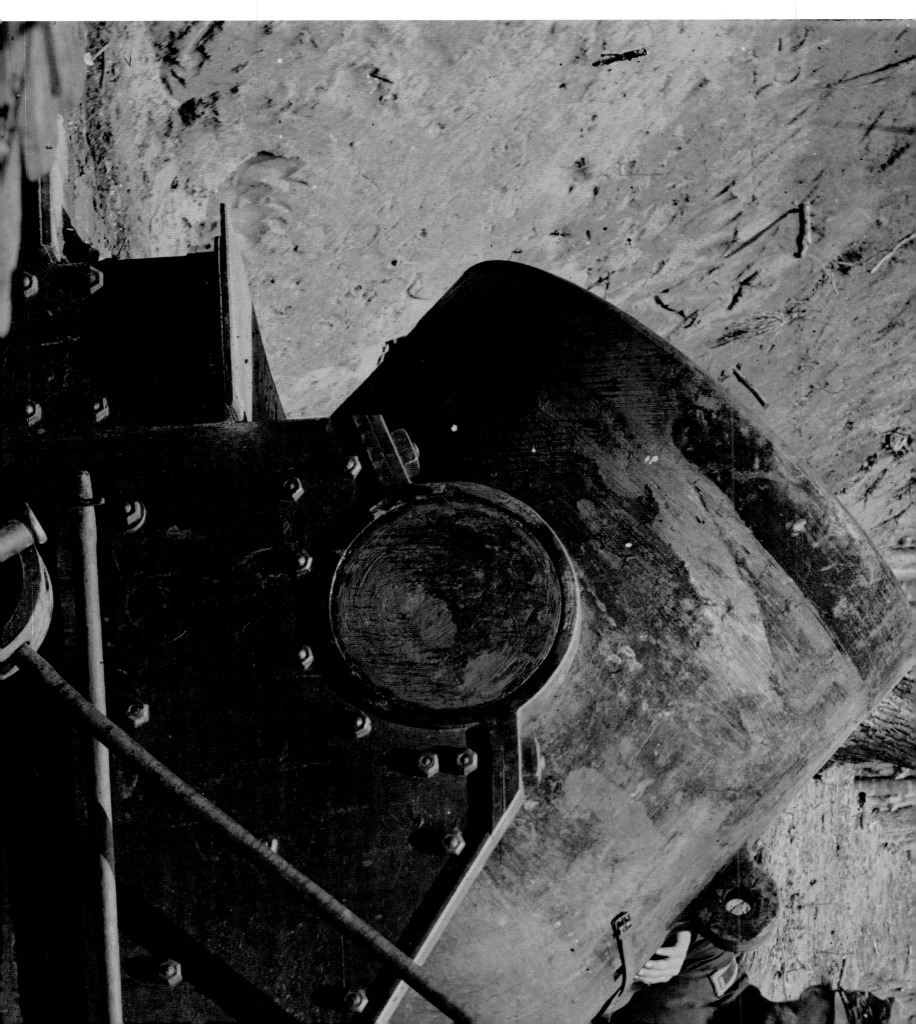

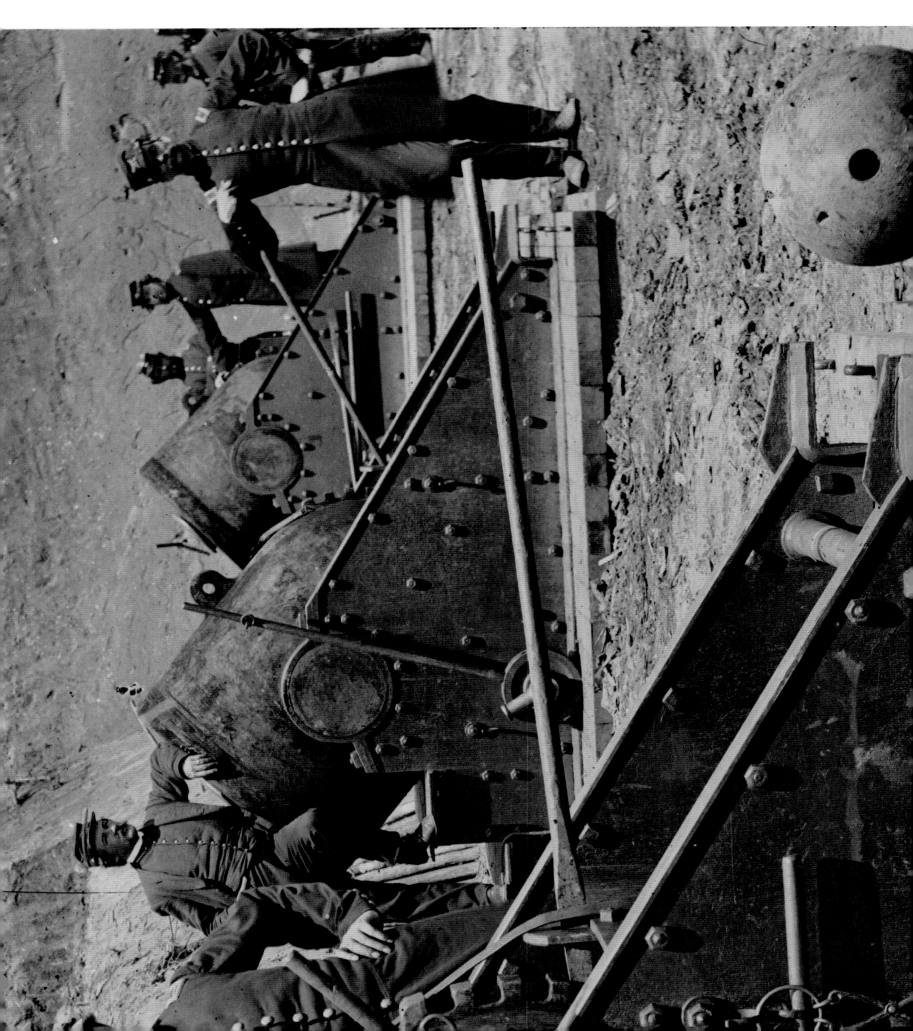

RIGHT: Showing an interest in the camera being operated by George N. Barnard, these Union soldiers are occupying a Confederate fort on the Heights of Centreville, Virginia, complete with Quaker guns, March 1862. Quaker guns were simulated cannon used to deceive an enemy into believing a force had more weapons than it actually had. The name derives from the Quaker religious opposition to war and violence.
(Library of Congress)

FAR RIGHT: Union soldiers lying dead on the right of the Federal lines on the Gettysburg battlefield, July 1, 1863. In what was to become the bloodiest battle in American history, the dead alone numbered more than 6,000. By July 3, General Lee suffered a staggering 20,451 men in casualties in all, while the Federals lost 23,049. The Battle of Gettysburg was to be Lee's last offensive operation of the Civil War.
(Library of Congress)

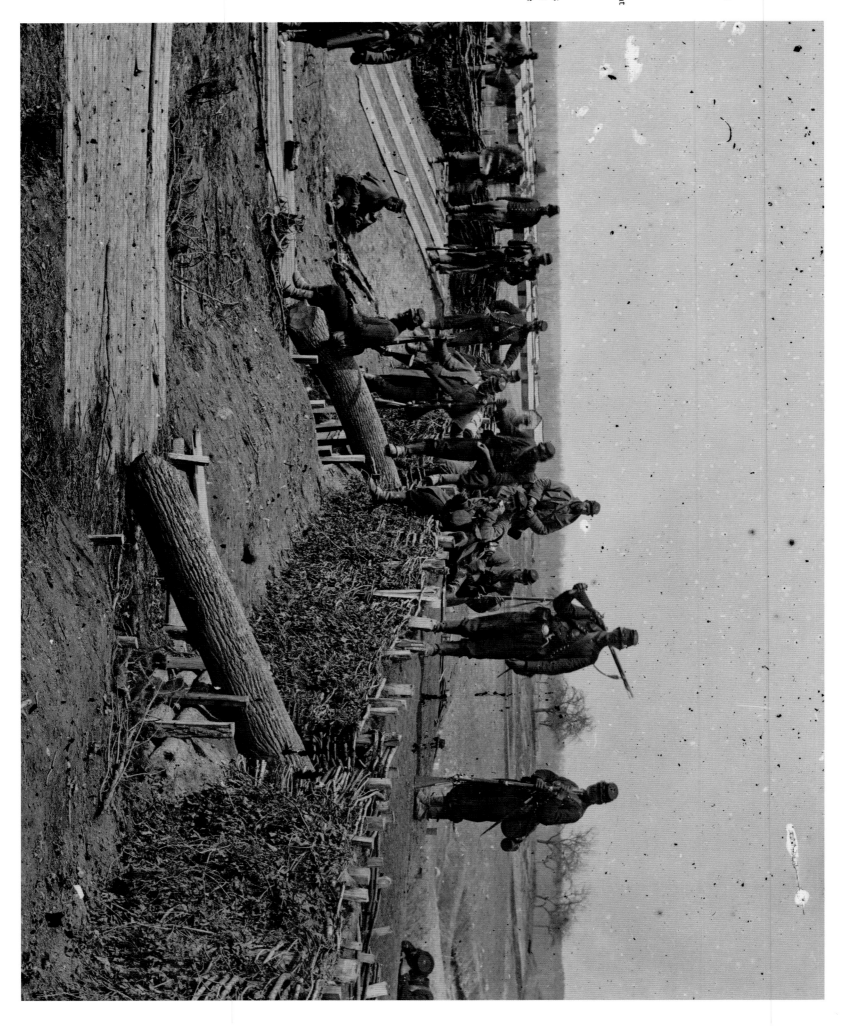

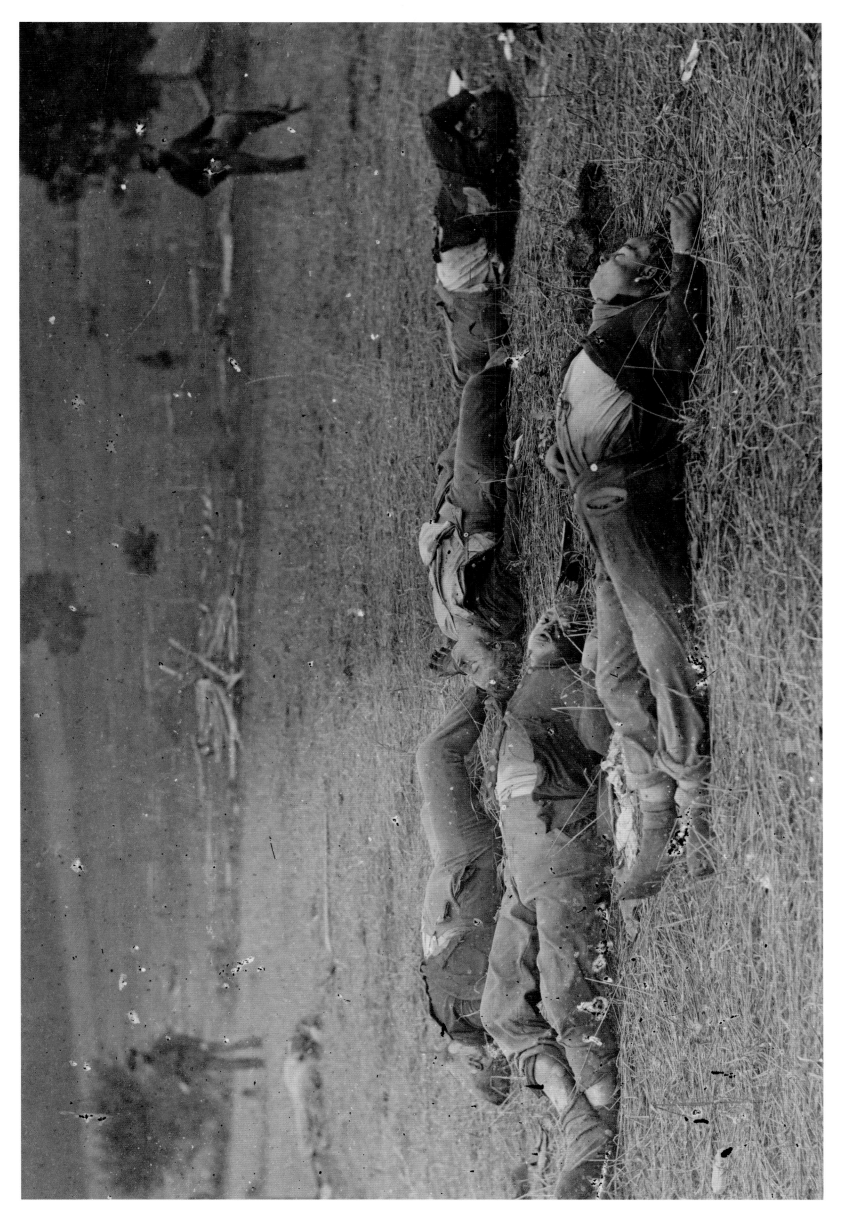

120

LEFT: A couple of Union soldiers at Camp Lincoln, near Richmond, Va., in June 1862 show interest in the work of photographer James F. Gibson. Note blankets hanging on a rope line, and Sibley tents at right.
(Library of Congress)

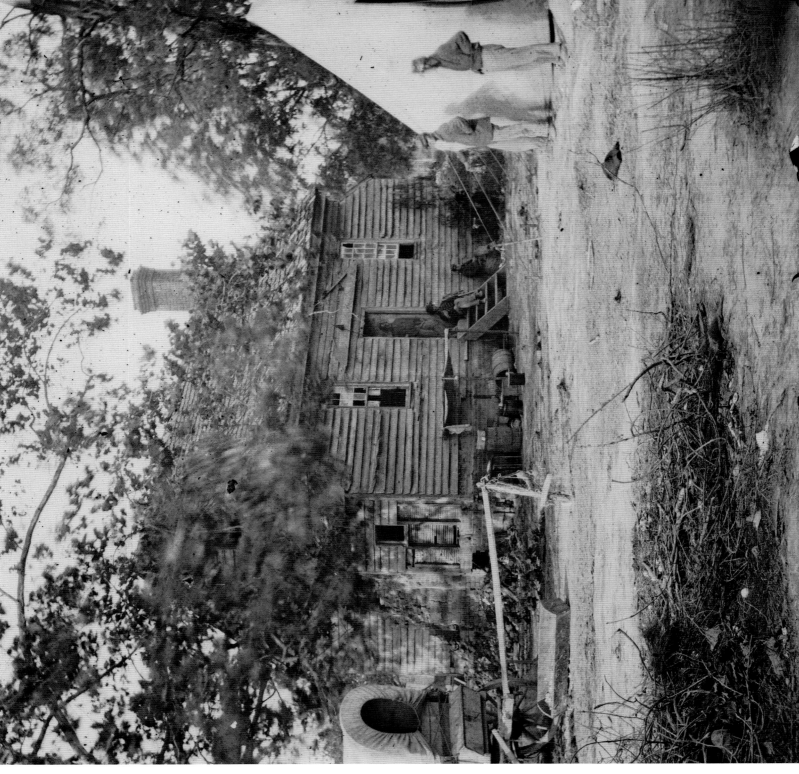

ABOVE: Some 2,500 wounded Union soldiers were left to be captured following the Battle of Savage's Station, Virginia, June 27, 1862, fourth of the Seven Days' battles (Peninsular Campaign).
(Library of Congress)

RIGHT: This house was used as a Union hospital following the Battle of Fair Oaks (also known as the Battle of Seven Pines), on May 31 and June 1, 1862. A total of some 11,000 casualties were suffered by Federal and Confederate forces in the largest battle in the eastern theater up to that time.
(Library of Congress)

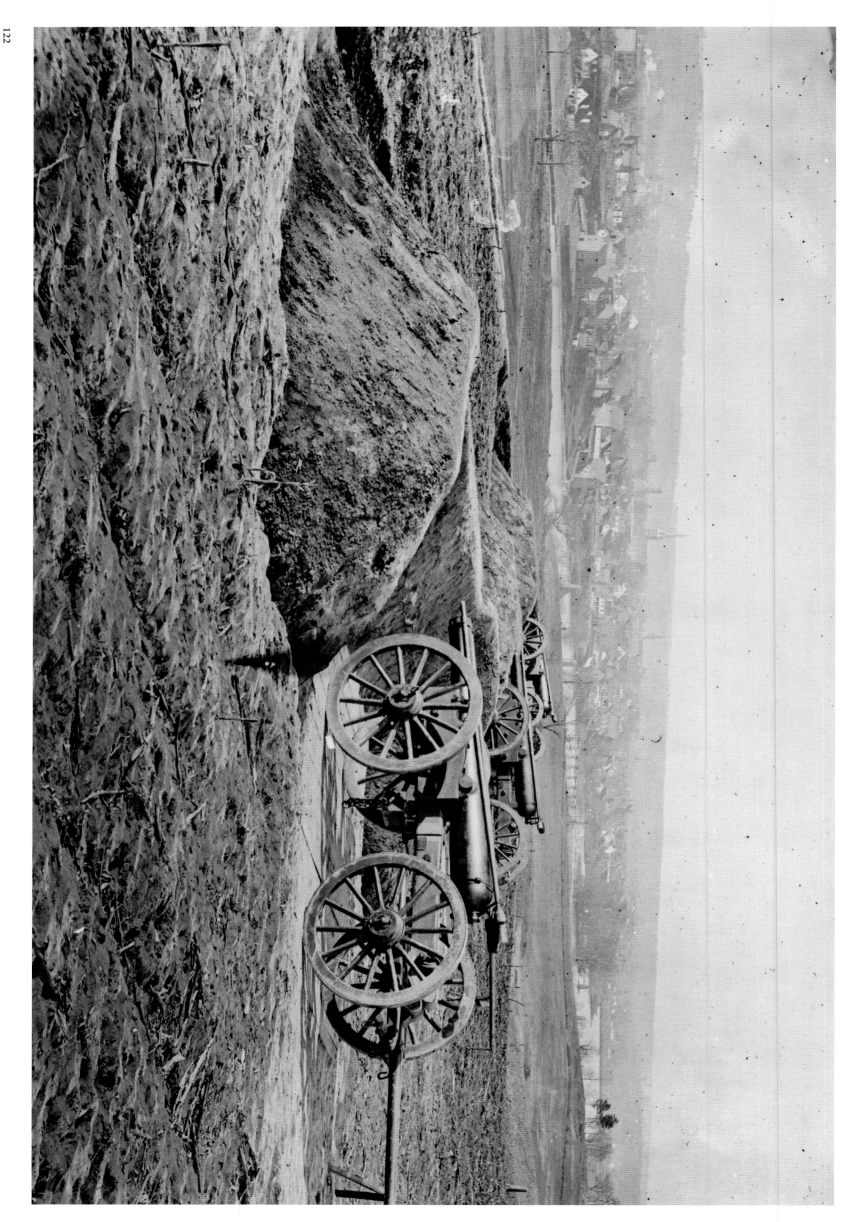

FAR LEFT: Seemingly abandoned, the Union guns lay silent overlooking Fredericksburg, Virginia, in James Gibson's photograph, made in February 1863. The Battle of Fredericksburg, fought just eight weeks earlier, was one of the most one-sided battles of the American Civil War. The Union Army suffered terrible casualties in futile frontal assaults on December 13 against entrenched Confederate defenders on the heights behind the city, bringing to an early end the Federal campaign against the Confederate capital of Richmond. *(Library of Congress)*

LEFT: In May 1862, Union General Fitz-John Porter made this simple farmhouse his headquarters near Williamsburg Road, Yorktown, Virginia, with the corps of Major General Edwin V. Sumner and Brigadier General Samuel P. Heintzelman camped in the background. *(Library of Congress)*

RIGHT: These fortifications and winter quarters at Manassas, Virginia, built by the Confederates in 1861, teem with Federal soldiers in this photograph made by James F. Gibson in March 1862.
(Library of Congress)

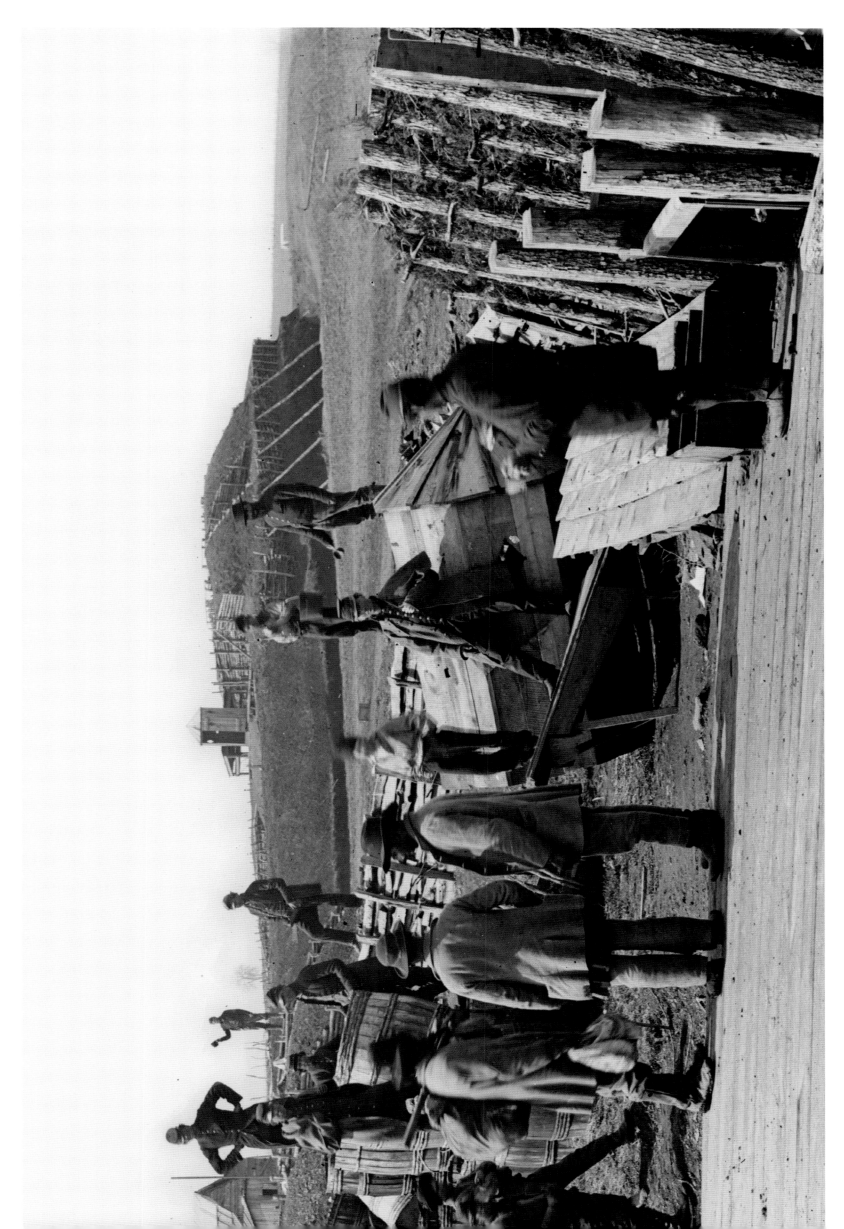

RIGHT: A 32-pounder field howitzer on the Seven Pines (Fair Oaks) battlefield, during the Peninsular Campaign in the eastern theater, in a photograph made by George N. Barnard in June 1862. Few campaigns producing major battles saw as many fights, over so much ground, as the Peninsular Campaign. Ultimately, the campaign costs the Federals nearly 10,000 casualties out of his 100,000 men, and the Confederates some 20,000 out of their 80,000.
(Library of Congress)

FAR RIGHT: Horses were vital to both sides during the war, for the cavalry and for hauling guns, ammunition, and other supplies between and across the battlefields. Here, in a photograph made by Brady associate Alexander Gardner in September 1862, a blacksmith is shoeing horses at the headquarters of the Army of the Potomac, Antietam, Maryland.
(Library of Congress)

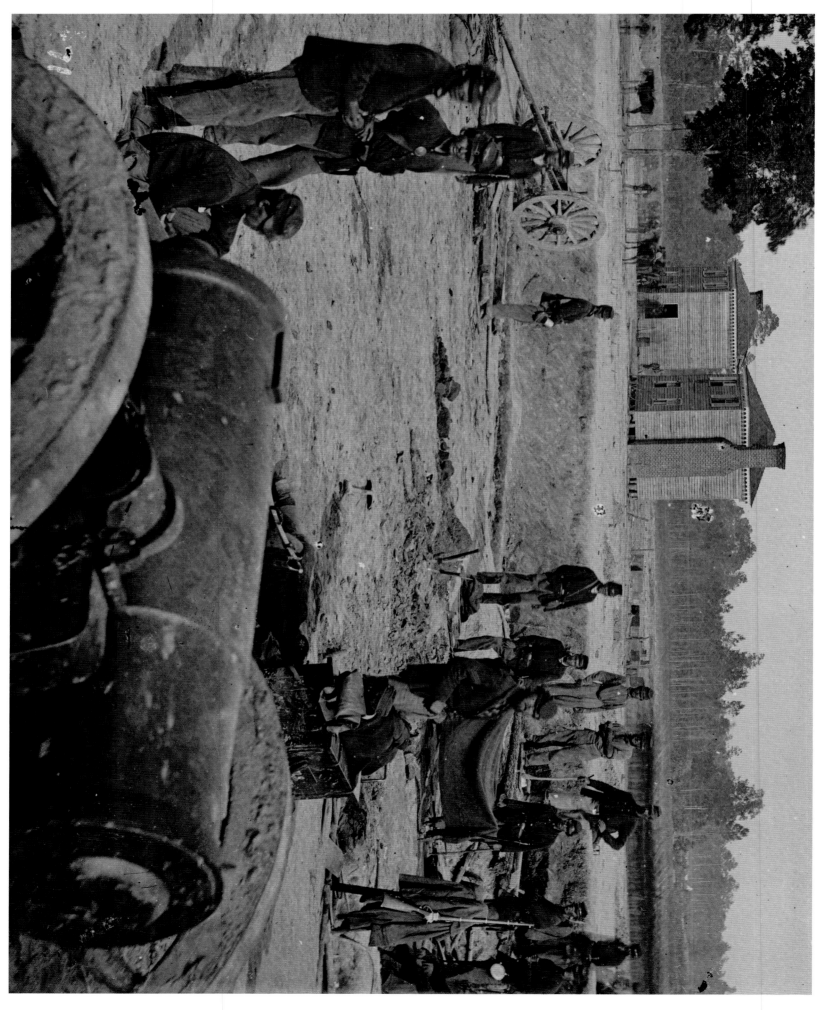

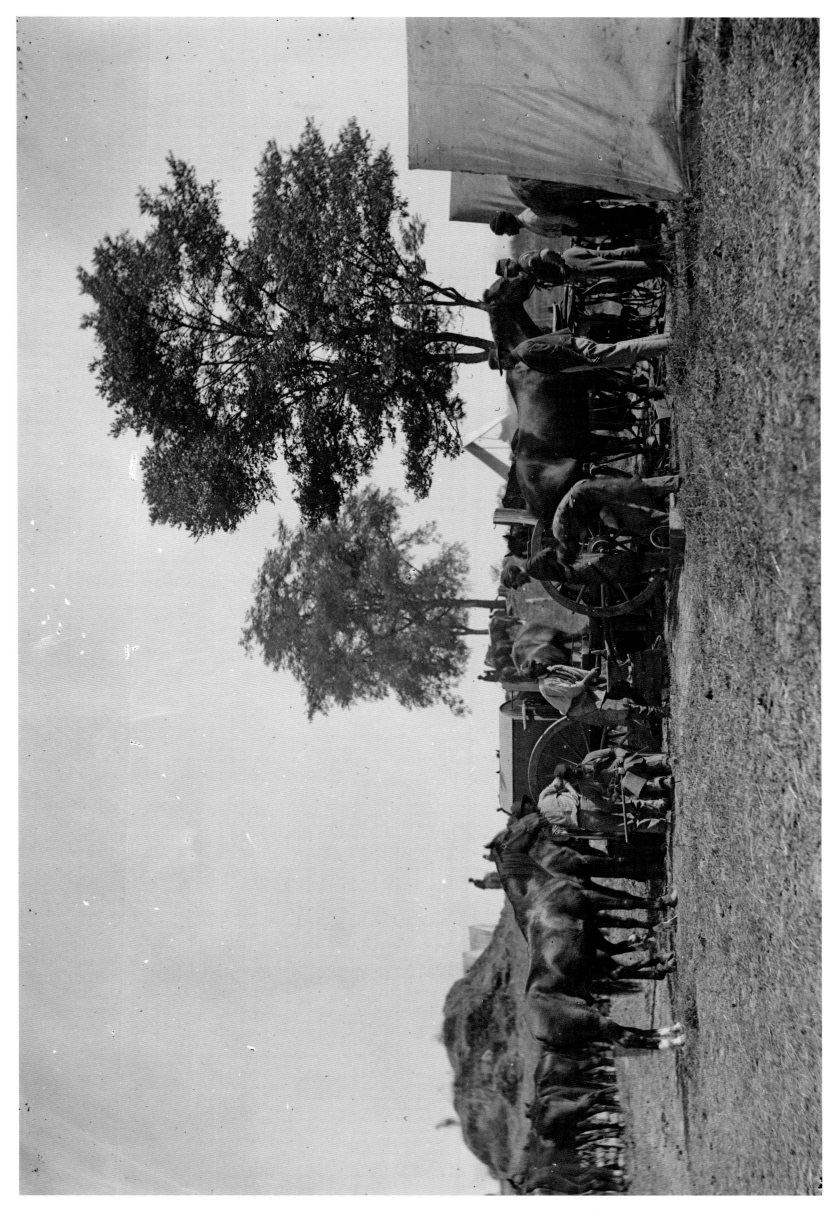

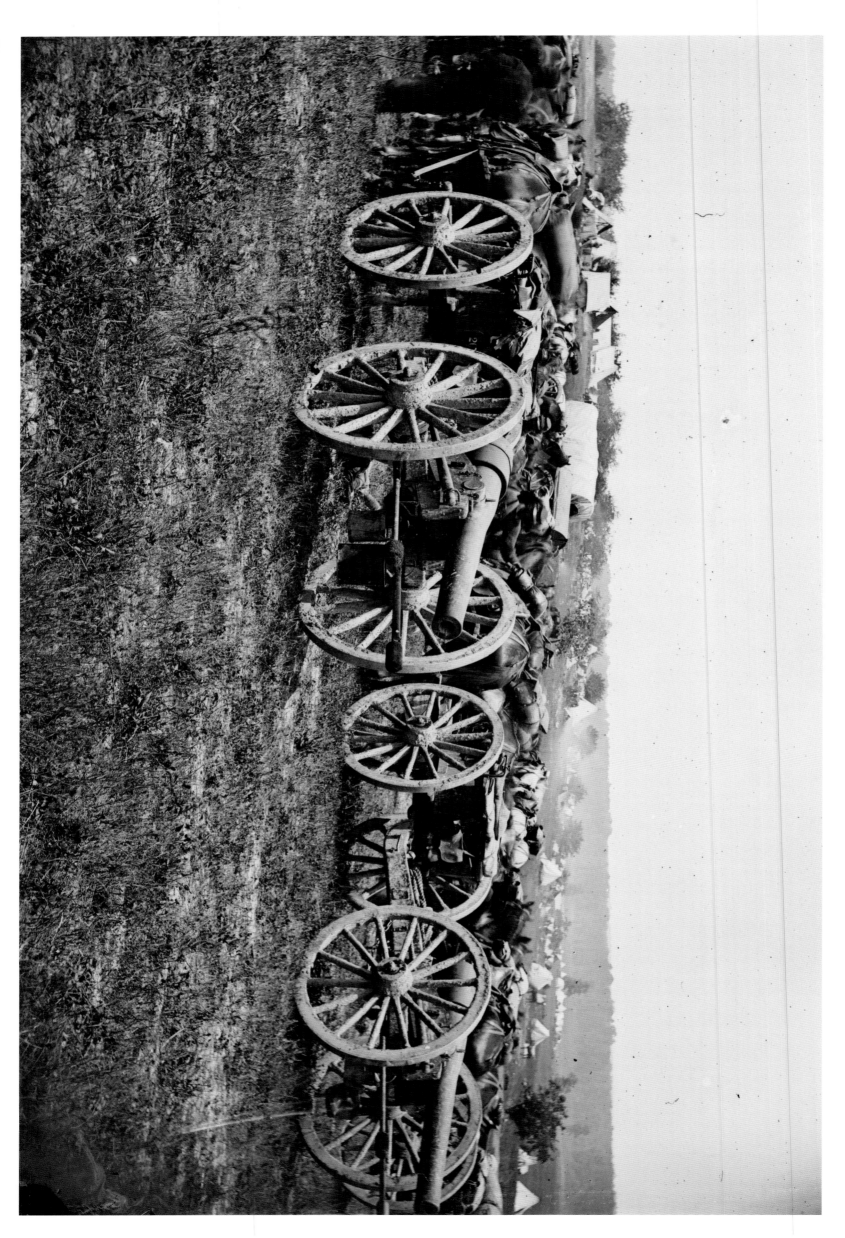

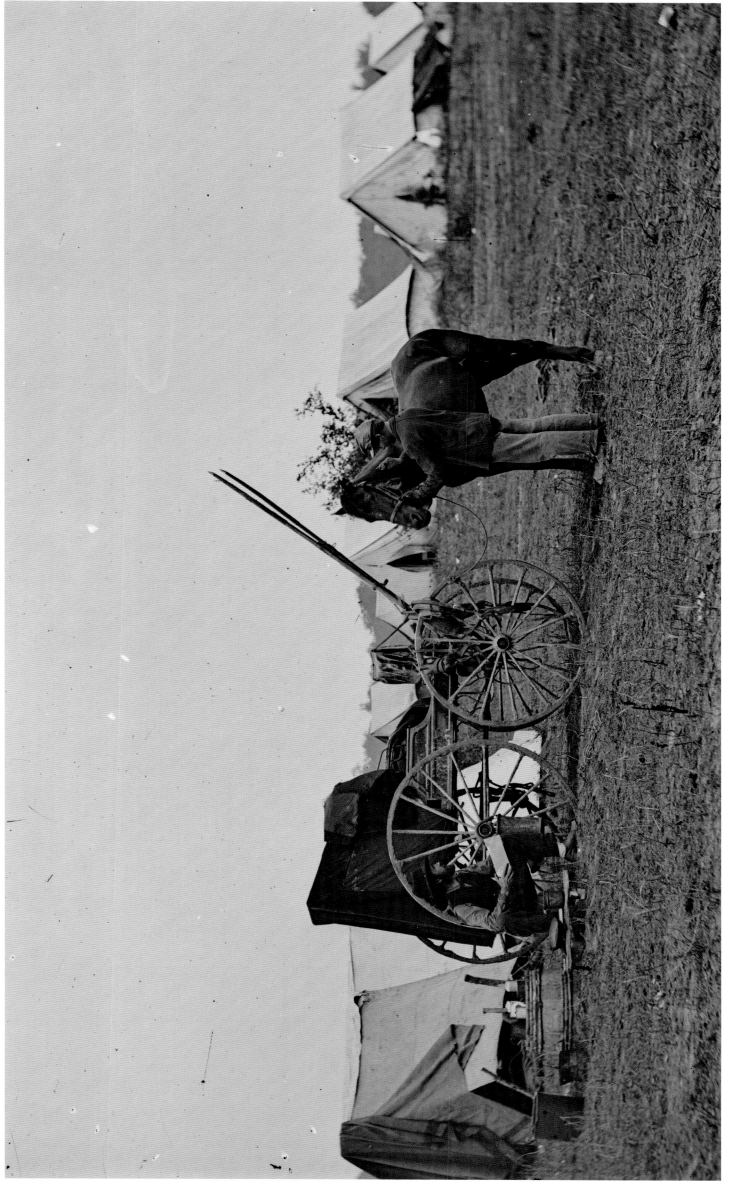

LEFT: During the Peninsular Campaign of 1862, James F. Gibson photographed these 20-pounder Parrott rifled guns of the 1st New York Battery near Richmond, Virginia.
(Library of Congress)

ABOVE: One of Brady's operatives, with fully equipped mobile darkroom, set up camp at Cold Harbor, Virginia, where, during the Wilderness Campaign, May–June 1864, Grant blundered by making a full frontal assault on Lee's forces in one of America's bloodiest and most one-sided battles.
(Library of Congress)

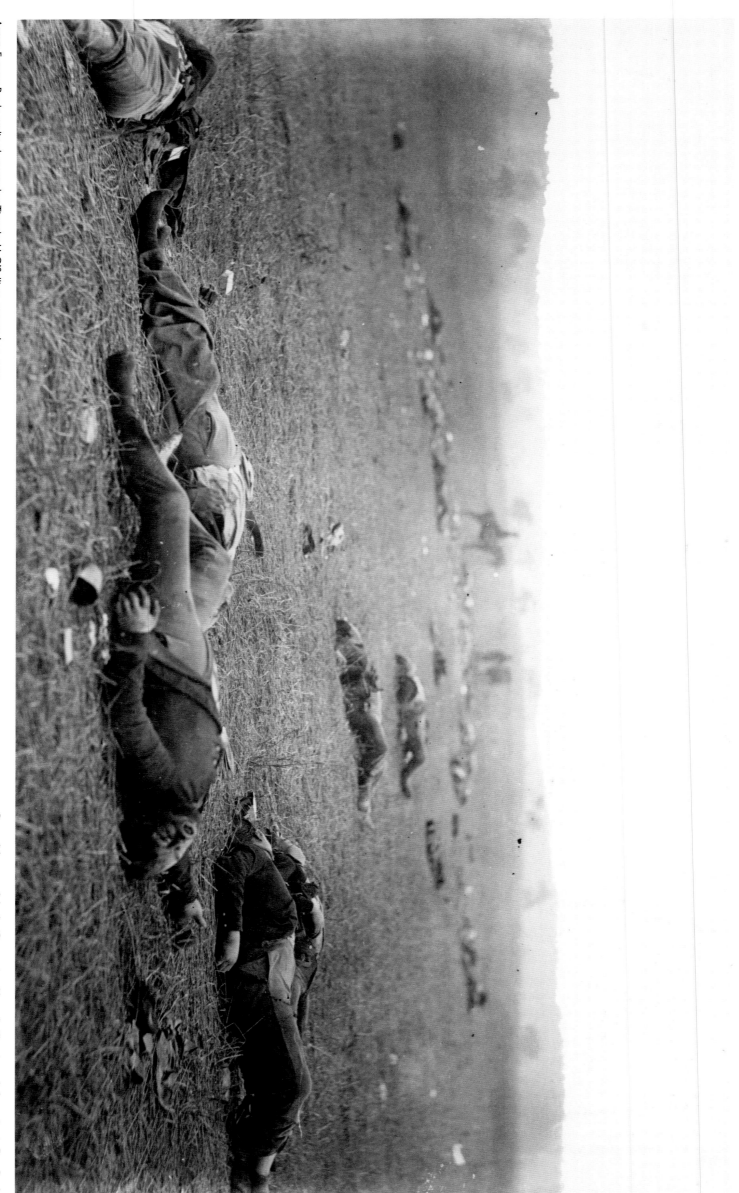

ABOVE: Former Brady studio photographer Timothy H. O'Sullivan captured on camera the full horrors of war on the Gettysburg battlefield, July 1863: Union soldiers who had fallen during the three-day battle. In all, some 6,000 Rebels and Yankees died at Gettysburg, the worst carnage of the war, and the bloodiest battle in American history. (Library of Congress)

RIGHT: A battery of the 1st Connecticut Heavy Artillery is ready for action in Fort Brady, on the James River, near Aiken's Landing, Virginia, in 1864. (Library of Congress)

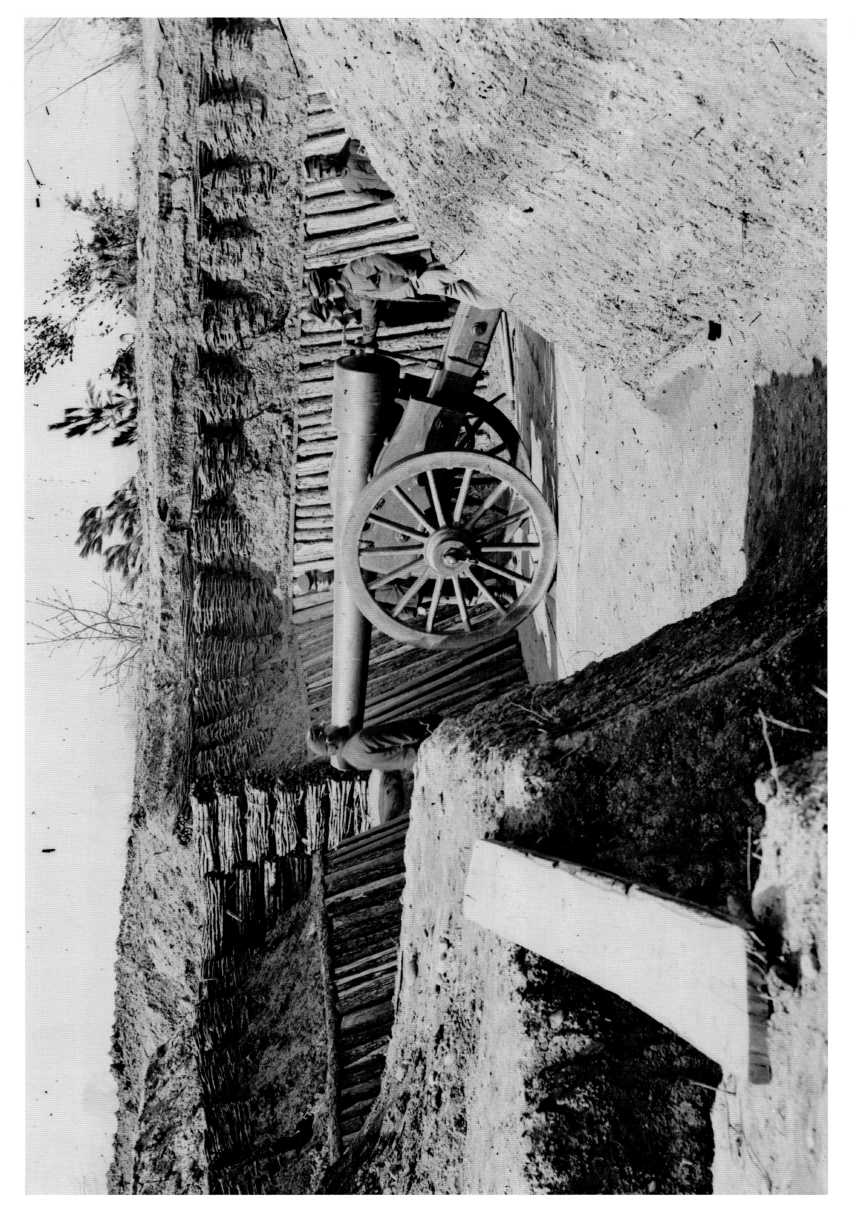

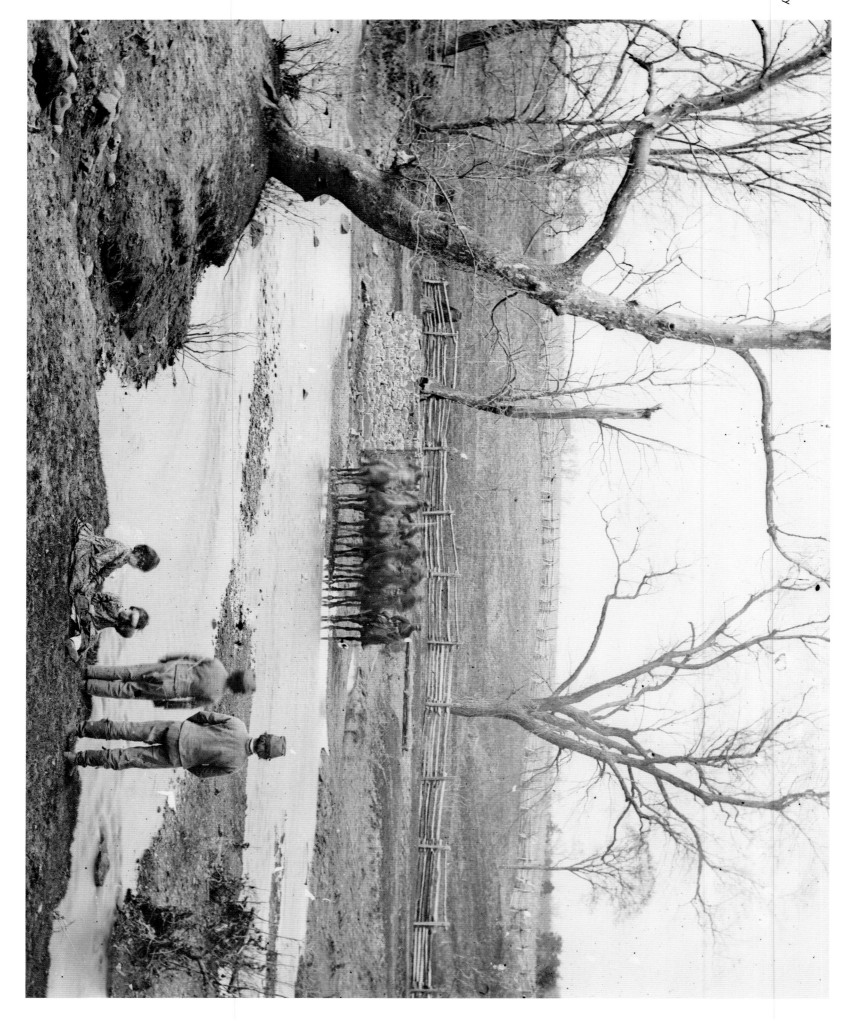

RIGHT: In March 1862 Brady associate George N. Barnard clicked his shutter as, under the bemused gaze of a family seemingly enjoying a picnic, Federal cavalry prepare to cross Sudley Spring Ford, Bull Run, Virginia, the site of two early Civil War battles (First and Second Manassas). (*Library of Congress*)

LEFT: Horse-drawn wagons crossing a
pontoon bridge built by Federal engineers
across the James River, Richmond.
Retreating Rebel forces had destroyed
stone bridges to deny their use to
Federal troops.
(Library of Congress)

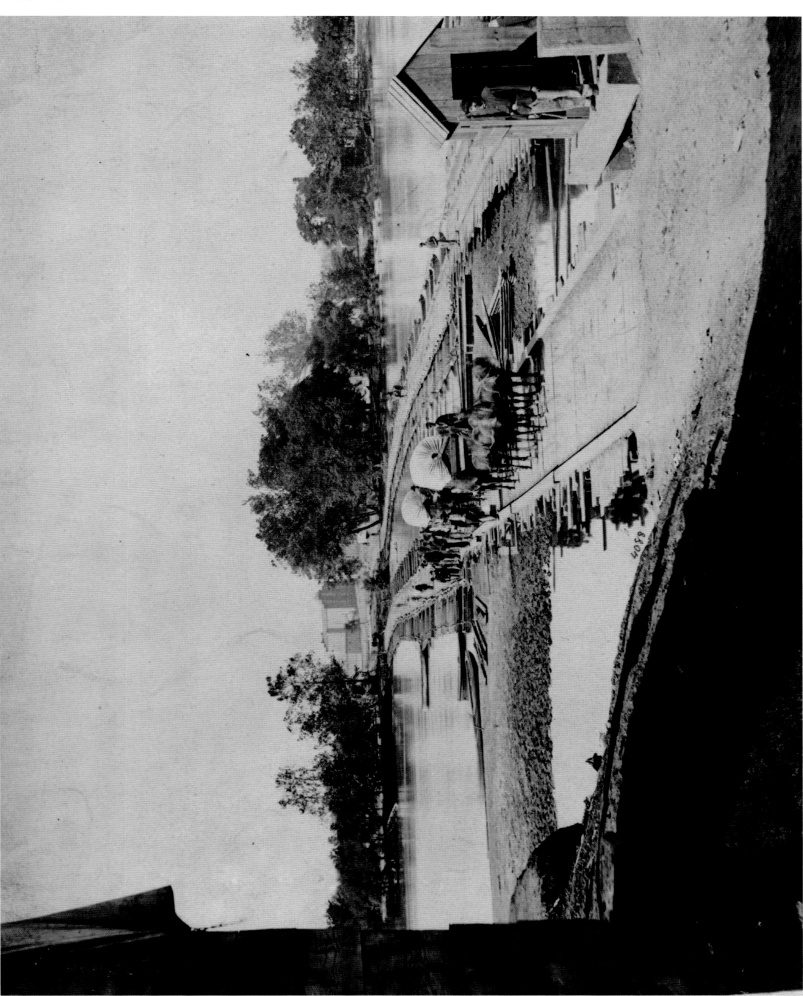

LIFE DURING WARTIME

As soon as volunteers began swarming into the nation's capital, Brady's and other photo galleries were overrun with soldiers wanting their pictures on *cartes de visite* for loved ones before marching off to battle. As a result, thousands of studio photographic images of individual soldiers still exist, and soldiers became aware of photography before they encountered it in camp and on battlefields.

But there's another, entirely different aspect to this, the first photographed war: that is, scenes of life during war. In camp, a soldier's life, as many have observed, was a case of "hurry up and wait." Other than the relatively few hours actually spent in terrifying battle, a soldier's life at the time of the Civil War was one of unprecedented boredom. This was due both to leadership problems and the nature of the war. Camp life included drills and training, to be sure, but it also included card games, writing letters home, a bit of play, and carving Minnie balls (bullets) into interesting shapes.

Brady's wartime images of military life included elements of all these things. But his photographers were also constrained by having to pose shots so that everyone would stand or sit still long enough for a clear exposure. Some of the photographs show soldiers with their prized weapons, both large and small. Others are simple group shots of officers or soldiers in and around camp. Some depict conversations and, presumably, strategizing. Still others illuminate a bit of humor, whether it's soldiers hamming it up for the camera or the cameraman getting unusual shots. A few of the more unusual photos feature visiting mail wagons, soldiers swimming, and even the occasional female visitor in camp.

All of these peeks into life during wartime give us glimpses of an intense period in the lives of thousands of scared and uncertain young men waiting to go to battle more than a hundred and thirty years ago.

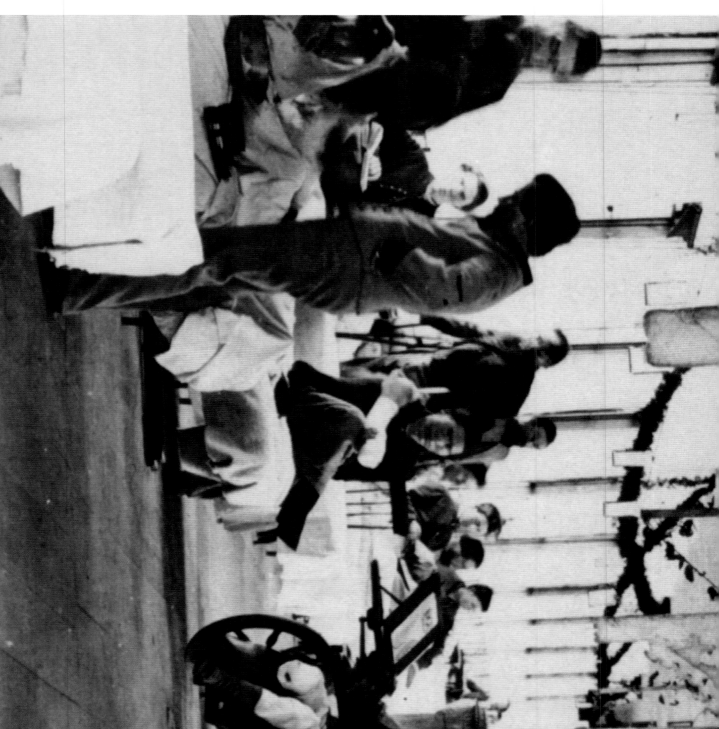

RIGHT: Their war is over ...wounded Union soldiers, some suffering amputations, at Armory Square Hospital, Washington, D.C. North and South, the wounded and the sick may have survived the field hospitals only to face deadly disease in such establishments as this, treated by overworked and undertrained medical staff. *(Library of Congress)*

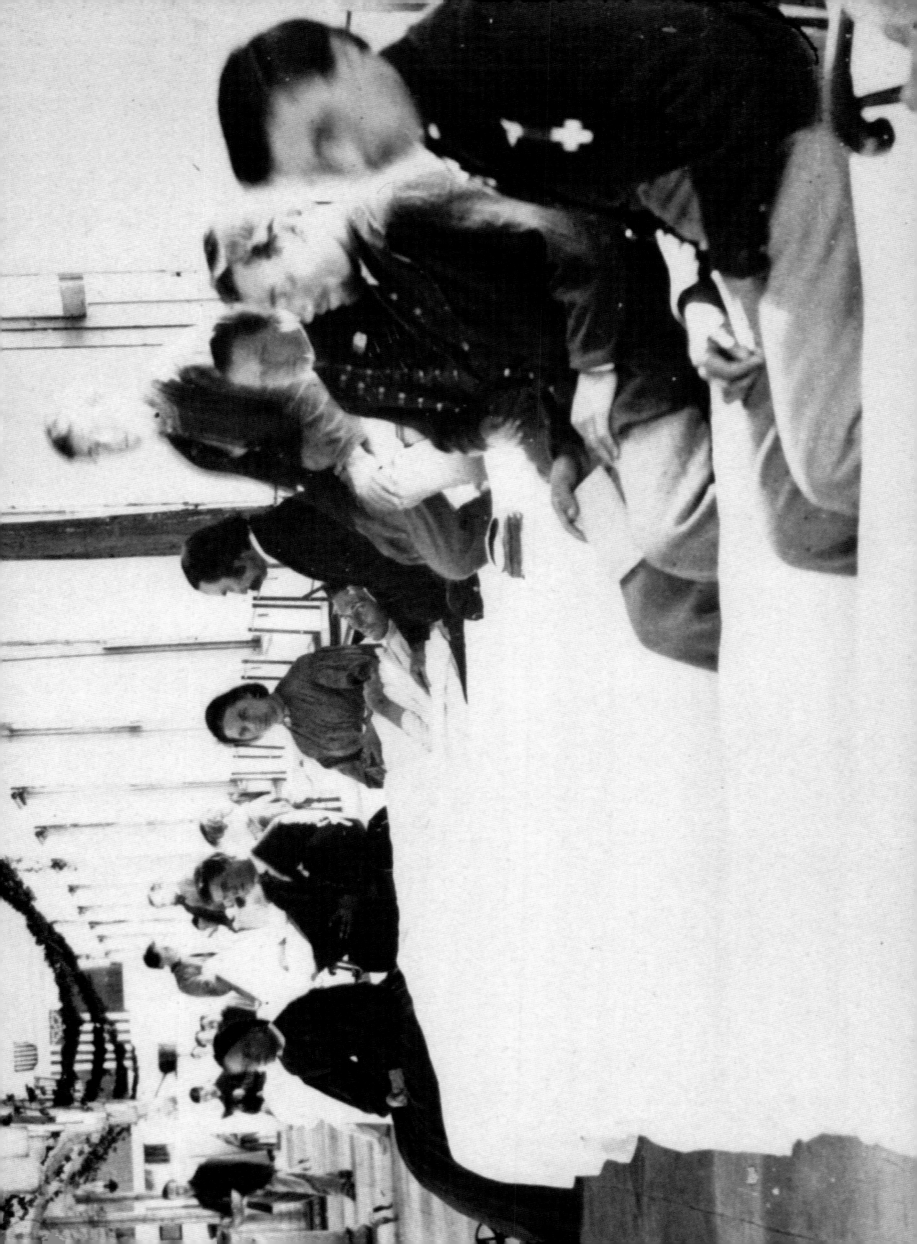

136

RIGHT: These Federal hospital tents were thrown up at Gettysburg to deal with casualties from the battle there in July 1863. Despite the seemingly large number of tents, the hospital regularly turned less-wounded soldiers away. There was no room.
(Library of Congress)

FAR RIGHT: An ambulance crew practice removal of casualties from a battlefield during an obviously staged drill. Some of the troops are dressed as Zouave soldiers, who wore one of the more colorful types of uniform in the Civil War.
(Library of Congress)

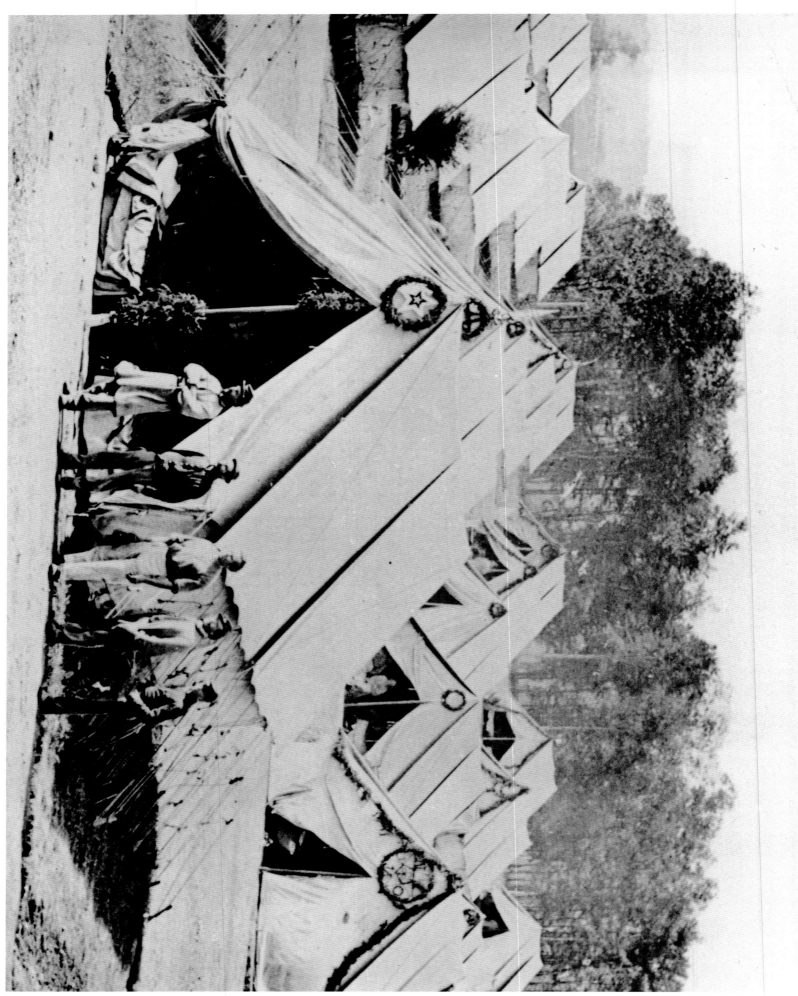

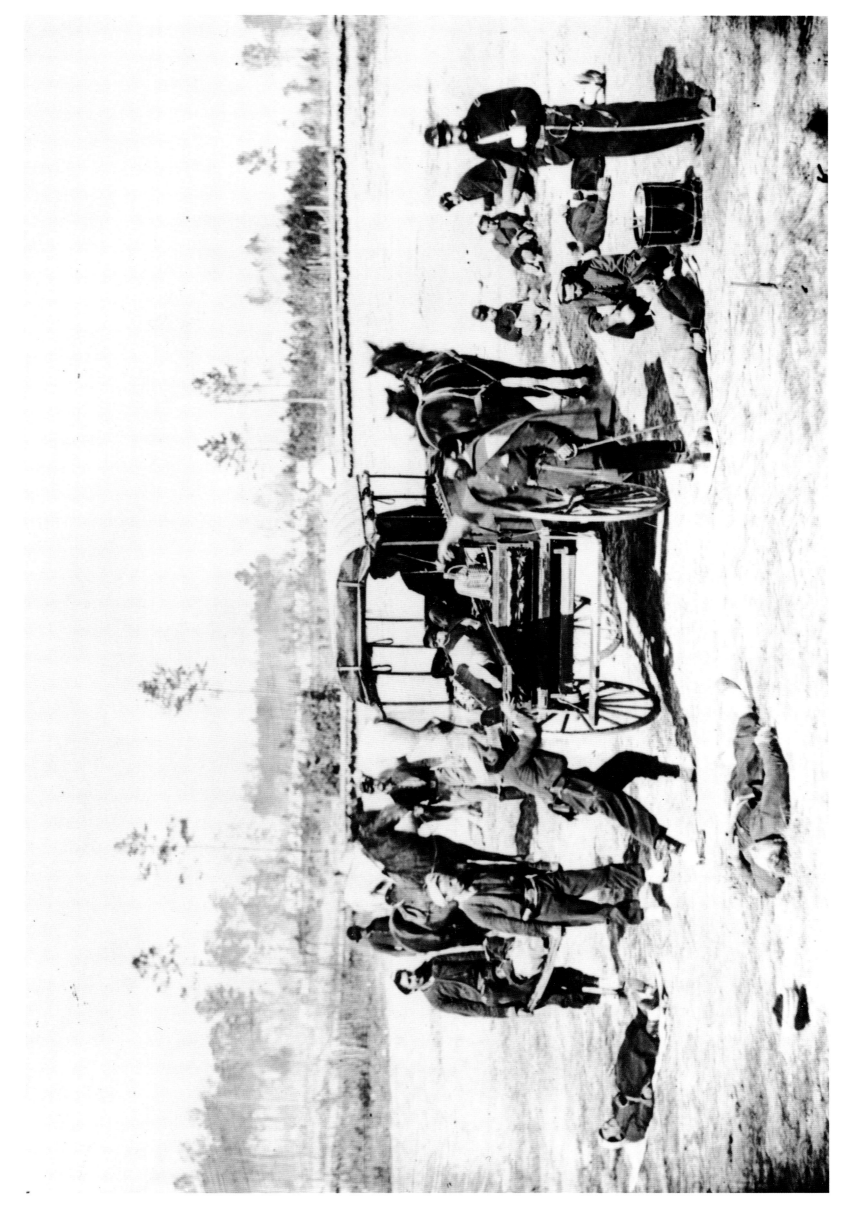

RIGHT: With Washington's old and established military hospitals becoming overwhelmed early in the war, Federal authorities ordered the erection of temporary wooden hospitals, such as this hastily built complex, near the capital, which looks like an elongated shed. *(Library of Congress)*

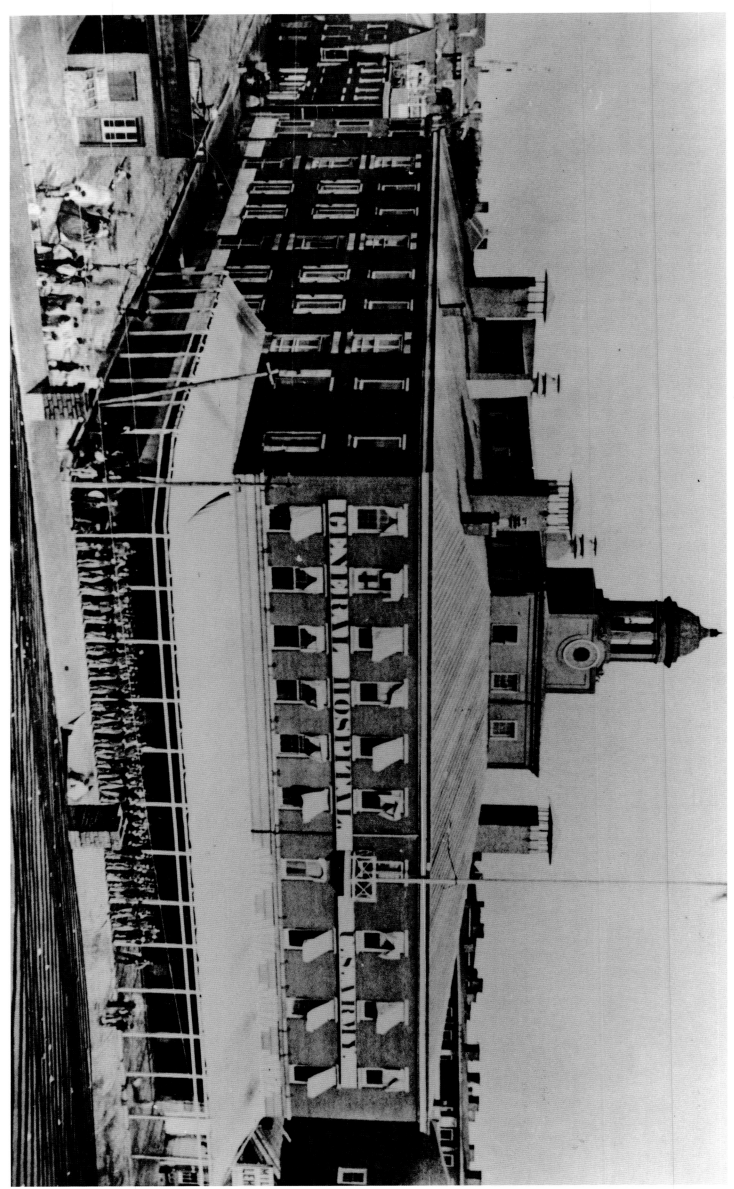

ABOVE: One of the very few permanent-structure hospitals used for Civil War wounded was the U.S. Army's General Hospital, located at the corner of Broad and Cherry Streets in Philadelphia.
(Library of Congress)

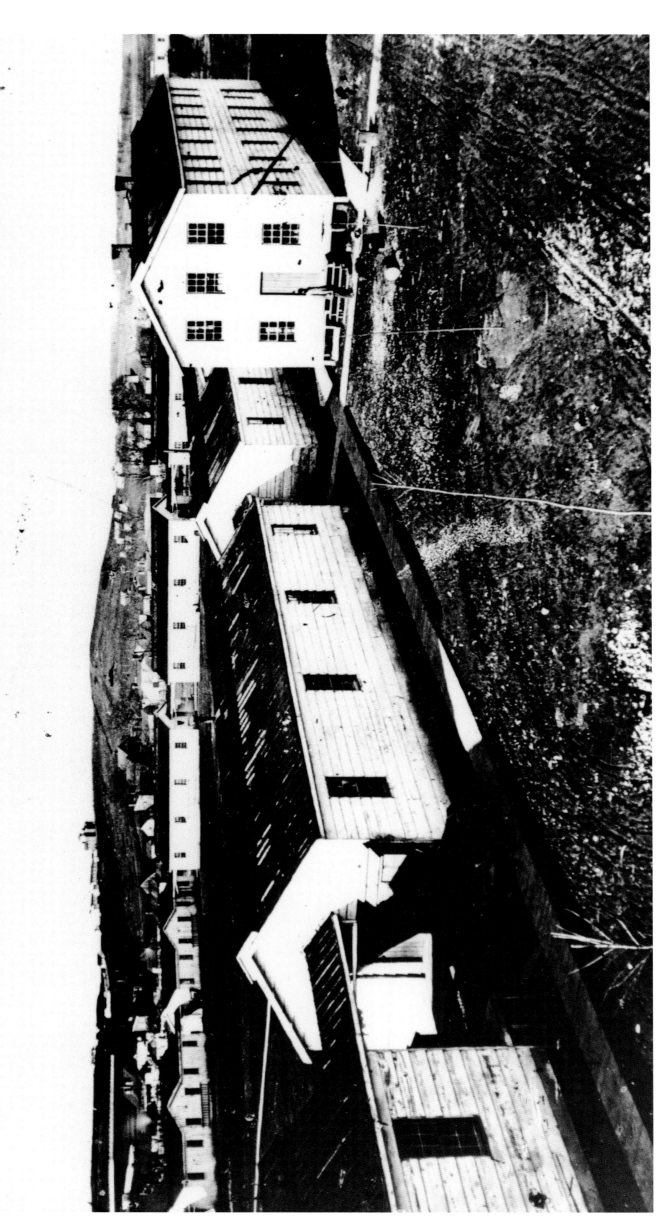

ABOVE: The Slough Hospital in Alexandria, Va., was hastily erected to provide care for the vast numbers of wounded and ailing Union soldiers during the Civil War. The image was among many created by Mathew Brady and his field photographers of Northern hospitals and convalescent camps around the capital. *(National Archives)*

ABOVE: Northern infantrymen drill in front of their big Sibley tents. Drill was a vital part of training troops during the Civil War. Many volunteers, North and South, had never taken orders before, let alone been involved in dressing a line, or marching in unison. As Private Oliver Norton of the 83rd Pennsylvania wrote home: "The first thing in the morning is drill, then drill, then drill again. Then drill, drill, a little more drill. Then drill, and lastly drill. Between drills, we drill and sometimes stop to eat a little and have roll-call." (Library of Congress)

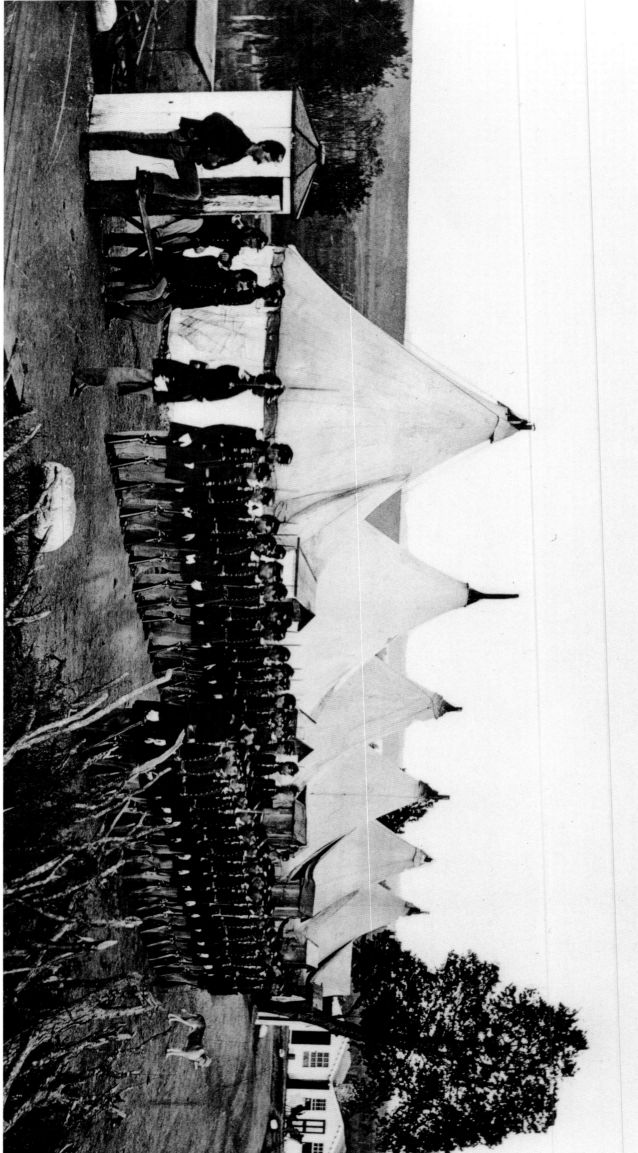

RIGHT: Helping to relieve the boredom of life in camp, a sutler's cabin provides a base for some welcome fun for Union soldiers, who are hamming it up for the camera: one fellow is about to try the contents of a huge beer jug, while another pretends to play the fife behind his colonel's back. (Library of Congress)

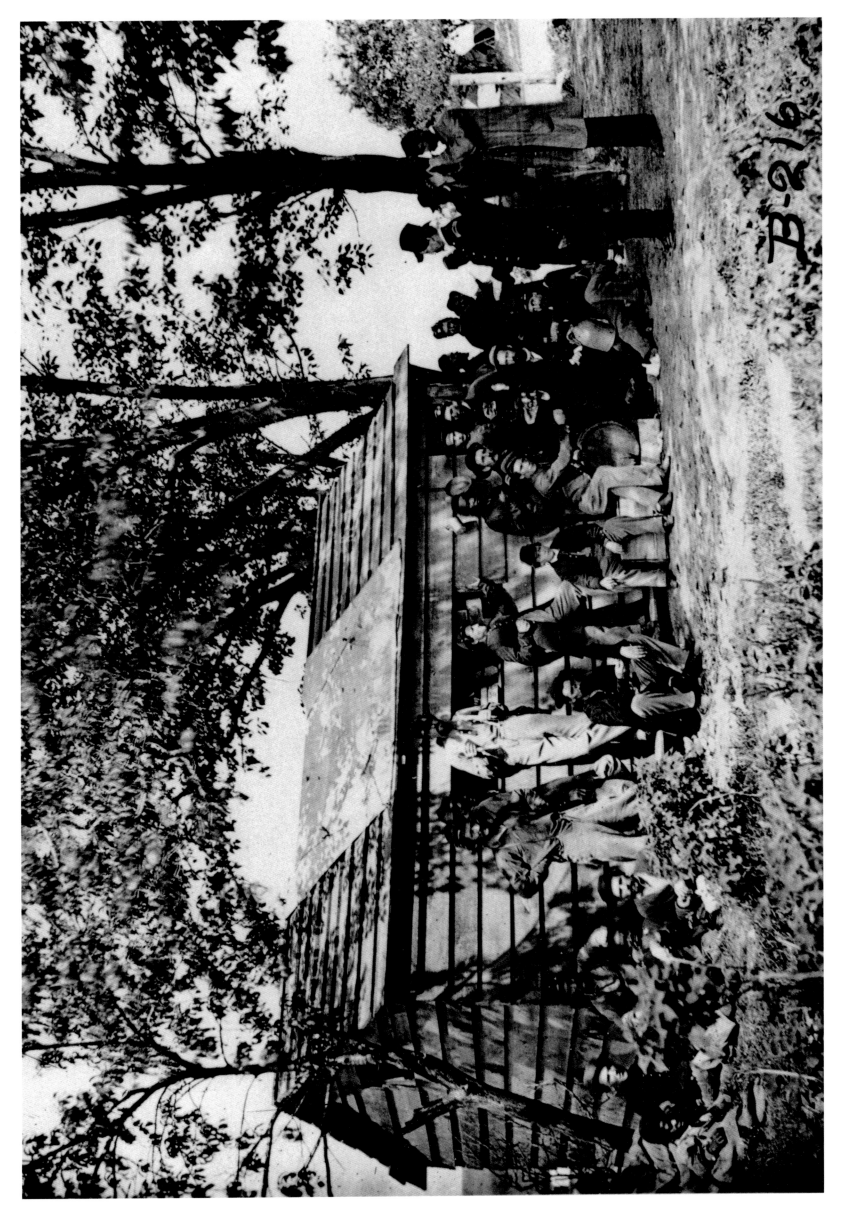

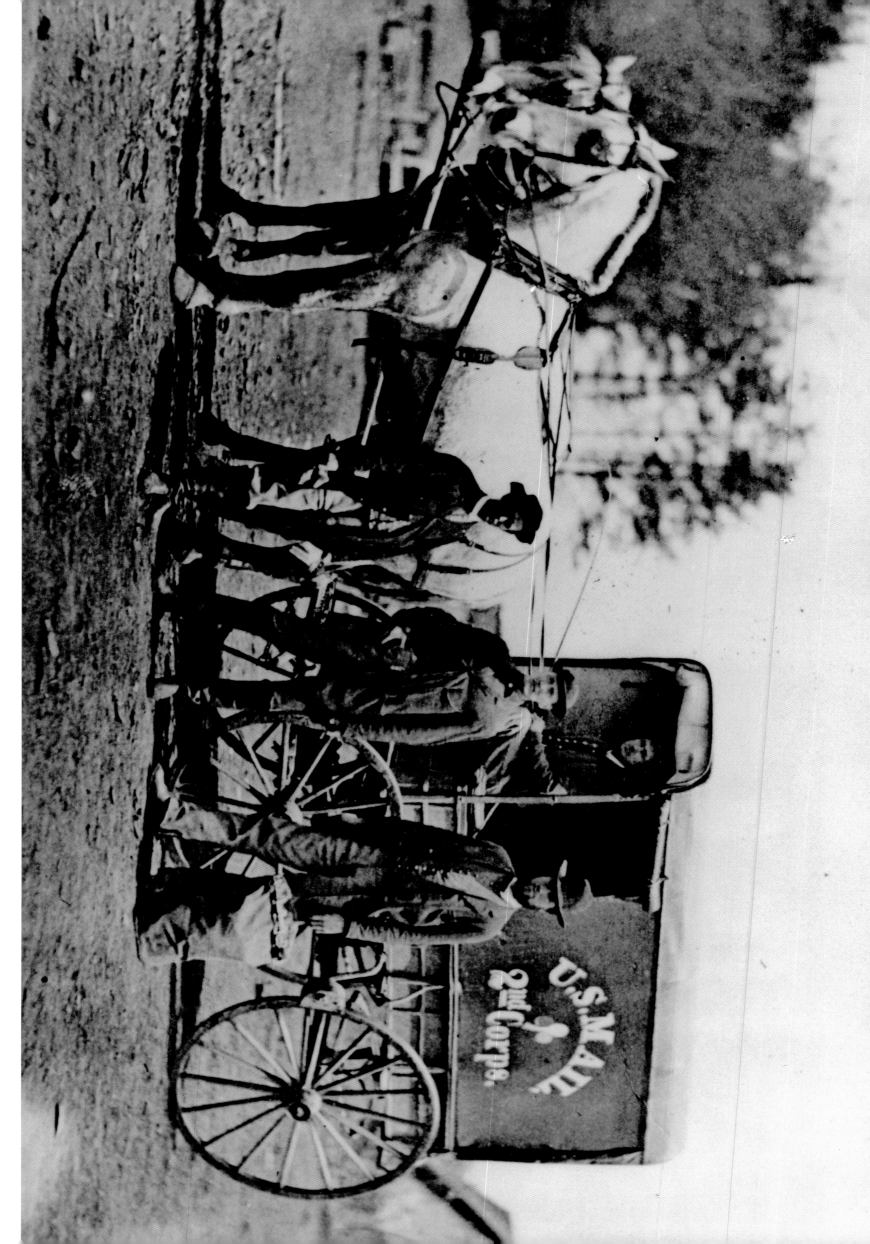

FAR LEFT: Bringing welcome news from home: a mail wagon for the Union 2nd Corps, Army of the Potomac, arrives at Brandy Station during April 1864.
(U.S. Army Military History Institute)

LEFT: Larger, more permanent bases, such as Grant's at City Point, Va., had their own hospitals, with fleets of ambulances parked nearby.
(Library of Congress)

RIGHT: By the time this image of a photographer's portable dark room had been taken by George Barnard, in a picket post close to Atlanta, Georgia, he had gone independent of the Brady studio set-up, and was trailing the armies of Sherman, south from Chattanooga. The photo has frequently been erroneously attributed to Brady.
(Library of Congress)

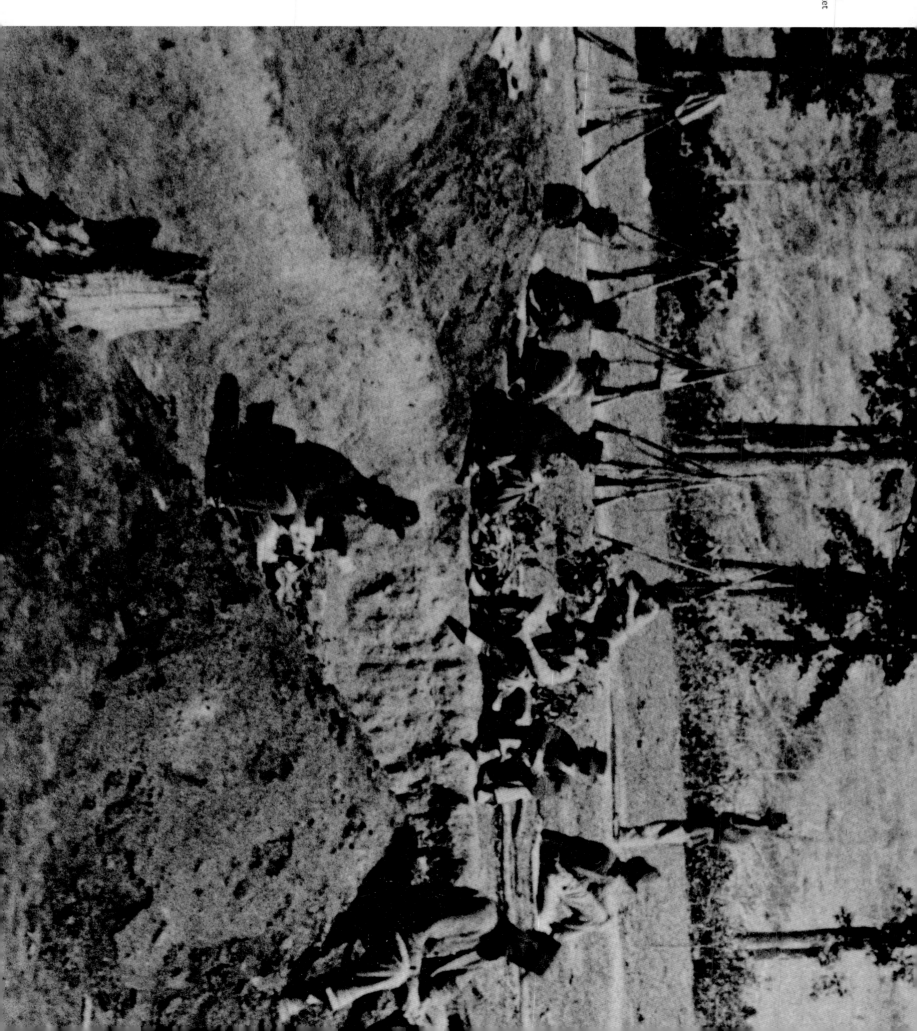

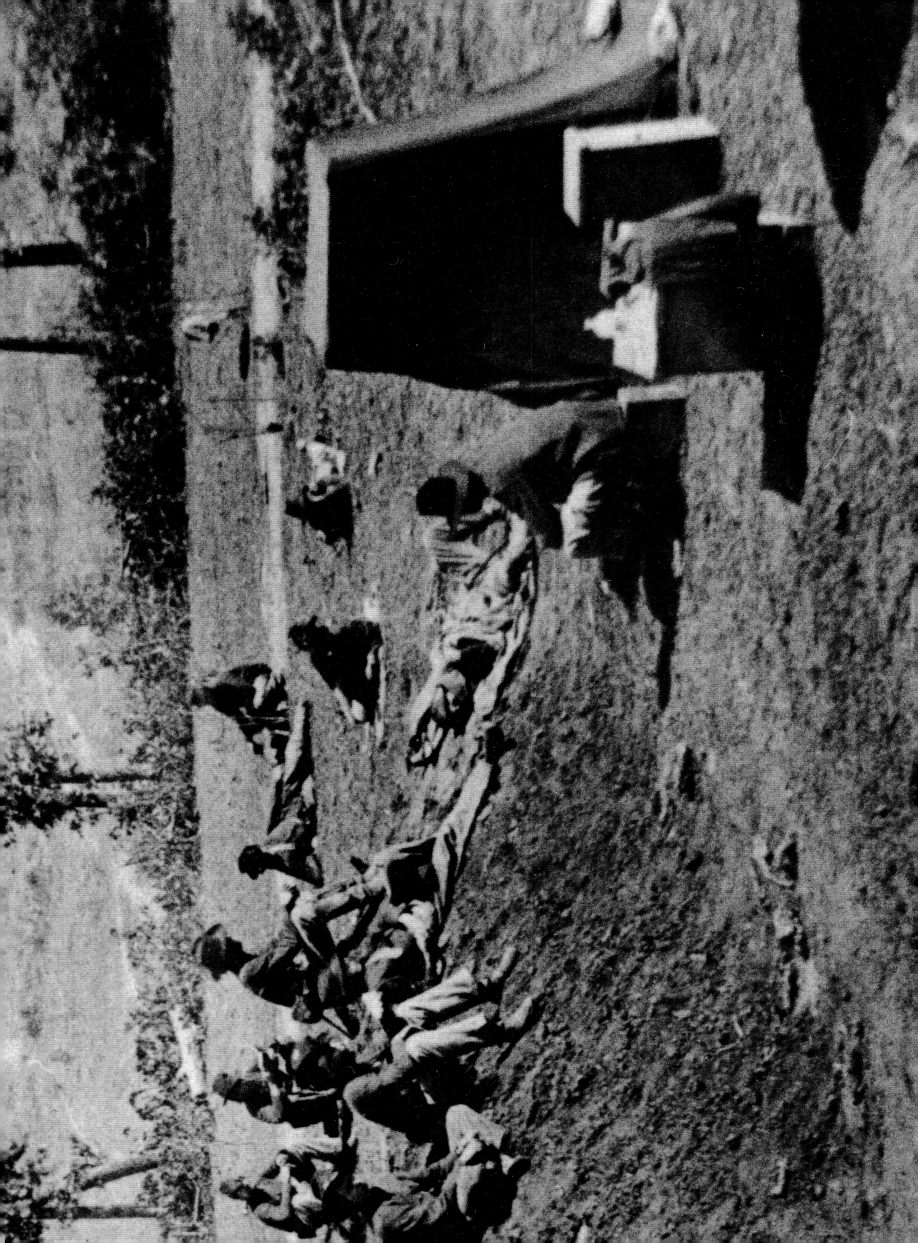

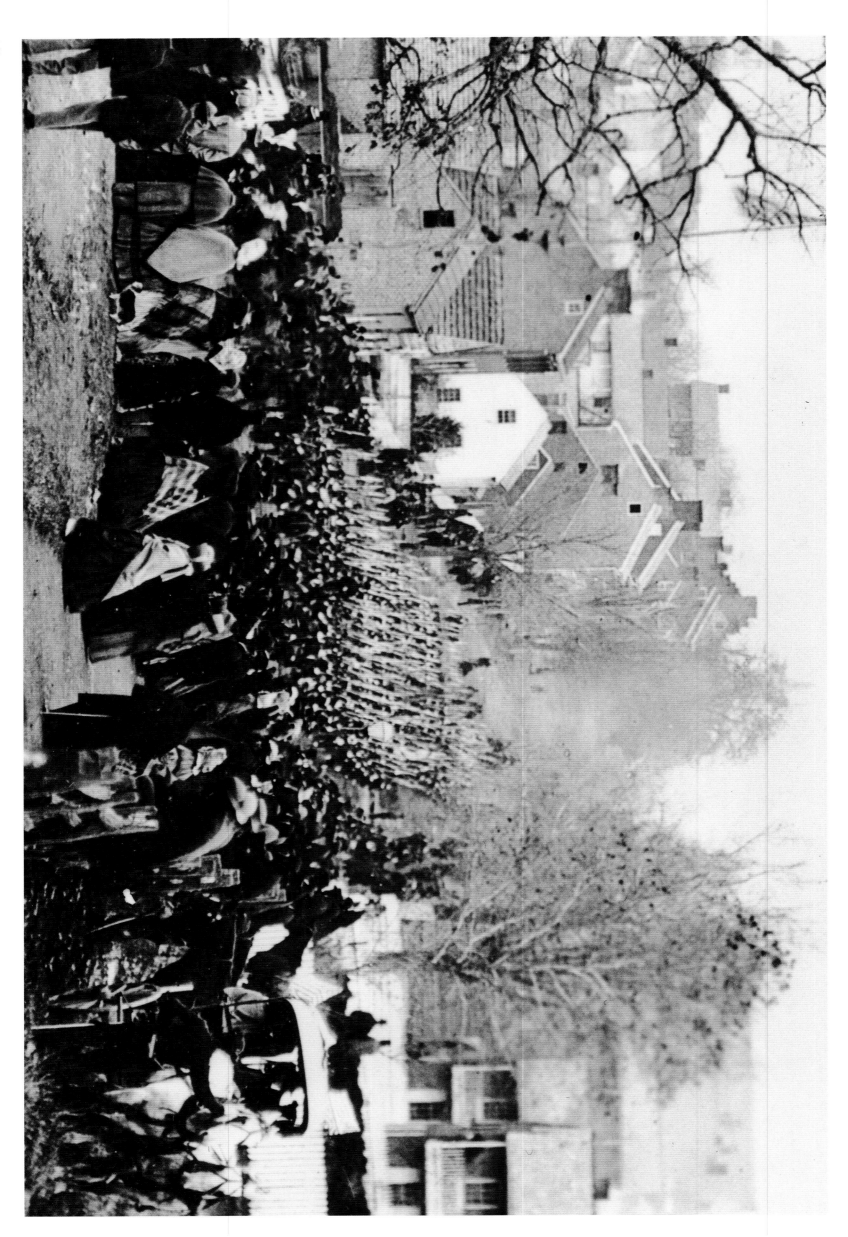

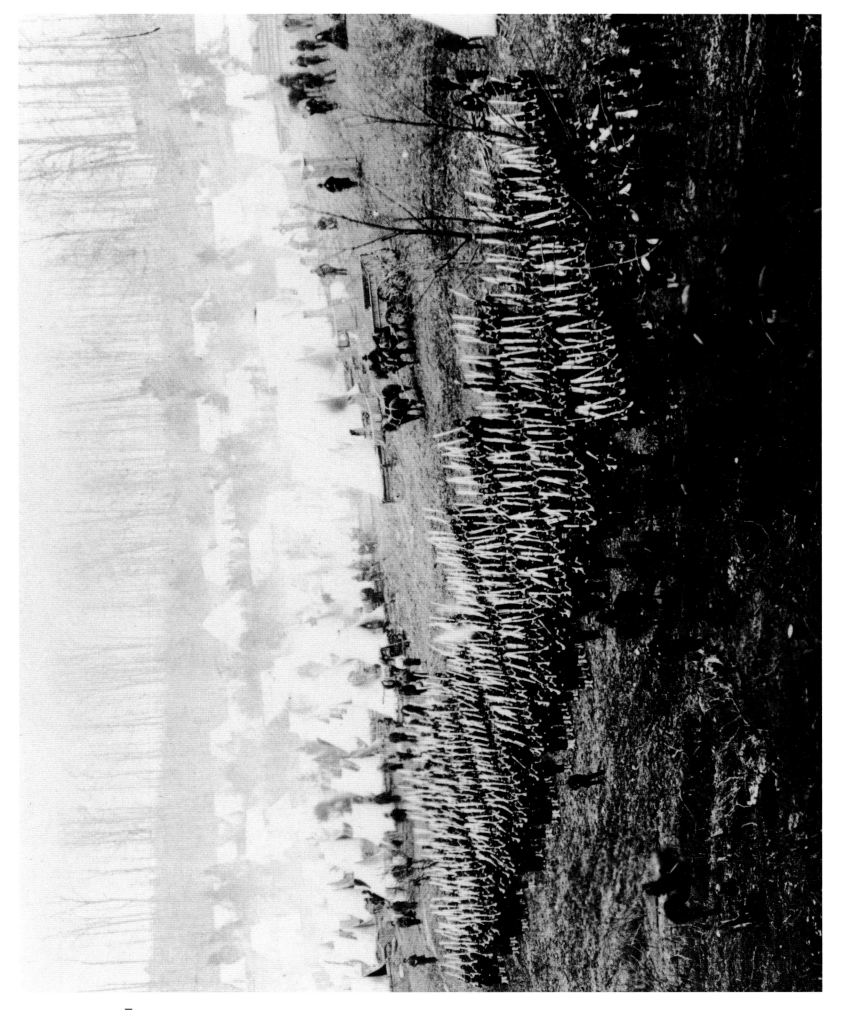

LEFT: A regiment marches through the streets of Gettysburg on their way to the dedication of the cemetery, 1863. The photo points up how difficult it was to capture action on camera at the time.
(*Library of Congress*)

RIGHT: General view of the 96th Pennsylvania Infantry Regiment during drill at Camp Northumberland, with the camp in the background.
(*Library of Congress*)

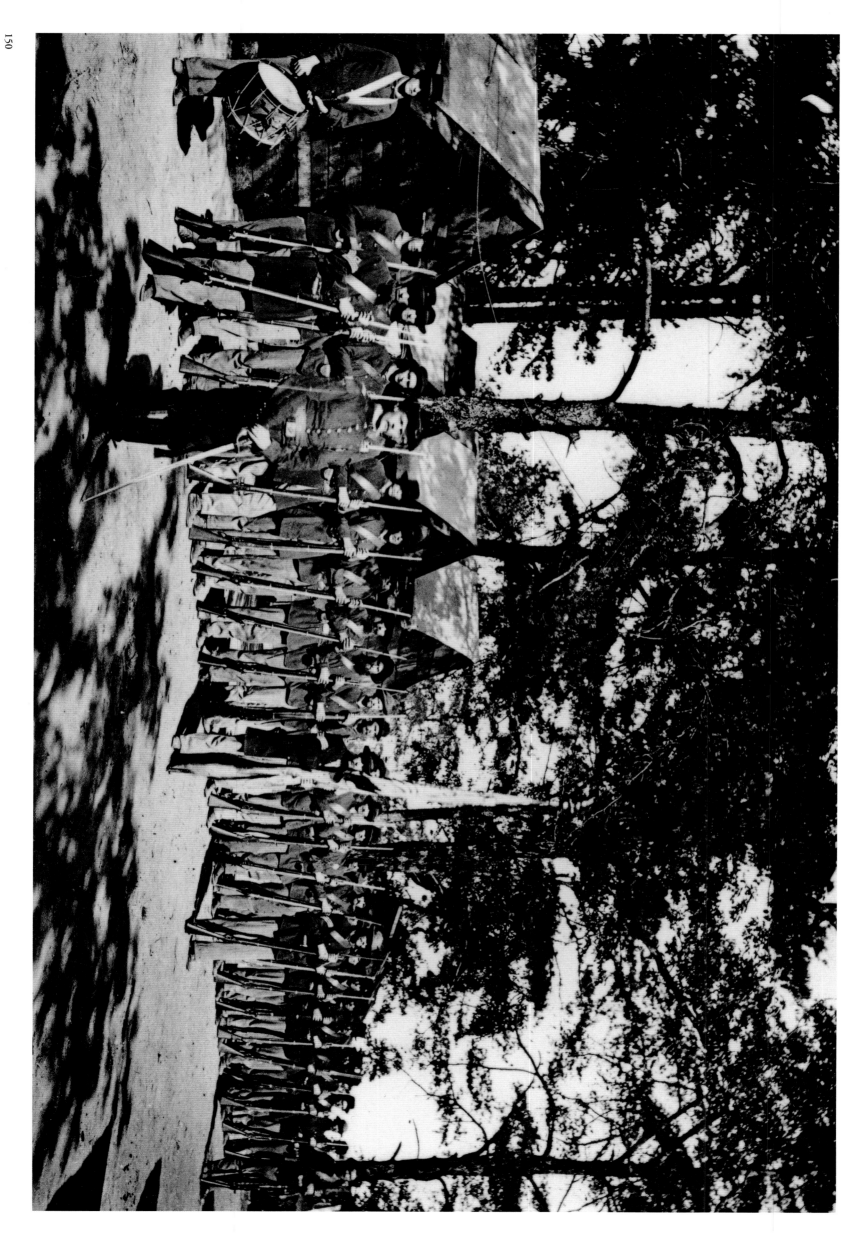

FAR LEFT: A company of the 21st Michigan Volunteer Infantry at attention in winter camp. The 21st was mustered into service at Ionia and Grand Rapids, Michigan, on September 9, 1862, and mustered out on June 8, 1865. In between it fought in several major battles, including Stones River and Chickamauga. (*Library of Congress*)

LEFT: Both North and South were entirely unprepared to deal with captured enemies, such that when 1861 dawned there was not a single military prison capable of holding more than a few ill-behaved enlisted men. Many prisoners of war were held outdoors, at camps like this, where Confederate prisoners captured in the Shenandoah Valley, Va., were housed in May 1862. (*Library of Congress*)

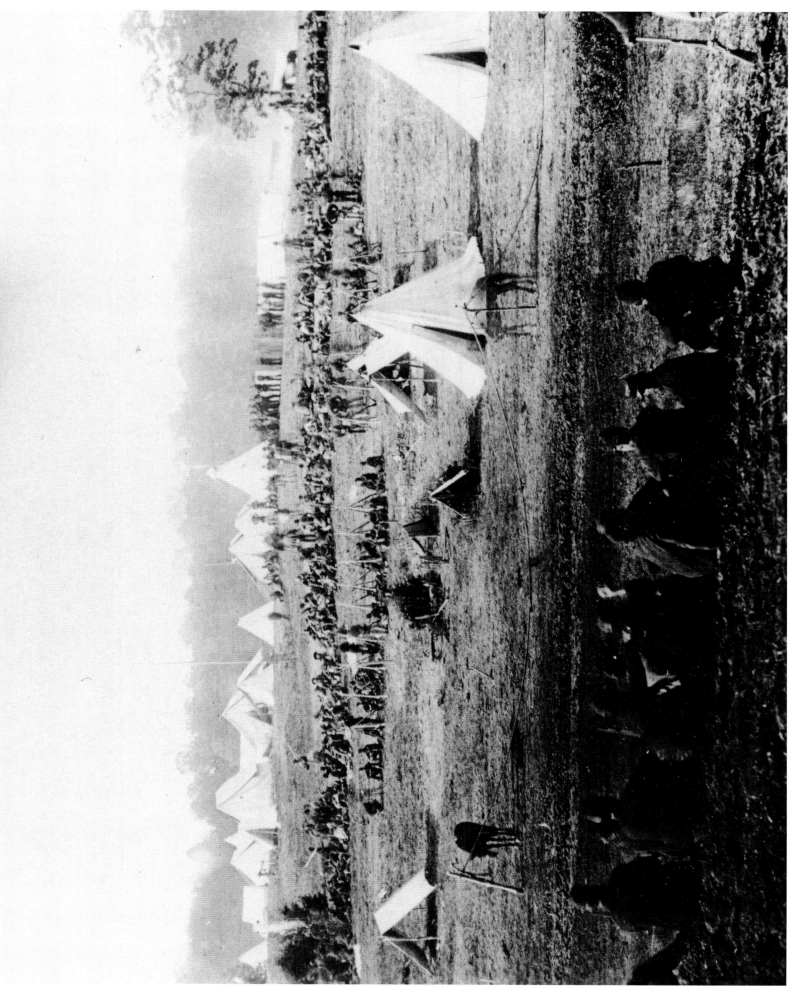

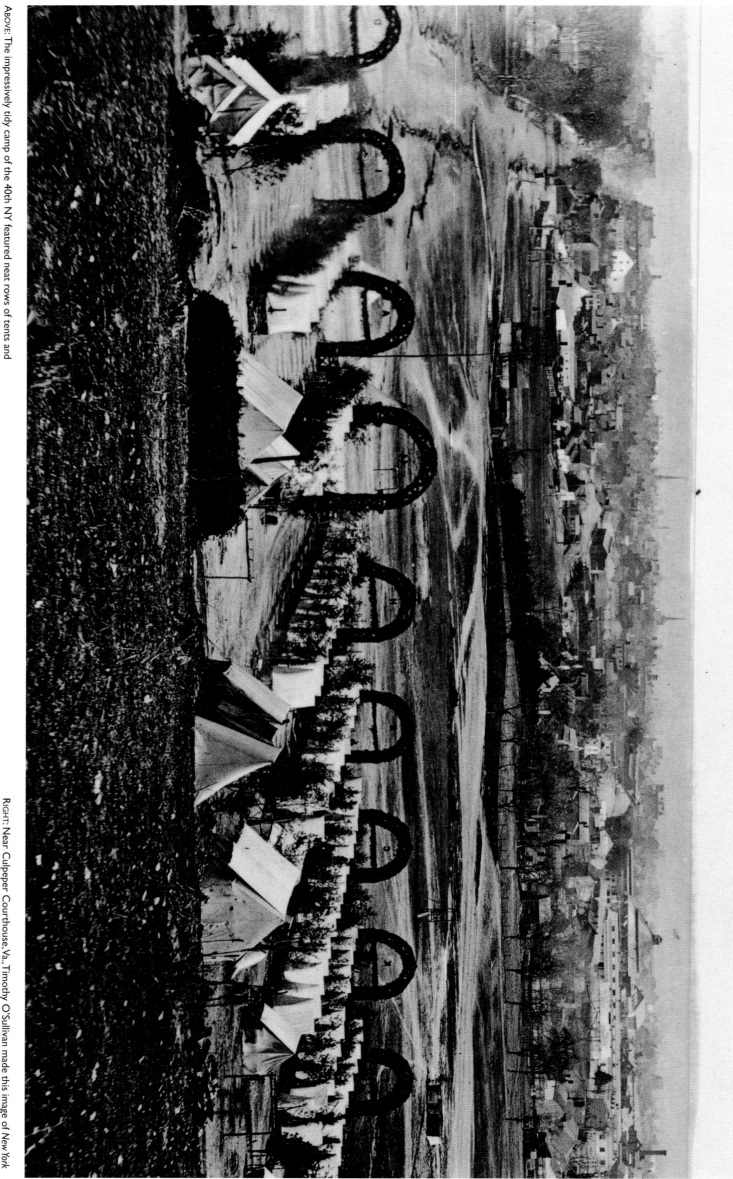

ABOVE: The impressively tidy camp of the 40th NY featured neat rows of tents and arches. The city of Alexandria, Va., can be seen in the background.
(*Library of Congress*)

RIGHT: Near Culpeper Courthouse, Va., Timothy O'Sullivan made this image of *New York Herald* reporters discussing the progress of the war they have been reporting, August 1863, next to their tethered headquarters wagon.
(*Library of Congress*)

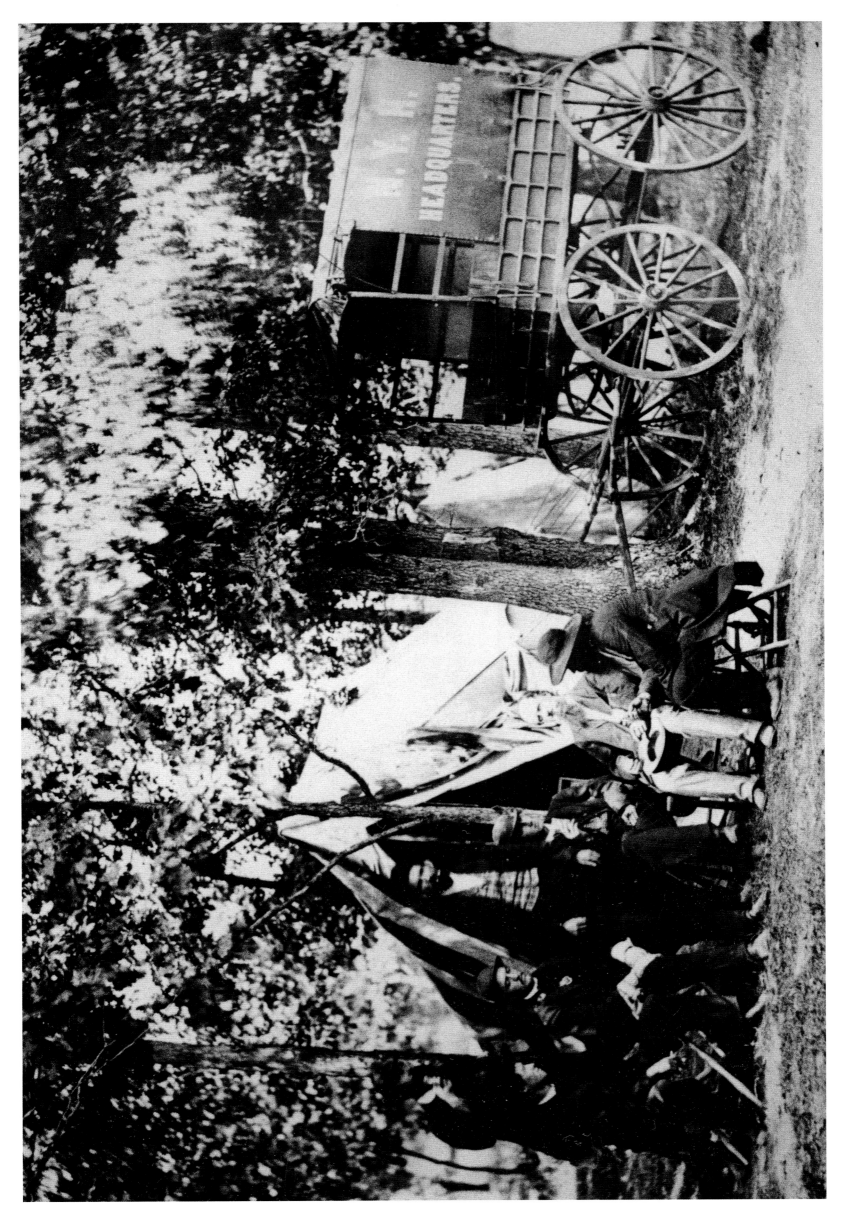

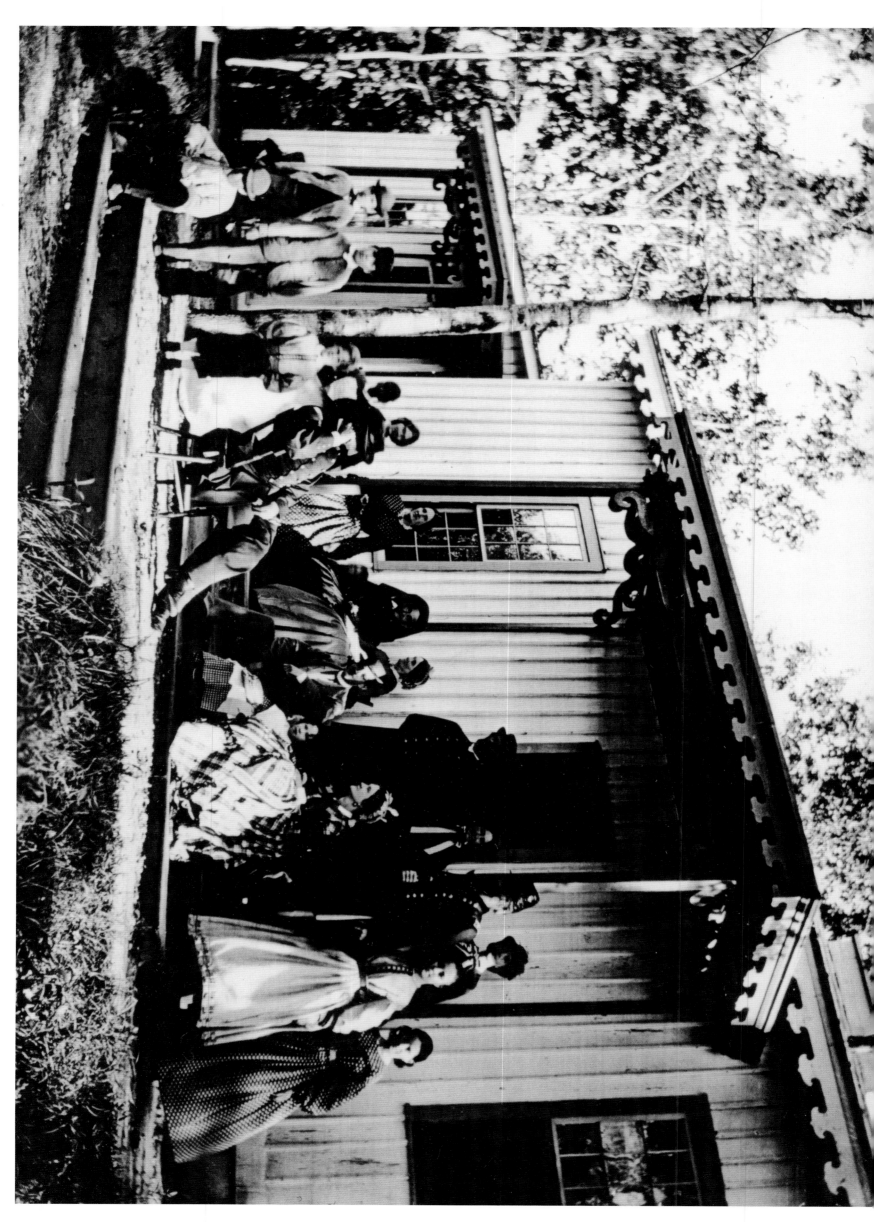

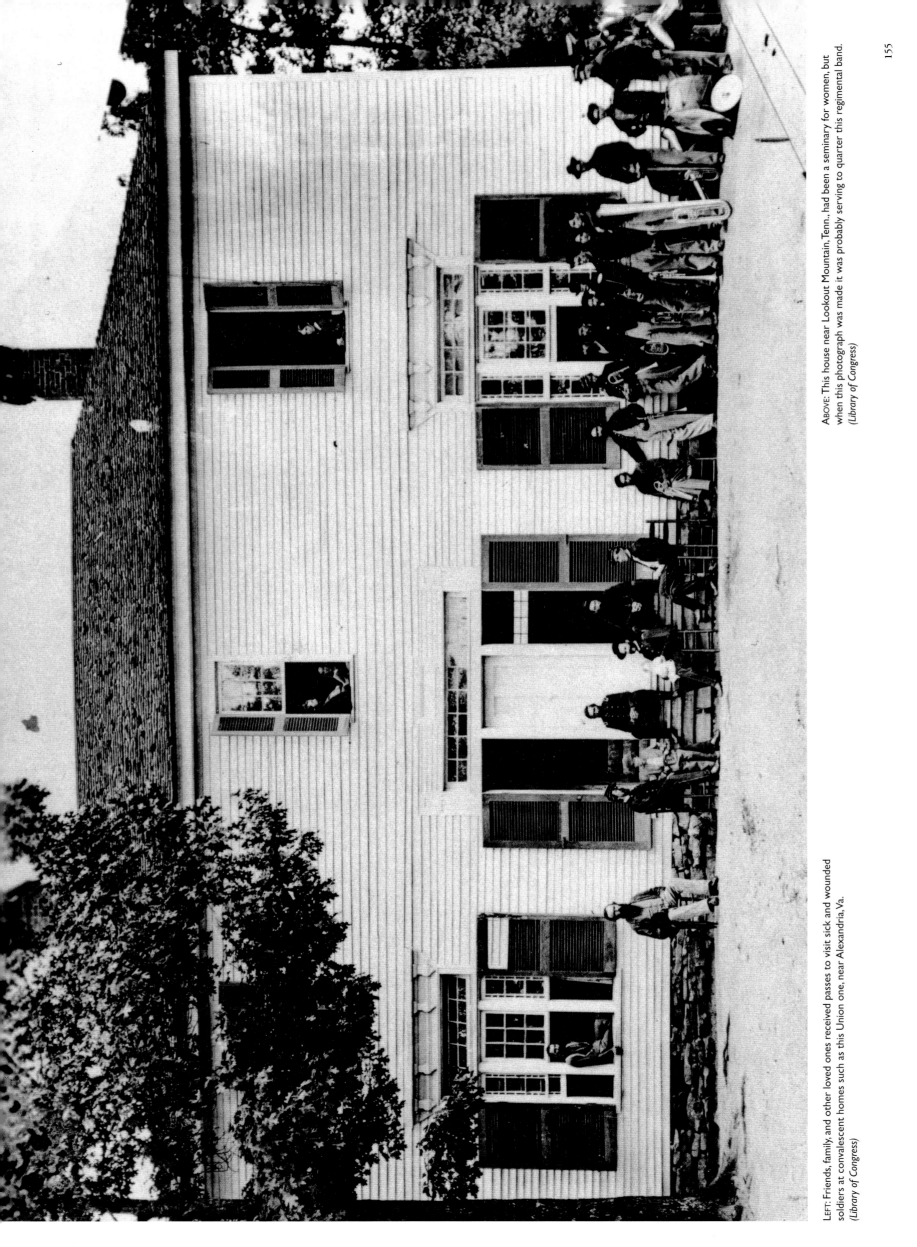

Left: Friends, family, and other loved ones received passes to visit sick and wounded soldiers at convalescent homes such as this Union one, near Alexandria, Va. *(Library of Congress)*

Above: This house near Lookout Mountain, Tenn., had been a seminary for women, but when this photograph was made it was probably serving to quarter this regimental band. *(Library of Congress)*

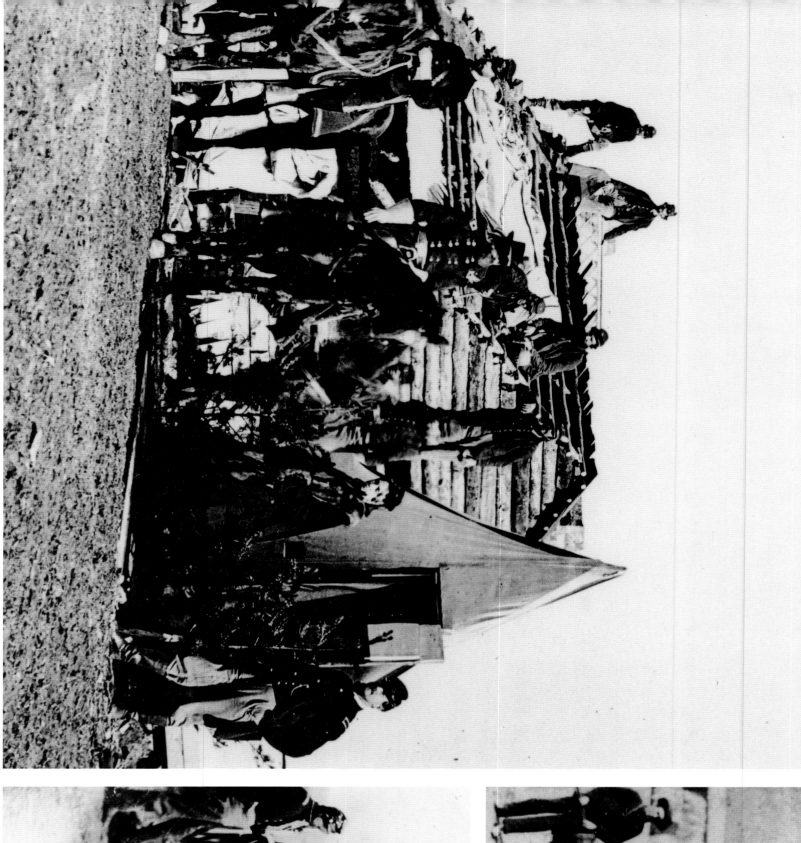

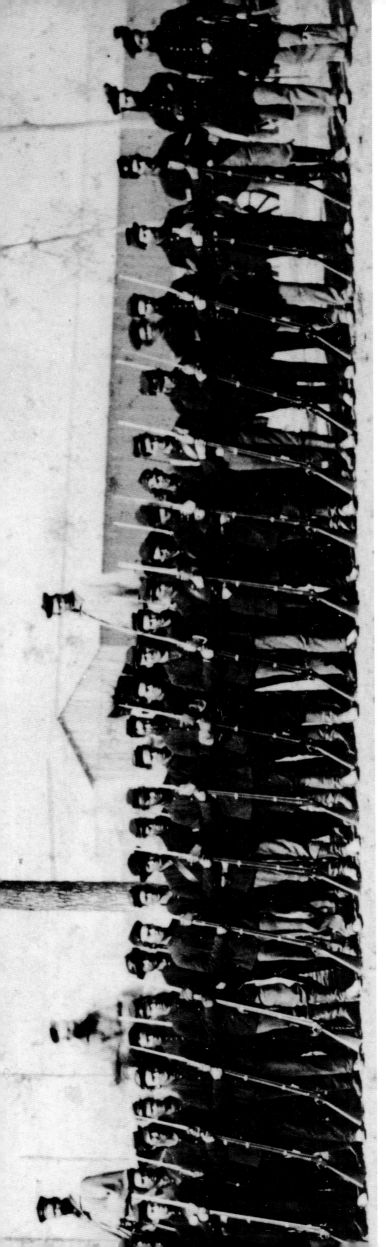

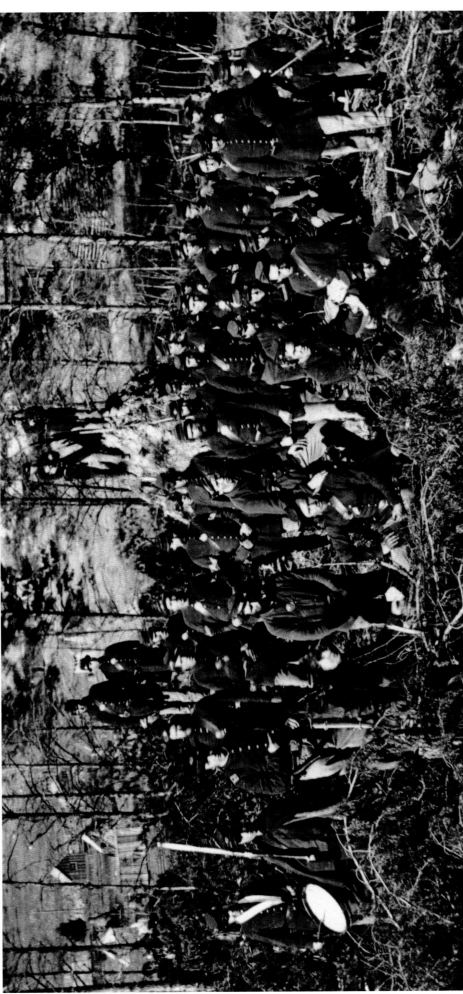

ABOVE: Members of Company D, the 22nd Ohio Volunteer Infantry, one of the fighting units of the western theater, pose near Corinth, Miss., in 1862.
(Library of Congress)

FAR LEFT:
Enlisted men provided most of the labor for constructing winter camp housing. They were not paid for the extra duty.
(Library of Congress)

CENTER LEFT: Cards, coffee, and pipes were the staples of soldiers at rest between marches. The men at center appear to be "fortifying" their coffee.
(Library of Congress)

LEFT: A group of soldiers from the 170th New York Volunteers, part of the so-called "Corcoran Legion," poses on a hillside. The "Legion" was raised by Brigadier General Michael Corcoran when he returned to U.S. Army duty, having been held for thirteen months as a prisoner of war by the Confederates.
(Library of Congress)

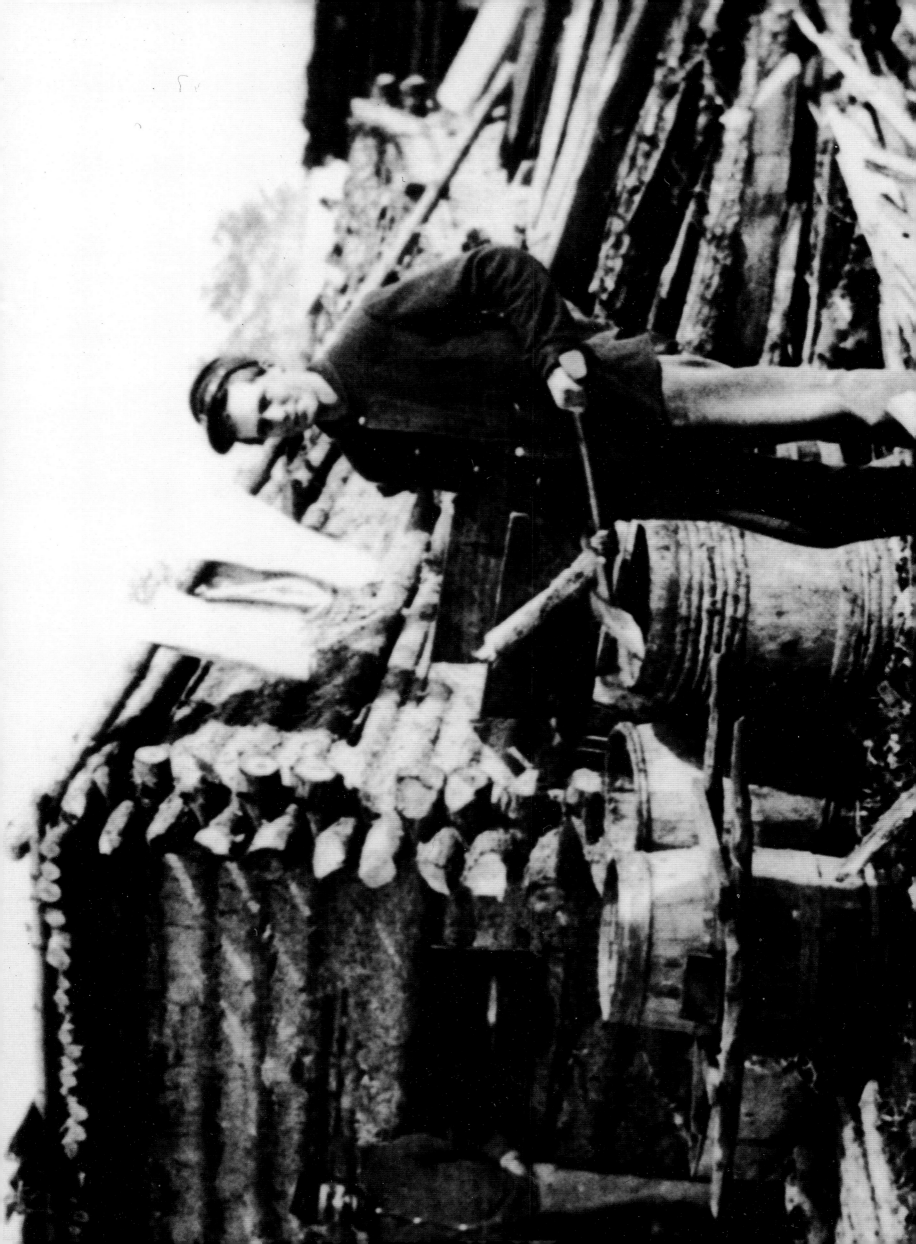

MATHEW B. BRADY

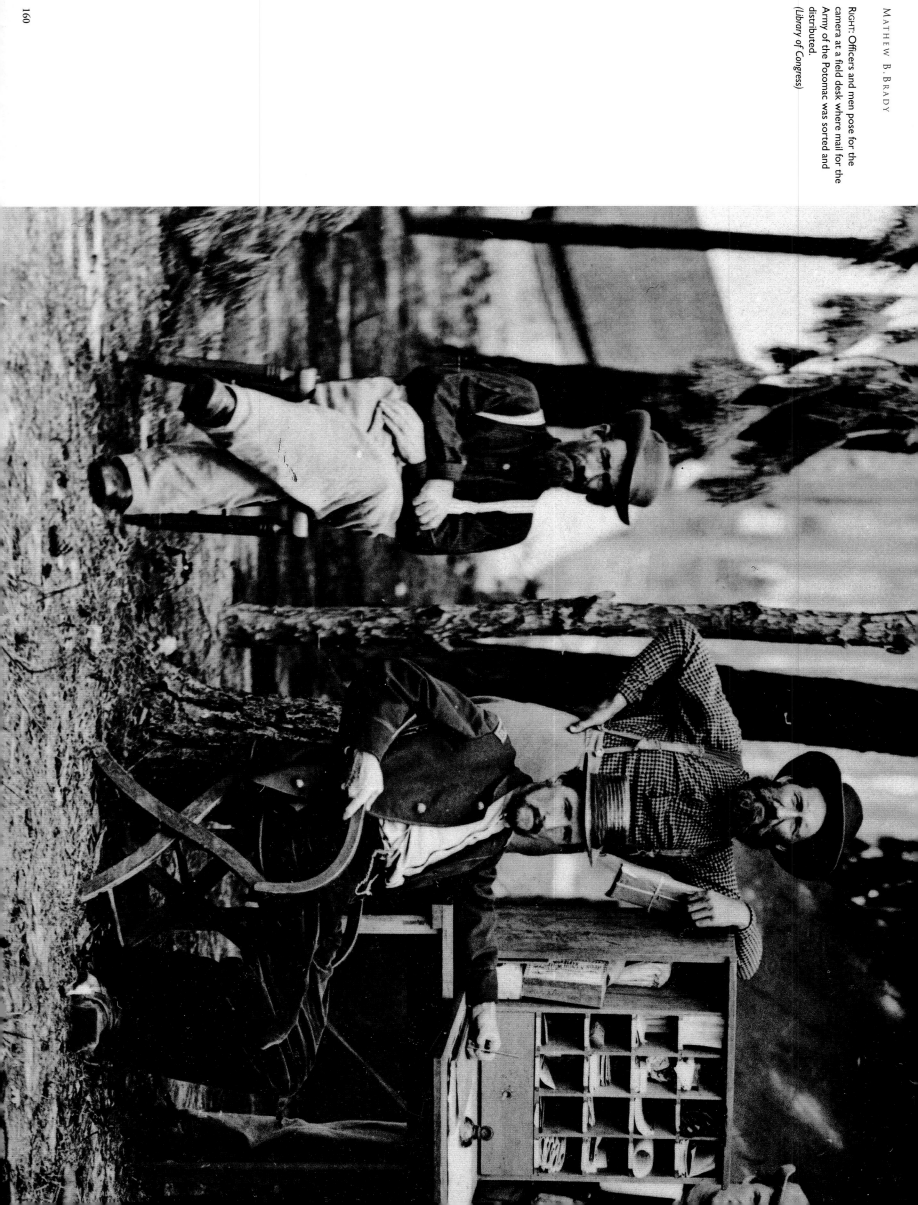

RIGHT: Officers and men pose for the camera at a field desk where mail for the Army of the Potomac was sorted and distributed.
(Library of Congress)

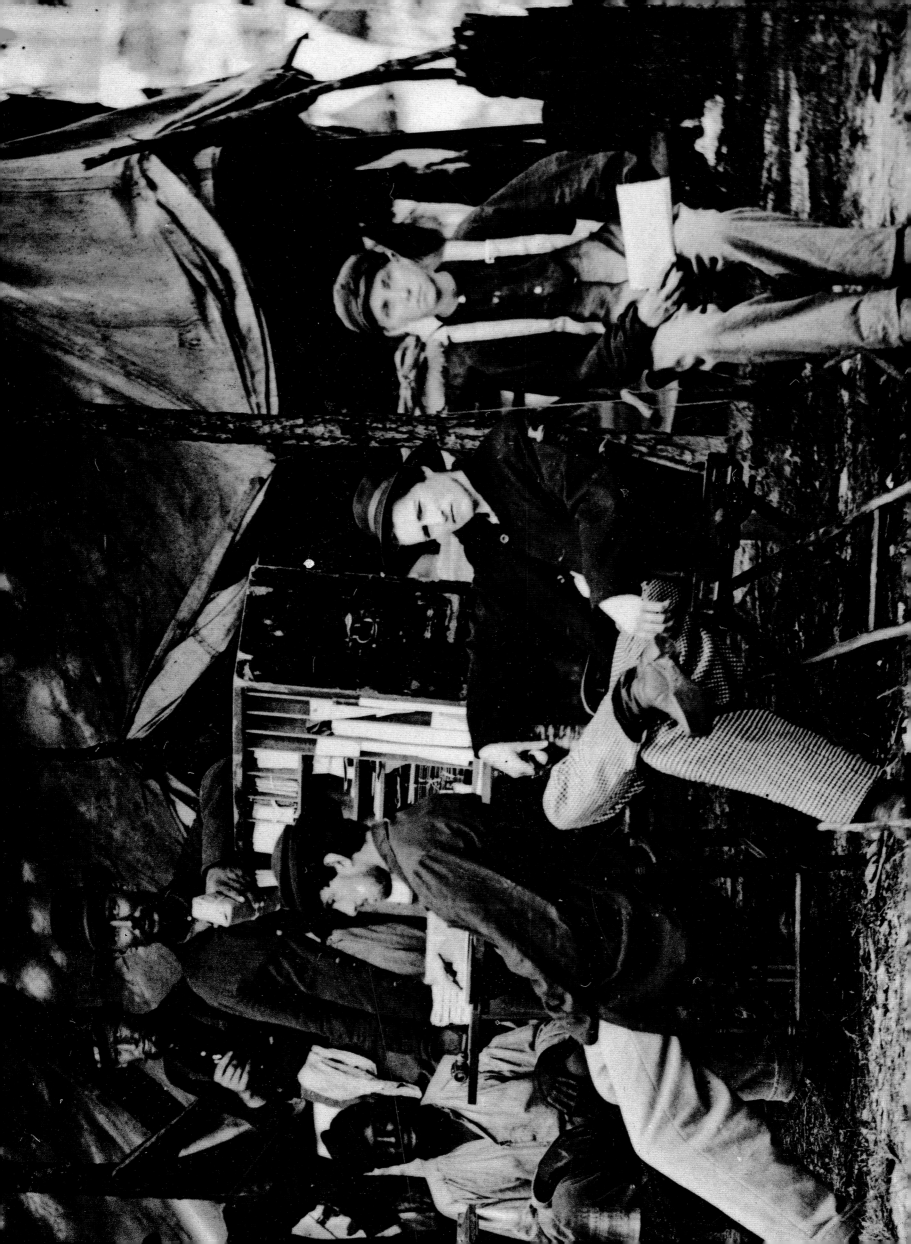

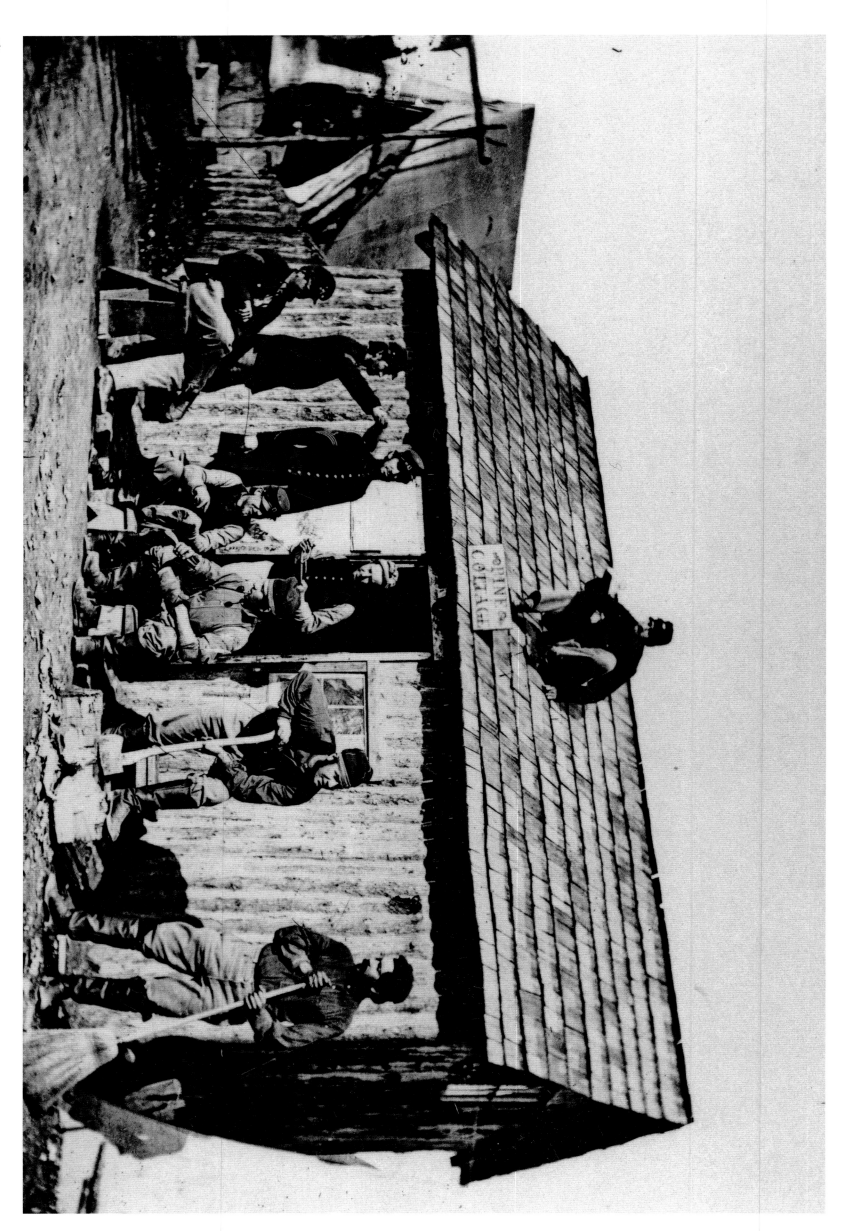

FAR LEFT: "Look natural," said the photographer, so the residents of this winter camp log cabin, given the name "Pine Cottage," hammed it up for the camera at Winter Quarters, Brandy Station, Va., 1864.
(Library of Congress)

LEFT: Lord knows how many layers of grime came off these Yankee soldiers into Virginia's North Anna River, photographed by Timothy O'Sullivan in May 1864.
(Library of Congress)

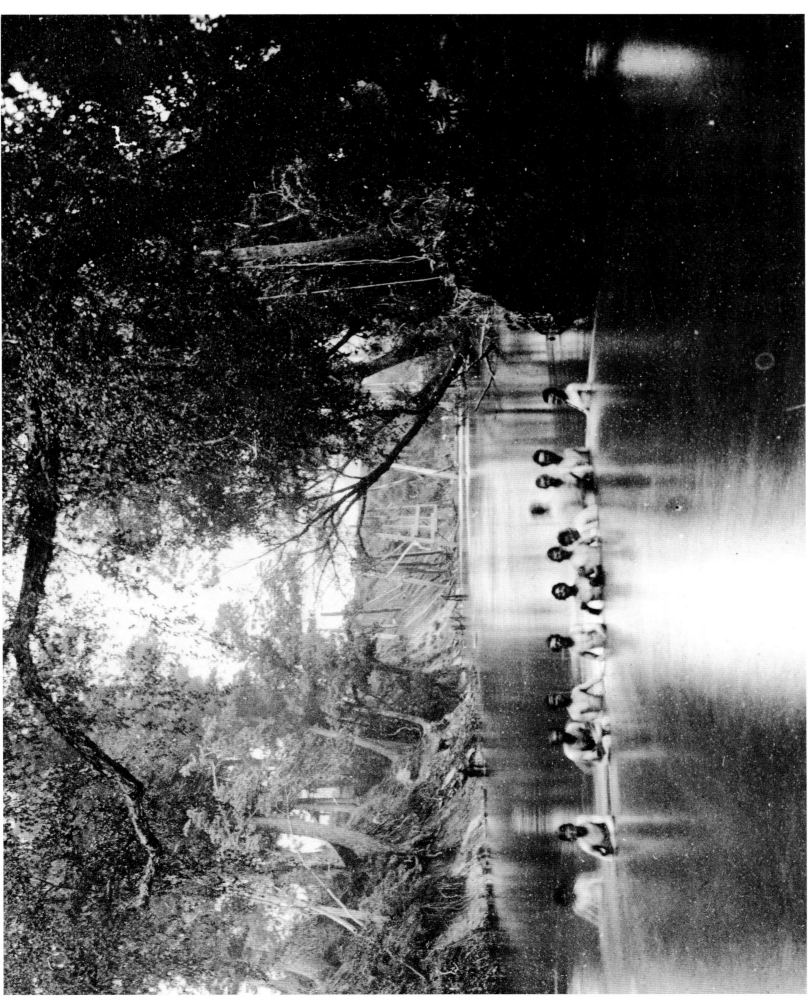

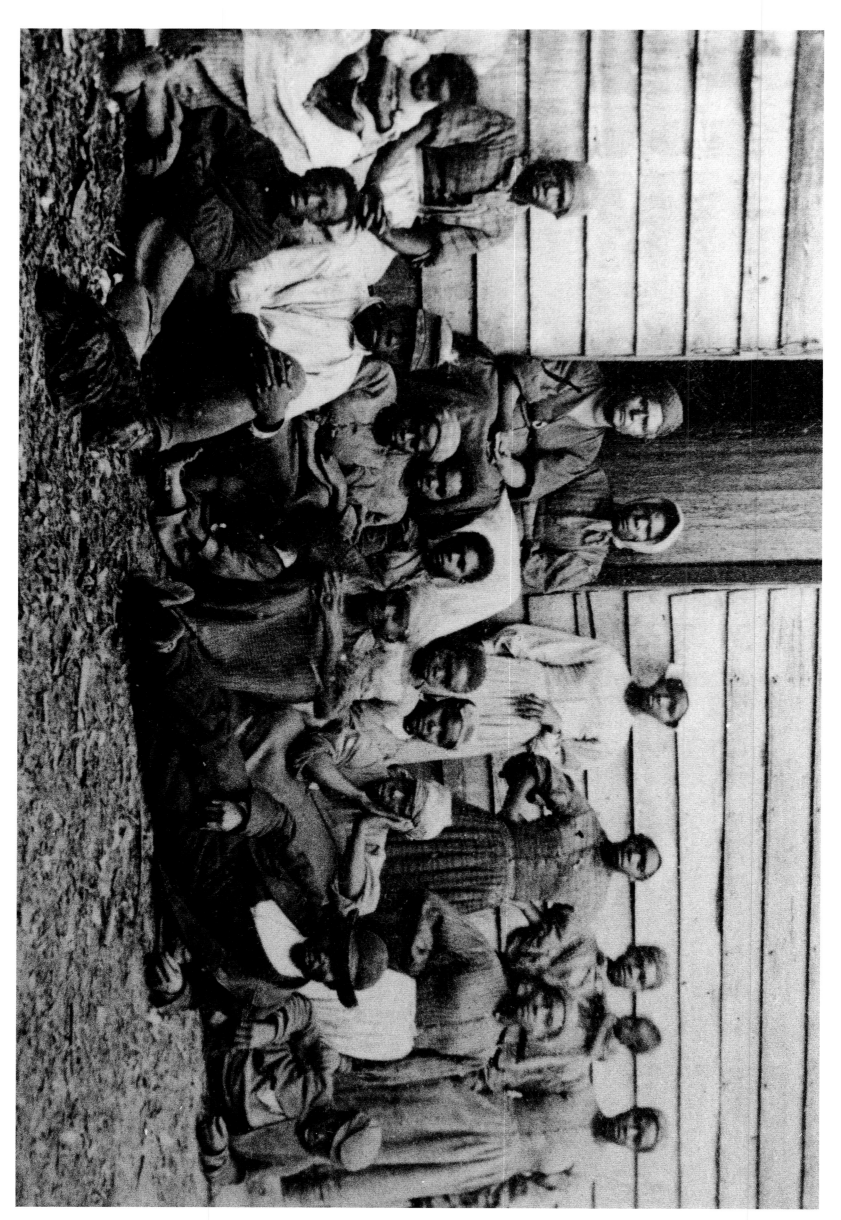

FAR LEFT: Photographer James Gibson photographed these contrabands—former slaves—at Follie's Farm, Va., in 1862. While some of the male contrabands were allowed to fight for the Union, little was done to help women and children, who frequently found life in freedom more difficult than had been life in slavery. *(Library of Congress)*

CENTER LEFT: Female visitors to camp were a fairly rare occurrence and, like this young lady riding side-saddle, would have caused quite a stir. *(Library of Congress)*

LEFT: A signal tower at Cobb's Hill, New Market, Va., ca. 1864. Prior to November 1863 the new U.S. Army Signal Corps used both "wig-wag" flags and telegraphy for communications but, following political disputes in Washington, after that date the Corps was permitted to use only "wig-wags," which meant ever-taller signal towers had to be built. *(Library of Congress)*

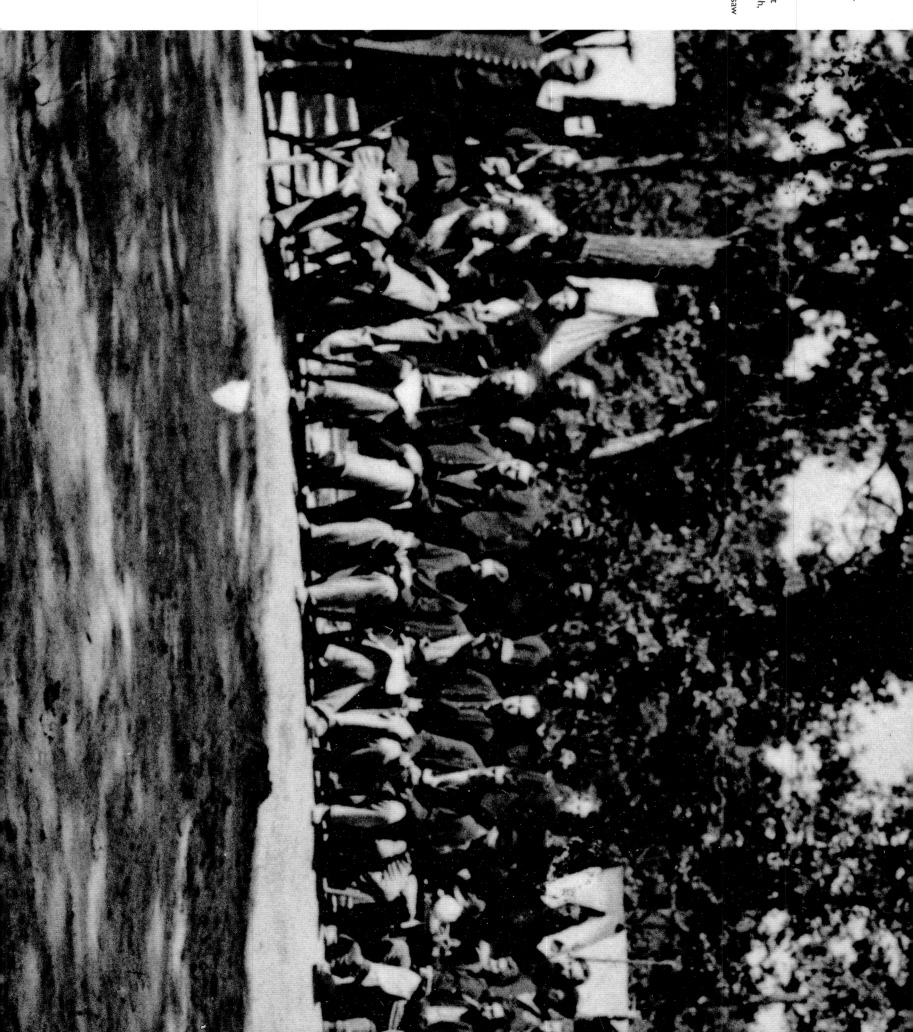

RIGHT: It was probably quite a chore for the photographer to bring together the members of the 9th Indiana Volunteer Infantry for the camera. Striking a very informal pose, they are clearly off-duty, judging by the wide variety of their apparel. The 9th performed well when it came to battles, including those at Shiloh, Stones River, Chickamauga, Lookout Mountain, Missionary Ridge, and Kennesaw Mountain.
(Library of Congress)

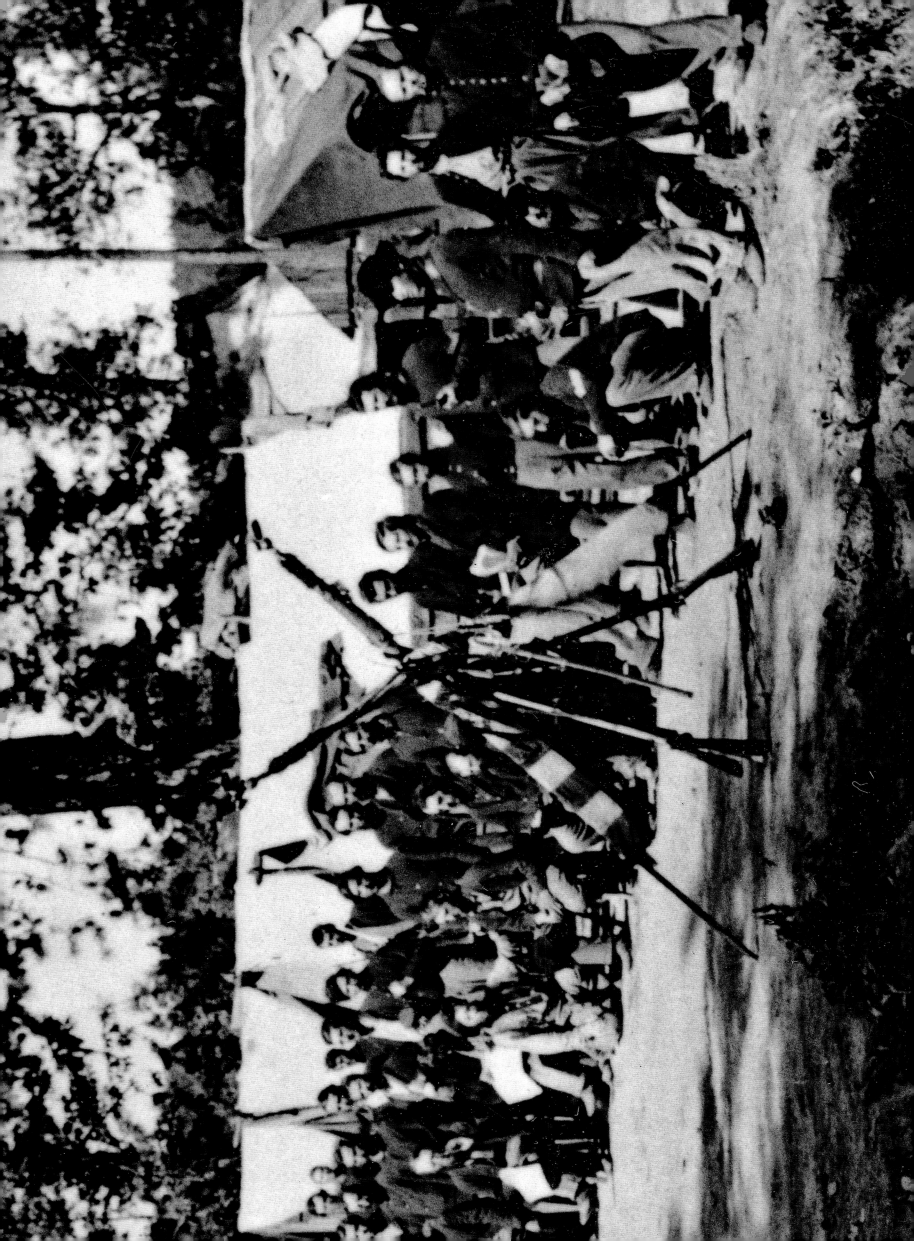

FAR LEFT: At an unidentified Union camp, the photographer called together some officers and their female guests for a "photo opportunity," bringing in a young boy as a "color-bearer" to add interest. *(Library of Congress)*

LEFT: Colonel James P. McMahon of the 14th New York ponders his next move in a game of chess (for the camera at least), while his wife stands behind him, and his son sits, absorbed in the work of the photographer. *(Library of Congress)*

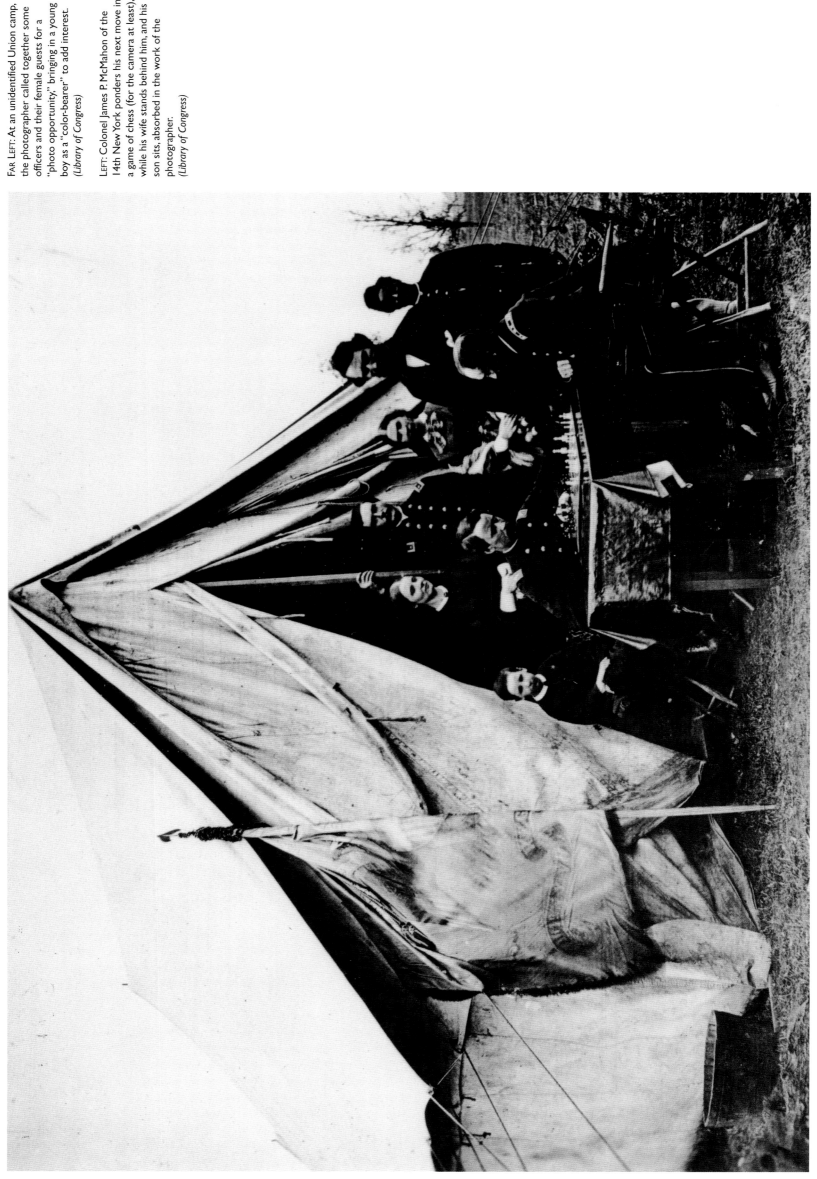

RIGHT: A crossbeam structure that resembled a long garden arbor or pergola, the Chain Bridge over Potomac River, near Washington, D.C., was a convenient crossing for Federal forces to access outlying encampments from Fairfax County. The Chesapeake & Ohio Canal is in the foreground.
(Library of Congress)

FAR RIGHT: A view of the Aqueduct Bridge and Georgetown from the Virginia bank. The bridge was designed thirty years before the Civil War by Major William Turnbull to carry canal boats across the Potomac River and downriver on the Virginia side without unloading in Georgetown. Construction of it and the Alexandria Canal took ten years to complete, in 1843. The war interrupted plans to make an upper level for a railroad crossing above the lower canal level, and instead the canal was drained to make a roadway for military troops.
(Library of Congress)

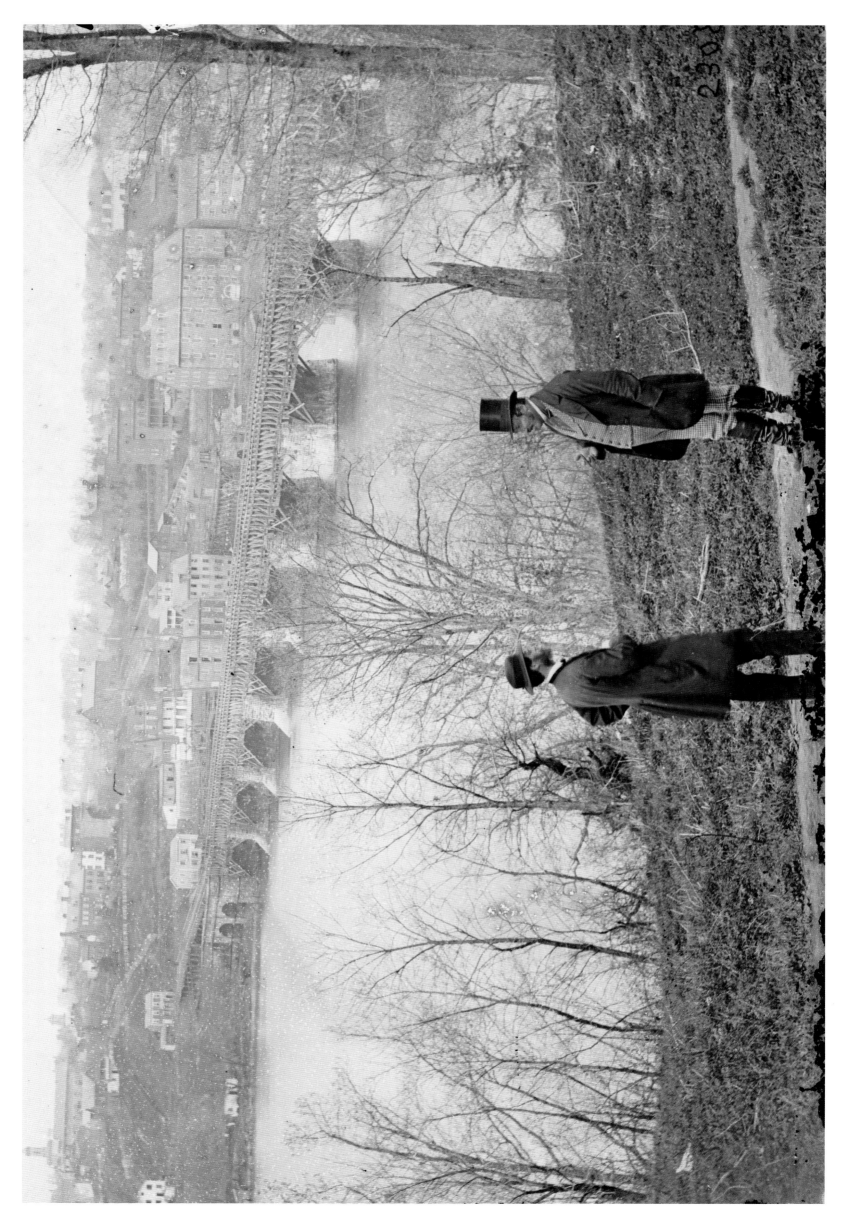

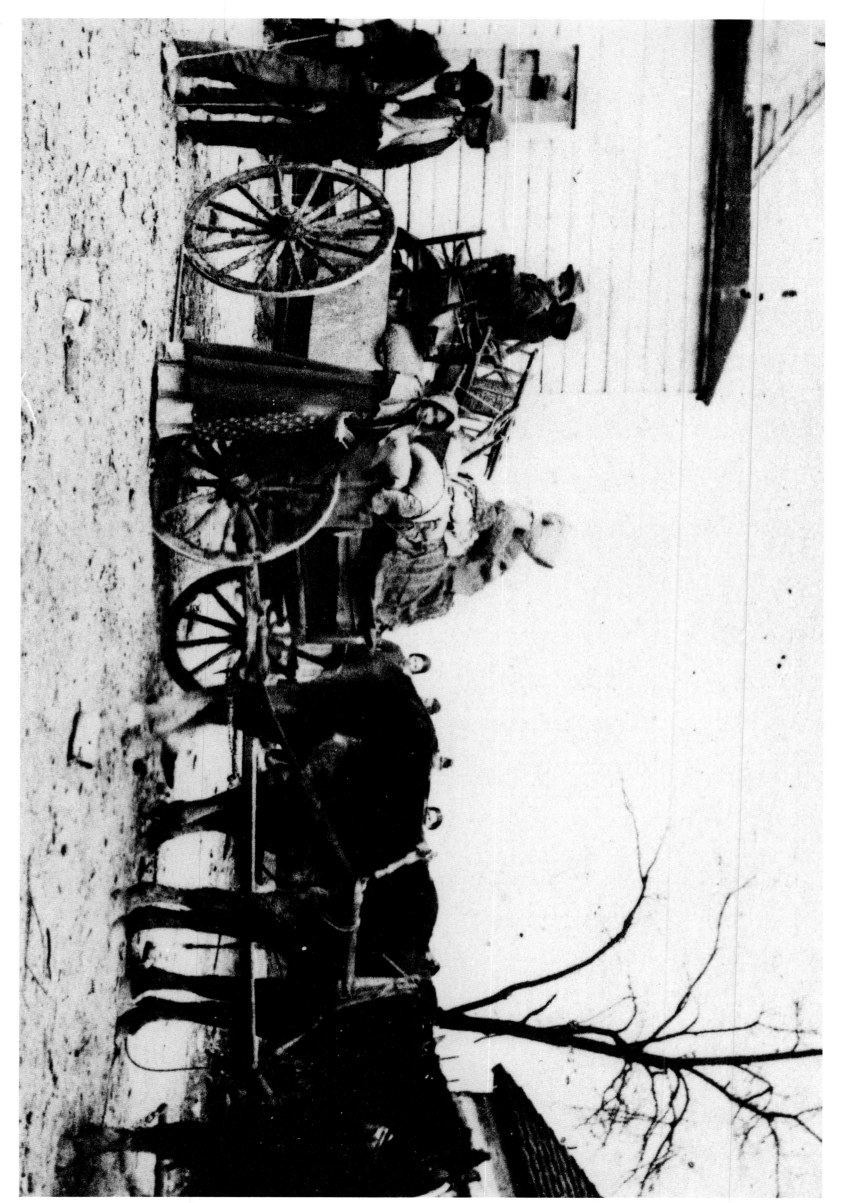

FAR LEFT: Whenever a region was overcome by the enemy, residents could expect just a few hours to pack up their worldly goods and get out. Here, in 1861, as happened frequently, a farming family leave their homestead to become refugees, as many Southern towns and cities were depopulated by Federal commanders.
(Library of Congress)

LEFT: Near the ducts used to circulate air below decks, the ship's officers and crew attend a religious service aboard the single-turret monitor USS *Passaic* off Charleston, S.C., in 1864.
(National Archives)

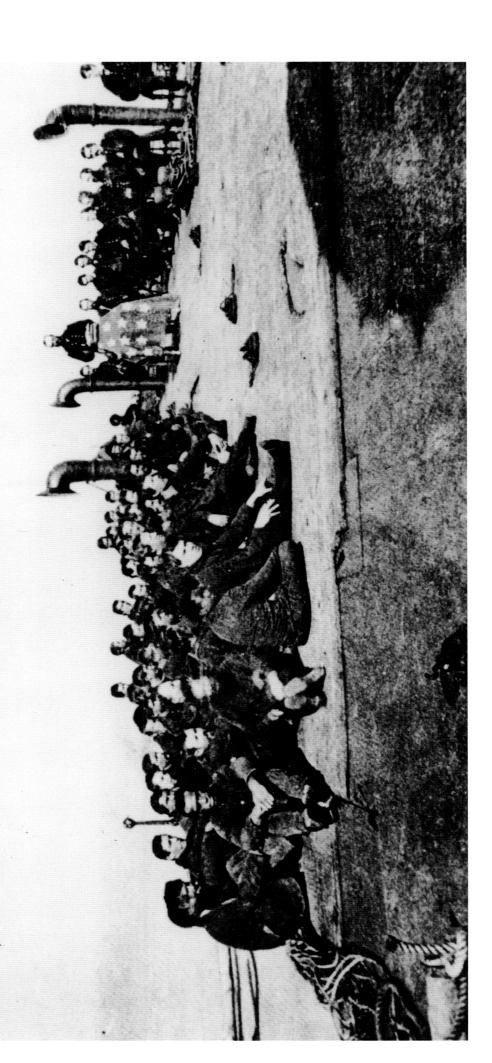

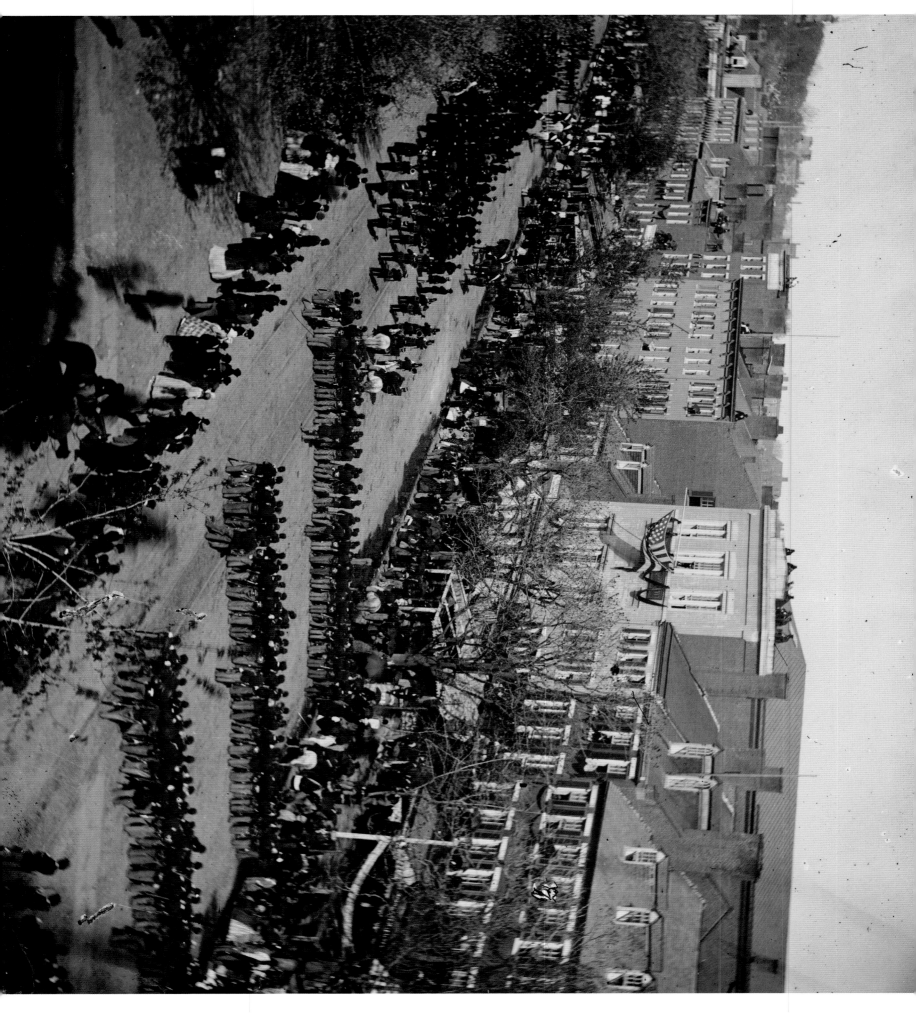

RIGHT: Mathew Brady, regarded as a friend by President Abraham Lincoln, made this photograph of the president's funeral procession as it moved along Pennsylvania Avenue, Washington, D.C., April 1865.
(Brady-Handy Collection, Library of Congress)

FAR RIGHT: Old Ford's Theater, 10th Street N.W., Washington, D.C., where President Lincoln was shot dead by actor and Confederate sympathizer John Wilkes Booth on April 14, 1865, just five days after the Confederacy's surrender.
(Brady-Handy Collection, Library of Congress)

RIGHT: Brady or one of his associates photographed this group of black "contrabands," former slaves, standing outside a shanty toward the end of the Civil War. The image is a print from a stereograph negative; the original is a glass plate.
(Library of Congress)

RIGHT: In May 1865, a few days after the Confederate surrender at Appomattox, infantrymen proudly march down Pennsylvania Avenue during the Grand Review of the Army in Washington.
(Library of Congress)

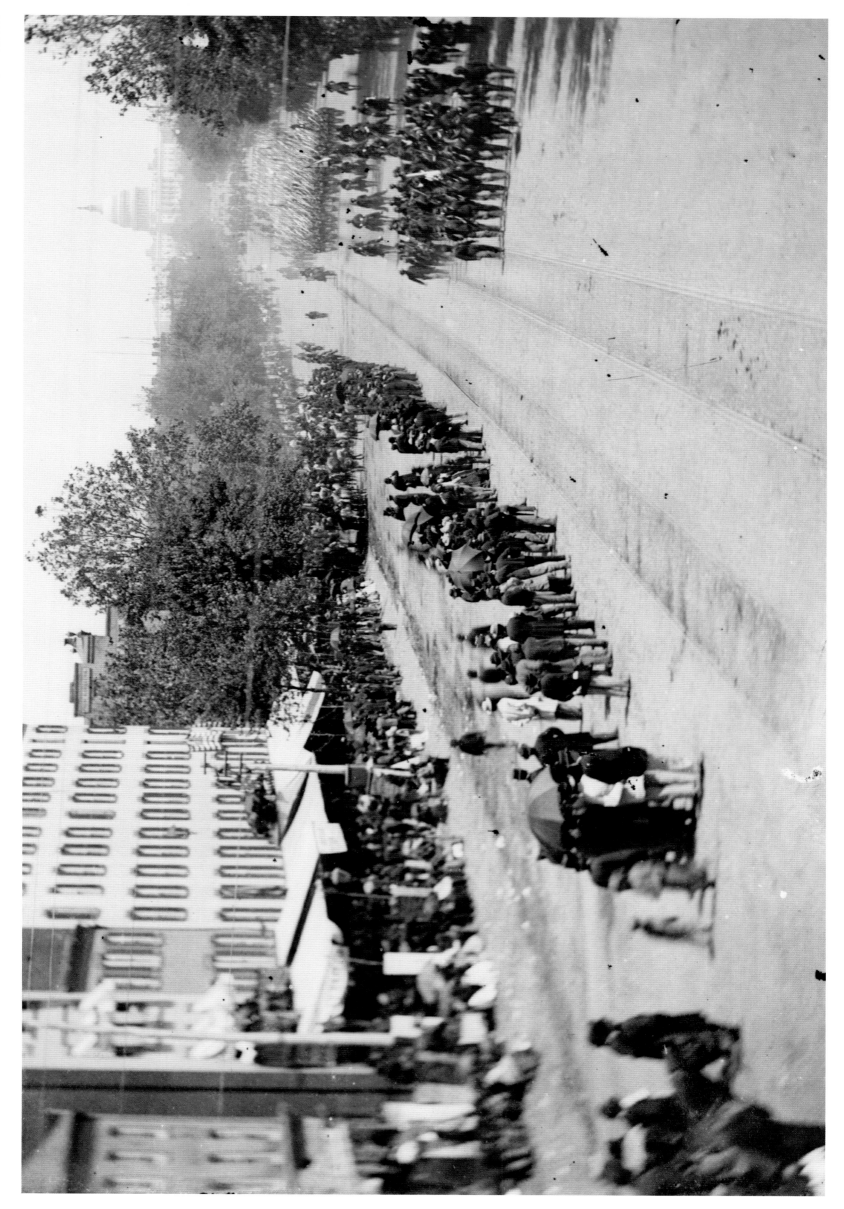

FAR LEFT: One of Brady's photographic teams attempts to find shade for the darkroom wagon at Manassas, Va., July 4, 1862. It is likely that this photograph was made by Timothy H. O'Sullivan.
(Library of Congress)

LEFT: To ease the boredom of camp life, these Union soldiers create havoc as they play it for laughs in front of the camera at the Army of the Potomac's headquarters, Falmouth, Va., April 1863.
(Library of Congress)

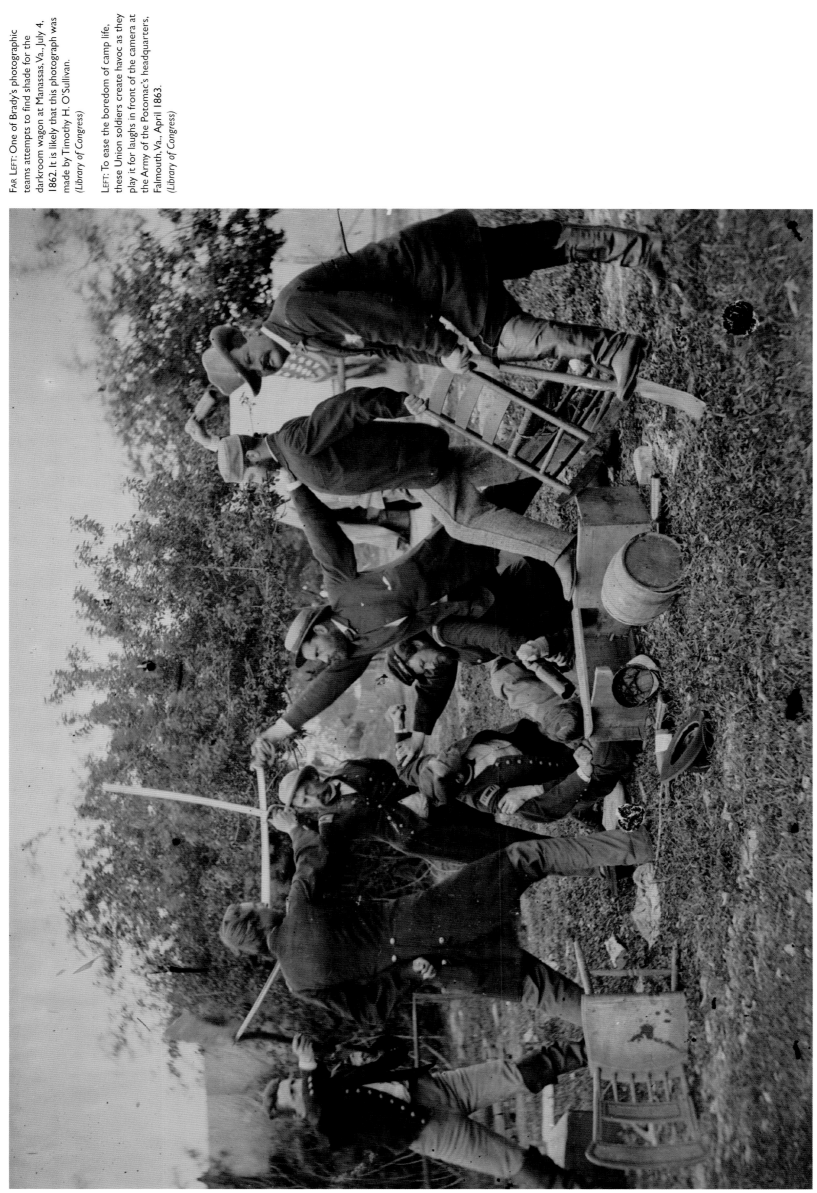

RIGHT: Getting in line at the tent of sutler A. Foulke, who is preparing to satisfy the needs of members of the 1st Brigade, Horse Artillery, at Brandy Station, Virginia, February 1864.
(Library of Congress)

FAR RIGHT: William R. Pywell (1843–1886) was one of many photographers employed by Mathew Brady during the Civil War period. This is Pywell's photo of a group of Federal Signal Corps officers in camp near Georgetown, Washington, D.C., in August 1865.
(Library of Congress)

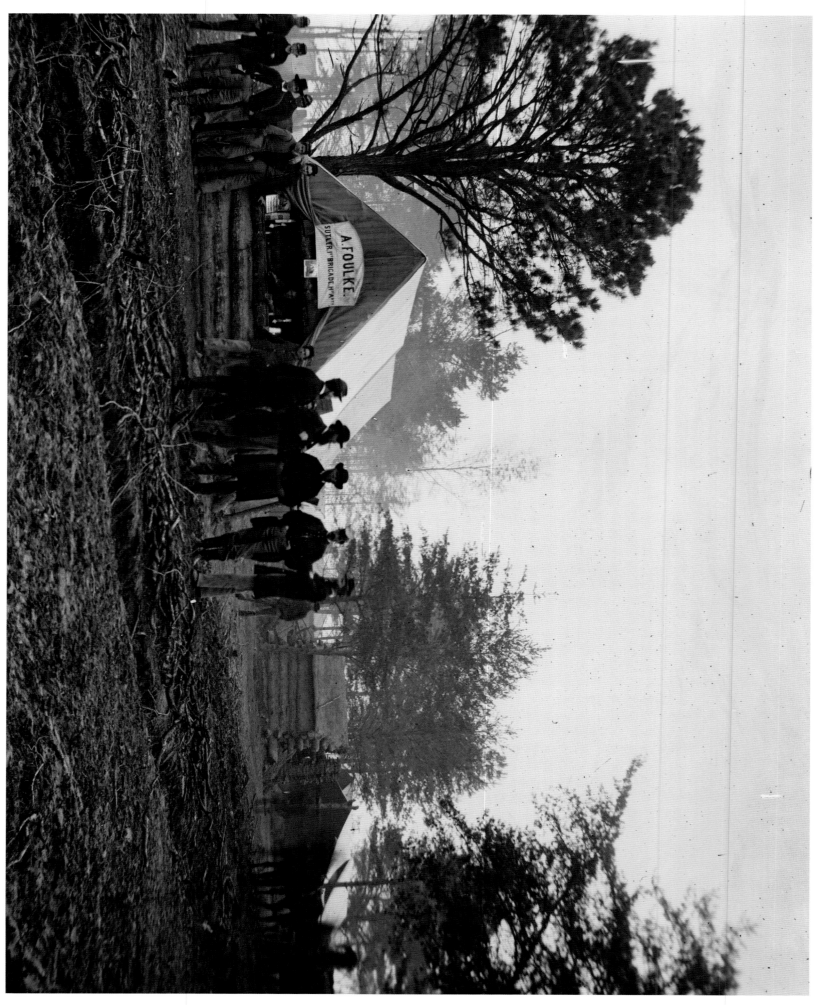

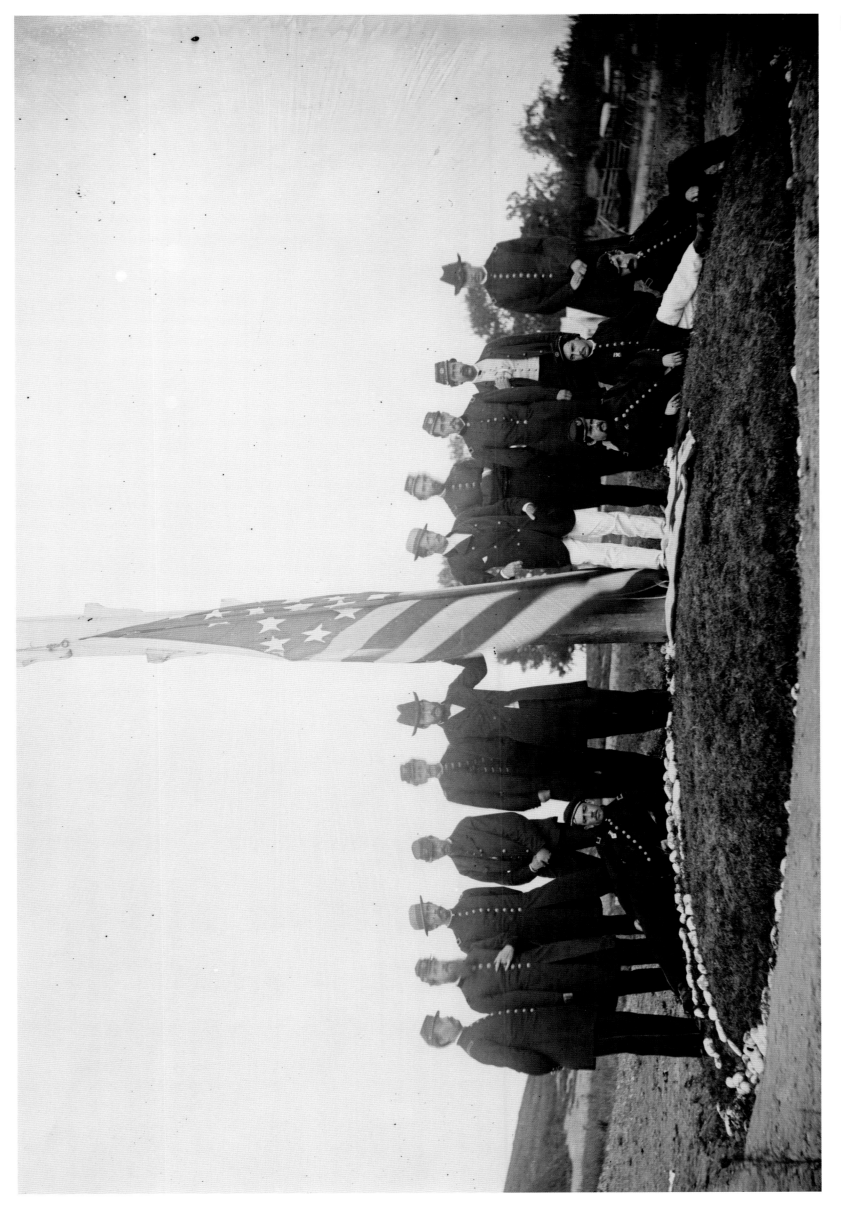

182

RIGHT: Union Secret Service men (and a "contraband") meet at Fuller's House, Cumberland Landing, Virginia, May 1862, photographed by James F. Gibson. The Secret Service was the first domestic intelligence and counterintelligence agency.
(Library of Congress)

FAR RIGHT: Scottish-born Allan Pinkerton (August 25, 1819–July 1, 1884) photographed on the Antietam battlefield by Brady associate Alexander Gardner in September 1862. During the Civil War Pinkerton served as head of the Union Intelligence Service. He and his agents often worked under cover as Confederate soldiers and sympathizers, Pinkerton using the alias "Major E. J. Allen."
(Library of Congress)

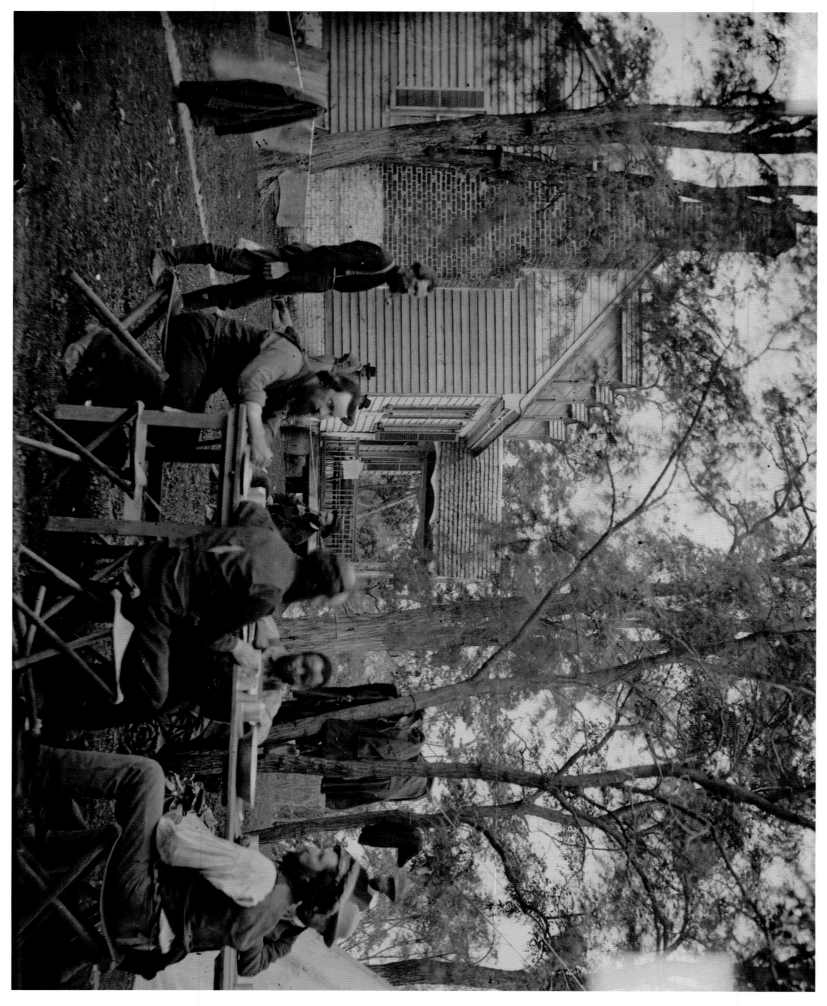

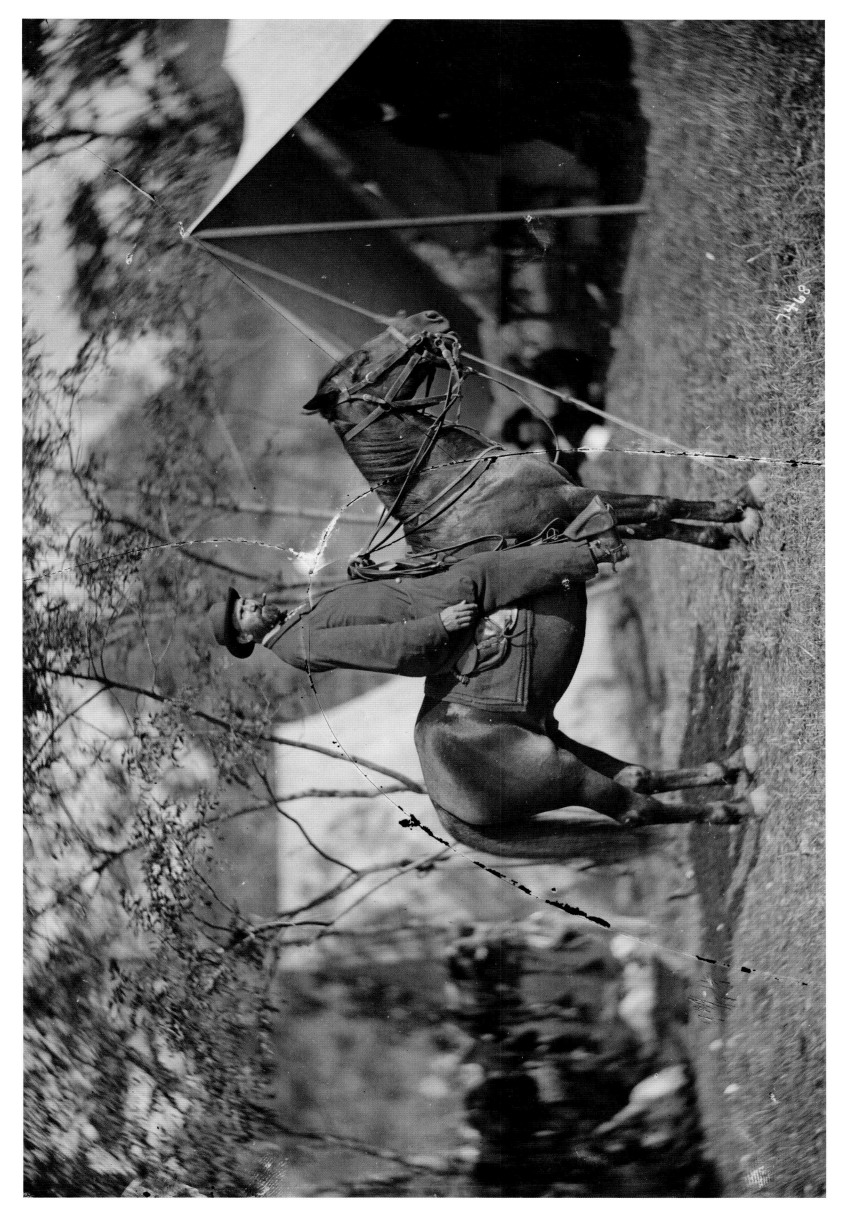

RIGHT: Watched by civilian onlookers, a soldier takes time out to relax with a brew and a game of cards outside a photographic tent, in the vicinity of Yorktown, Virginia, during the Peninsular Campaign. The photograph was made by Brady photographer James F. Gibson in May 1862; it is possible he was one of the group.
(Library of Congress)

RIGHT: Keeping the lines of communication was vital to North and South during the war. Here men are repairing a single-track railroad in the vicinity of Murfreesboro, Tennessee, after the Battle of Stones River (December 31, 1862–January 2, 1863).
(Library of Congress)

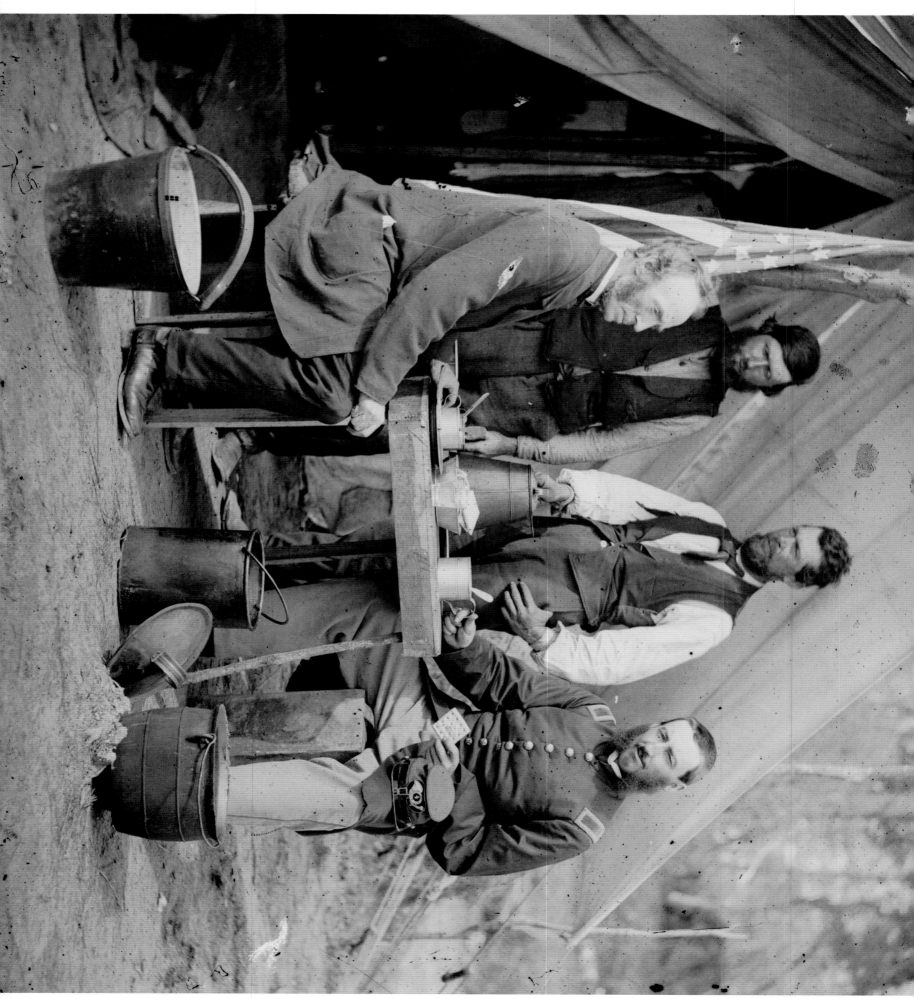

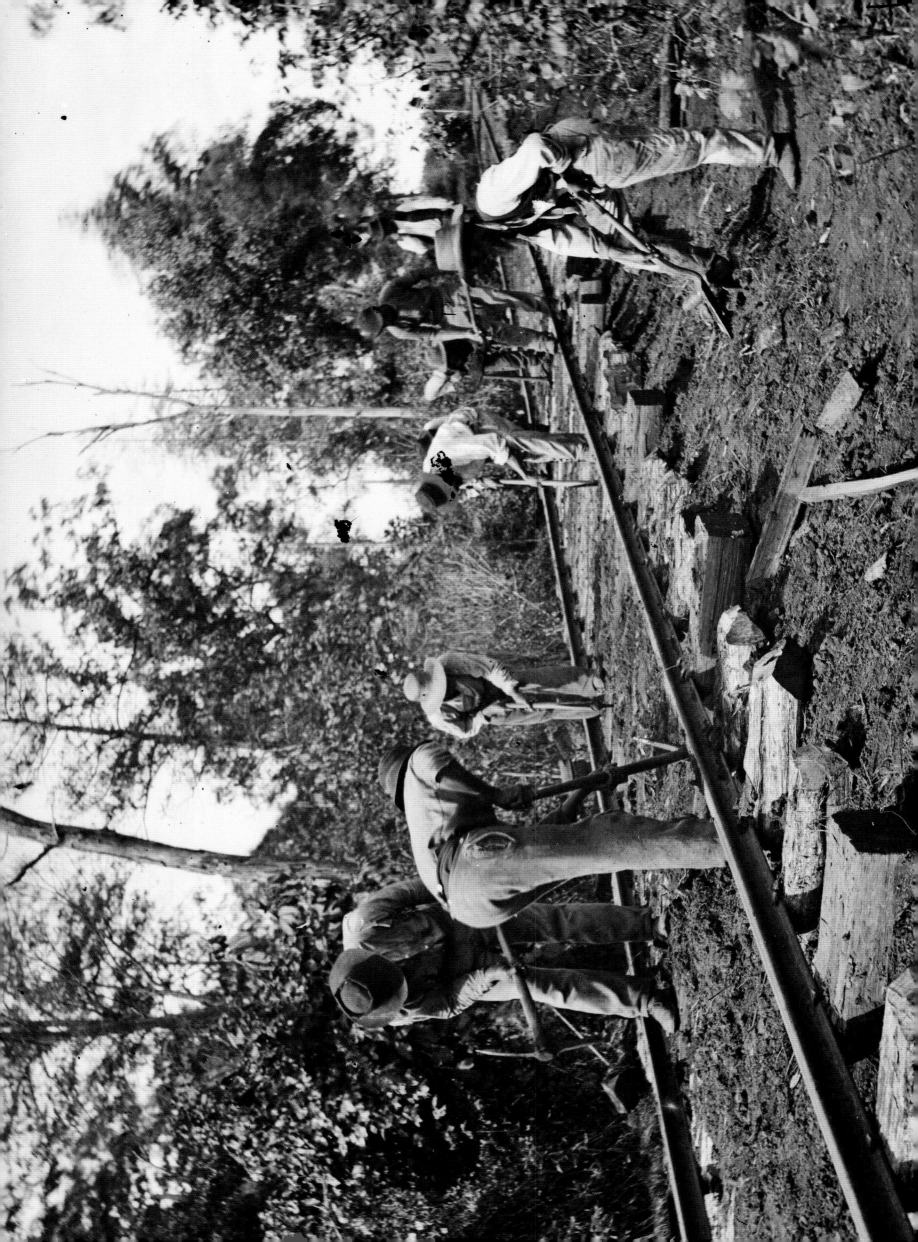

WAR ON WATER

The vast majority of the Civil War was fought on land. And, as a semi-official part of the military, Brady's camera crews spent most of their time photographing land-based movements and operations. However, Brady and his associates also made a number of notable images of the water-based aspects of the war.

By far the single most memorable image from an artistic standpoint is that of the "powder monkey," a young boy (perhaps eleven or so) leaning against a cannon on the deck of the USS *New Hampshire*, off the coast of Charleston, S.C., in 1864. Powder monkeys were invariably young boys whose very dangerous duty was to bring gunpowder from the ship's magazine to the men operating the guns. Even a stray spark could end their lives.

Brady and his teams also were able to board the original *Monitor*, called a "cheese box on a raft" by the Confederates. Brady noted in his lecture book that the sailors aboard "can always congratulate themselves that they took part in the famous fight which revolutionized the navies of the world."

Much of Brady's naval photographic activity took place along the James River, Virginia, from late 1863 on, and the variety of vessels that he and his teams captured on camera is nothing short of amazing. Evidence suggests he was present during many of these shoots. Some of the vessels were civilian ships pressed into action and fitted with guns. Some were built during the Civil War as gunboats, monitors, and other types. A few were ungainly and seemed unlikely floating—much less fighting—and there were a few that looked impressive, but didn't perform well.

Some of the photos show officers and crews on deck—with or without big guns—and engaged in numerous activities ranging from attending religious services to playing instruments and reading newspapers. Some photos even show evidence of the battles these ships and sailors endured.

RIGHT: Sailors, including some blacks, have crammed onto the deck of a Union gunboat, so as to be included in the photograph. Anything to relieve the boredom of constant patrolling along a river, probably the James, Virginia. *(Library of Congress)*

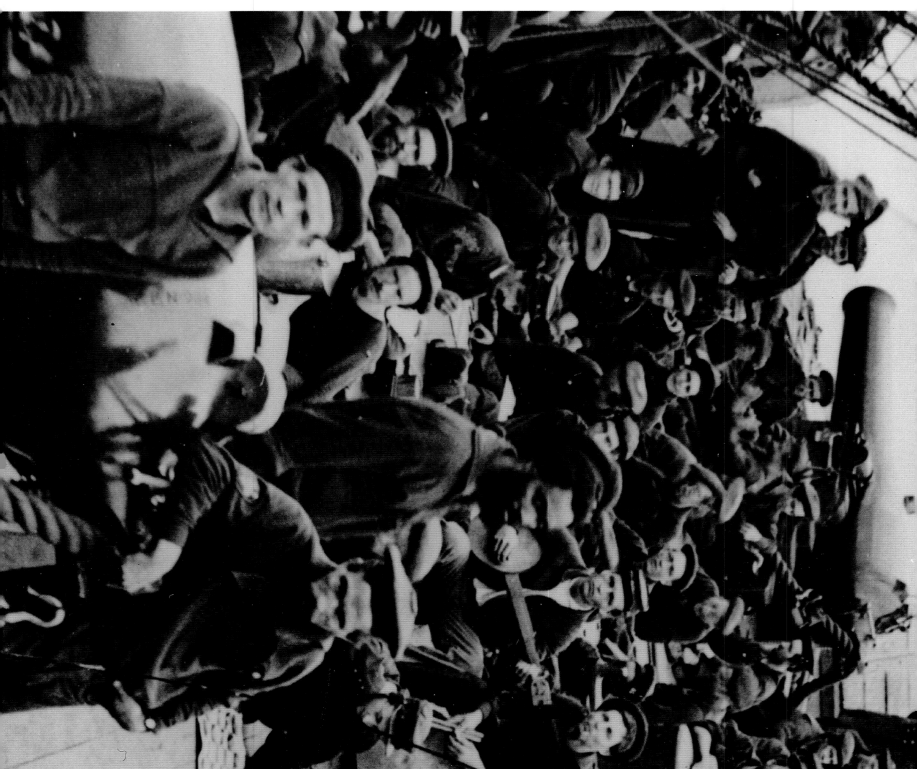

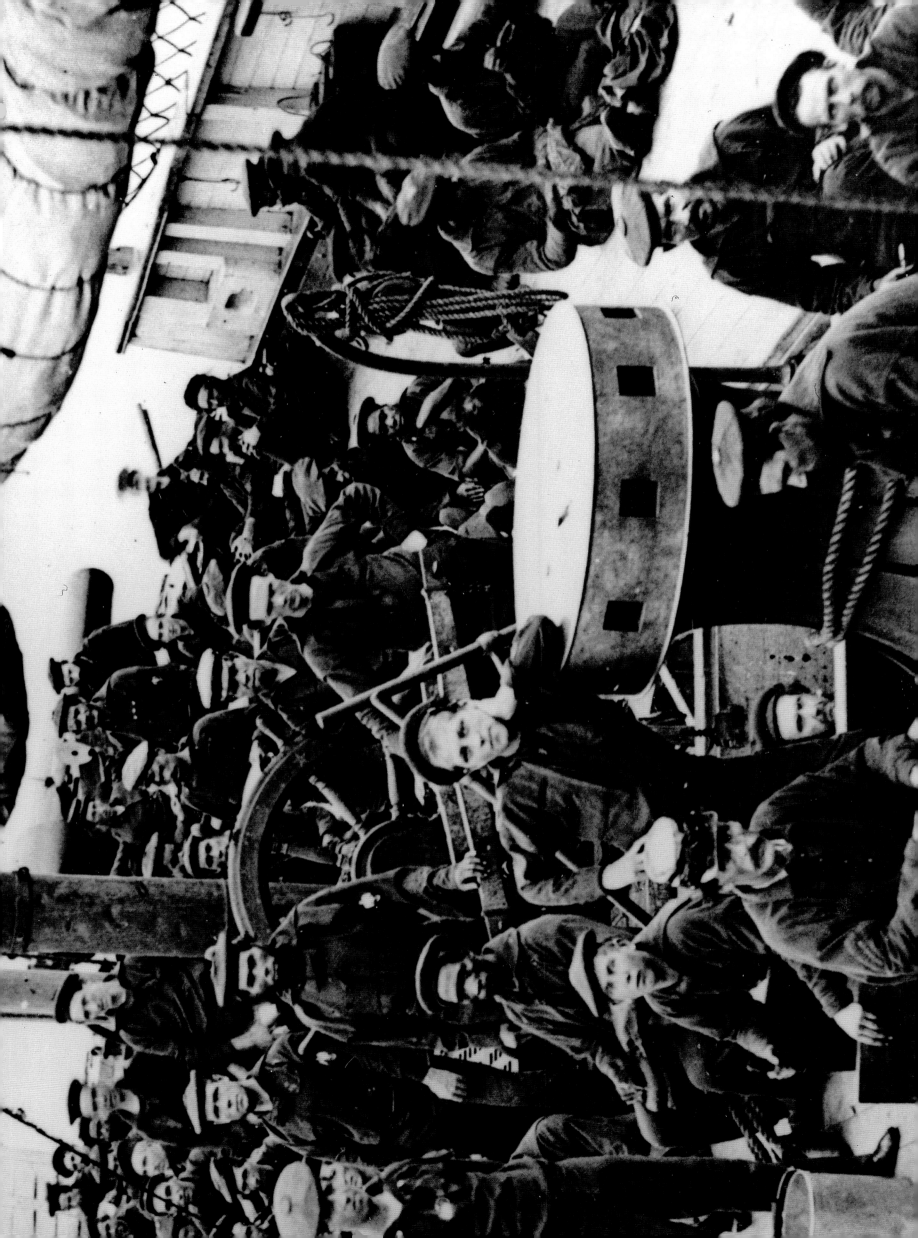

RIGHT: The deck of the USS Merrimac, which was originally rigged as a wooden frigate. It was raised from the river and converted into the ironclad CSS Virginia. (Library of Congress)

LEFT: USS *Kansas*, commissioned in December 1863, was the first of a class of 836-ton screw steam gunboats, photographed on the James River, ca. 1864. The *Kansas* took part in the abortive attempt to capture Fort Fisher in late December 1854, and also the successful effort the following month. *(Library of Congress)*

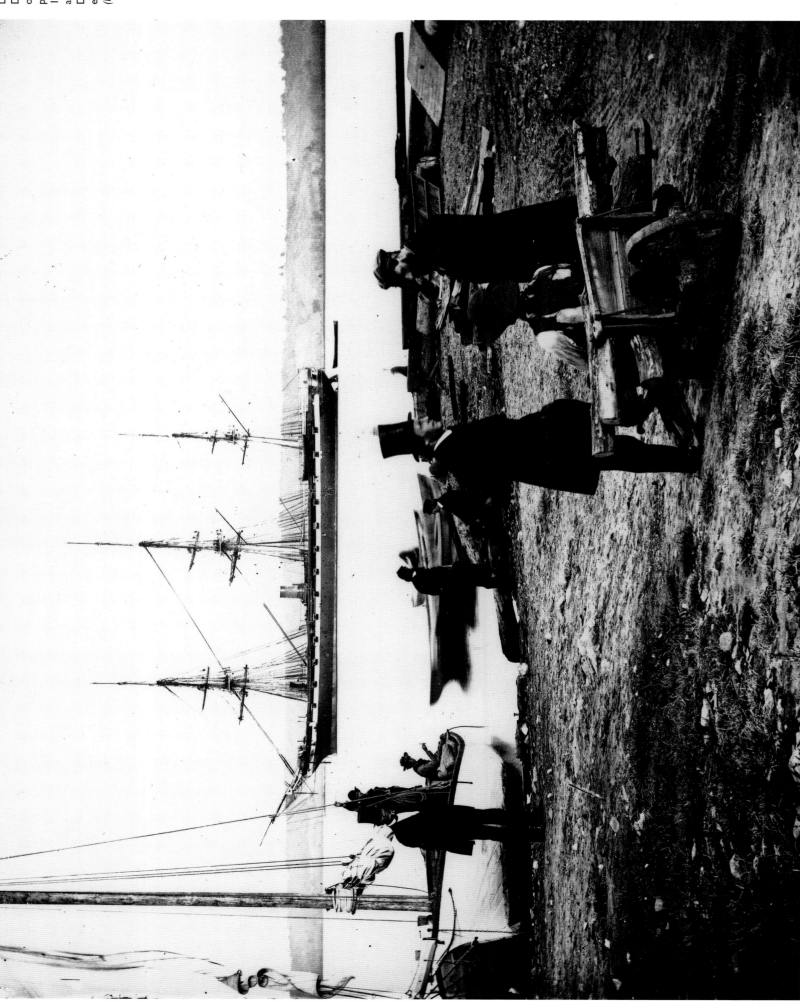

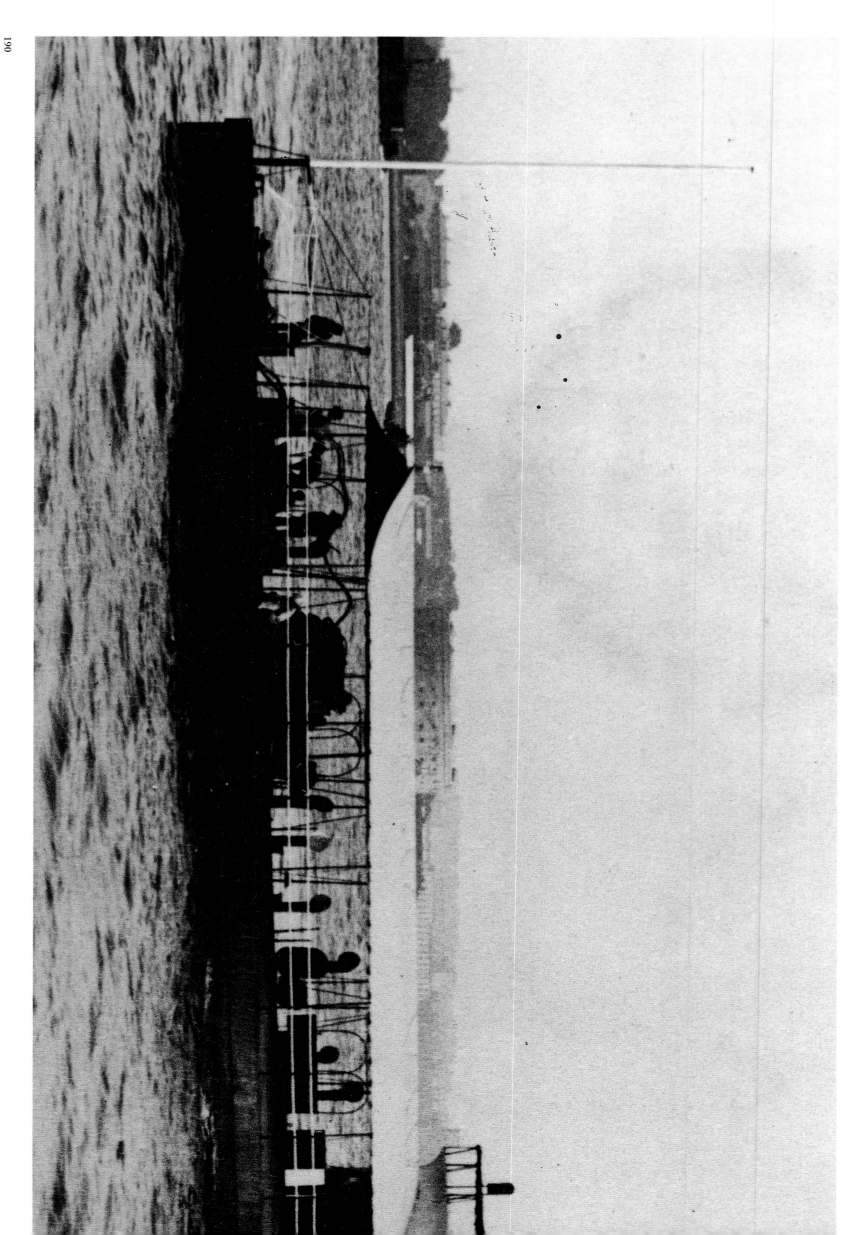

Left: Passaic-class coastal monitor vessel, the USS *Nantucket*, was commissioned on February 26, 1863, and served with the South Atlantic Blockading Squadron off Georgia and South Carolina. (*U.S. Navy*)

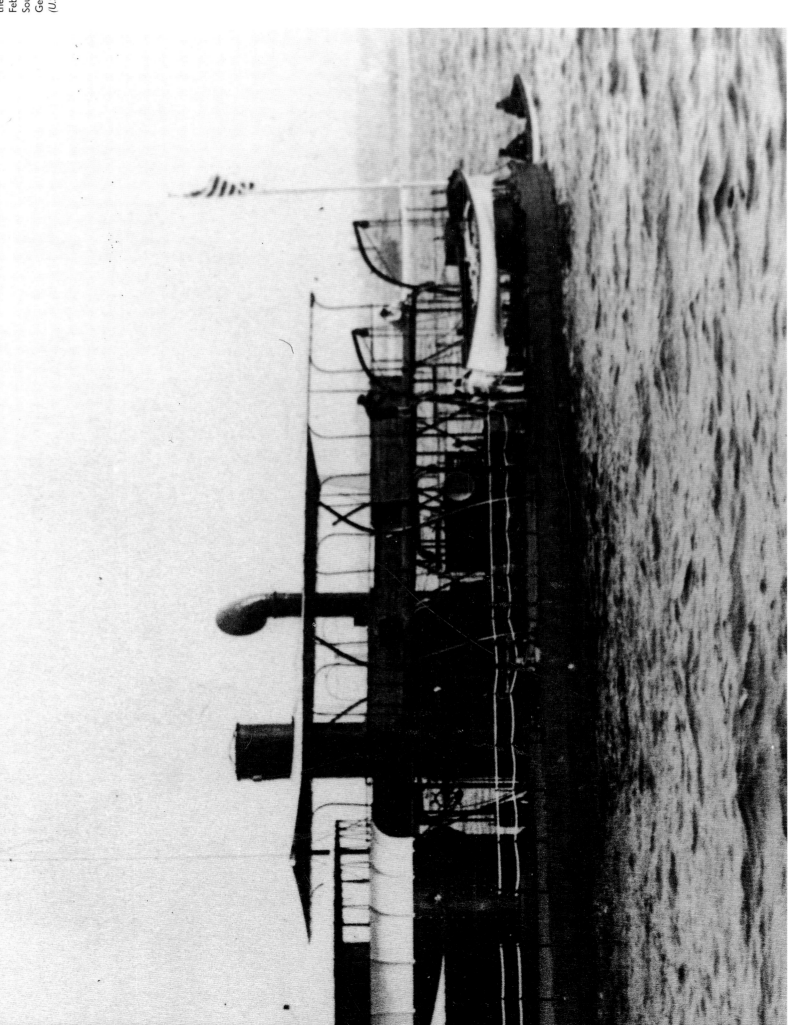

MATHEW B. BRADY

RIGHT: The 1,335-ton Passaic-class monitor vessel USS *Lehigh*, photographed spring 1863. She took part in an expedition up the James River in July that was intended to threaten the defenses of Richmond, and thus divert Confederate resources in the wake of the Battle of Gettysburg.
(*U.S. Naval Historical Center*)

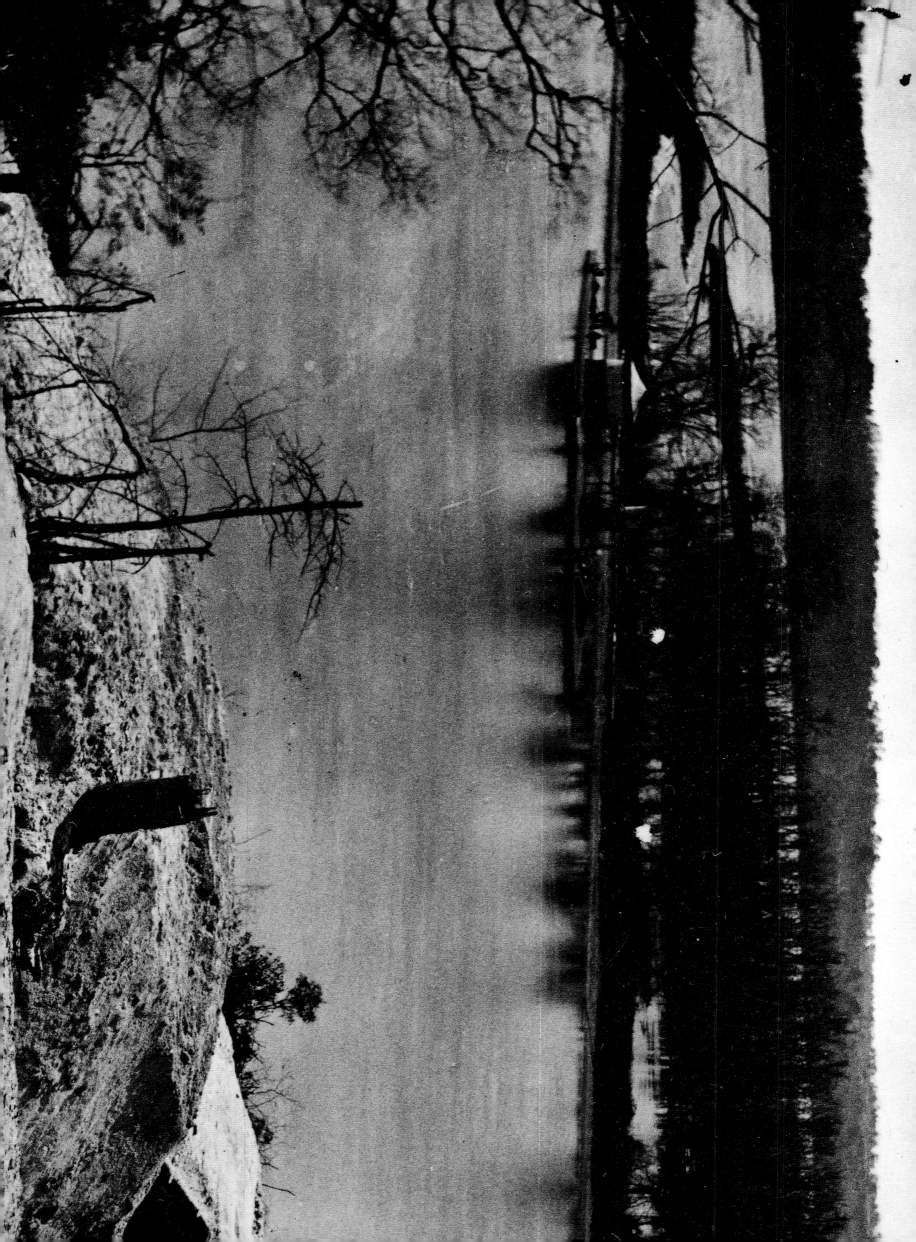

LEFT: The USS *Sangamon*, a Passaic-class monitor boat commissioned in February 1863, served mainly on the James River, where she is shown steaming past Crow's Nest Battery, following the monitor USS *Saugus*.
(U.S. Army Military History Institute)

MATHEW B. BRADY

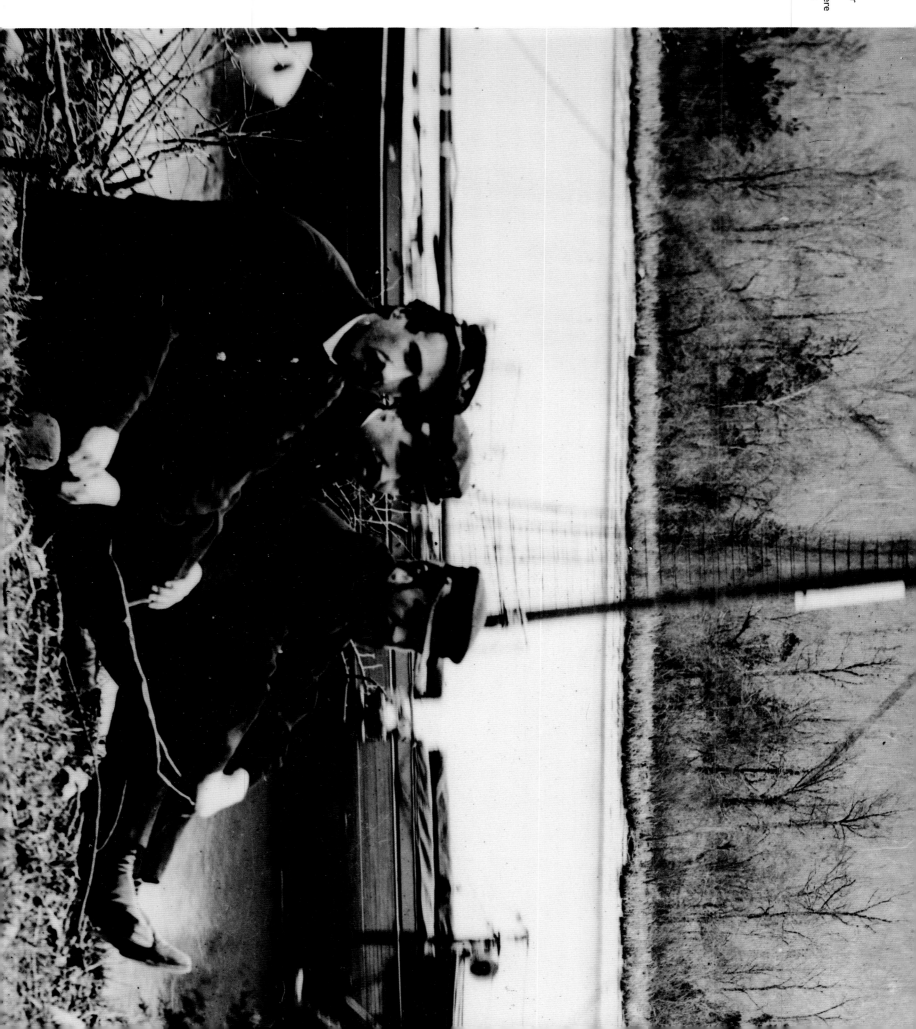

USS Kansas, commissioned in December 1863, was the first of a class of 836-ton screw steam gunboats, photographed here on the James River, ca. 1865. The Kansas took part in the abortive attempt to capture Fort Fisher in late December 1854, and also the successful effort the following month.
(Library of Congress)

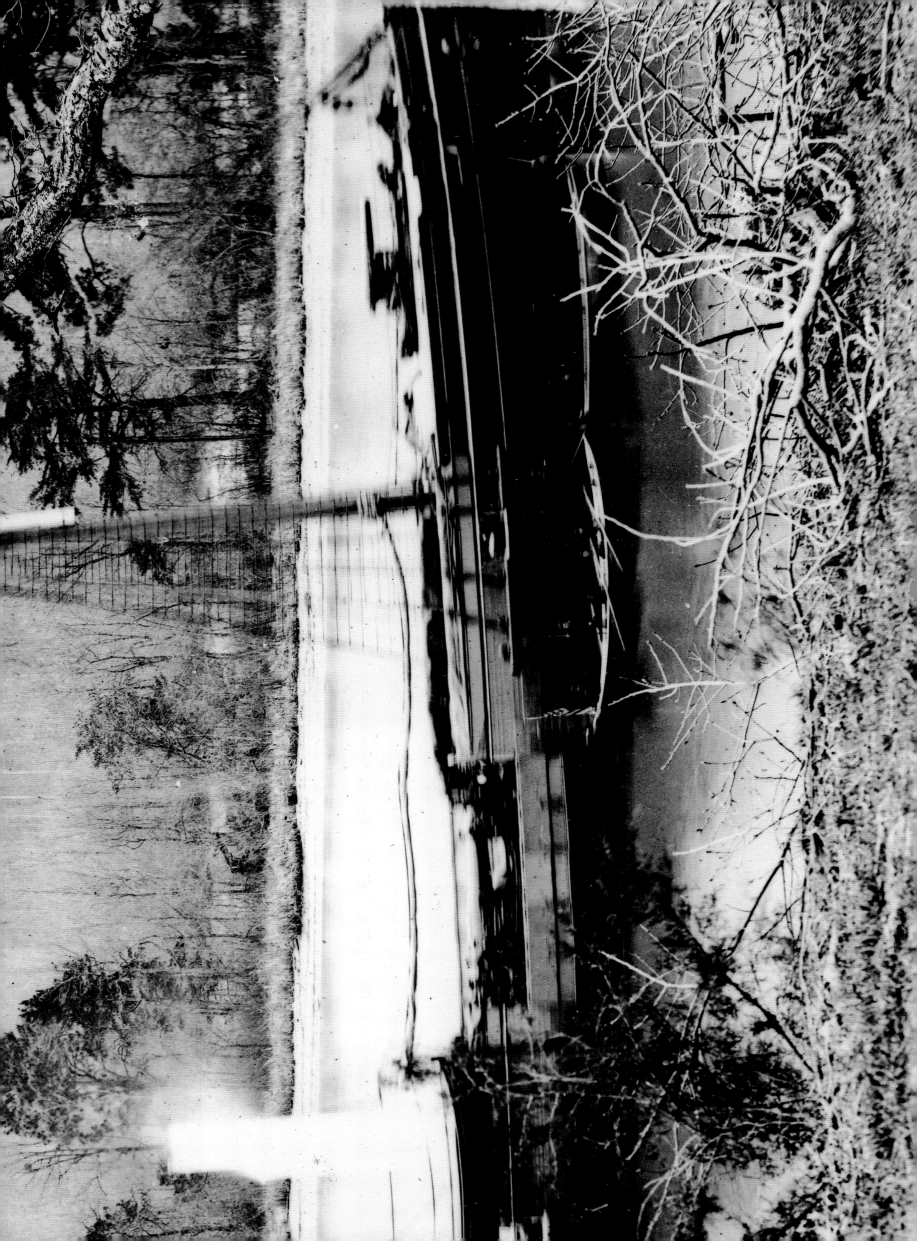

RIGHT: During the Civil War, USS *Mahopac*, a 2,100-ton *Canonicus*-class monitor, served mainly along the James River, although in January 1865 she joined a large Federal fleet and land force that overwhelmed the powerful Confederate fortification Fort Fisher, North Carolina. (*U.S. Army Military History Institute*)

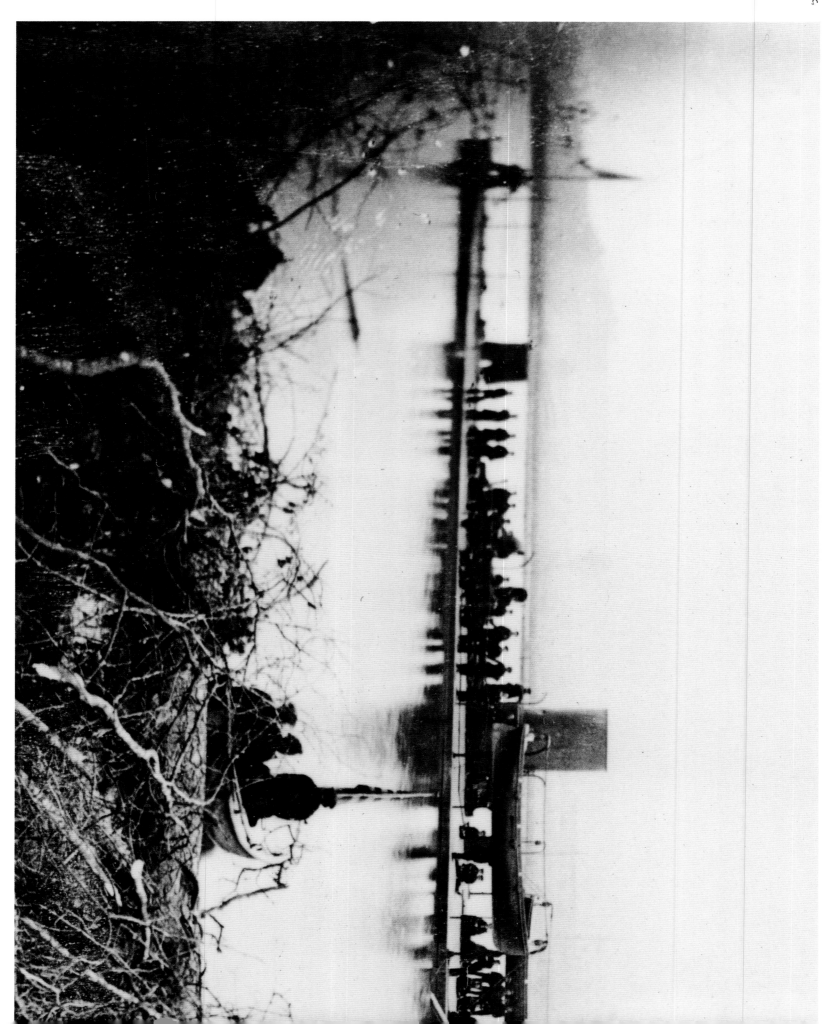

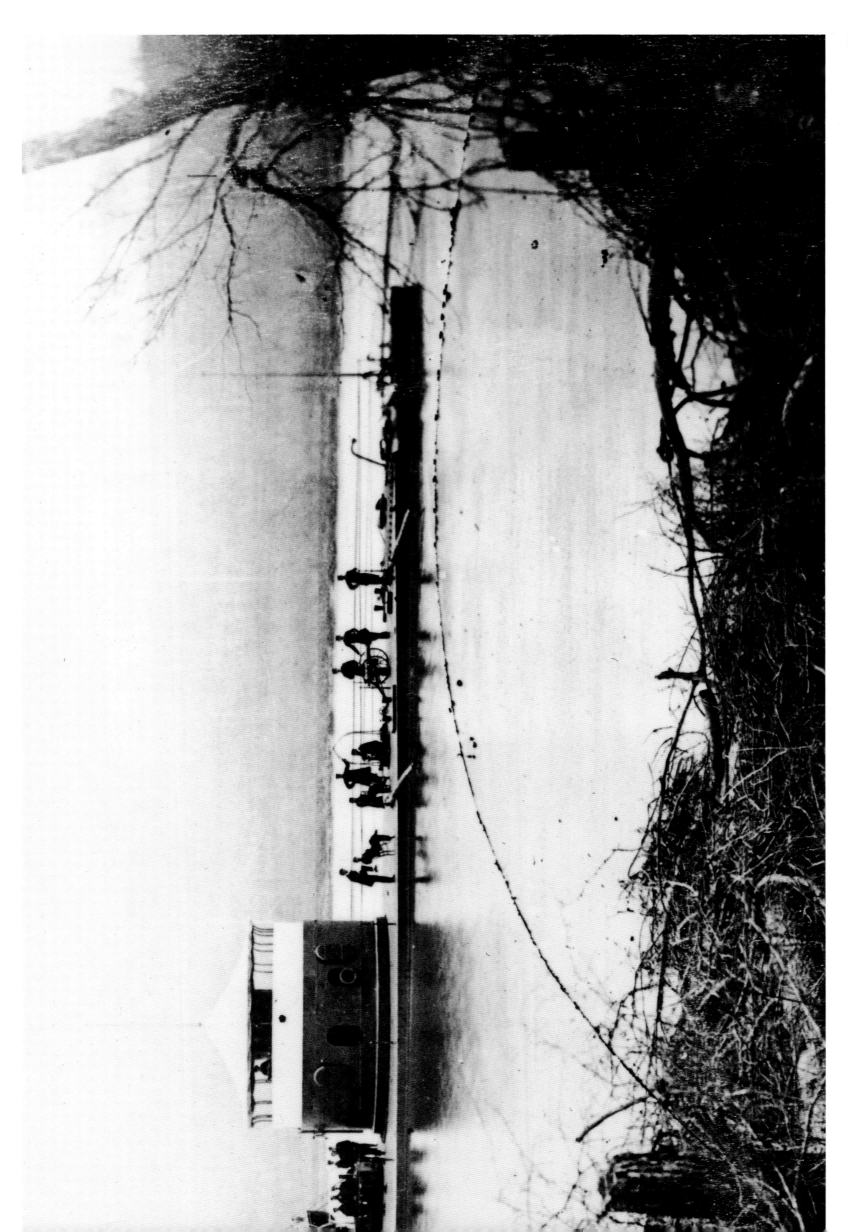

LEFT: The USS *Onandaga*, photographed on the James River, was one of a few monitors that had two turrets. While increasing firepower, the added length and weight degraded speed and maneuverability.
(Library of Congress)

RIGHT: Crew of the USS Monitor (the
Union's first ironclad) cooking on deck on
the James River in Virginia, July 9, 1862.
(Library of Congress)

FAR RIGHT: A Federal colonel rests his arm
on an 11-inch Dahlgren gun (called a
"soda pop" by many, due to its shape).
(Library of Congress)

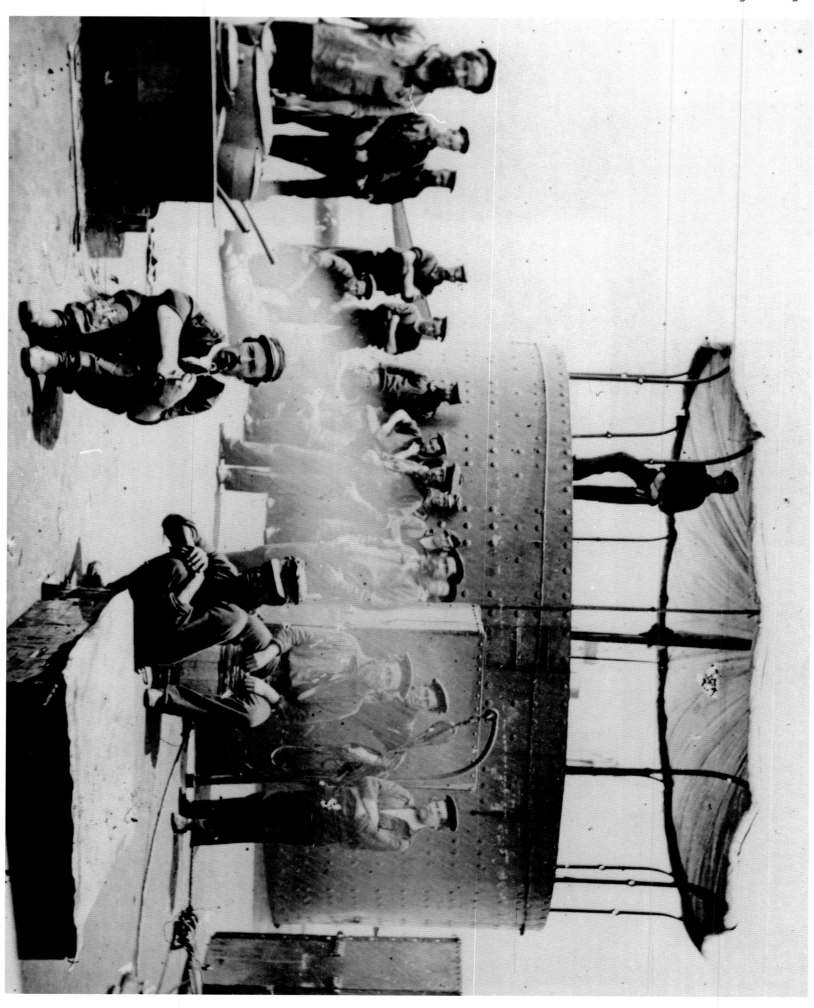

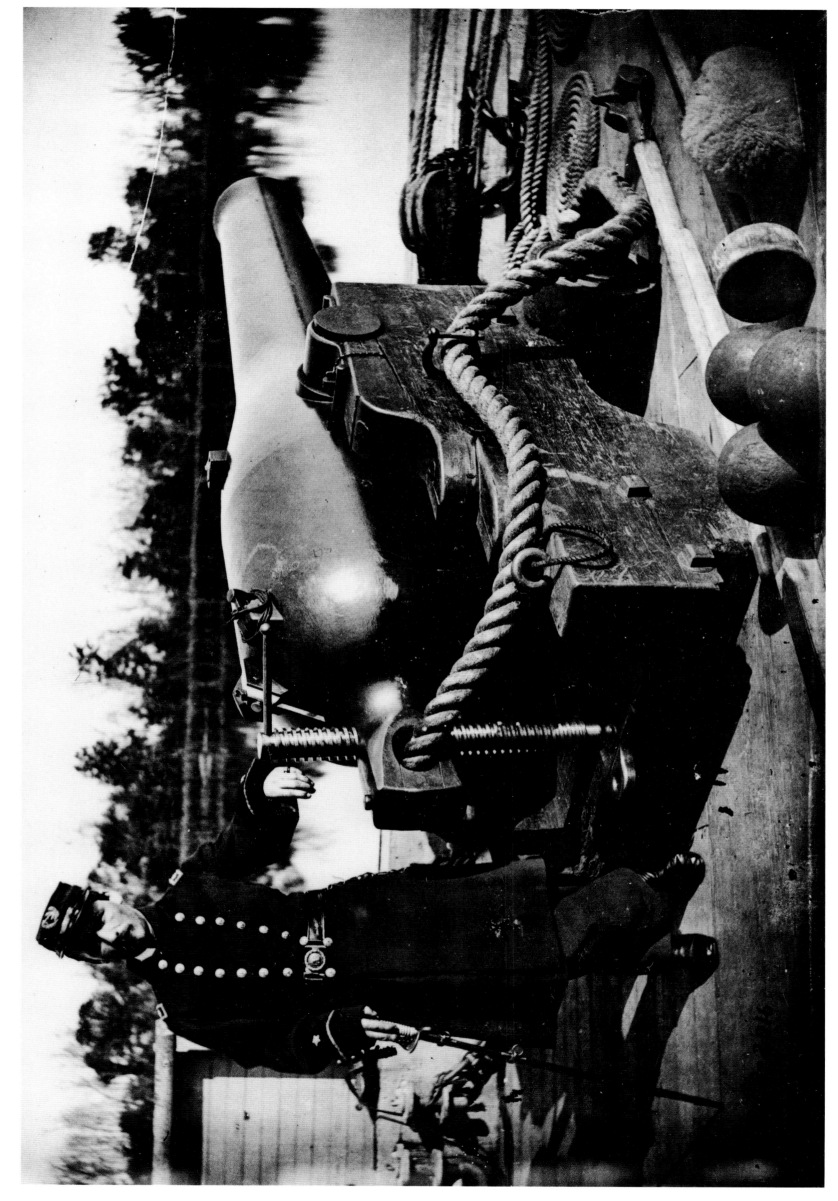

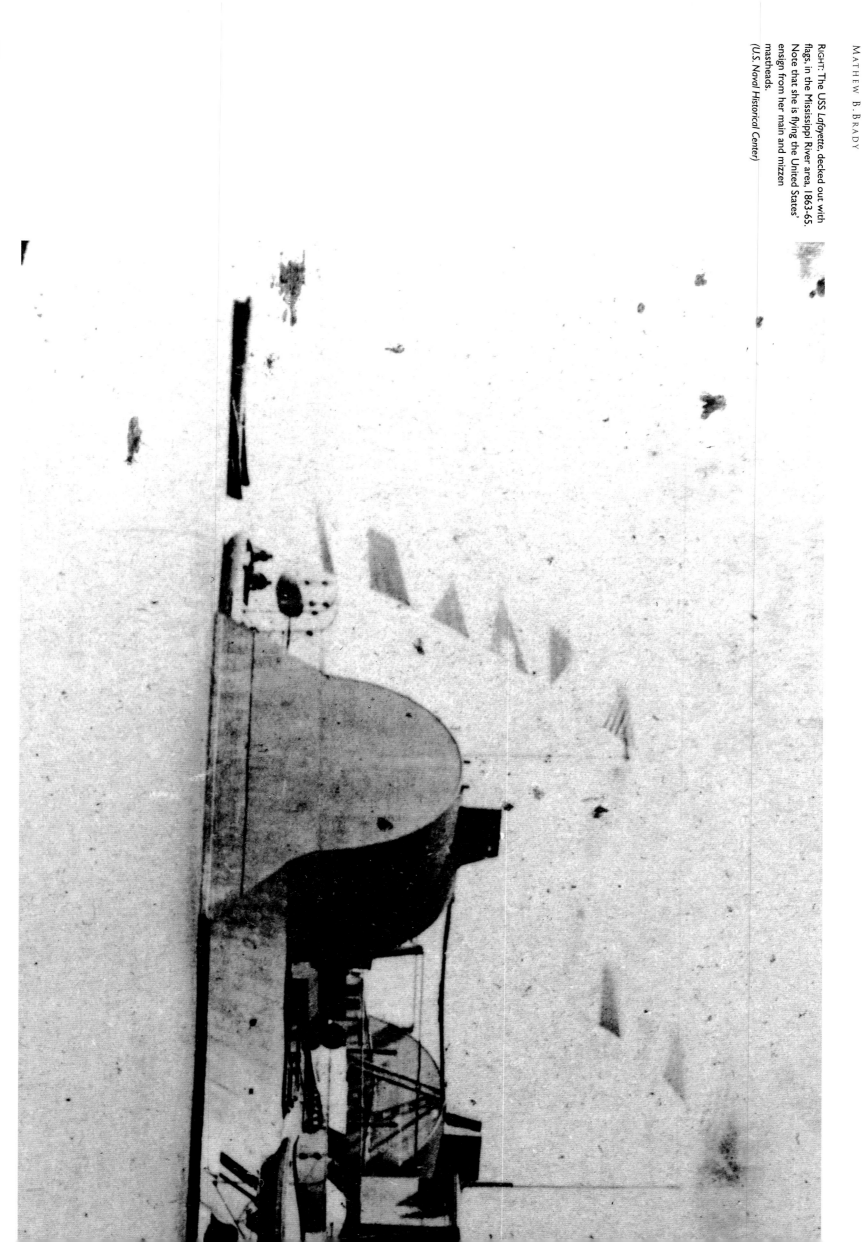

RIGHT: The USS *Lafayette*, decked out with
flags, in the Mississippi River area, 1863-65.
Note that she is flying the United States'
ensign from her main and mizzen
mastheads.
(U.S. Naval Historical Center)

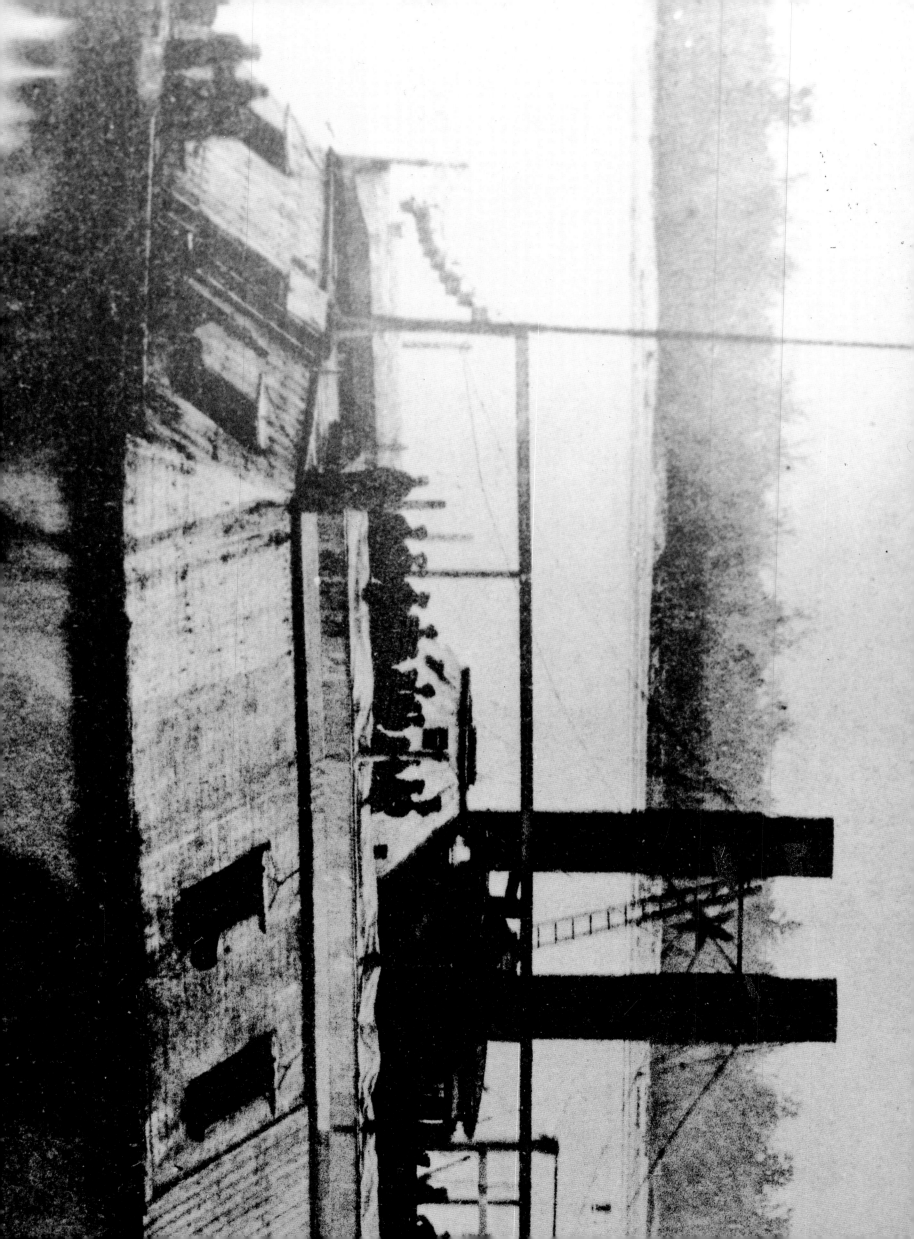

LEFT: The USS *Carondelet* was a 512-ton Cairo-class ironclad river gunboat, built for the U.S. Army's Western Gunboat Flotilla in 1862. She saw action immediately in the captures of Forts Henry and Donelson, Tennessee, and played an important role in the campaign to capture the Confederate fortress at Island No. 10 on the Mississippi, before being transferred to the Navy in October 1862. Thereafter, she was involved almost constantly in combat or patrols before decommissioning in June 1865. *(U.S. Naval Historical Center)*

RIGHT: Officers and crew aboard the
USS Lehigh, a 1,335-ton Passaic-class
monitor. She served mainly in the vicinity
of Hampton Roads and the James River,
Virginia, but also participated in several
bombardments of Confederate
fortifications along the South Carolina
coast. Though she was struck several
times by cannon fire, she survived the
war and remained active for a further
forty years.
(U.S. Army Military History Institute)

FAR RIGHT: A group of musicians
performing on the deck of the USS
Wabash, ca. 1863. Along with other
combat action, the steam screw frigate's
Civil War service was climaxed by the
assault on Fort Fisher, North Carolina, in
January 1865.
(Library of Congress)

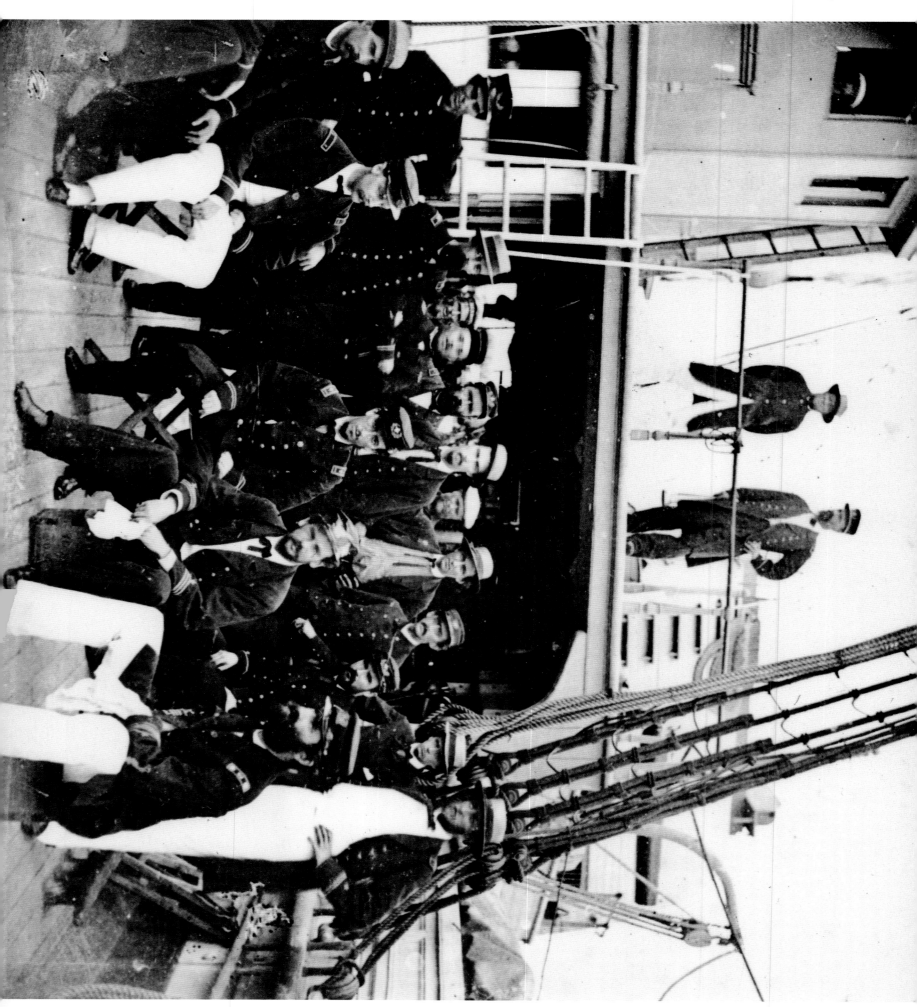

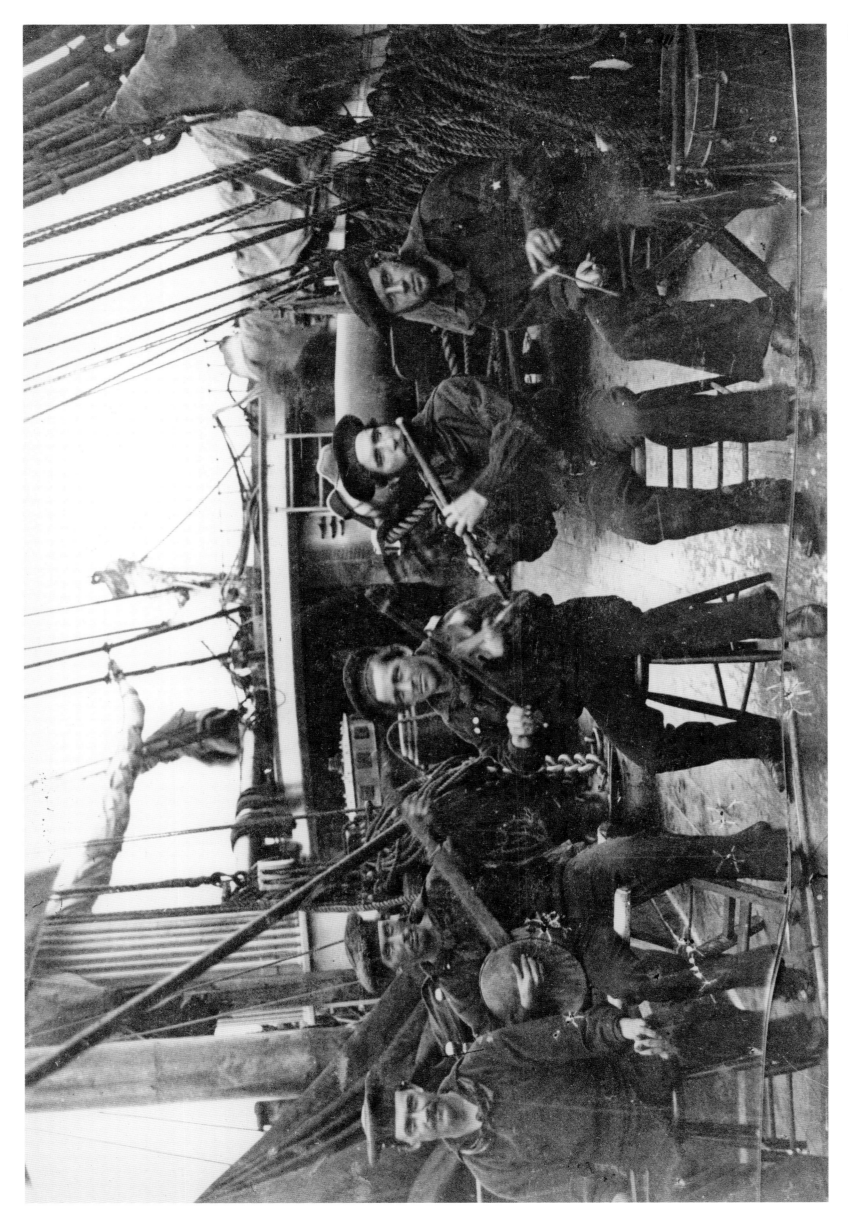

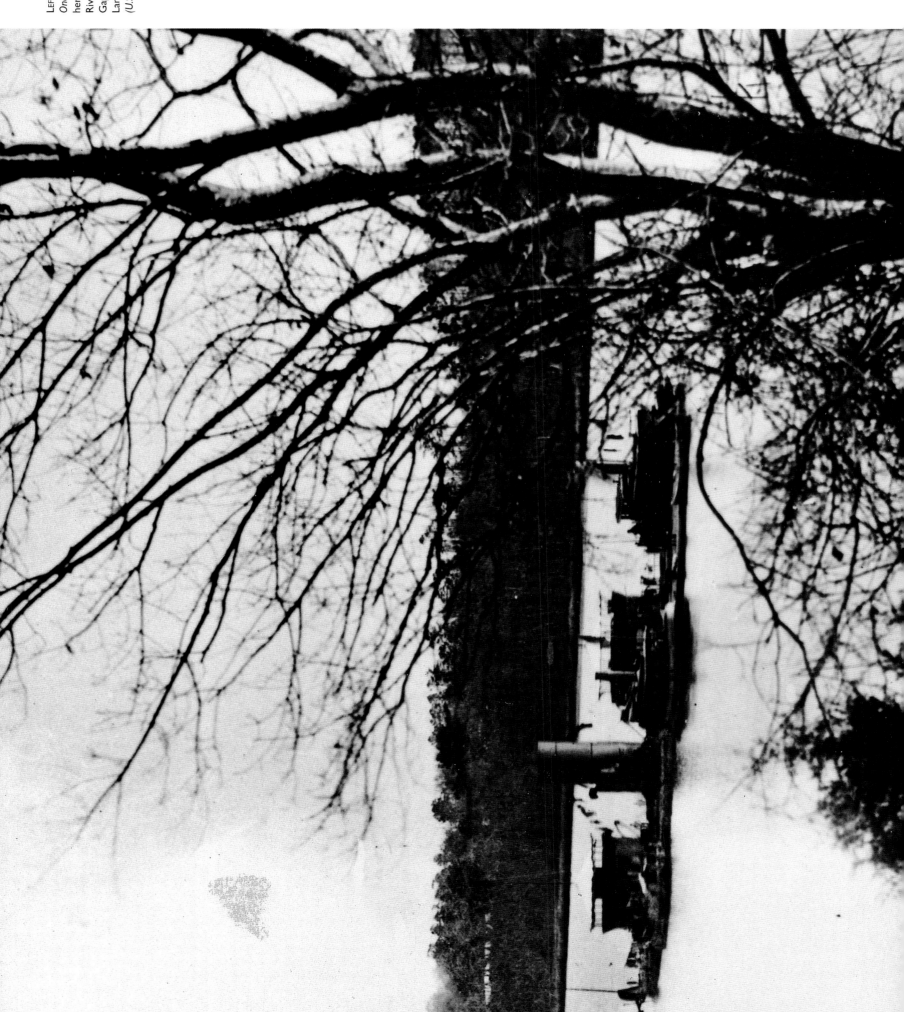

LEFT: The twin-turret monitor USS *Onandaga*, photographed ca. 1864, spent her entire active career with the James River Flotilla. Here she is below Dutch Gap, looking east. Nearby is Aikens Landing, site of prisoner of war exchanges. (*U.S. Army Military History Institute*)

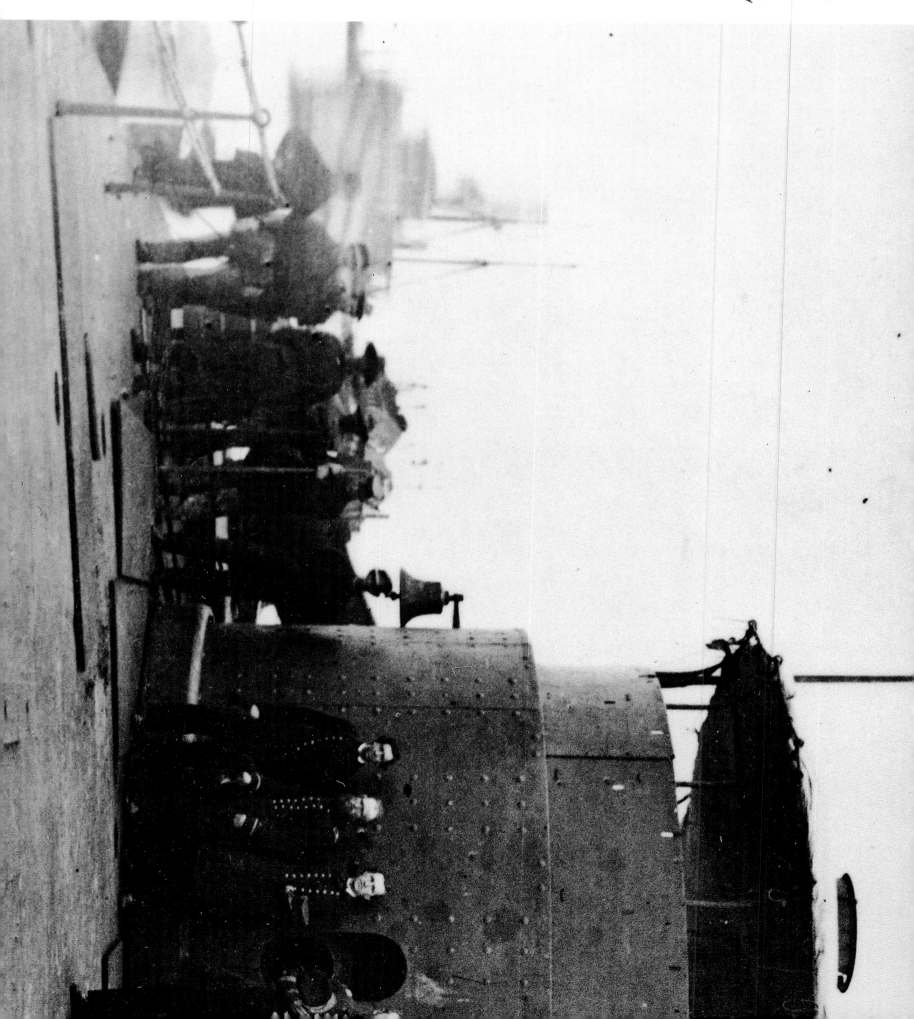

RIGHT: The USS *Nahant*, a Passaic-class monitor, was one of nine ironclads that attacked Fort Sumter, South Carolina, on April 7, 1863. In this action against the centerpiece of Charleston harbor's defenses, the limitations of the monitor design were clearly demonstrated, along with their powers of resistance to heavy gunfire. *Nahant* was hit thirty-six times by Confederate gunners, resulting in a disabled turret and one man killed. *(Library of Congress)*

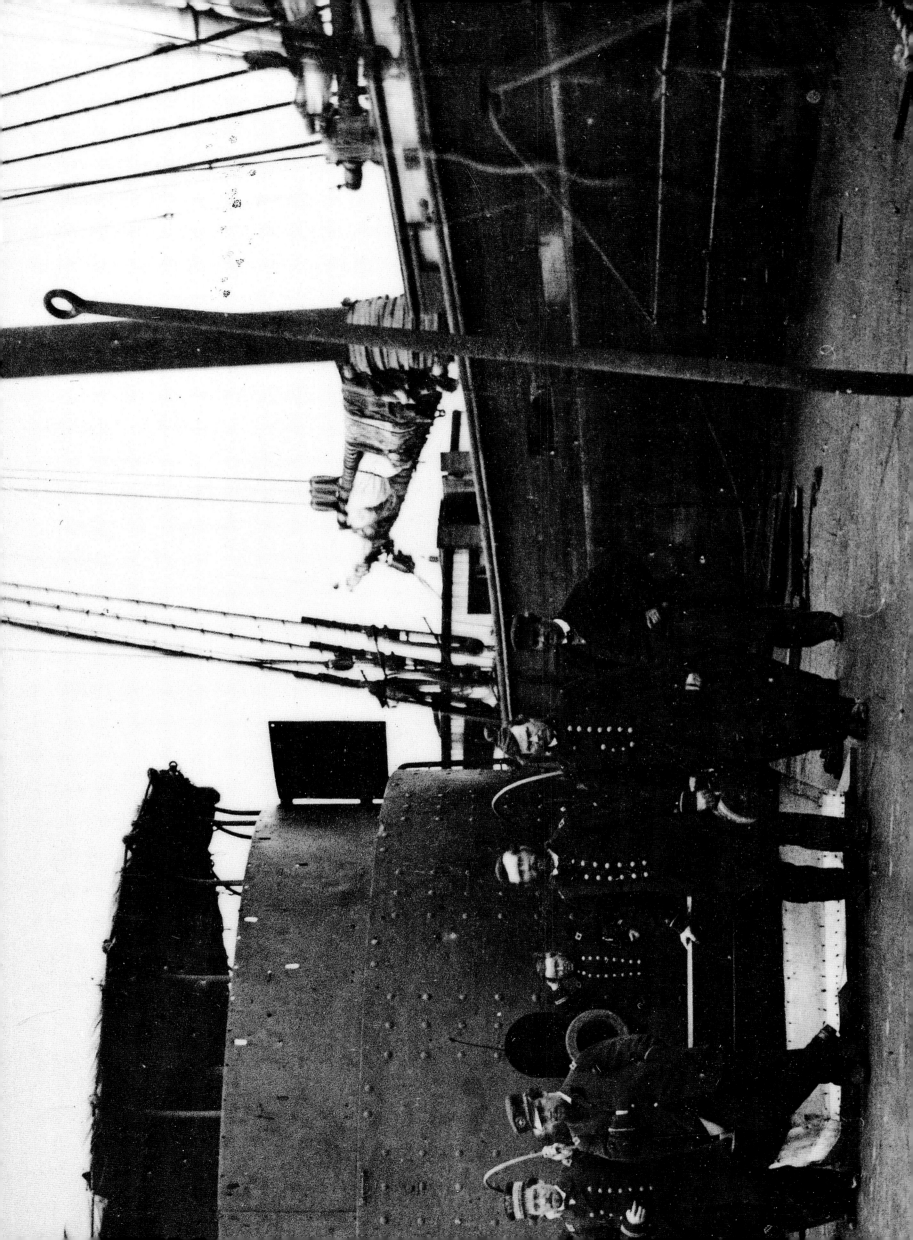

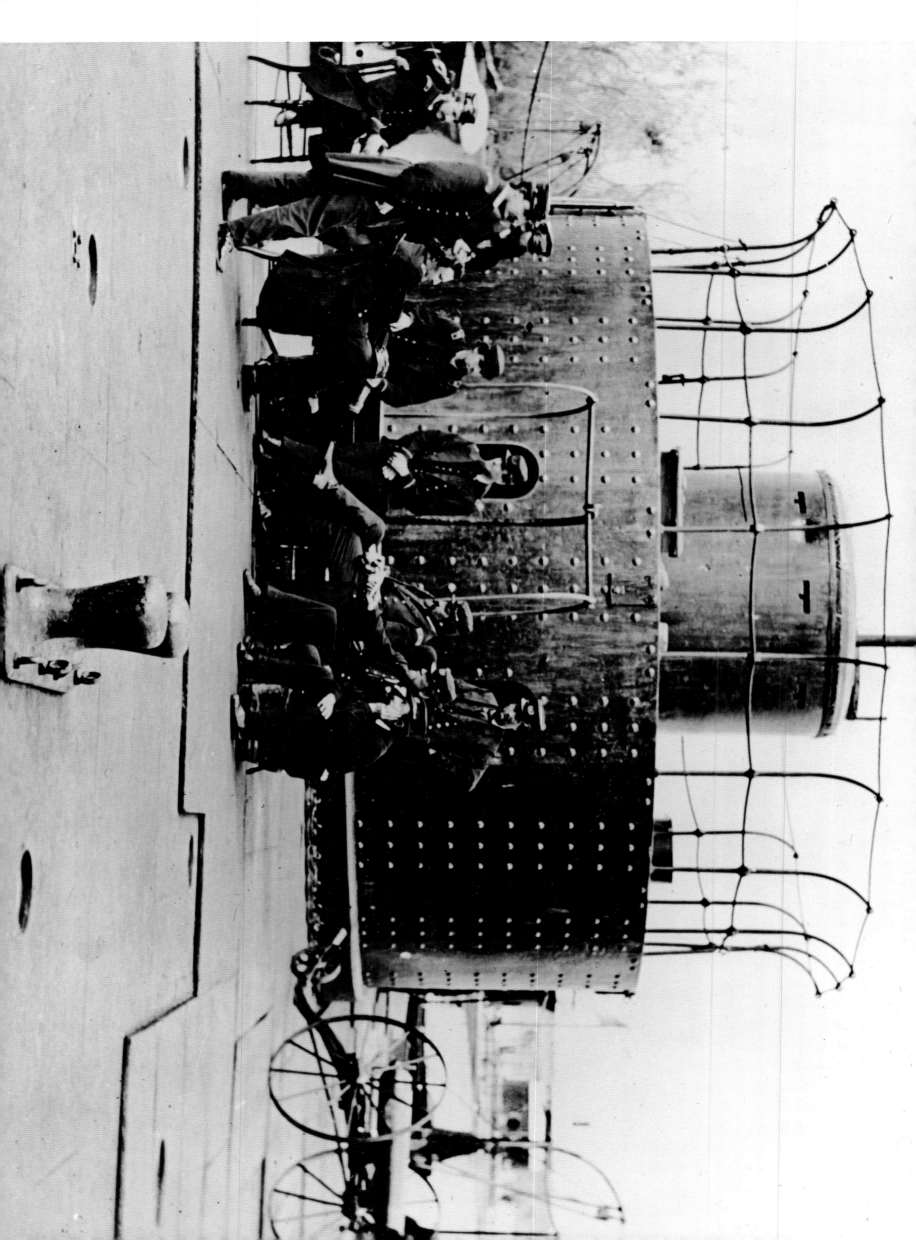

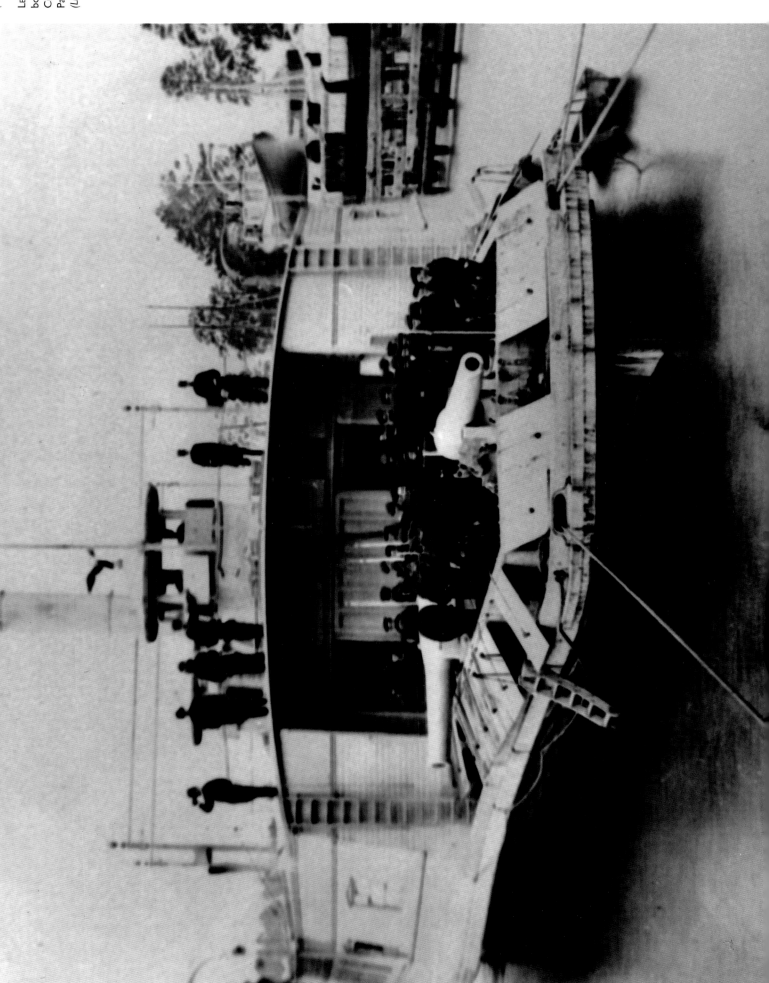

FAR LEFT: Officers aboard the monitor USS *Lehigh*, ca. 1864-65, seem to be having a casual discussion about the progress of the war. Evidence of more frantic action is clear above them: a dent in the conning tower made by a Confederate cannonball. *(U.S. Naval Historical Center)*

LEFT: The USS *Commodore Perry*, a ferry boat converted into a gunboat for the Civil War. This view was taken along the Pamunky River, Va., in 1864. *(Library of Congress)*

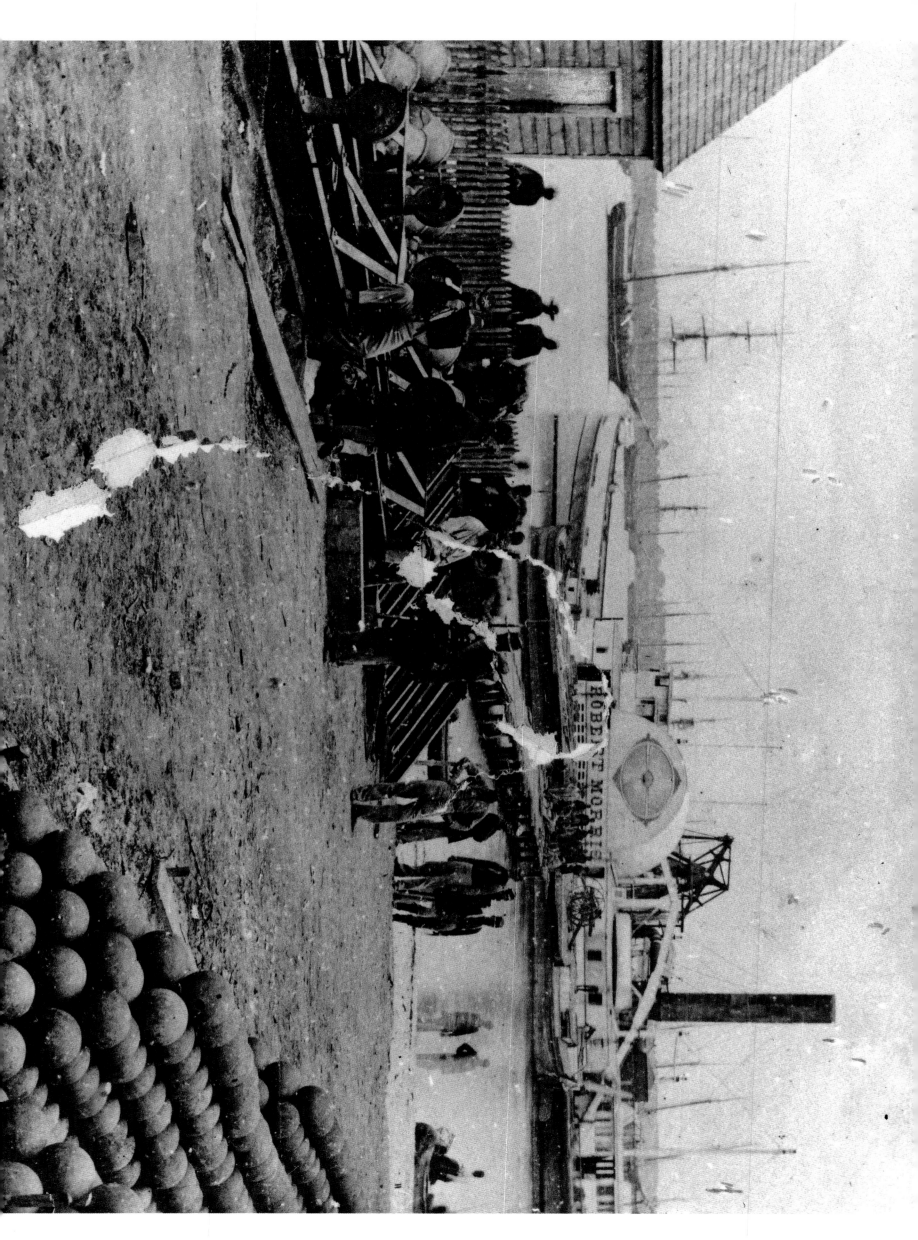

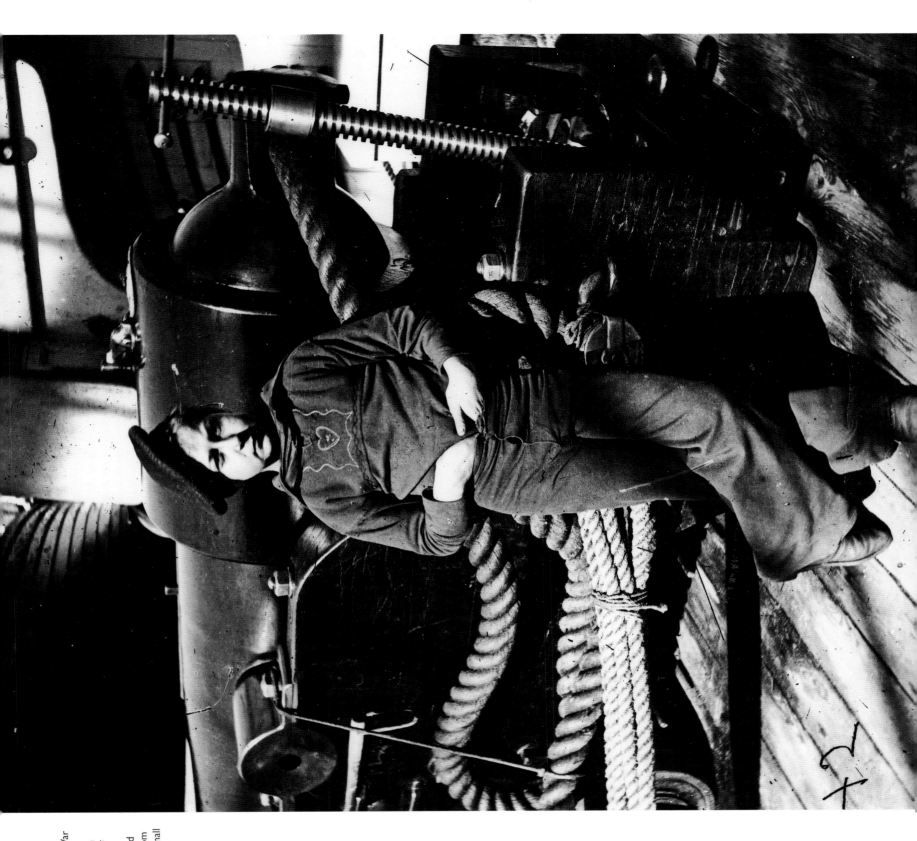

LEFT: This port scene features the steamer *Robert Morris* near the pier, with transport schooners further offshore. Note artillery in foreground. The photograph was likely taken in 1864, along the James River, Va. Note artillery rounds in foreground.
(U.S. Naval Historical Center)

RIGHT: Probably the best-known Civil War naval photograph features a powder monkey, about nine or ten years old, on the deck of the USS *New Hampshire*, off the coast of Charleston, S.C., in 1864. Grown men were mainly too big to feed huge naval guns with powder lugged from cramped magazines, and hundreds of small boys were recruited for this inherently dangerous duty.
(Library of Congress)

RIGHT: Union troops performing drills at the Washington Navy Yard during the Civil War. The steamers in the background are non-military.
(U.S. Naval Historical Center)

FAR RIGHT: The Union medical supply boat Planter at the General Hospital wharf on the Appomattox River, near City Point, Virginia, during the siege of Petersburg, June 1864–April 1865.
(Library of Congress)

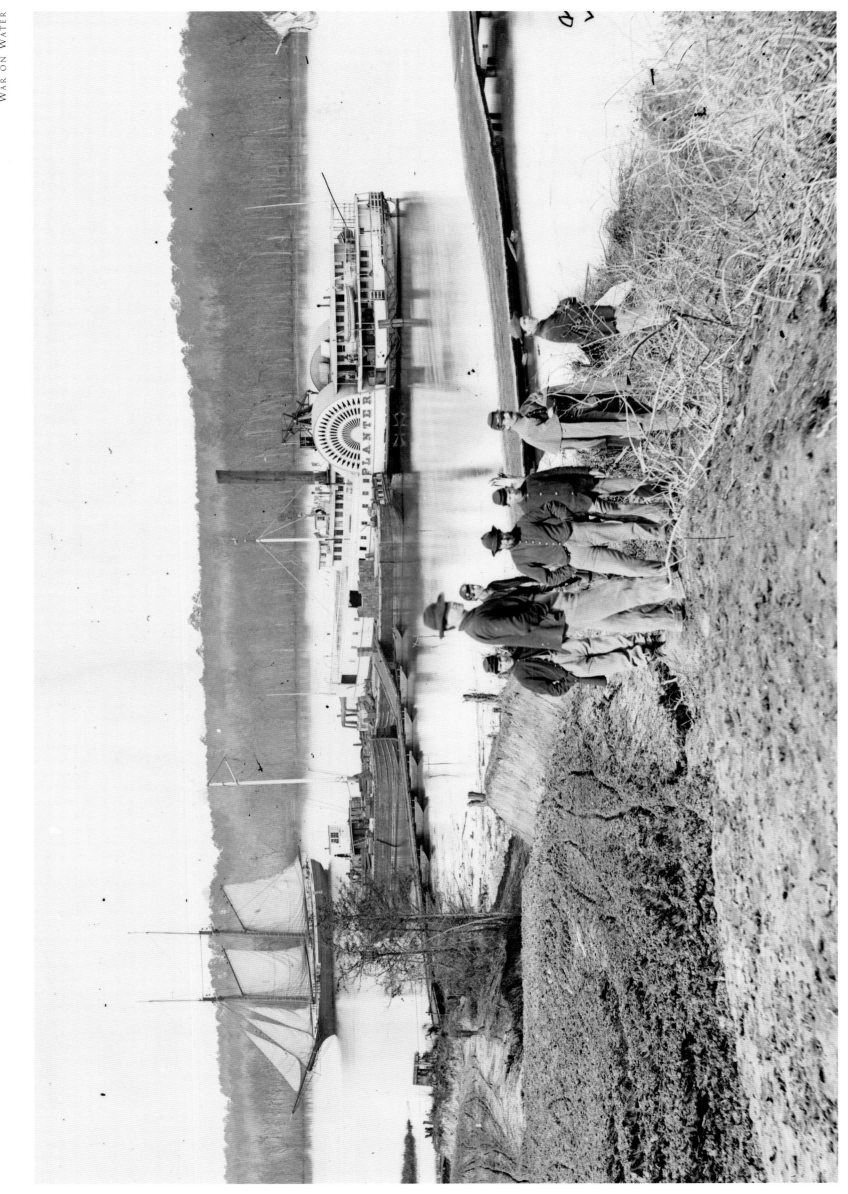

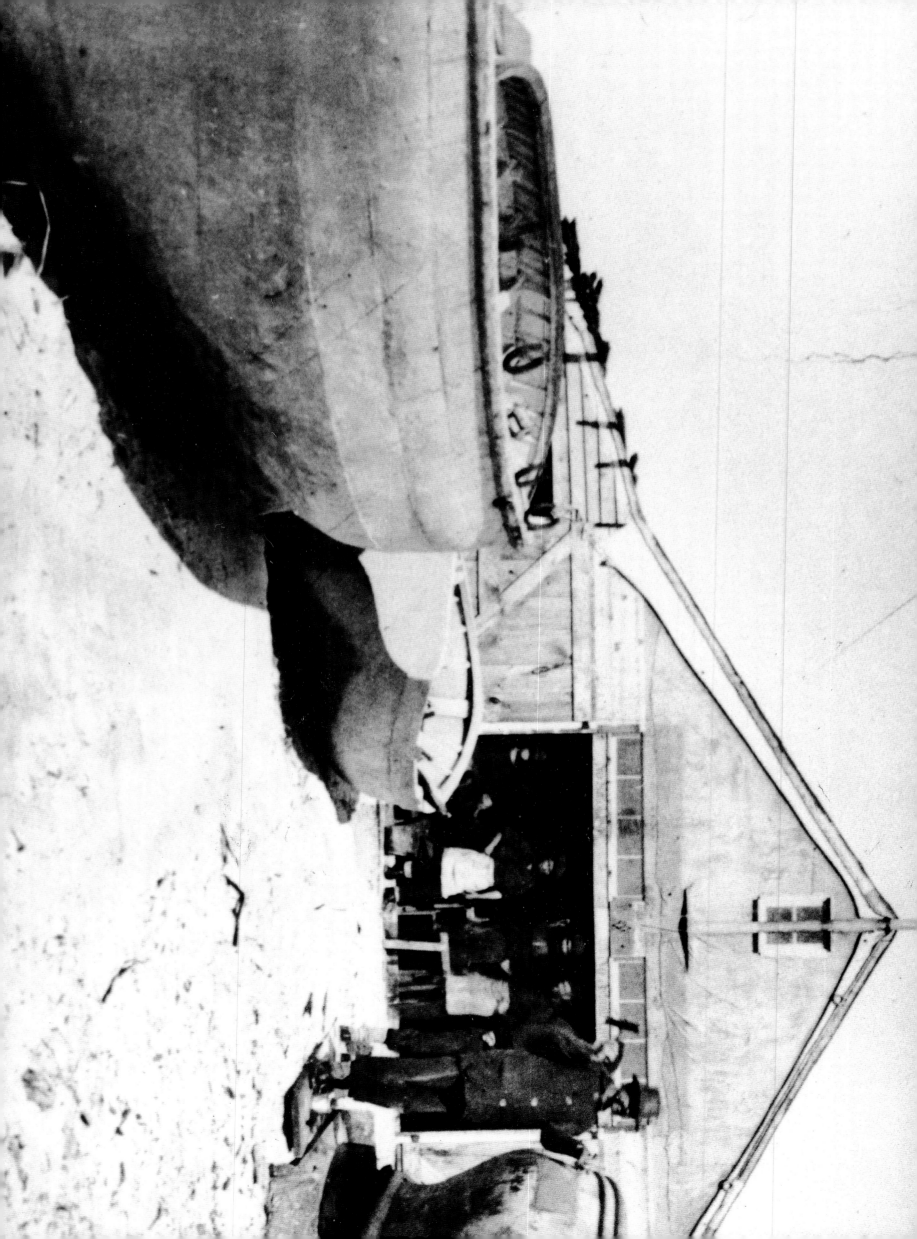

LEFT: A U.S. Navy boat repair shop on Morris Island, at the mouth of Charleston Harbor, South Carolina, photographed ca. 1865. Heavily fortified by the Confederates, the island was a strategic location during the Civil War, where desperate fighting ensued during the Union Army's campaign to capture Charleston. *(National Archives)*

RIGHT: Two members of the USS *Hunchback*'s crew, leaning on the ship's 12-pdr Dahlgren howitzer, 1864–65. The *Hunchback* was built in 1852 as a civilian side-wheel paddleboat and converted into a gunboat. She was commissioned in January 1862.
(U.S. Naval Historical Center)

FAR RIGHT: In this photograph attributed to Mathew Brady, two officers sit on folding chairs on the deck of USS *Hunchback*, in the James River, Va., ca. 1864–65. Note 12-pounder Dahlgren howitzer and "walking beam" machinery in the background.
(U.S. Naval Historical Center)

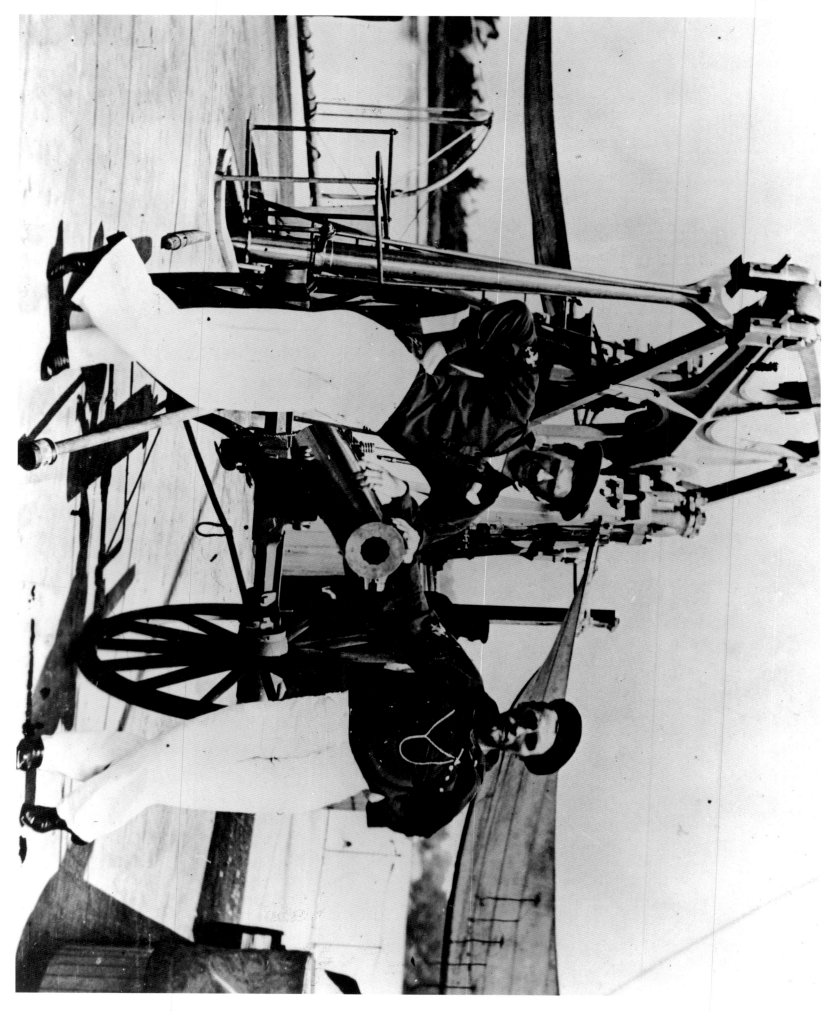

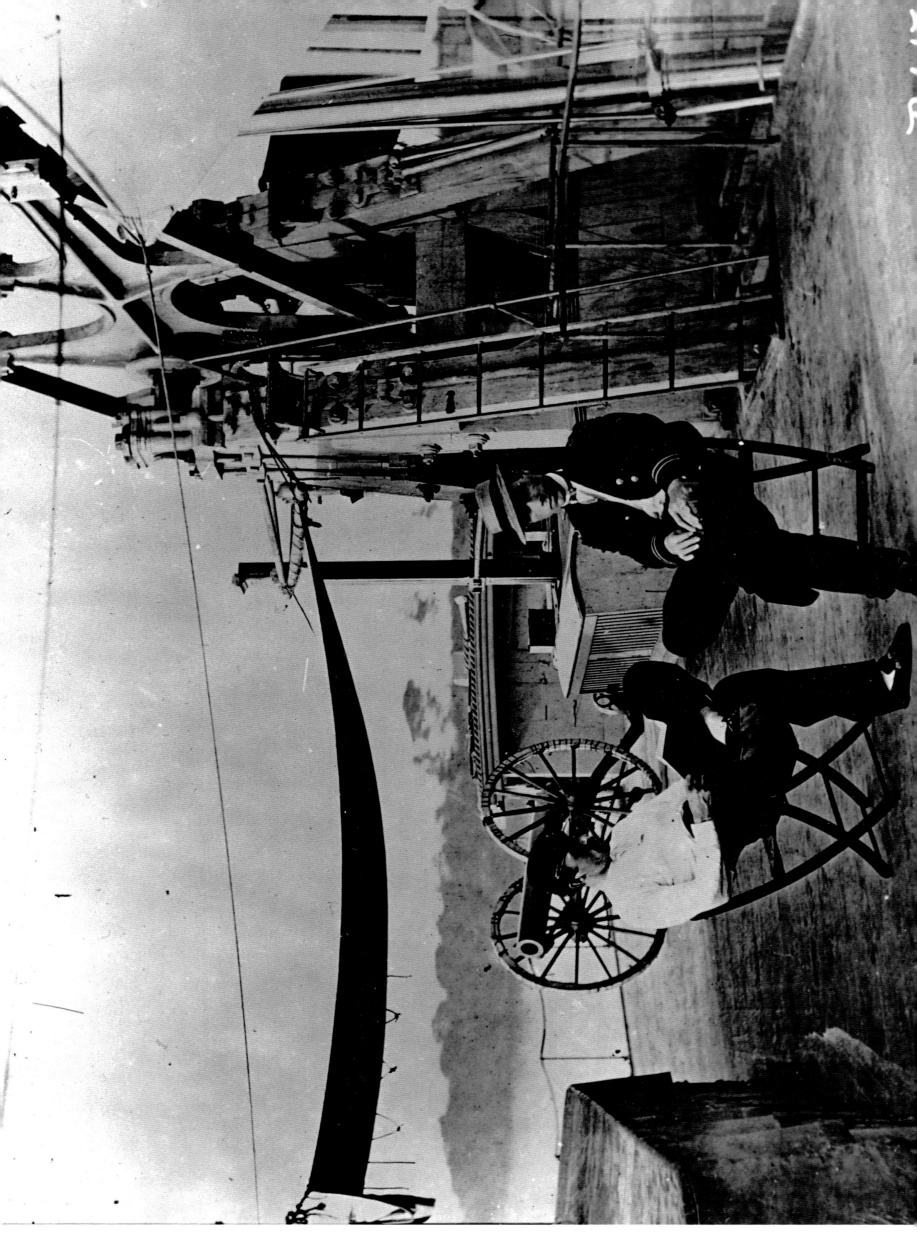

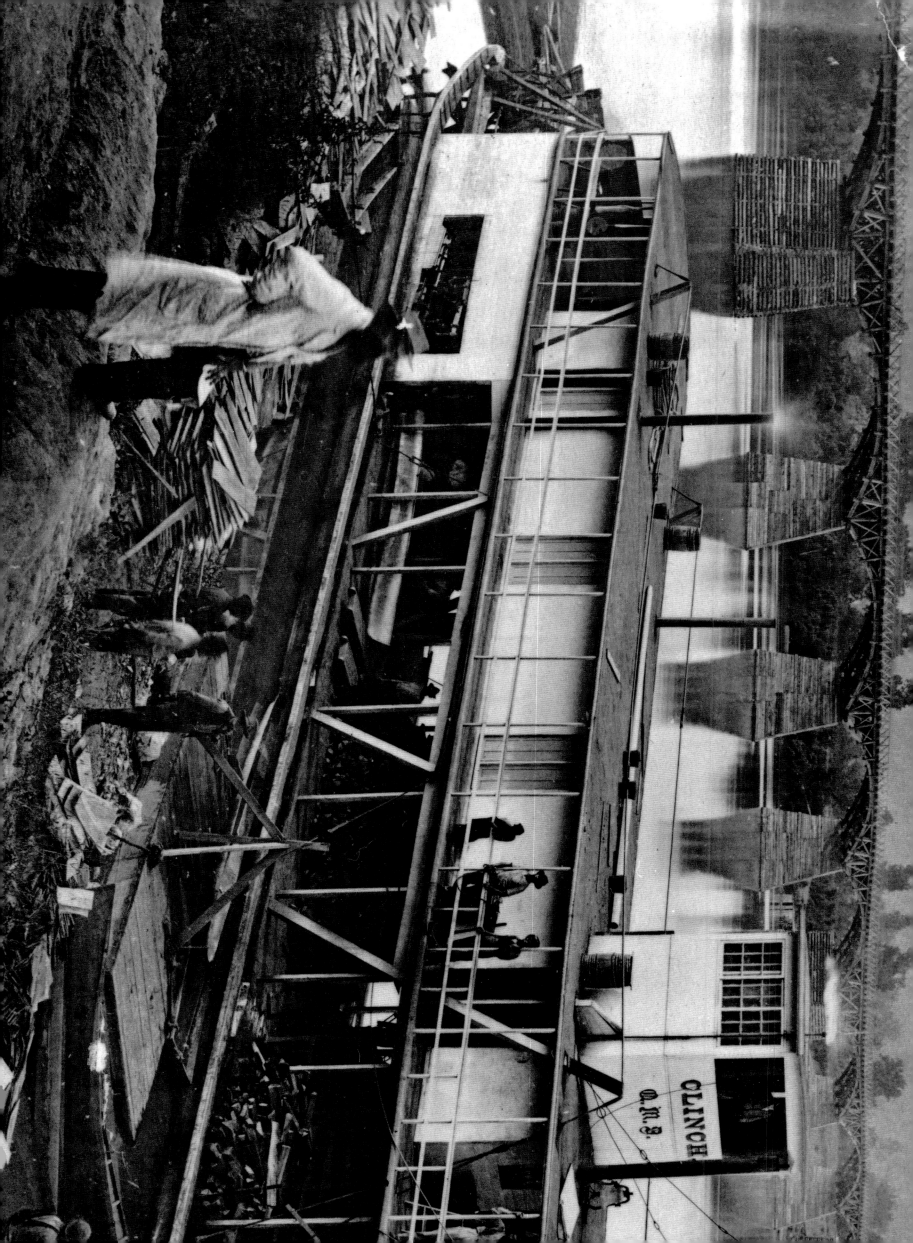

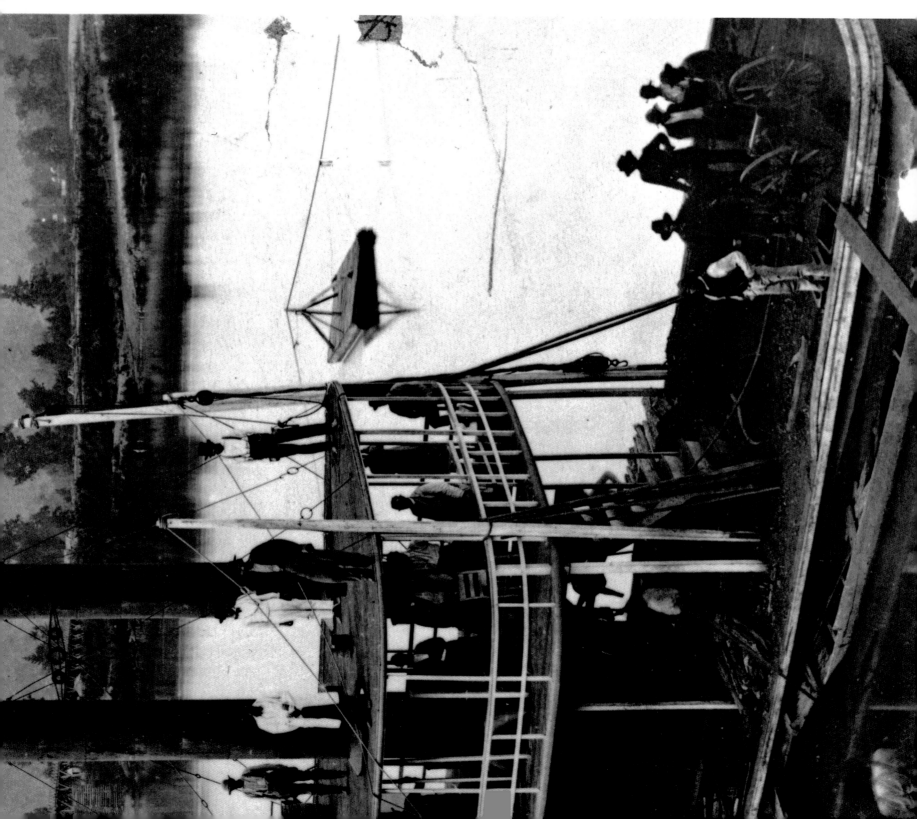

LEFT: The figure at left is thought to be photographer Brady, and he and his team's activities have certainly caused a stir among the crew of the steamer *Clinch* on the Tennessee River.
(U.S. Naval Historical Center)

226

RIGHT: The civilian to the far left of this picture, in a straw hat, is believed to be Mathew Brady, listening intently as a gunboat crew discusses the workings of the 100-pound Parrott gun.
(Library of Congress)

FAR RIGHT: Ropes stowed on shore helped gunboats and transports boats get through rough areas of river, as here, on the Tennessee.
(Library of Congress)

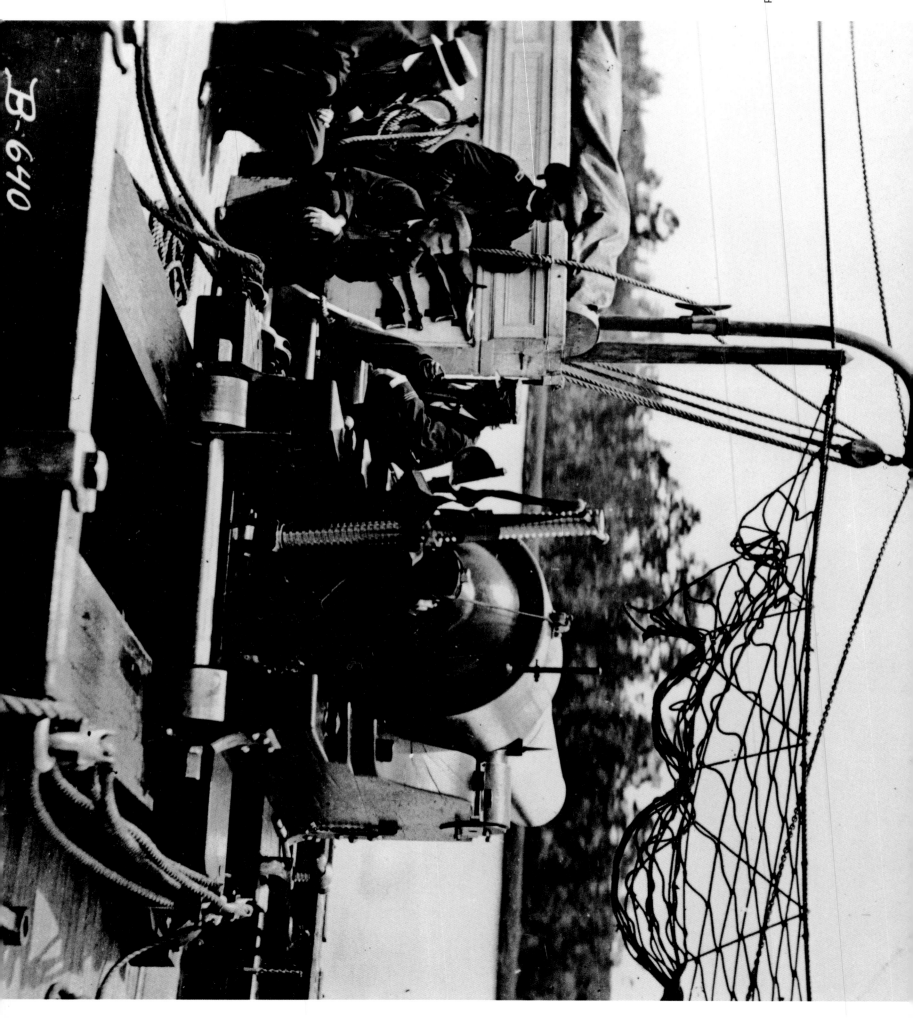

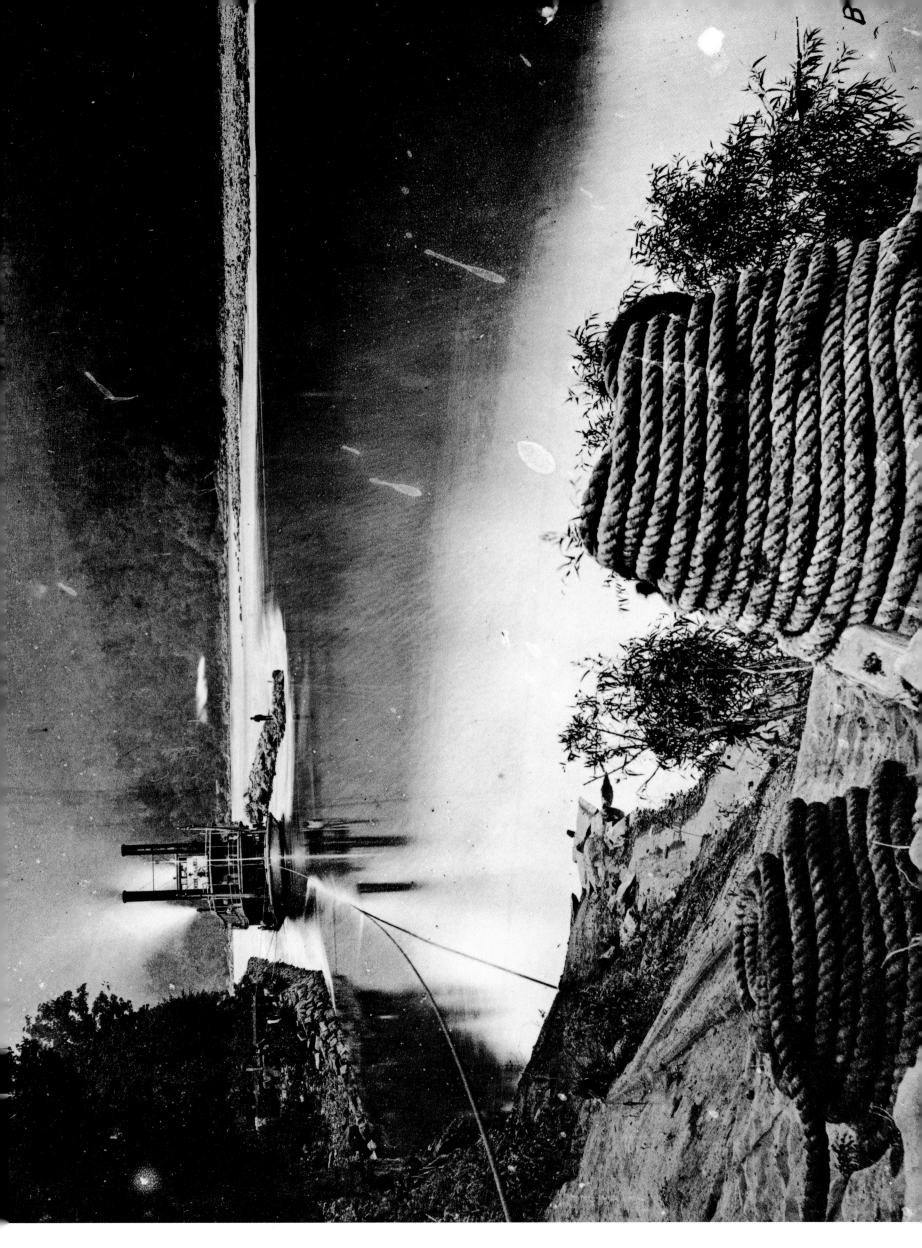

MATHEW B. BRADY

RIGHT: Ship's officers on board the deck of
USS Sangamon, a Passaic-class monitor
vessel, circa 1864-65. Note the Dahlgren
howitzer on a field carriage.
(U.S. Army Military History Institute)

FAR RIGHT: In a carefully staged
photograph by Brady (note newspaper
reader at left, and the potato peeler at
right), none of the crew of the USS
Hunchback looks particularly pleased to
be entertained by a banjo player. Perhaps
the reason is the cramped conditions
aboard the gunboat, seen on the James
River, ca. 1864-65.
(Library of Congress)

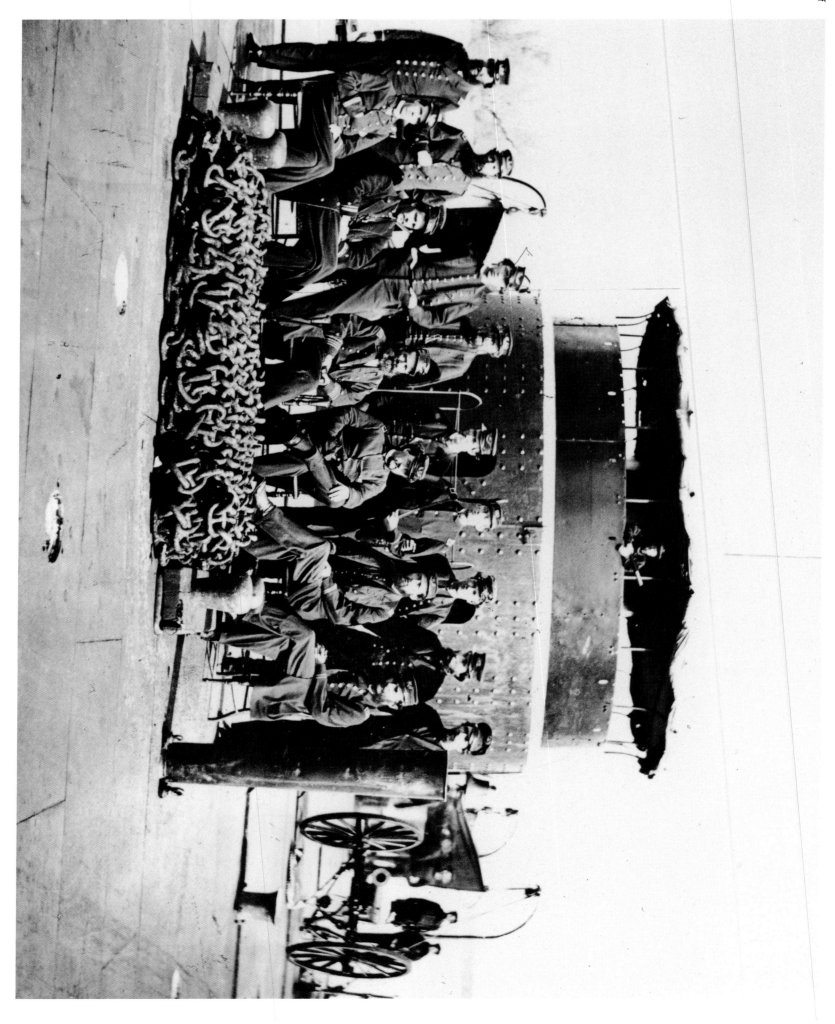

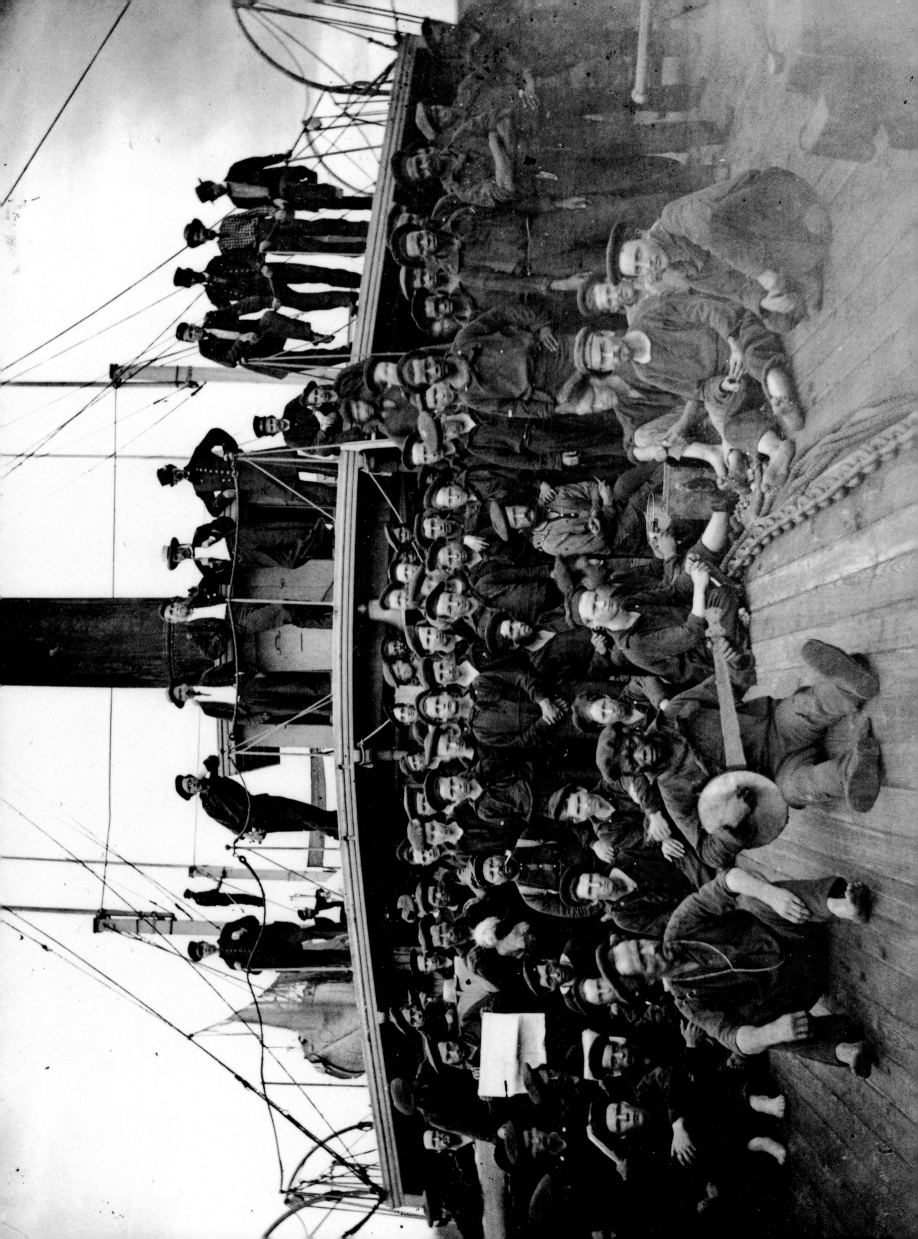

RIGHT: Scores of caissons are lined up
ready to be loaded aboard the Union
transport *Silver Star* (at left) at an
unidentified landing on the James River.
(Library of Congress)

FAR RIGHT: Belle Plain Landing, Virginia, was
specially constructed on Potomac Creek
as a base for supplies for General Grant's
army. It was a desolate place, with no
houses or other buildings, at the foot of a
range of wooded hills, with Fredericksburg
nine miles away along precipitous roads.
It was an active landing, however, filled
constantly with transports and naval
vessels receiving and unloading supplies.
Moreover, when Confederates were taken
prisoner following battles in the vicinity of
Belle Plain they would be taken to a
holding area nearby, to await transfer to a
secure prison.
(Library of Congress)

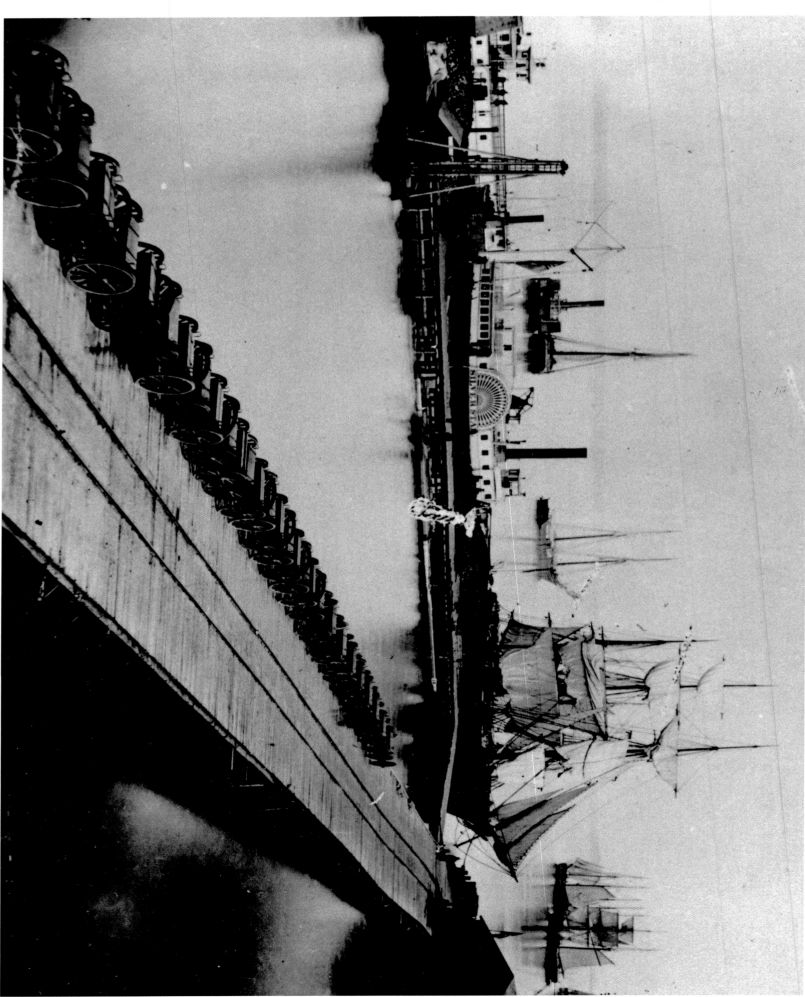

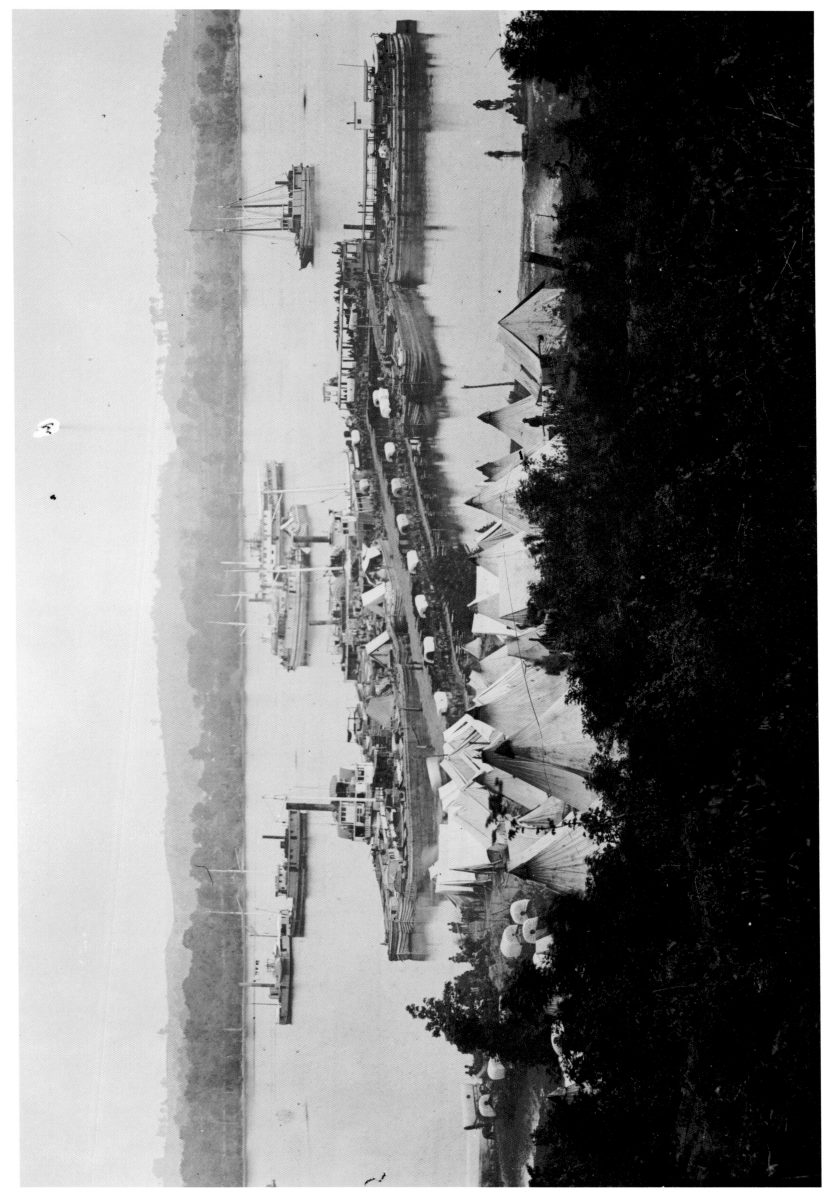

A LAND LAID WASTE

Brady and his crews captured a great deal of war mayhem on camera. One element fairly new to warfare during the Civil War—one that was acceptable to Lincoln—was the total destruction of property to financially drain and humiliate the enemy. No one was more effective at the so-called "scorched earth" tactic than General William T. Sherman, who was relentless—and successful. His 1864 "March to the Sea" laid waste to millions of dollars of livestock, crops, and supplies. He also ordered his men to destroy civilian infrastructure along their path. The destruction of tranportation systems was also vital. Locomotives were wrecked and destroyed; twisted, broken rails were wrapped around tree trunks and soon became known as "Sherman's Neckties." One of the most notable and oft-reproduced of these images is one of a crippled locomotive at the Richmond & Petersburg Railroad Depot in Richmond, Va., sometime between April and June 1865.

In an effort to keep Federal forces from utilizing anything of value, Confederate troops also destroyed millions of dollars of private and government property. The vast majority of Richmond's destruction was at the hands of fleeing Rebels.

The incredible destruction of the war was brought home numerous times by Brady and his staff. Many shots of smoking ruins, wrecked locomotives, and destroyed factories dot his photographic landscape. Among the cities worst hit by both Federal and Rebel destruction were Richmond, Va., Charlotte, N.C., and Savannah, Ga. These images today help us understand the painful defeat that even civilians felt.

The geography of North America would never be entirely the same as before the conflict. Rivers had been diverted, hills leveled, whole forests denuded, and the fields of million farmers sown with lead and iron. Cities had been reduced to rubble, and bridges had been smashed such that some rivers could not be crossed for months or even years.

Following the Confederate surrender in April 1865, North and South began their final tally of the cost of the madness: more than 600,000 dead; over a million wounds inflicted. A section of the country had been ravaged of all its resources, material, agricultural, and human. Four million black Americans, once enslaved, were now free, with little but their freedom and the clothes on their backs.

RIGHT: Truly reflecting a land laid waste to war, Carey Street in Richmond was before the conflict a thriving industrial center. At war's end, citizens could only stand and stare at the crumbling ruins.
(Library of Congress)

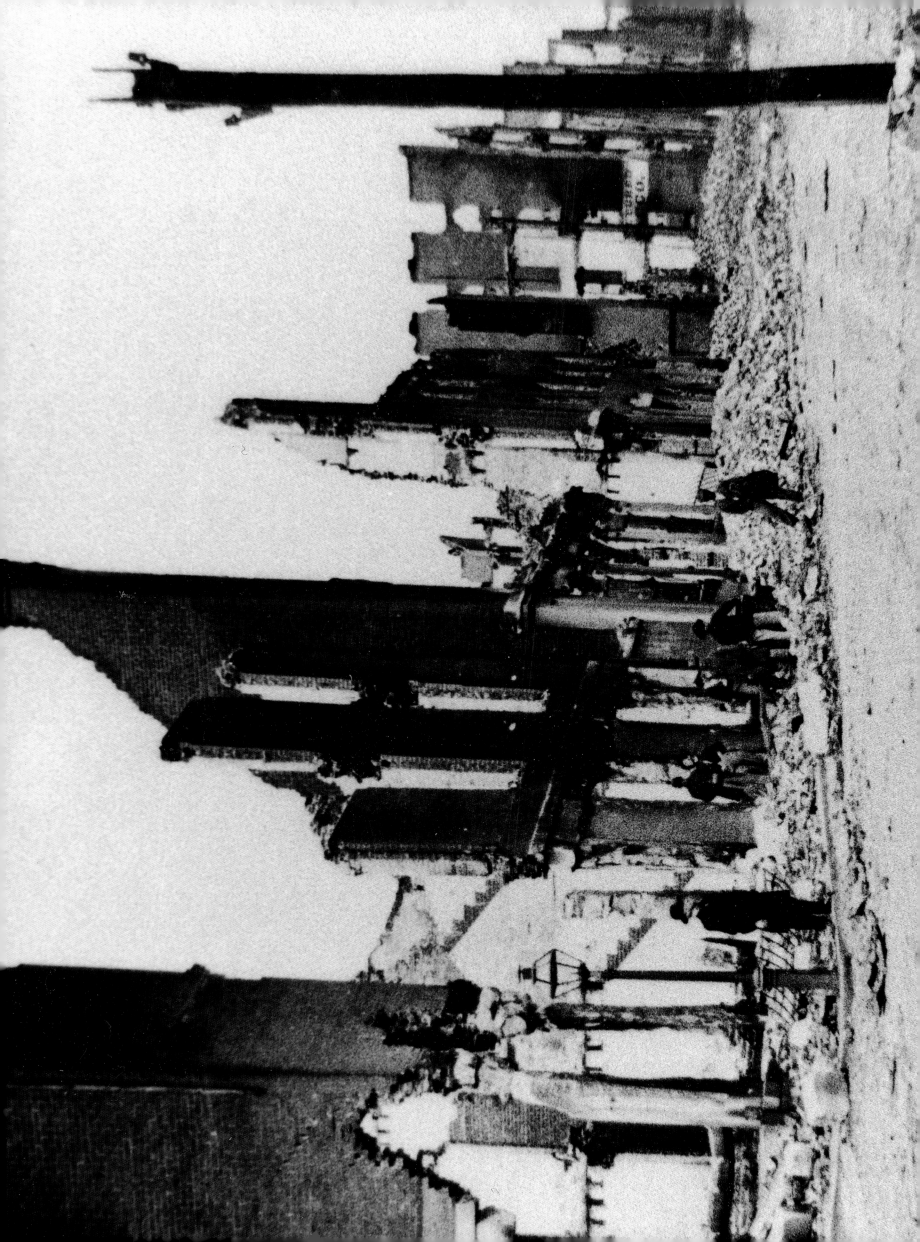

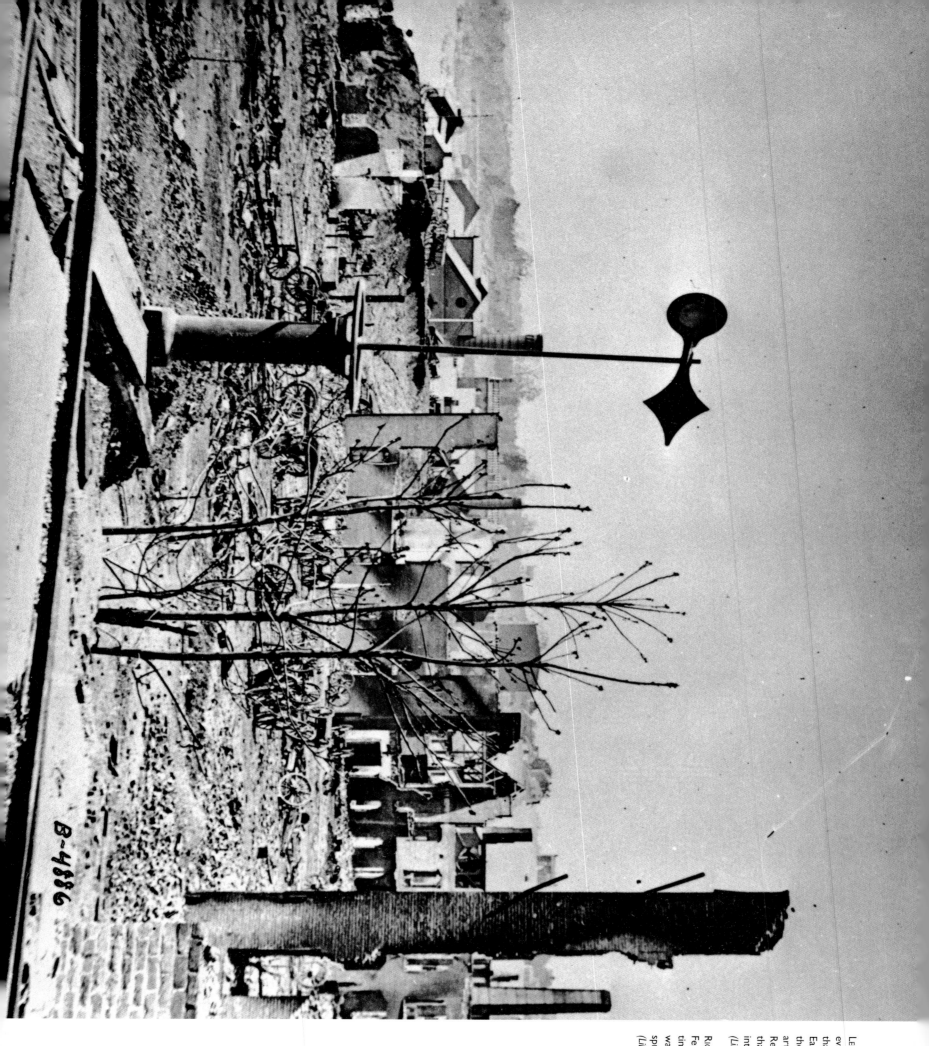

B-4886

LEFT: Richmond lay in ruins after its
evacuation and fall, and the dreadful fire
that swept most of the city away in 1865.
Early analysts mistakenly concluded that
the damage was caused by Federal
artillery fire, but it is more likely that
Rebels torched and detonated the city so
that nothing of military value would fall
into Union hands.
(Library of Congress)

RIGHT: Strategically positioned Harpers
Ferry and armory changed hands eight
times during the war. When the fighting
was over, there was not much left of the
sprawling Harpers Ferry installation.
(Library of Congress)

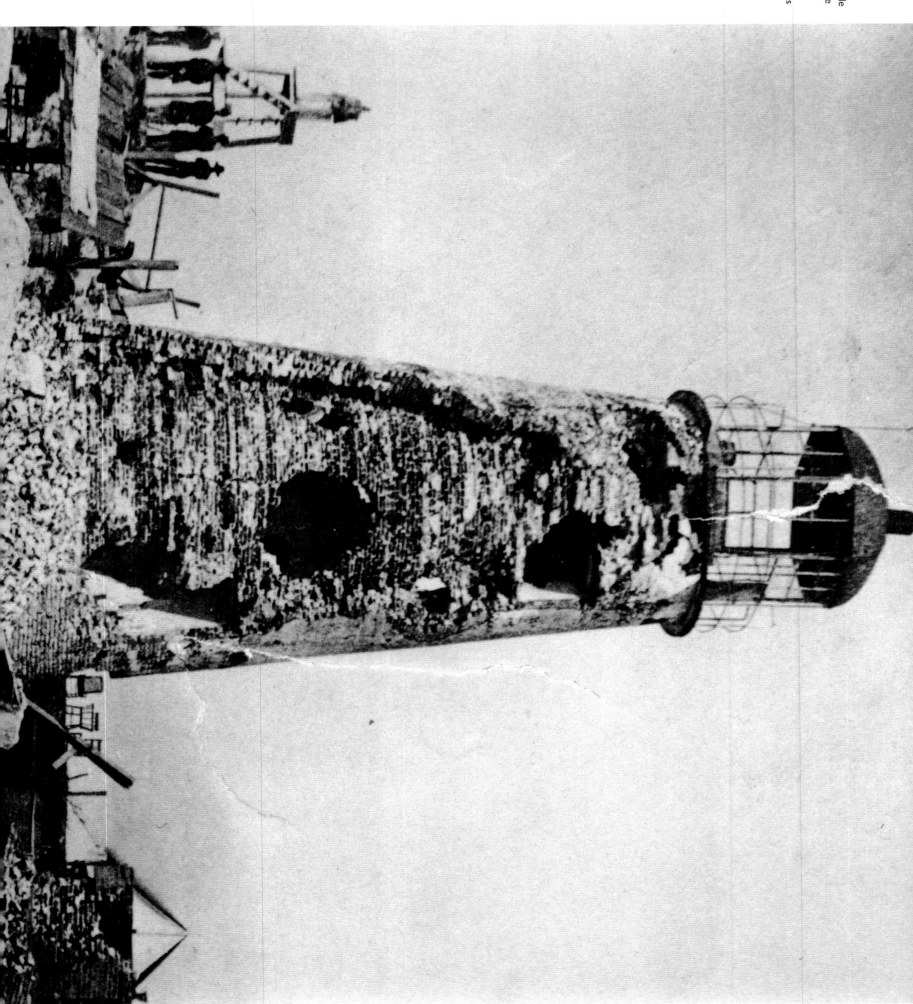

RIGHT: Fort Morgan, Mobile Point, Alabama, and its lighthouse took a terrible hammering from the former Confederate Tennessee in August 1864 after the U.S. Navy had captured and repaired the massive ironclad, and then turned its guns on the fort.
(Library of Congress)

LEFT: Acting independently, George N. Barnard made this photograph of the badly damaged, but still standing, Circular Church, in Charleston, South Carolina, in 1865.
(*Library of Congress*)

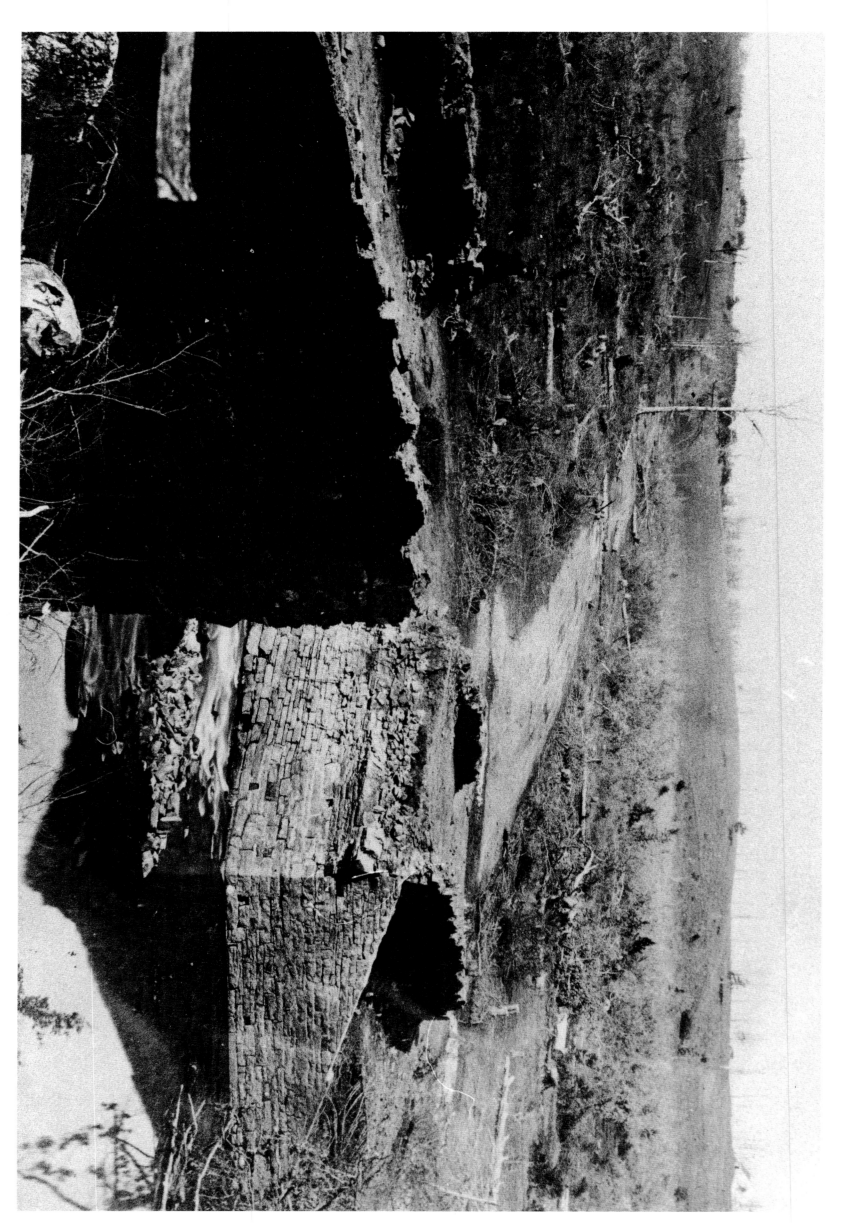

FAR LEFT: In March 1862 Brady photographers George N. Barnard and James F. Gibson, apparently working together, captured on camera the damaged bridge over Virginia's Bull Run stream, which gave the battles their name. Local residents had to go miles out of their way to cross the stream. *(Library of Congress)*

LEFT: Ruined buildings in the Norfolk Naval Shipyard, Virginia, the U.S. Navy's oldest shipyard, which for a period early in the Civil War was under the governance of the Confederates when Union forces evacuated the yard. It was in this yard that the partly burned steam frigate USS *Merrimac* was converted by the Rebels into the CSS *Virginia*. In March 1862, world-wide attention focused on the battles between the *Virginia* and the wooden Union ships USS *Congress* and USS *Cumberland* and the federal ironclad USS *Monitor*. The battles in Hampton Roads spurred changes in naval technology around the world. *(Library of Congress)*

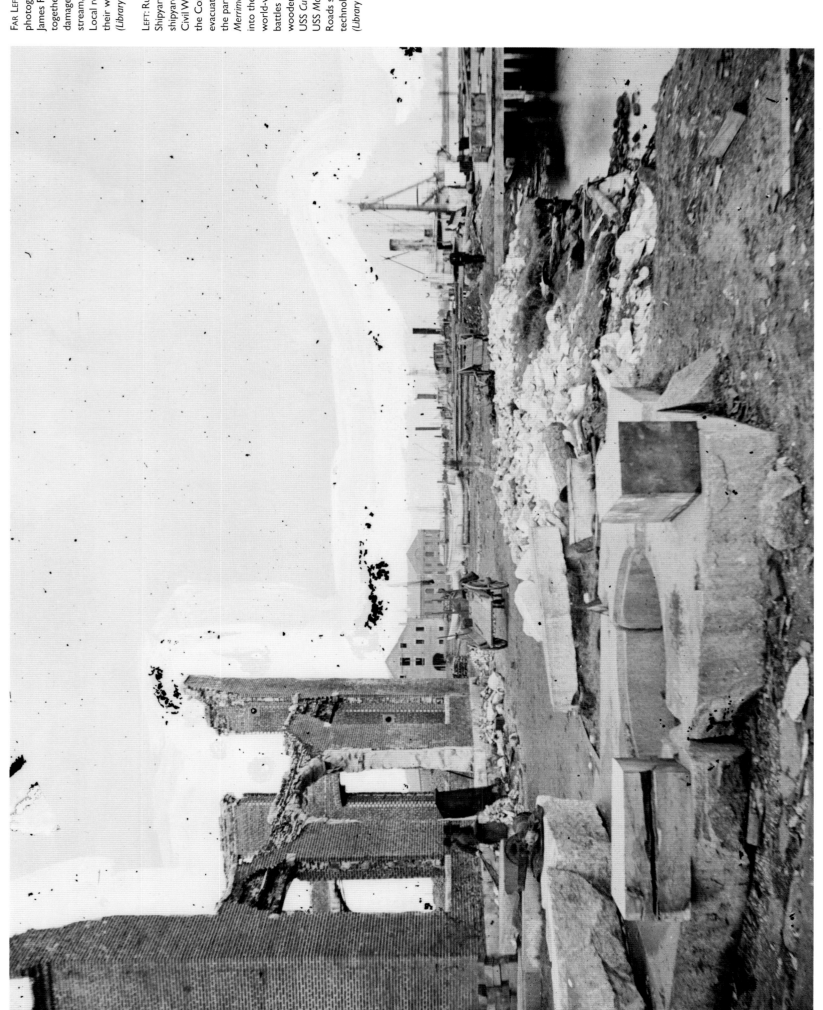

FAR LEFT: As the conflict moved toward a close in Richmond, everywhere that Brady's photographers turned there was devastation, as here, the "Burnt District." (*Library of Congress*)

LEFT: Piles of solid shot, canister, and other heavy ammunition captured on camera by Alexander Gardner in the Arsenal grounds between April and June 1865, after the fall of Richmond to the Federals near war's end. The damaged Richmond & Petersburg Railroad bridge can be seen at right. (*Library of Congress*)

RIGHT: Mayo's Stone railroad bridge, Richmond, Va., ca. 1865, destroyed by the Confederates so that Federal forces could not make use of it. (*Library of Congress*)

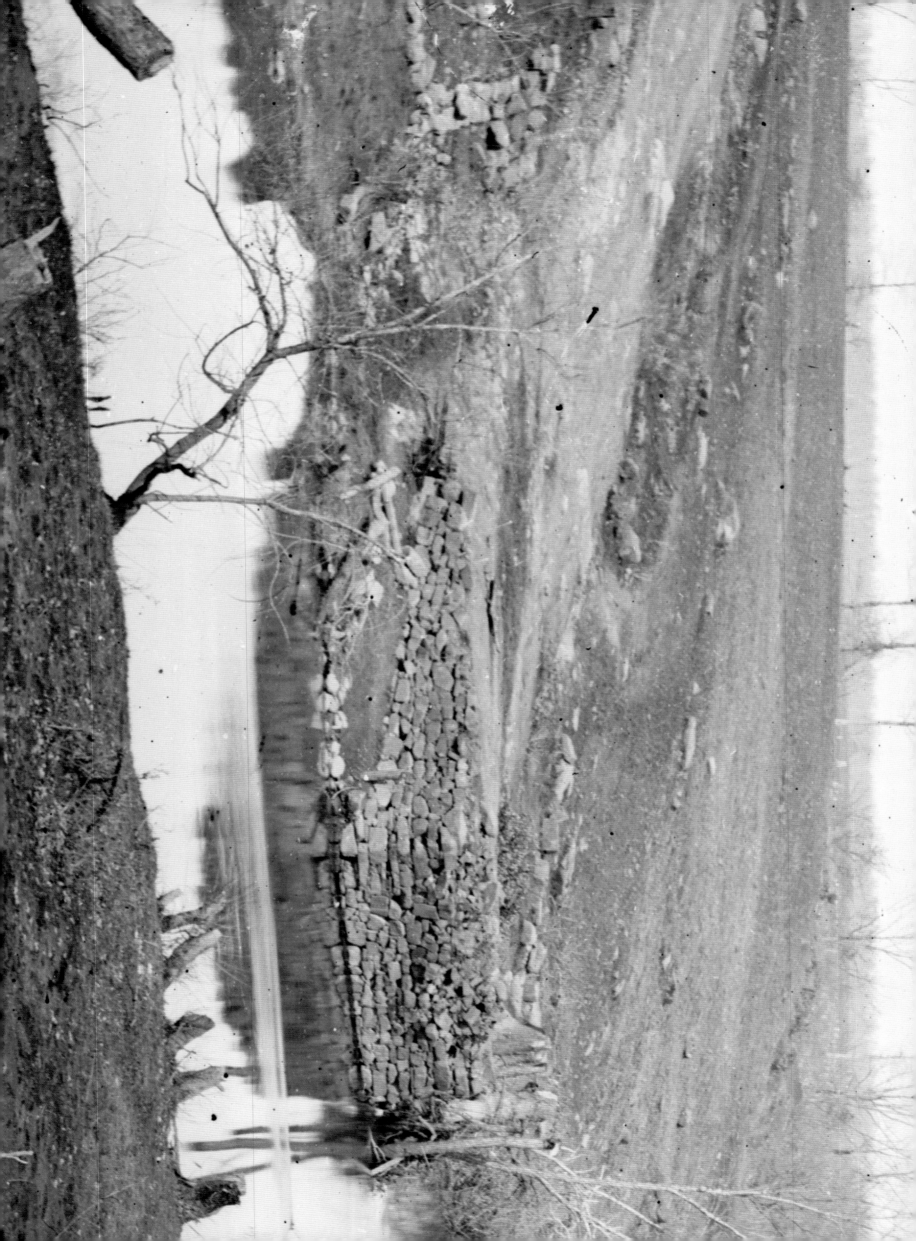

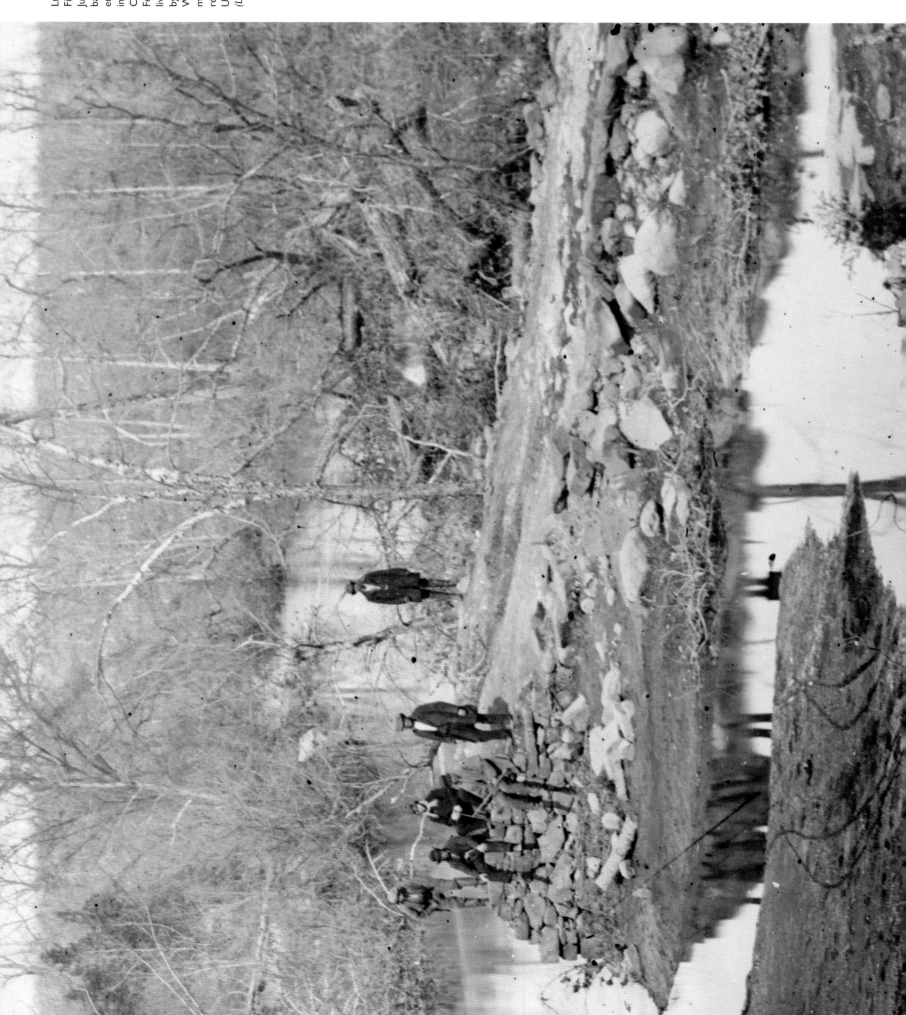

LEFT: Following the Federal defeat in the First Battle of Bull Run (First Manassas), July 21, 1861—indeed, the first major land battle of the war—Union soldiers and engineers ponder how to repair the important bridge at Cub Run Creek, in Centreville, Virginia. It was here that the Federal forces panicked and ran for their lives when a Union wagon was overturned by artillery on the bridge. With Washington, D.C., only about twenty-five miles away, the Federal forces' ungainly retreat was watched by citizens of the Union's capital..
(Library of Congress)

MATHEW B. BRADY

RIGHT: Ruins of Hazall's Mills, Richmond, 1865. Little is known of what was manufactured there, but Rebels were intent on destroying it before Federals could take control.
(Library of Congress)

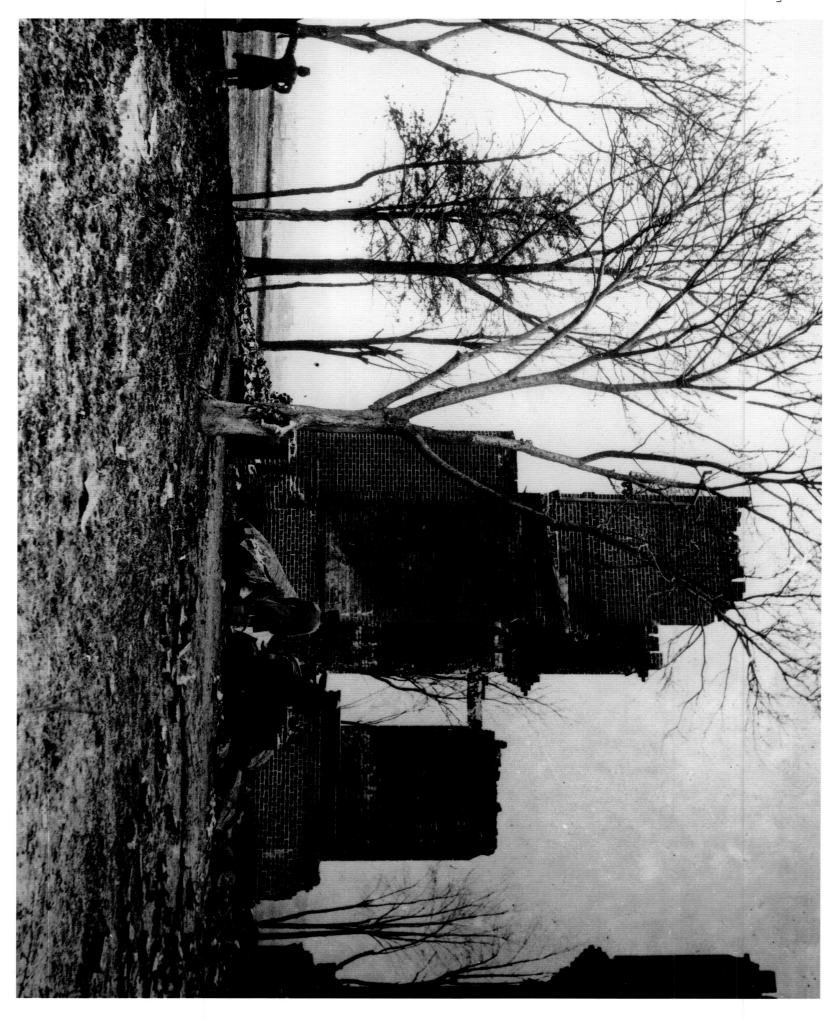

RIGHT: Ruins of the Phillips House, Fredericksburg, Va., 1862. Gen. Ambrose Burnside seized the home and used it as headquarters during the battle. Standing in despair, the house's previous incumbents were rendered homeless refugees. (National Archives)

LEFT: The North Eastern Railroad Depot, Charleston, S.C., 1865, after Rebels had rendered it useless to oncoming Union forces.
(Library of Congress)

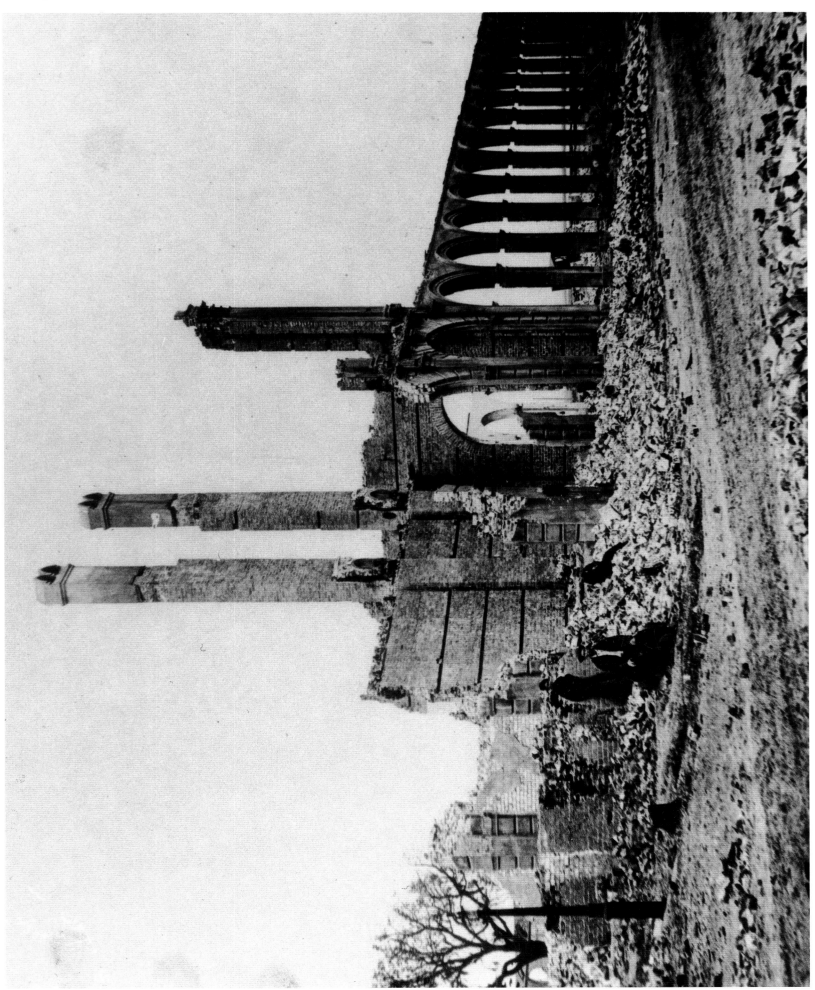

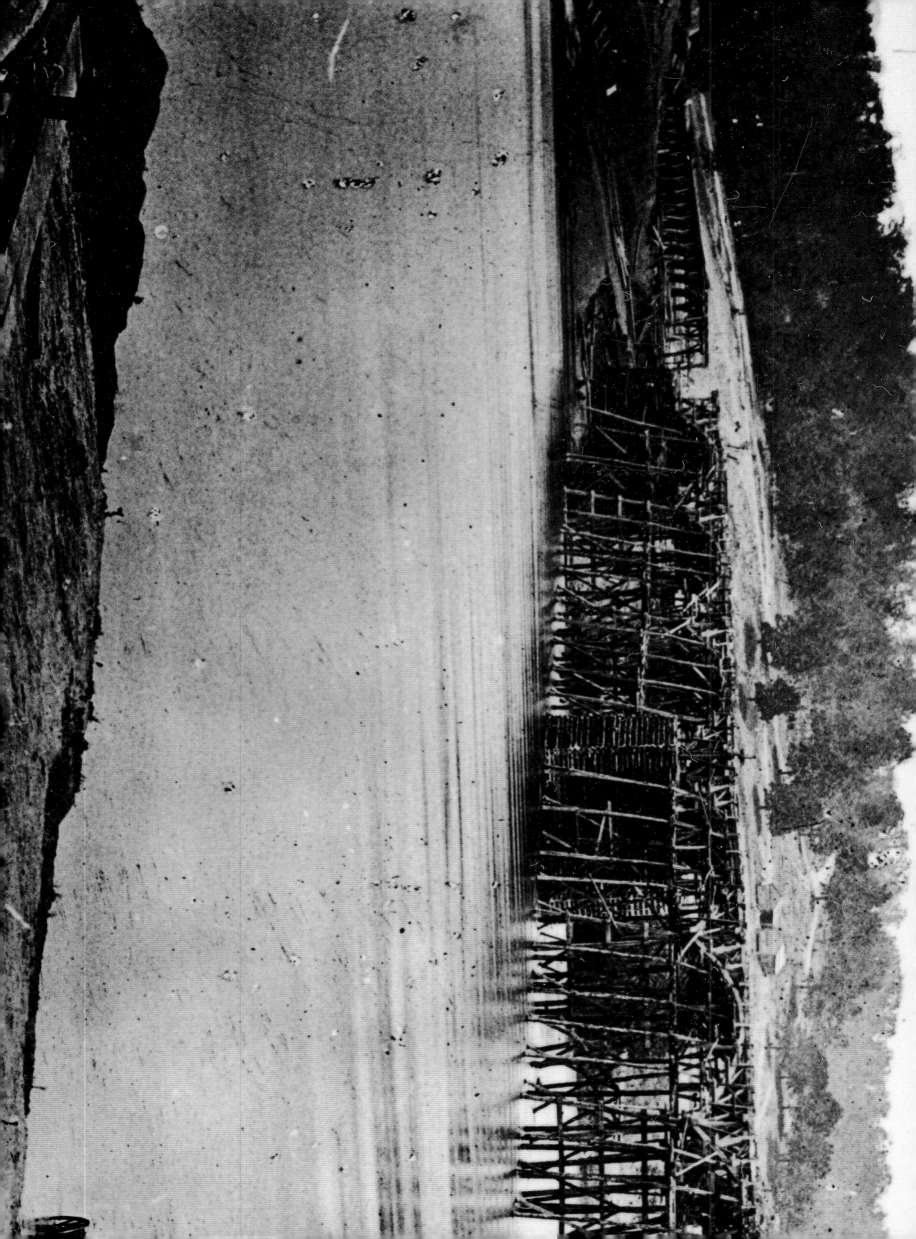

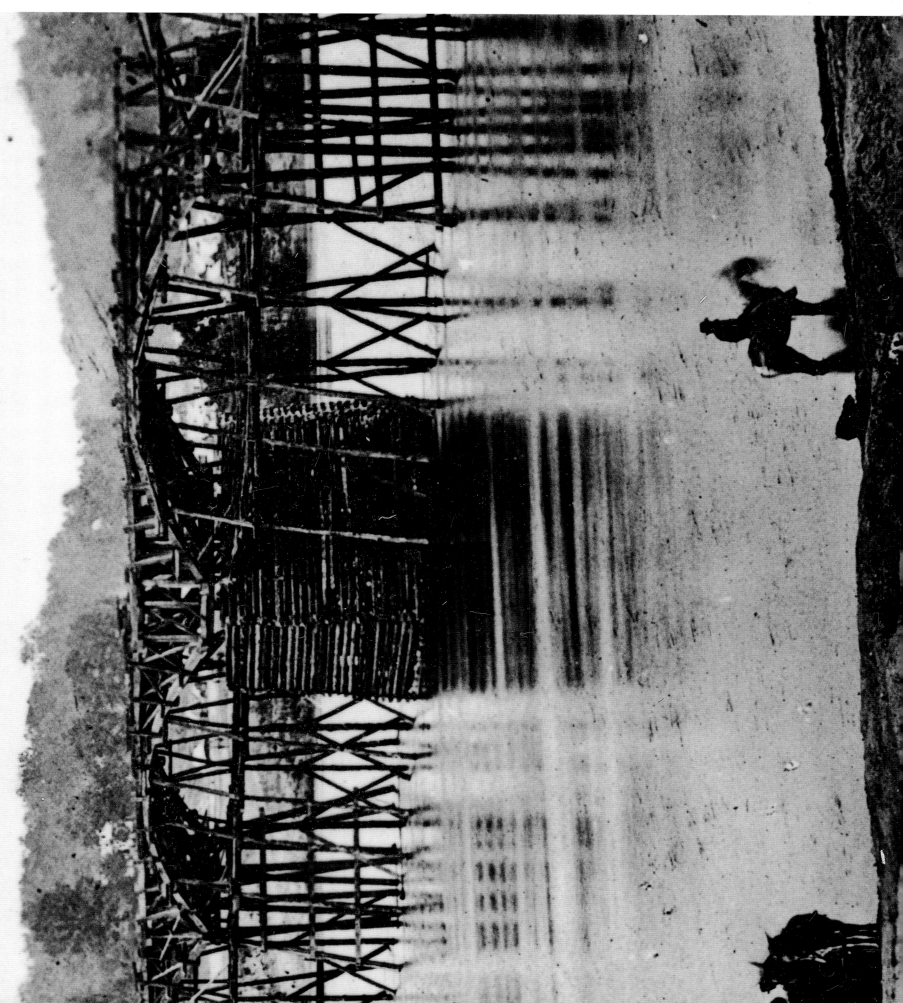

LEFT: Federal engineers had to carry out hasty repairs to this bridge over the Cumberland River, near Chattanooga, Tenn., which had been damaged by a Confederate demolition crew.
(Library of Congress)

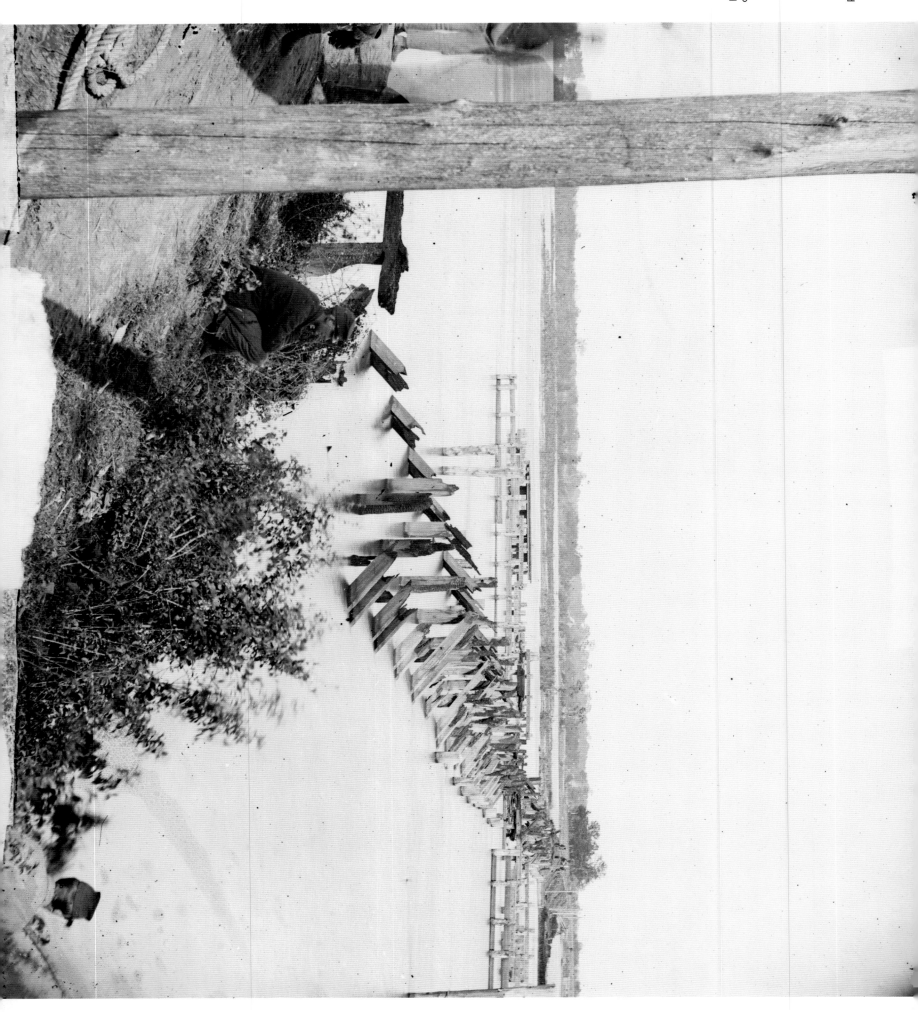

RIGHT: Ruins of a bridge on the Richmond & York River Railroad, Virginia, in May 1862, destroyed so that it would be of little or no use to the enemy.
(Library of Congress)

FAR RIGHT: This photograph, made by Brady's associate George N. Barnard in March 1862, shows the damage caused to part of the Orange & Alexandria Railroad by retreating Confederates.
(Library of Congress)

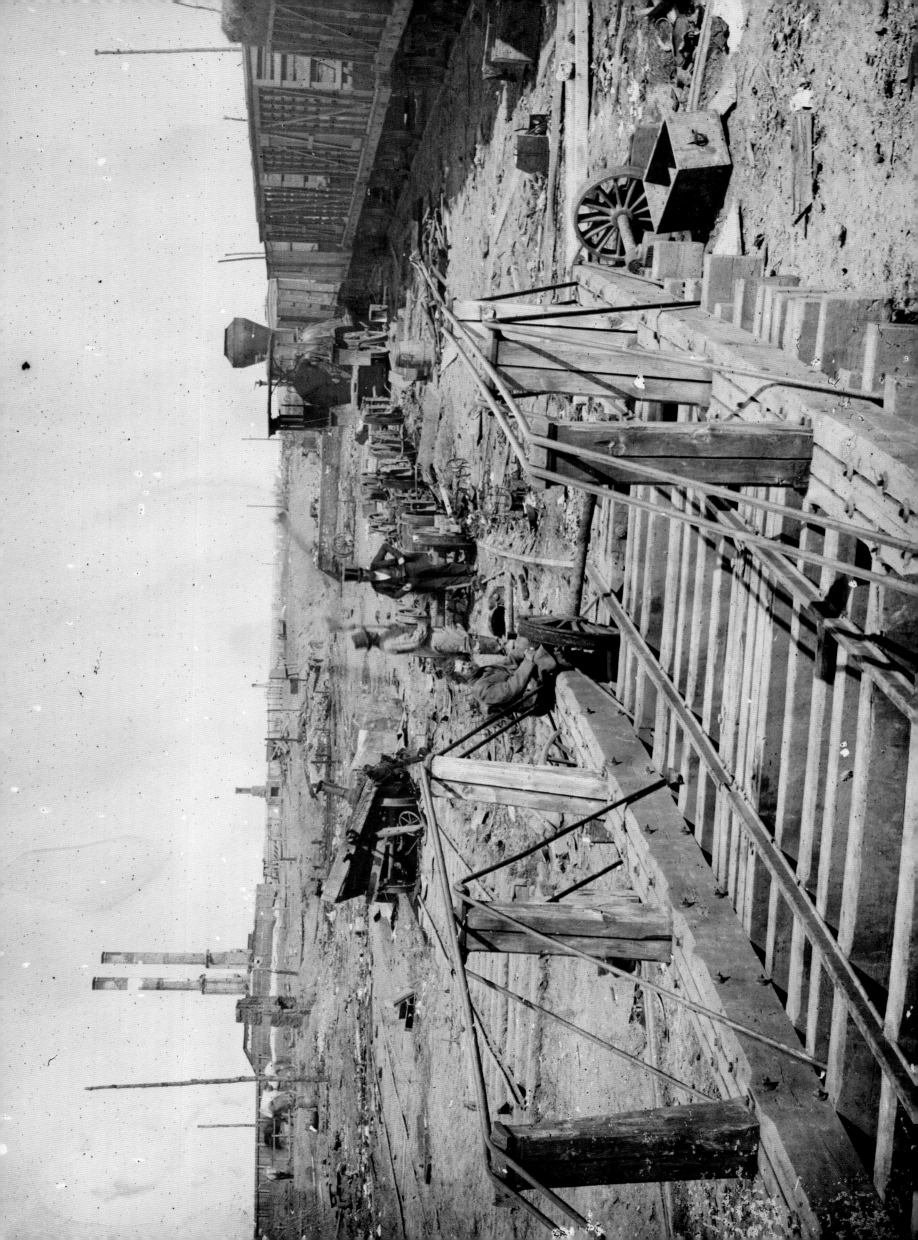

LEFT: The empty shell of the ruined and abandoned Virginia State Arsenal in Richmond, looking down onto the James River in the background. The bleakness of the image is exacerbated by having cracks in the photographer's plate glass negative. (*Library of Congress*)

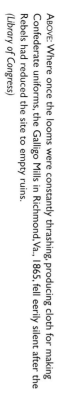

ABOVE: Where once the looms were constantly thrashing, producing cloth for making Confederate uniforms, the Galligo Mills in Richmond, Va., 1865, fell eerily silent after the Rebels had reduced the site to empty ruins.
(Library of Congress)